Cross-Media Promotion

PETER LANG
New York • Washington, D.C./Baltimore • Bern
Frankfurt am Main • Berlin • Brussels • Vienna • Oxford

Jonathan Hardy

Cross-Media Promotion

PETER LANG
New York • Washington, D.C./Baltimore • Bern
Frankfurt am Main • Berlin • Brussels • Vienna • Oxford

Library of Congress Cataloging-in-Publication Data

Hardy, Jonathan.
Cross-media promotion / Jonathan Hardy.
p. cm.
Includes bibliographical references and index.
1. Mass media–Marketing. 2. Product placement in mass media.
3. Mass media–Economic aspects. I. Title.
P96.M36.H37 302.23–dc22 2009029351
ISBN 978-1-4331-0146-5 (hardcover)
ISBN 978-1-4331-0137-3 (paperback)

Bibliographic information published by **Die Deutsche Nationalbibliothek**.
Die Deutsche Nationalbibliothek lists this publication in the "Deutsche
Nationalbibliografie"; detailed bibliographic data is available
on the Internet at http://dnb.d-nb.de/.

The paper in this book meets the guidelines for permanence and durability
of the Committee on Production Guidelines for Book Longevity
of the Council of Library Resources.

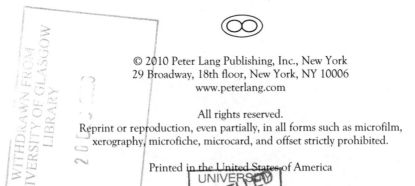

© 2010 Peter Lang Publishing, Inc., New York
29 Broadway, 18th floor, New York, NY 10006
www.peterlang.com

Printed in the United States of America

Contents

Abbreviations

ASA	Advertising Standards Authority
AVMSD	Audiovisual Media Services Directive
BBC	British Broadcasting Corporation
BSkyB	British Sky Broadcasting
CMO	cross-media ownership
CMP	cross-media promotion
CPBF	Campaign for Press and Broadcasting Freedom
CPE	critical political economy
CoE	Council of Europe
DCMS	Department for Culture, Media and Sport
DG	Directorate Generale
DGFT	Director General of Fair Trading
DNH	Department for National Heritage
DTI	Department of Trade and Industry
DTT	digital terrestrial television
DTV	digital television
EC	European Community/ also European Commission
EU	European Union
ECJ	European Court of Justice
ECHR	European Convention on Human Rights
EFJ	European Federation of Journalists
FCC	Federal Communications Commission
FTC	Federal Trade Commission
HFSS	High in fat, sugar or salt (foods and drink)
IBA	Independent Broadcasting Authority
IFJ	International Federation of Journalists
IPTV	Internet protocol television
ITA	Independent Television Authority
ITC	Independent Television Commission
ITV	Independent Television
MMC	Monopolies and Mergers Commission
NBC	National Broadcasting Company

NI	News International
NvoD	near video-on-demand
OFCOM	Office of Communications
OFT	Office of Fair Trading
PCC	Press Complaints Commission
PP	Product placement
PPV	pay-per-view
PSB	public service broadcasting/broadcaster
RCP	Royal Commission on the Press
TUC	Trades Union Congress
VOD	video-on-demand

Acknowledgments

I would like to thank all those who gave generously of their time to answer my questions and all those colleagues, fellow researchers and students who have provided a vital mix of advice, encouragement and example. I am very grateful to all those who commented on earlier incarnations or sections of this work including Des Freedman, Peter Goodwin, Tom O'Malley, David Hesmondhalgh, Janet Wasco, Daya Thussu, Julian Petley, Granville Williams, Pat Holland, Barry White, Mark Wheeler, Chad Raphael, Andrew Blake, Matthew McAllister. I would like to thank those who agreed to be interviewed for studies in this book, especially Michael Begg, Ian Blair, Lord Borrie, Robin Foster, Tim Gopsill, Jane Reed, John Sadler, Mike Smith, Raymond Snoddy, Irwin Stelzer, and Richard Tait. I wish to thank my colleagues at the University of East London, at Goldsmiths College, London and in the Campaign for Press and Broadcasting Freedom. Mary Savigar at Peter Lang has been creatively engaged throughout and I am deeply grateful for her contribution and support. I would especially like to thank my doctoral supervisor Professor James Curran for his enduring generosity, guidance and vision. Jessica and Sean were both born during the early stages of research for this book. For them, for everything, I thank Gill, the greater maker.

Foreword

Viewers of the February 3, 2009, US broadcast of the NBC television program *30 Rock* were treated to an 'exclusive preview' of the Universal film *Land of the Lost*, not due in theaters for another 3 months. Immediately following the opening credits of that week's episode, the 90-second segment was sandwiched (so to speak) between two sponsorship tags ('Brought to you by . . . ') from Subway, the fast-food chain that also was product-placed in the movie. The beginning of the 'preview' presents Will Ferrell's character from *Land of the Lost* interviewed by the real-life NBC morning-talk-show-host Matt Lauer on *The Today Show* set, with textual authenticity established by the use of the actual announcer, musical riff and graphics that introduce *The Today Show*. (A longer version of this scene also appeared in the movie.) Viewers are told at the end of the segment that 'Subway brings you more *Land of the Lost*, at nbc.com/subway'. Perhaps serendipitously, but weirdly revealing, Lauer also appeared as himself later in this particular episode of *30 Rock*, complaining when having to compromise his newscast at the insistence of the faux-GE executive on the program, Jack Donaghy, played by Alec Baldwin. And the final indignity? As summer reviews indicated, *Land of the Lost* as a movie stank. Lauer, however, received good reviews.

This example, one of literally dozens—if not hundreds—of large-scale media campaigns from that year, illustrates many of the trends and dangers that are the focus of Jonathan Hardy's important and comprehensive examination of media promotion. The above-described promotional segment exemplifies the commercialization of entertainment via a fast-food company's sponsorship and product placement in a major Hollywood film; the use of the Internet to bring expanded promotions (illustrated by the web address's combination of media company and advertiser); the involvement of corporate synergy, given that *30 Rock*, *The Today Show* and *Land of the Lost* are properties of NBC-Universal; the blurring of iconography and textual forms that are often bizarre hybrids of promotions, advertisements, news and other feature segments (in this case, an example of Sponsored Synergistic Fake-Journalism Promotainment?); and the cooptation of news personnel and resources to promote entertainment properties—a Fourth-Estate involvement that Hardy labels as generating 'the most disquiet of all forms of cross-promotion'.

Hardy discusses all of these issues of cross-media promotion, and more, in this book. Critics of media commercialism (and the steroid version, hyper-

commercialism) often use as exemplars of such trends the influence of adver-
tisers who are outside of the media industries: soft-drink, beer, automobile,
soap, and retail outlets brands, among others. But, as Hardy points out, corpo-
rations such as Time Warner, Disney and News Corp are not just media
companies that accept money to advertise such non-media brands. They also,
increasingly, have their own brands to sell. They are major spenders of adver-
tising dollars while also simultaneously being major receivers of advertising
dollars. And because they own media outlets, they can promote their products
in their other media products without spending money on advertising *per se*.

Media promotions are at the 'forefront' of the breaking of traditional ad-
vertising taboos that serve as barriers to the invasion of large-scale corporate
promotion in our lives. *The Los Angeles Times* attracted criticism in April 2009,
for example, not just because it accepted a front-page ad for the LA-based TV
program *Southland*, but because that ad was designed to look like a newspaper
article about the program, albeit with a small 'Advertisement' disclaimer
(Clifford, 2009a). Despite the criticism, it accepted a similar tactic by covering
its front page in June 2009 with a giant ad for the HBO program *True Blood*
(Associated Press, 2009). In another print medium, the covers of magazines
have featured ads for media brands, such as 'pull-out' inserts in the cover of
Entertainment Weekly for the ABC program *The Unusuals*, and *US Weekly*'s faux
cover for HBO's *Grey Gardens* (Clifford, 2009b). Fan fiction and video mash-
ups of beloved movies and programs, around for many years and gladly ex-
ploited for promotional purposes by media companies, foreshadowed the use
of 'prosumer' user-generated commercials that have been cultivated by brands
such as Doritos.

Cross-media promotion is one of the most salient characteristics in our
modern media systems, arising out of a context that involves virtually every
level of media studies: media ownership, advertising and funding, technologi-
cal trends, and regulatory issues—the last a specialty of the author of this book.
These factors often work together, and Hardy is masterful in interweaving in
an insightful but accessible way the complexity of media promotion. So, for
example, media are not just looking to "monetize," and thus promote, televi-
sion programs because new technologies such as DVDs and other digital
versions allow these programs to be more easily sold directly to the public than
in the past. These changes are also occurring as new promotional outlets such
as websites are exploited; as advertising revenues shift from traditional media
such as newspapers (perhaps a fatal shift in this case) to digital media; as
changes in regulation facilitate corporate maneuvering; as media companies
attempt to reach global markets; and as shifts in ownership facilitate partner-
ships among producers, distributors and advertisers.

Serving as our guide through a complex landscape, Hardy is careful to highlight the most important landmarks and the changing nature of media topography. In addition to in-depth discussions of the different elements that influence media promotion (financing, ownership, regulation, technology, textual characteristics and genres), he also walks us through different theoretical perspectives on these changes, from the functional to the radical. He works hard at not essentializing media promotions as all the same, careful to make distinctions between different historical moments, different media, different funding systems, different genres (news vs. fictional entertainment, for example), different geographic/cultural contexts, and different regulatory environments. He also negotiates exploring general trends with in-depth specific case studies to give us both the broad picture as well as how this picture is made visible in our everyday media lives.

Perhaps most important, this book engages head-on with the 'so-what' issues that are crucial in media studies. Why should we care about cross-media promotion? How can we understand changes in media promotion historically, and are even such changes unique to our times? What do such trends mean for our democratic and aesthetic lives? What roles may the state play? And how might we understand our own options in intervening in such trends when we understand them to be destructive?

Jonathan Hardy's *Cross-Media Promotion* provides a framework and analysis that allows us to work through these questions. These questions will only become more crucial as traditional assumptions about how media operate— assumptions that media studies scholars, regulators, advocates and citizens took for granted—are increasingly complicated.

Matthew P. McAllister

Preface

Cross-media promotion is the promotion of one media service or product through another. The phenomenon of media firms cross-promoting their allied media interests has increased dramatically in recent decades. This is linked to broader changes including digitalisation and the technological expansion of multimedia, corporate consolidation and integration, increased commercialism and competition in media markets, changes in regulation, professional media practices and consumption. Convergence and concentration in media and communications industries have generated ever increasing varieties and forms of cross-media promotion. Since the 1980s there has been a marked growth of synergistic practices whereby media firms have sought to maximise profits through the co-ordinated promotion, diffusion, sale and consumption of media products, services and related merchandise. Cross-media promotion (CMP) has thus become a defining feature of media conglomeration and contemporary media. It has been integral to the marketing and diffusion of new media forms and become more widespread and strategically important across all mass media.

This book examines the various forms cross-media promotion takes but also critically explores the 'problems' of CMP from a variety of standpoints. Forms of cross-promotion, this book argues, erode and transgress regulatory and normative boundaries between editorial and advertising, 'independent' and commercially bought or interested speech. Consequently, cross-media promotion constitutes an important element of the challenges for communications regulation in the 21st century.

We are now so far from that world where media companies tended to own discrete media with few having a significant cross-media portfolio. Today almost all national newspapers have online editions; radio stations have a multimedia presence, and branded media content is repurposed across a variety of media formats and merchandising forms. There has been enormous change. But there is value in combining an examination of contemporary practices with an archaeological investigation that examines how CMP was conceived, addressed and problematised by those who engaged with it—policy-makers and regulators, those working in industries affected, scholars and researchers, commentators and journalists, civil society groups and publics. In particular, this book traces cross-media promotion from the late 1980s when

policy makers and regulators grappled with multimedia expansion and intensifying cross-media ownership.

The trends examined here are evident, albeit unevenly, across almost all media systems. However, this book focuses mainly on two media systems, the United States and the United Kingdom. America is chosen as the best place to observe the dynamics of cross-media promotion in an advanced, market-driven, commercialised media system. The United Kingdom is a media system in transition, from one that has been highly regulated, and with a strong public service tradition, towards a more liberalised and marketised one. The UK is thus also a good place to look at policy responses. Examining both the US and UK provides a valuable comparative dimension in which to address key topics which this book explores: the conditions in which CMP has developed; the dynamics of industry practice; the changing role and influence of regulation as well as considerations for media reform. The book integrates three areas of study: media practices, media policy and media theory.

This book is organised in four parts. Part one introduces cross-promotion and the main arguments of the book. This first chapter considers how cross-promotion has developed across converging media industries in the United States and describes the conditions that have given rise to synergistic cross-media promotion. Chapter two establishes the nature of the 'problem' of cross-promotion according to key paradigmatic perspectives on media power (neoliberal, liberal, consumer, postmodernist, libertarian and critical political economic).

Part two examines cross-promotion in different genres: in entertainment media and news media. Chapter three examines synergistic promotion and commercial intertexuality for such megabrands as Harry Potter. It also reviews approaches to intertextuality and transmedia storytelling and considers both critical differences and grounds for synthesis between culturalist and critical political economic perspectives. Chapter four explores cross-promotion in news media. The focus of this chapter on US media is complemented by a study of CMP in UK newspapers. Chapter five investigates how papers owned by News International (NI), a wholly owned subsidiary of News Corporation, cross-promoted SkyDigital in which News Corporation had a 40 per cent controlling share.

Part three examines the regulation of cross-promotion though various case studies and in the broader context of changes in media markets and communications policies from the late 1980s to the present. Chapter six examines how cross-media promotion has been addressed in the regulation of broadcasting, print publishing, advertising, new media, and in competition and consumer law. The chapter focuses on media policy and regulation in the United

Kingdom, including relevant European regulation, and compares the UK with the United States. The chapter traces the ways in which cross-media promotion has been constituted as an object of policy. It shows that each of the various regulatory tools and each main institutional approach, developed historically for discrete media sectors, has largely neglected cross-media promotion as a problem for regulation to tackle. This chapter also assesses the significance of the first attempt to establish rules governing cross-promotion in the *Enquiry into Standards of Cross-Media Promotion* (Sadler 1991).

Chapter seven examines the industry dynamics of cross-media promotion in fiercely competitive digital television markets in the UK. It then addresses regulatory responses towards cross-promotion in digital television and related audiovisual services from the 1990s to the present. Chapter eight focuses on product placement and product integration in broadcasting. The integration of commercial references in programme content has been strictly regulated in the UK. UK and European television regulation has upheld the principle of separation of editorial and advertising, but in 2008, under pressure from a powerful coalition of commercial media and advertising interests, European rules were changed to allow product placement. This chapter compares industry practice, regulatory responses and wider policy debates in the United States and the UK.

Part four develops critical arguments and policy proposals. The concluding chapter examines a variety of policy proposals and alternative responses to cross-media promotion associated with the key traditions introduced in part one.

This book argues that cross-promotion is one of the key practices that are eroding and transgressing regulatory and normative boundaries between editorial content and advertising. Aggressive corporate CMP, it argues, threatens the foundations for culturally diverse and democratic media systems. Cross-promotion is an important aspect of the broader controversies generated by media commercialism and marketisation, conglomeration and synergy. The policy challenges arising from cross-promotion also highlight more deep-seated problems and contradictions within current systems of converging media regulation.

Contexts

Dynamics and Varieties of Cross-Media Promotion

Cross-media promotion takes an increasing variety of forms including cross-platform advertising, the synergistic marketing of mega-brands such as Harry Potter or Disney products, promotional plugs in news programmes, repurposing media content, stars and brands across other media and outlets, product placement and integration of media content and advertising. Cross-media promotion (CMP) has been integral to the marketing and diffusion of new media forms and has become more widespread and strategically important across all mass media. Major changes in media systems including increasing concentration of ownership, integration of firms and convergence of industries, digitalization and marketisation have influenced the scale and scope of cross-promotion and its myriad evolving forms. Altogether, these changes have led to cross-media promotion becoming one of the defining features of corporate media in the 21st century. This chapter focuses on the American media system since the factors giving rise to CMP, and the resulting forms, are most advanced and evident there. The United States best illustrates the trajectory and tendencies of cross-media promotion across advanced media systems.

Defining Cross-Media Promotion

Marketers use the term cross-media promotion to describe any promotional campaign that uses more than one medium. There is nothing new about the promotion of brands across more than one medium. The term, cross-media promotion, however is used by marketers to refer to a planned promotional strategy in which multiple media are used to promote a product or service. According to this broad definition the term media refers to any sign-carrying vehicle including packaging and point-of sale promotional materials. There is a second more specific use of the term. Following Sadler (1991: 1), I use cross-media promotion to refer to any way in which media companies 'promote

their own or any associate's interests in the provision of media services or products'. As it is this activity that is the principal focus of this book I use cross-media promotion (or CMP) to refer to the promotion by media of allied media and other interests. For clarity, cross-media campaigns by advertisers or their agents are best described as cross-media marketing.

Another general term used by marketers is cross-promotion, which refers to any joint promotion involving two or more companies. Cross-promotions involving media content and third-party brands have increased in 'frequency, visibility and sophistication' argues McAllister (1996: 137–8) who describes how marketers have sought out cross-promotional deals with entertainment companies for tie-in promotions with films. This book focuses on the increase in self-promotion and cross-media promotion in media content. But it argues that cross-promotion must be understood in the broader context of media and marketing practices. In particular, CMP must be located within the dynamic interpenetration of media content and merchandising, entertainment and shopping, editorial and advertising, whose various hybridising forms have prompted industry-coined neologisms such as 'infotainment', 'advertainment', 'promercials', 'merchantainment', and 'content cobranding'.[1]

Forms and Varieties of Cross-Media Promotion

There are eight principal ways in which media companies promote their own media products, services or identities. The first is designated media advertising, that is advertising that is recognisable as such and which is usually subject to regulations governing form, content and placement. The other forms are sponsorship; cross-promotion through merchandising and licensing; product placement and brand integration; advertorials; channel/programme promotions: self-promotion and cross-promotion; editorial (or 'in-programme') self-promotion; editorial cross-promotion.

One of the most discussed forms of CMP arises from the synergistic marketing of entertainment mega-brands such as Spiderman or Harry Potter. Synergy describes a strategy whereby corporations cross-promote their own stars, programmes and merchandise across their various media outlets (Andersen and Strate 2000:5).

Eileen Meehan (2005) breaks down such synergy into five main tactics or 'behaviours': recirculation, repackaging, reversioning, recycling, and redeployment. Importantly, for Meehan all of these describe the strategies of firms, but they also involve different relations of control and agency between firms, fans and users. Examples of *recirculation* include re-running cinema-release films on

television. Here media firms control the movement of a product across media outlets. With *repackaging* (for instance, releasing a film and added content on DVD or online retail) viewers have greater agency. *Reversioning* includes remaking older content or creating new versions. Discussing the synergistic promotion of Star Trek to fans, Meehan (2005: 98–99) describes such reversioning as Viacom's packaging of special edition boxed sets of the original movies with directors' cuts to generate new revenue and 'must have' purchases for fans. *Recycling* involves the reuse of an artefact in the creation of a second; while in *redeployment* 'the symbolic universe encapsulated in one intellectual property is used to create a new property that is both dependent on and removed from the original' (Meehan 2005: 104). The example she gives is the redeployment of Star Trek in four TV brands: *The Next Generation, Deep Space Nine, Voyager,* and *Enterprise.*

The repackaging or repurposing of content across different media involves various forms of connected promotion. It is important to note that these are not limited to intentional acts or forms of promotion but can occur wherever meanings are created. Synergy involves forms of connection between media content that are usefully captured in such notions as intertextuality and branding that are examined in chapter three. To use Wernick's (1991: 101) term, 'promotional reflexivity' need not arise from promotional tactics or behaviours alone. However, this book does focus on the cross-promotional activities of media organisations. Here, three main kinds can be distinguished for analytical purposes: advertising, promotions, and editorial.

Media firms can cross-promote by arranging for their advertisements to be carried by other media. Where this is a transaction between separate economic entities, this is inter-firm advertising. Usually, this involves payment of fees to place the advertisement, although there may be other reciprocal arrangements instead. When media firms advertise in outlets that are linked by ownership then we can speak of intra-firm advertising. Such advertising may be offered free or at discounted rates and this can generate competition concerns about fair access and rates from rival firms. The second form is promotions. Broadcasters engage in station or corporate promotion and programme promotion. Promotions for allied channels, content or media services are all forms of CMP and have tended to increase significantly in the period examined here. On television and radio, channel promotions generally take place between advertising and programmes. The term editorial promotion captures cross-promotion that is integrated into media content itself. How a media firm covers its allied media interests is the central topic of this book. This can take the form of a newspaper article or TV news programme that cross-promotes allied entertainment content. It can involve how media firms cover themselves

and their business activities in news reporting. The various forms of editorial cross-promotion raise different sets of concerns, and this book seeks to explore both the practices themselves and different perspectives on the 'problems' they represent. For Sadler (1991: 4) 'Promotion of one media service or product through another should be taken to include, although not exclusively, favourable or unfavourable reporting or editorial comment about their own, their associate's or their competitor's media services and products'

Another form of editorial promotion arises from product placement. In most cases this is inter-firm but can also be intra-firm. More broadly the integration of editorial and advertising is examined as an integral aspect of CMP. One of the reasons it is useful to draw distinctions between advertising, promotions and editorial is that there are often important distinctions in how these have been treated in regulation as well as in firms' practices. This book argues that cross-media promotion raises a variety of problems that regulation has largely failed to address and needs to address. However, this argument is based on identifying problems connected to specific practices of cross-media promotion, as different practices give rise to different critical concerns.

Advertising in films and merchandising around films have provided extensive and sophisticated forms of cross-promotion. Many scholars have analysed the processes of commodification whereby film represents not only a commodity in itself but also serves as an advertising medium for other commodities and generates additional commodities (Wasco 1994; Miller 1990; McAllister 1996, 2000; Schatz 1997; Meehan 1991). Conglomerates have also exploited opportunities to cross-promote film across their other media outlets. It is now common for all 'event' films to have their own website as well as soundtrack CD, related publishing ventures, merchandising and cross-promotional deals. Croteau and Hoynes (2006: 118–120) describe the enormous number of products and promotion that accompanied *Titanic*, a co-production of Twentieth Century Fox studios (owned by News Corporation) and Paramount Pictures (owned by Viacom). Both conglomerates exploited their other media outlets. News Corporation, used its television network Fox to cross-promote the film via programmes on 'the making of . . . ' and specials such as *Titanic: Breaking New Ground*. Viacom could 'in effect, run commercials for the film on MTV' by featuring a Celine Dion music video of the theme music (Croteau and Hoynes 2006: 125). McAllister (2000: 109) cites stories about twisters featured on the covers of *Time* and *Entertainment Weekly* in the month Time Warner, which owned both, launched the film *Twister*.[2] Such deals show conglomerates' strategic use of intra-firm promotion examined further in chapters three and four.

The 'movie franchise' displays most vividly the blurring of distinctions between entertainment and shopping, programming and promotion, media content and advertising (See Schatz 1997: 96; Andersen 2000: 7). Moreover, these practices have been largely normalised in entertainment business strategies, although not without opposition from some media workers and from public interest advocacy groups, and, as this book also shows, there have been strong countervailing traditions especially within news journalism.

Media Commercialism and the Intensification Thesis

Those scholars who have examined promotional content in either entertainment or news media from critical perspectives generally agree that cross-promotion has intensified since the 1970s (Turow 1992a; Balasubramanian 1994; Bagdikian 1997; Bogart 2000; Wasco 1994; McAllister 1996; Andersen 1995; Andersen and Strate 2000; Herman and McChesney 1997; McChesney 1999, 2004). At the same time, many proponents of what may be called the intensification thesis are also careful to point out the longer historical continuities and discontinuities regarding cross-media promotion. At its best, this work has brought a long-range historical and analytical perspective and resisted the tendencies to presentism, and autonomisation, in media analysis. Scholars have identified how various factors have led to a return and reworking of promotional practices which dominated the early years of radio and television broadcasting in the United States, such as advertiser influence through programme sponsorship, in-programme promotions and product placement and plugola (Wasco 1994; Smulyan 2001). Baker (1994: 105) notes, for instance, how programme-length commercials and product placement are 'basically identical' to the paid 'reading notices' which appeared in American newspapers at the turn of the century. Another approach has been to identify the close and enduring relationship between promotional and media content in both news and entertainment media, against either ahistorical idealisations of media performance, or generalised accounts of commercialism (see McQuail 1992; Curran 1977).

Another example is Balasubramanian (1994), who examines what he calls 'hybrid messages', publicity messages carried within media (editorial) content. Hybrid messages combine the element of control derived from paid promotions with the credibility and expectations of independence and 'objectivity' associated with much media content.

Viewed from the sponsor perspective, both advertising and publicity have shortcomings. That is, neither advertising nor publicity provides the desirable "benefit-mix" whereby the sponsor retains control over the message while the audience perceives the message as credible. This could explain the growing popularity of another distinct genre of marketing communication which promises this benefit mix. Communications in this genre can be characterized as hybrid messages because they creatively combine key elements from the definitions of advertising and publicity (i.e., they are paid for and do not identify the sponsor) such that their respective advantages are consolidated, and their shortcomings are avoided (Balasubramanian 1994: 29–30).

Balasubramanian distinguishes between established and emergent types of hybrid messages. Established varieties include product placement, programme-length commercials (PLCs, also known as 'infomercials') and programme tie-ins. Typical examples of tie-ins are arrangements for advertisers to buy ad spots surrounding a broadcast programme in exchange for product exposure within the programme.

Balasubramanian cites the example of a Coke vending machine displayed in a CBS network show *TV 101*, in return for a promise from Coca-Cola Corporation to advertise heavily around this program (Balasubramanian 1994; see also McAllister 1996). Emergent types include 'masked-Art', 'masked-news' and 'masked-spokespersons'. Balasubramanian (1994: 35) finds 'a common evolutionary pattern for established hybrid messages: they existed in some rudimentary form prior to the 1970s, experienced a hiatus or low growth in the 1970s, and re-emerged or grew substantially in the 1980s alongside emergent hybrid communications'.

In contrast to such historically grounded accounts, there is a marked tendency in postmodernist readings to perceive promotional speech, reflexivity and intertextuality to be intrinsically embedded, at least in contemporary media discourses (see Carpini and Williams 2001). As this book argues, such approaches may be criticised, in particular, to the extent that they ignore changes in the regulatory and political-legal frameworks governing media speech and conduct over recent decades. The intensification thesis needs to be enriched by what is often lacking, detailed empirical case studies and longitudinal and comparative studies. The history of CMP is contiguous with that of media and advertising, as media products and forms become topics for other media discourse and become a source for advertising and promotion. But the configuration of market, regulatory, organisational and ideational forces that constrained cross-promotion has changed, as we now consider.

Dynamics of Cross-Media Promotion

Cross-media promotion has increased as a result of a mixture of opportunities and imperatives facing media firms in rapidly changing market environments. The main factors influencing CMP practices can be summarised as follows: media integration and conglomeration; rising costs and competitive pressures in media and entertainment industries; corporate synergy strategies; competitive and creative media marketing and branding strategies; changing media and advertiser relationships; technological changes, in particular digitalisation and convergence; changes in regulatory conditions; broader changes in retail, merchandising and marketing; changes in user behaviour and attitudes; and shifts in the professional ideology and organisational practices of media professionals in various converging sectors.

Media ownership, concentration and integration

The condition for most strategic cross-media promotion is mutual economic interest. Media concentration and the corporate integration of firms provide conditions for CMP to thrive. CMP certainly occurs between separate, competing firms, particularly through advertising, merchandising or product licensing agreements, but the opportunities for cross-media promotion are enhanced when two media companies are owned by the same parent company (McAllister 2000: 109). Moreover, the opportunities for synergistic cross-promotion have been widely cited in corporate literature as amongst the central objectives for media mergers.

Different patterns of ownership have tended to prevail in different media industry sectors and across different markets. Into the 1980s the prevailing pattern in most media sectors was mono-media operation and expansion. Most media firms tended to provide one kind of media—whether newspapers, magazines, television or radio broadcasting. When they expanded, firms usually acquired other companies providing the same media. This is referred to as horizontal integration, the process by which one company buys others in the same sector and at the same level of production as the acquiring company. Horizontal growth occurs where two firms engaged in the same activity combine forces, usually through acquisition, takeover or merger. This process is evident in the 'chain' ownership of US newspapers in the late nineteenth century. There is no necessary connection between horizontal expansion and market concentration. However, when a firm attempts to secure as large a market share as possible the 'successful' outcome is greater concentration. The UK national press, for instance, remains dominated by a handful of firms; the

10 titles are owned by seven large media companies, all with substantial other media interests. The top four companies control nearly 90% of the total market.

Multisectoral and multimedia integration is a process by which firms acquire other businesses involved in different kinds of cultural industry production (Hesmondhalgh 2007: 22). Such multimedia integration provides the conditions and incentive for CMP to thrive as 'media conglomerates assemble large portfolios of magazines, television stations, book publishers, record labels, and so on to mutually support one another's operation' (Croteau and Hoynes 2003: 41–43).[3] Multimedia integration long pre-dates the corporate consolidations of the 1980s and beyond. The production of art, information and communication has involved the combination and recombination of different forms of 'media'. Music videos, for instance, were an important precursor for the expanding range of multimedia commodities found today (Goodwin 1992). Producers have combined emergent, as well as dominant or residual, media production for reasons including risk-reduction and diversification that remain as pertinent in explaining contemporary firms' strategies today. For instance, the combination of printing, music and spectacle in early modern Europe justifies Briggs and Burke's (2002: 40) provocative claim for the presence of rich 'multimedia communication'. Then, as now, old media forms coexisted with and interacted with 'new' media. Manuscripts survived as major channels for the public circulation of messages into the early modern period (44–46).

There were large capitalist enterprises with diverse media interests from the late nineteenth century. By the 1870s some newspaper companies in the US were amongst the largest manufacturing firms there (Hallin and Mancini 2004a: 203). One entrepreneur, E. W. Scripps (1854–1926), owned the largest chain of newspapers while another, William Randolph Hearst (1863–1951), established a cross-media empire, which by 1918 included 31 newspapers and six magazines as well as cinema and telegraphic services. Multimedia integration refers to the 'tying together within one parent company of different types of media and media-related materials, thus generating synergies'; Wayne (2003: 94) distinguishes this cross-media integration from cross-industry integration where media companies are part of corporations with substantial non-media holdings, such as NBC, owned by General Electric one of the world's largest conglomerates with interests in manufacturing, financial services, medicine and domestic electric appliances.

Vertical integration refers to the acquisition of companies in different stages of the 'value chain' leading from production to circulation and consumption. Economists speak of 'downstream' or 'upstream' integration, for

instance when a company buys a firm that supplies another stage from conception to production, distribution, retail. Again, the process is not new. The Hollywood studio system in the 1920s is the classic example, notable also as a system dismantled in part through regulatory pressure, when the Supreme Court ruled in 1948 that the studios must give up their exhibition operations, and subsequently reconstructed (Schatz 1997). However vertical integration was a major feature of changes in corporate organisation and business strategy from the 1980s.

Into the 1980s, the main industrial pattern tended to be one of mono-media operation and mono-media concentration rather than cross-media expansion. In the 1950s and 1960s many leading media firms, were conglomerates, operating a range of media and non-media businesses.[4] Yet, few had major holdings in more than one of the main forms of 'mass' media. Bagdikian, in his preface to the 1997 edition of *The Media Monopoly*, noted:

> Only fifteen years ago, it was possible to cite specific corporations dominant in one communications medium, with only a minority of those corporations similarly dominant in a second medium (Bagdikian 1997: xxv).

During the early and mid-20th century, the different media industries tended to function autonomously, 'having their own revenue streams, trade organizations, media technologies, dominant companies, and regulatory environments' (Proffitt et al. 2007). By the end of the 20th century the dominant model was increasingly that of large scale integrated conglomerates. Since the mid-1980s there has been a relentless phase of concentration in multimedia companies and merger mania. In 1999, for instance, 72% of media companies operating in Europe were involved in some form of merger or acquisition activity. Jin (2008: 363) identifies 3,467 mergers and acquisitions worldwide in the newspaper industry alone between 1983–2005. The growth of media companies has very often involved acquiring other media firms to form ever-larger conglomerates (Sánchez-Tabernero et al. 1993: 94).

It has been argued that trends in Western media 'illustrate more commonalities than differences with regard to business practices among the nations' (Albarran and Chan-Olmsted 1998: 331). Central to these trends has been the growth of large media corporations that have exploited new opportunities to establish multiple media ownership nationally and to transcend national boundaries in ownership and operations. In their analysis of structural trends in the US media industry, Croteau and Hoynes (2006: 77–115) identify four broad developments: growth of corporations; integration; globalisation; and concentration of ownership.

Conglomeration trends in the United States

Following a sustained phase of merger activity, nine major global multimedia companies now dominate US media (McChesney 2008, 2002; Herman and McChesney 1997). These firms have responded to the dynamics and imperatives of capitalist accumulation and economic, institutional and market conditions forcing them to become larger, integrated and increasingly global. Growth and consolidation patterns may be illustrated by a selective record of merger activity.

1985 Murdoch's News Corporation buys Twentieth Century Fox
1986 Matsushita acquires RCA for $6.4bn (then the largest non-oil acquisition in history)
1989 Sony acquires Columbia Pictures (and Tristar) (Japanese electronics hardware company buying entertainment software)
1990 Time and Warner merge
1991 Matsushita acquires MCA (lasted only four years)
1994 Viacom acquires Paramount ($8bn) and Blockbuster ($8.5bn)
1995 Westinghouse acquires CBS ($5.4bn)
1995 Disney acquires ABC/Capital Cities ($19bn) (vertical integration)
1995 Seagram acquires Universal Studios
1996 Time Warner acquires Turner Broadcasting ($7.4bn)
1998 AT&T acquires TCI (inc Liberty) (Telecoms-media convergence)
1999 Viacom and Columbia Broadcasting System (CBS) merge ($80bn)
2000 Vivendi acquires Seagram/Universal ($35bn)
2000 AOL acquires Time Warner ($166bn) (ISP-media conglomerate)
2003 News Corporation buys a controlling interest in Hughes Electronics (DirectTV) ($6.6 bn) (US satellite/global satellite TV)
Sony and Bertelsmann merge music units into Sony BMG ($5bn)
2003 General Electric (NBC) buys Vivendi Universal ($5.2bn)
2005 News Corporation acquires MySpace ($580m)
2006 Disney acquires Pixar ($7.4bn)
2008 Liberty Media acquires DirecTV Group Inc ($16.2)

Media mergers and acquisition activity have been part of a wider trend across capitalist economies. For instance, 1986, the 'year of the deal', saw 3,300 corporate acquisitions in the US alone. A sustained period of growth and consolidation in US media culminated in the AOL-Time Warner merger. That deal, valued at around $166 billion, was nearly 500 times larger than any previous media deal and at the time the largest in business history. In the

period 2000–2002 a series of shocks affected media corporate growth, notably the collapse in Internet stock value, a short worldwide advertising recession and the impact of the 9/11 terrorist attacks. The dot com stock collapses of 2001 revealed AOL-Time Warner's overinflated value, the company reported losses in 2002 and reverted to 'Time Warner' the following year (see chapter three). 2001 marked a general slowing in corporate growth and some spectacular failures (including several of the early developers of digital television services in Europe), although this shakeout itself gave rise to further takeovers and consolidation. Growth picked up with the expanding market for digital devices and the corporate rush to occupy new spaces of communication and congregation, such as social networking sites MySpace.com, purchased by News Corp., and YouTube acquired by Google for $1.6m in 2006. In 2008 AOL (then part of the Time Warner conglomerate) acquired Bebo, a global social networking site whose Open Media platform enables media companies to promote, distribute and sell programmes.

The relative saturation of domestic media markets and opportunities for expansion of overseas markets also encouraged corporate growth. Hollywood firms, for instance, increasingly generate more revenue from international sales than from the domestic box office for a given blockbuster film (Wasko 2003). Diversification strategies have been driven, in part, by efforts to spread the risks and costs of securing strategic positions from which to increase profits. In particular, leading conglomerates have sought to control all or some of the 'value chain' from production to distribution–promotion and use, the key driver for vertical integration. Companies have been eager to take advantage of converging hardware and software systems that enable them to control major pieces of the entire circuit of production, distribution and exhibition or display. However, if trends towards integration are clear, the patterns of consolidation remain uneven and include processes of disintegration, demergers as well as the creation of new network interdependencies between firms (Hesmondhalgh 2007).

Corporate synergy

Herman and McChesney (1997: 53–54) identify two main kinds of 'profit potential' driving merger activity. The first is cost savings arising from 'fuller utilization of existing personnel, facilities and 'content' resources.' The second is the combined benefits of synergy, 'the exploitation of new opportunities for cross-selling, cross-promotion, and privileged access'. Time Warner, for instance, has a dominant market position across film production, cable

television systems and channels, magazines, books, music, online. For McChesney (2004: 183):

> Media conglomeration offers such a company tangible benefits: programs can be extensively promoted across all the company's platforms; media "brands" can be used to create new programming in different sectors; spin-off properties like soundtracks, books, video games that are generated by movies can be kept in-house; firms have increased leverage with advertisers; they have increased negotiating leverage with labor and supplier; and, in a hit-or-miss business like media, the increase in scope reduces overall risk. In short, the theory behind media conglomeration is that the profit whole is greater than the sum of the profit parts. The word used to describe this is *synergy*.

The 'merger mania' of the mid-1990s has given way to increasing use of alliances and joint ventures between major companies and with smaller firms, to strategic investment and leverage in place of outright acquisition (Herman and McChesney 1997; McAllister 2000: 110). Such joint agreements have often included cross-promotional arrangements (Herman and McChesney 1997; Croteau and Hoynes 2003, 2006). The diversification of conglomerate interests has opened up greatly enhanced opportunities to promote media across a variety of outlets, platforms and products. Corporate integration of firms has a powerful economic and business rationale in exercising control and utilizing cost-savings over production, distribution and marketing of media products. But conglomeration is also driven by the desire to increase market power, not just economic efficiency (McChesney 1999: 22; Herman 1999: 46).

When Disney purchased Capital Cities/ABC in 1995, Chief Executive Michael Eisner enthused, '[t]he synergies are under every rock we turn over' (*Columbia Journalism Review* 1997). Amongst the leading proponents, Disney, established a Director of Synergy at board level. Synergy has been a recurrent buzzword since the 1980s. Journalist and writer Ken Auletta remarked, '[i]f you went to the press conferences when Disney took over ABC or when Westinghouse took over CBS or when Viacom took over Paramount, you heard the word synergy repeated over and over again' (*Columbia Journalism Review* 1997). The term itself must be understood in the broader context of efforts by senior corporate executives to validate the rising costs of mergers and acquisitions, to win approval from shareholders, stakeholders and publics, to identify 'synergy' with necessary and unavoidable changes in business structures and operations, and to counter and evade critical responses challenging the concentration of media power.[5]

Synergistic branding and merchandising are also risk-reducing strategies. Disney can guarantee its films will be shown on its ABC network, cable/satellite channels and websites, and can exploit the property to create

soundtracks, spin-off television shows, amusement park rides, comic books, DVDs, and merchandising (including its owned or licensed Disney retail stores). Disney's animated films *Pocahontas* and *Hunchback of Notre Dame* were only marginal successes at the box office, taking roughly $100 million in gross US revenues, but both films generated some $500 million in profit for Disney, once it had exploited all its other venues. According to one critic, 'Firms without this cross-selling and cross-promotional potential are simply incapable of competing in the global marketplace' (McChesney 1998: 14).

The quest for retail and marketing synergies has driven what a leading critical scholar calls hypercommercialism (McChesney 1999, 2004). This denotes how media are subject to ever increasing commercialisation as dominant firms use their market power to generate the greatest possible profit from their product, entering into merchandising, tie-in deals and so on. For Turow (1992b: 683–684), synergy is at the 'hub' of related strategies to 'optimise [companies'] presence across as many media channels as possible'. A key component of corporate synergy has been the drive to extract maximum value from creative products across various media and non-media forms (Bogart 2000: 51). Synergy has been particularly associated with marketing and cross-promotion by large entertainment conglomerates, as we will examine. But the term also has wider usage to indicate benefits arising from operational efficiencies in business. Negus (1997: 85) describes synergy as 'a strategy of synchronizing and actively forging connections between directly related areas of entertainment' (see also Bagdikian 1997: xxv). He describes four potential synergies that attracted major cultural producers in the 1990s: textual connections or synergies of software; connections between hardware and software; convergence of previously distinct hardware components; connections between technologies of distribution (Negus 1997: 84–86). Another analyst, McAllister (1996: 147) writes:

> The driving force of organizational "synergy," where the whole of the corporation is greater than the sum of its parts, has influenced corporate growth. With a synergistic philosophy, corporations will acquire other businesses not because of their businesses' profit margins, but because these businesses contribute to the goals and character of the parent corporation. This is especially true in the promotional sector.

Synergy has functioned in corporate discourses as an imperative, connoting cost savings and the maximising of value. But the record of achievement of 'synergy' has been mixed, with many examples of expected benefits and profits failing to materialise. Certain operational combinations, such as newspaper chains, broadcasters and magazine or book publishers have been more successful than others, for instance newspapers and film studios (McChesney 1999: 25). Efforts to integrate corporate divisions have also encountered

problems of divergent corporate cultures and fierce intra-firm as well as inter-firm rivalries which characterise such highly competitive industries. Negus (1997) identifies the problems that occurred when Sony attempted to integrate staff from different hardware and software divisions. He uses these to illustrate a more general argument that there is a 'lack of 'fit' between the rational, macro structures of ownership' established by corporations through formal acquisitions, and 'the more messy, informal world of human actions, working relationships, and cultural meanings through which the companies' goals have to be realized on a day-to-day basis' (Negus 1997: 94). However, emphasising employees' agency, exercised as it is within the constraints of conformity to corporate requirements, does not answer the critical concerns raised by corporate control beyond the vital, if obvious, point that such 'goals' are by no means always smoothly realised.[6]

A contrasting account is provided by Alger (1998: 144) who describes how synergy 'violates the pure economic competition standard'. Alger (1998: 146, 147) argues that the consequences of synergy are best captured by a US anti-trust term 'predatory cross-subsidization' and cites the argument of former FCC commissioner Nicholas Johnson:

> Synergy is actually the annihilation of competition When you contract with an author to write a book and sell it in the stores you own, produce the movie in the studio you own and run it in the theaters you own, make it into a video and distribute it through the stores you own, then put it on the cable system you own and the broadcast stations you own, promote it on the TV network you own, and write it up in the entertainment magazine you own, that's pretty tough to compete with.

While Negus's account, like others, ignores media regulation, for critical scholars synergy must be understood in terms of policy shifts that allowed corporate concentration and multimedia expansion. According to Meehan, modern synergy depends on 'deregulation and transindustrial conglomeration' (2005: 90).

Having been a buzzword in the 80s and 90s, synergy claims became somewhat more muted in the 2000s especially where economic benefits were not realised to the satisfaction of investors. Profitable synergies proved difficult to achieve in many sectors and companies began to sell or spin off media outlets. A new watchword was 'focus' indicating a reversal of diversification and accumulation strategies (Baker 2007: 42). One report found a rising trend of US media companies divesting 'non-core' assets during the recession of 2008 (PriceWaterhouseCoopers 2009). In 2008–9 Time Warner hived off its cable businesses and AOL into separate businesses to concentrate on core production and distribution of branded content (see chapter three). However, while this rightly indicates the dynamic, complex patterns of business activity

across converging sectors, both corporate integration and other forms of synergy remain very important aspects of contemporary news and entertainment media. The high volume of media and entertainment mergers and acquisitions peaked in 2008 with deals worth over $150 billion despite falling stock prices for many leading companies, with convergence of media formats across different media being the key driver (PriceWaterhouseCoopers 2009).

Synergy, marketing and cross-media promotion

Cross-media promotion needs to be understood in the context of changing patterns and dynamics in media promotion and marketing. An underlying shift in contemporary culture has been the increase in the amount of media content devoted to promotional coverage of cultural products (Marshall 2002). Different media have different patterns, but there are common features arising from increasing competition amongst an ever-expanding range of media. McAllister (2000) cites four main ways in which 'synergistic corporate ownership' has led to increased promotional activities. First, corporate holdings may be encouraged to buy advertising on one another, keeping revenues in-house. According to Mandese (1997), for instance, News Corporation subsidiaries increased their advertising spending on the Fox TV network by nearly 300 per cent in the mid-1990s.[7] Second, McAllister identifies incentives to create synergistic licensing deals to develop content through a variety of corporate holdings. Third, are 'promotional plugs in content', in other words, editorial cross-promotion. Fourth is the increase in entertainment marketing arising from a 'corporation's overall promotional ethos' (McAllister 2000: 109).

Underlying these has been a more general process: the extension of the marketing logic of branding across media promotion and production. Entertainment economist, Michael Wolf (1999: 230) proclaimed:

> [Entertainment companies] will thrive only to the extent that they can transform hits into megabrands. The impetus to create this brand awareness among consumers while at the same time extracting the last full measure of revenue out of every project has been the primary force behind the merger mania in Medialand.

One aim is to maximise publicity in order to build audiences, for instance around the limited space-time 'window' of a first-run film release. Another related set of aims is to maximise profits from sales of associated products in order to generate revenues and publicity, supporting the promotional objectives. Branding is also a risk-reducing strategy transferring 'the symbolic capital accruing from past reputation from one arena to another' (Murdock

2003: 28). Both branding and brand extensions have led to intensification of promotional activity and multiplying forms of cross-promotion. By the mid-1990s:

> . . . some media executives began to question the very idea that a media brand should remain in one place—a radio station, a cable network, a magazine. They began to distil their media formats—their logo, values, interests, and sponsors—across as many technologies as possible. The aim was to provide them and their sponsors with platforms to signal their connections with the values and lifestyles of their target audience wherever possible (Turow 1997: 114–115).

Amongst the key factors driving such branding strategies are the rising costs of media production and marketing (Wolf 1999; McAllister 1996, 2000). For Wolf (1999: 227):

> It is no longer sufficient merely to turn out a hit movie, television show, magazine or book because in many cases these products cannot be profitable on their own. A hit must become a franchise and, in so doing, become the hub from which a wide-reaching variety of products emanates.

This is illustrated by the tie-ins, advertising and licensing deals Warner Communications Inc. (WCI) established for its film release, *Batman* in 1989 (Meehan 1991). WCI's initial $30 million investment in *Batman* 'built the basic infrastructure necessary for manufacturing a line of films, albums, sheet music, comics and novelizations' (Meehan 1991: 54). Warner Brothers had already acquired DC Comics, creators of the original Batman, in 1971. WCI licensed the film's reworking of Batman together with Batman incarnations of earlier comics and television fame for merchandise. The resulting 'commercial intertext' brought together a huge range of Bat-products with $10 million paid advertising budget as well as a flood of free advertising from reviews, news stories and interviews, as well as a much-played music video, single ('Batdance') and album, by Prince, alongside another soundtrack album (Donnelly 1998: 144–145). Such publicity was significantly nurtured by film clips used in cross-promotional advertising together with 'free promotional materials for the interview and movie review circuits on both broadcast and cable television' (Meehan 1991: 47). When Time Warner produced the sequel, *Batman Returns* in 1992, it secured the equivalent of $65 million through cross-promotional publicity supplied by organisations such as McDonalds and Choice Hotels in their contracted tie-ins with the movie (McAllister 1996: 139). The Batman release illustrates the multimedia nature of film production and promotion of a 'franchise' brand (see chapter three).

The marketing logic applied to such entertainment franchises has been extended to media properties themselves. From the mid-1980s there has been

more intense effort to establish distinct brand identities for such properties as TV channels in the face of competition for audiences (see chapter seven). This has been motivated by the need to retain audience loyalty as well as to create distinct identities for niche channels aimed at specific market segments. While marketing and branding have been important since their inception, branding has become both more systematic and intensive as new TV channels have proliferated and segmented in fiercely competitive environments. Specialised cable channels seek distinct 'promotional identities' that 'can deliver demographically targeted audiences to other advertisers, including entertainment firms' (Weinraub, cited in McAllister 2000: 106; McChesney 1999: 24; Eastman et al. 2002). Such channel branding intensified with the creation of niche cable channels in the US from the late 1970s, following the commercial success of film channel Home Box Office.[8] By the late 1980s there were some 70 advertiser-supported channels on US cable systems. Some, like The Discovery Channel, USA Network, MTV and ESPN, saw dramatic increases in revenue as they took audience share from the networks (Wasco 1994: 88). After further consolidation, the dominant cable operators launched more targeted, niche channels such as the Cartoon Channel (Turner) and Sci-Fi Channel (USA Network).

There has been an increase in TV programme promotions arising from increased competition amongst the major six networks and between the networks and cable, satellite and other services (McAllister 2000: 111). This has been accompanied by increasing cross-promotion. In the 1990s, the US networks formed cross-promotional deals with cable channels such as NBC and CBS's deal with Comedy Central to market their network comedies (McAllister 1996). Increasing commercial integration between cable-system operations and programme suppliers has also made it 'more and more difficult to distinguish between cable, television and film industries' (Wasco 1994: 94). Time-Warner was able to release and to promote its 1992 sequel *Batman Returns* through its extensive cable network. The company's activities also included creation of what McAllister (1996: 161–163) terms a 'synergistic multilevel commercial'. Using its television production unit, Warner TV, Time Warner created a TV special, shown as a CBS Special Presentation in prime time, *The Bat, the Cat and the Penguin*. This 'network infomercial' included an advertising break promoting mainly Time Warner interests and an advert for Choice Hotels, cross-promotional partners in the film, which itself included audio and visual elements of the movie, resulting in 'commercials within commercials within commercials' (McAllister 1996: 162). As we examine below, critics charge that marketing logic increasingly shapes the conception and, to varying degrees, the editorial content of media products as well as

their promotion and related merchandise. It is the diffusion of this logic across all media, including media shaped historically by non-market values that defines the shift from media commercialism to 'hypercommercialism' (McChesney 1999).

Advertising and advertiser influence

Our focus is on the media as agents of promotion and not merely the vehicle or carriers of third-party advertising. However, cross-media promotion can only be fully understood in the context of the changing dynamics of advertiser-media relationships. Here a key dynamic has been increasing pressure on ad-financed media to satisfy advertisers' demands. This is not a simple or unilinear process. The influence of advertisers on media content is a complex phenomenon since there is a variety of forms of direct and indirect controls exercised by advertisers; many factors affect what actual influence and outcome these have, and there are a great many other variables shaping media content and performance.[9] Advertisers and commercial media share a history of struggles over such matters as costs, ad agency remuneration and control over editorial content (Spurgeon 2008: 19), and the power dynamics have shifted across different media in different periods. US Network TV dependence on single sponsors, the model that had come to dominate commercial radio, was broken in the late 1950s when rising programme costs and the quiz show scandal contributed to the shift towards selling spots between programmes (Smulyan 1994; Turner 2004).

Advertiser power is mitigated by the unavoidable uncertainty of securing advertising effectiveness in any given promotion and by many countervailing factors. From the 1980s there has been loss of advertiser control in some areas, however the balance of power has shifted towards advertisers. For a variety of reasons, pressure has increased on advertising-dependent media to secure advertising by complying with advertiser demands and by offering a host of added benefits (McAllister 1996). This is a core dynamic underlying the per-ceived erosion of the 'firewall' between the business operations and editorial content and decisions in newspapers and news journalism (chapter four). Advertisers have been able to exact more and more 'editorial support' beyond paid advertising (McAllister 1996, 2000; Turow 1997). Herman and McChesney (1997: 140) describe how:

> major TV networks offer their 'stars' to sell commercials and appear at advertiser gatherings; they enter into joint promotional arrangements with advertisers, each pushing the other's offerings; they show 'infomercials' produced entirely by or for

advertisers and displaying their products; and they co-produce programs with advertisers and gear others to advertiser requests and needs.

Media diversification strategies have been developed to meet advertisers' demand to reach niche markets and 'lifestyle' segments. According to Turow (1997:115) media companies began to 'test the cross-media waters' in the early 1990s:

> One goal was to help ad-driven subsidiaries corner media markets for their preferred demographics and their lifestyles. Their desire to stake out claims where they thought their audience might go led them into some regions, such as the Internet, which were only beginning to be hospitable to ad-supported media.

Such strategies have required strong branding of the media's own vehicles as well as increased marketing effort described in the previous section. An important motive for media conglomeration has been to provide advertisers with an integrated range of advertising vehicles. Commercial media face a major, ongoing challenge to adapt their digital services to meet advertisers' needs and interests (Spurgeon 2008; Powell et al. 2009).

The corporate integration and transnationalisation of media firms have been matched by those of advertising firms (Powell et al. 2009; Mattelart 1991). By the early 2000s over half of world marketing communications expenditure passed through four global agencies: Omnicom Group, Publicis, Interpublic Group and WPP Group (Cappo 2003:11). The major advertising firms vie for the accounts of brands that seek transnational reach. Here, the global, multimedia firms that have come to dominate media markets have been viewed as natural tie-in partners by advertisers (McChesney 2004). For instance, cross-promotional partners for the second-Matrix blockbuster, *The Matrix Reloaded*, included such companies as Coca-Cola, Heineken, and Cadillac, the last with extensive product placement for vehicles, while Samsung secured worldwide promotional rights covering wireless phone handsets (Hein 2003: 3). There has also been increasing integration between the two, with marketing agencies moving into media production or financing. An important factor here has been deregulation of controls preventing advertising agencies from owning media firms or being eligible for broadcast licences.

Shifts in professional values, ideology and practice

Advertiser pressure to integrate promotional content into editorial content is examined further, especially in chapter eight, but two considerations are important to note here. First, strategies of 'embedded persuasion' increase the promotional content of media discourse. Second, they influence norms and

professional ideology, as increased reliance on and accommodation to advertiser interests shape a more commercial and promotional orientation.

There are many accounts of the weakening of professional culture and ideology which functioned as an important countervailing force against the pressures of corporate control, market-driven imperatives and advertiser influence (Bogart 2000; McManus 1994; Squires 1994). In his extensive participant observation in the 1970s, Gans (1980) noted the strength of news journalists' resentment of advertiser influence and their institutionalised insulation from such pressure, given the operational separation between editorial and advertising departments. While journalists identified and criticised the influence of commercial considerations on senior producers and editors, Gans also argued that national news firms could control advertiser interference by their ability to attract and substitute other advertisers (1980: 257, see also McQuail 1992: 135). All these conditions have been significantly eroded since the 1980s in ways which have affected even the elite news media which Gans examined, although to a lesser extent than other media sectors. Bogart (2000: 288) observes a point that is crucial for this study when he states that journalistic professionalism mainly applies to news media not entertainment, 'the very idea of professionalism cannot be applied to the field of entertainment, which makes up most of media content'. He argues (2000: 290) that there are no comparable agreed-upon standards of acceptability in other realms of commercial culture:

> In the entertainment business there is no counterpart to the peer group pressures and professional traditions in fields like history and journalism that are self-consciously dedicated to the pursuit of truth.

One of our concerns will be to consider whether values in entertainment media and marketing may be reshaping media traditionally shaped by other distinctive professional norms such as editorial independence and impartiality. For Dahlgren (2001: 80) the professional identity and self-understanding of journalists have become more 'protean, as the boundaries of the profession become permeable to related media occupations such as public relations, advertising, editing and lay-out, and information brokerage'. Yet, Hallin (2000) while critical of media commercialism, rightly challenges some accounts for their perpetuation of a mythic 'golden age' of journalism and their validation of the elitist, often conformist and conservative journalism that emerged (see also Baker 1994; McChesney 2004). I argue below that it remains possible to

identify the increasing force brought to bear upon media professionals, even if the outcomes cannot be read of from consideration of macro forces alone.

Corporate integration has, in many cases, involved the incorporation of formerly autonomous news media into diversified conglomerates whose main business is entertainment. The drive to promote products and create synergies, especially for entertainment products, then sets up conflicts with the value and ethos of news divisions. Such tensions remain active and dynamic although a growing number of mainstream as well as critical scholars suggest that they are being resolved in favour of the commercial and marketing imperatives set by corporate owners (McChesney 2007: 94–97; see chapter four). An underlying concern has been the perceived erosion of conviction that the media should be treated differently from other commercial activity, occurring at all levels from CEOs to senior executives, through to staff (Auletta 1992; CJR 1997; Bogart 2000).

US regulation and deregulation

Later chapters examine UK and European regulation in more detail, here the focus is on shifts in regulation in the US. These shaped the conditions for corporate integration of firms that continue to dominate global media markets. Trends towards liberalisation in the US have also had repercussions for regulators in other media systems.

In contrast to the UK, US media regulation has not produced rules explicitly governing cross-media promotion. However, into the 1980s, structural, content and behavioural regulation limited the scope for cross-media promotion and in some cases prevented intra-firm promotion altogether. Industry deregulation and liberalisation policies, formed in the late 1970s under the Carter presidency and then extensively adopted during the Reagan presidencies (1980–1984; 1984–1988) (see Tunstall 1986; Horwitz 1989), and beyond, have largely promoted rather than prevented vertical, horizontal and multisectoral integration of private corporations, including communications and advertising companies.

There are two principal opposing accounts of US deregulation policies in the 1990s. One emphasises how technological developments in communications undermined the rationale and the capabilities of regulation to prevent concentration (Price and Weinberg 1996). The other account argues that concentration of capital, in the economy as a whole as well as in the communications industries, has had a deepening impact in shaping government economic and social policy, reversing or overturning laws and regulations that originated from pressure for anti-monopoly measures in the pre-World War II

Depression years. In advancing this argument, Herbert Schiller (1996: 249) stated:

> The merger and concentration movements in the United States over the last 25 years have derived mainly from successful corporate efforts to achieve deregulation of their activities. New technologies have played, at best, a supplementary role in accounting for the powerful combinations that have emerged.

Schiller may be rightly criticised for imputing a coherence of purpose to capital which does not give sufficient attention to competitive struggles between firms and contradictions within capitalist cultural production (Thompson 1995; Hesmondhalgh 2007). Nevertheless, his analysis is a salutary warning that the process of 'convergence' has been neither seamless nor predetermined, but rather actively shaped by regulatory behaviour. Changes in the regulatory environment in the United States are vital factors in understanding the dynamics of CMP. They are also important as an empirical test case from which to examine how commercial dynamics operate when regulatory controls are weakened, helping us assess the implications for other media systems notably, for our purposes, the UK (see Hoffmann-Riem 1996b).

The Federal Communications Commission (FCC), established by the Communications Act of 1934, adopted a presumption in favour of diversity of ownership and against media concentration.[10] The FCC was expected to protect against abuses by semi-monopolists and to confine licensees, in particular the TV networks and AT&T to their licensed area (Tunstall and Machin 1999: 41; Winseck 1998). Acquisitions and mergers in network TV were forbidden by the FCC until 1985 (Tunstall and Machin 1999). Schiller (1996: 261) describes diversification of ownership as an acceptable policy goal into the early 1980s.[11]

Already, by the 1970s the FCC had acquired a reputation as 'Reluctant Regulators' as one study was titled (Cole and Oettinger 1978). Under Reagan, deregulation was championed by FCC chairmen Mark Fowler (1983–4) and Denis Patrick. Fowler was appointed with the brief to remove 70 per cent of regulations from the FCC rulebook (Belfield et al. 1991: 196; Sterling and Kitross 2002). In fact, Congress passed little significant communications regulation between the break up of AT&T in 1984 and the 1996 Telecommunications Act (Tunstall and Machin 1999: 40–41). Deregulation arose, rather, from the removal or non-enforcement of FCC rules and the declining use of anti-trust powers by the FCC and Federal Trade Commission.[12] The 1996 Telecommunication Act endorsed the principle that telecoms and other companies should be allowed to advance into neighbouring businesses (Kunz 2007; McChesney 1999; Tunstall and Machin 1999; Aufderheide 1999). Before the Act, a single entity was limited to national ownership of twelve TV

stations and twenty AM and twenty FM radio stations. The 1996 Act removed the limits on aggregate radio station ownership and provided only that a single entity may not own TV stations that reach more than 35 per cent of national households.[13] Since the Act, the FCC has removed further restrictions on cross-ownership. In its 1998 review of the rules restricting cross-ownership in local markets, the FCC (1998: 12) sought comments on whether commonly owned newspapers or broadcasting stations 'express contrasting points of view or cover each other in a critical manner'. However, the FCC did not identify any broader problems arising from cross-media ownership, such as CMP. A combination of such liberalisation of ownership measures and a less interventionist approach in enforcement has been vital in providing the conditions for CMP. In 2002–3, opposition lobbying by media reform groups and organised public protest prevented the FCC from implementing further deregulation as demanded by the major networks, until the White House, under President Bush, orchestrated a Senate deal to raise the national ownership limit to 39 per cent. This allowed Viacom and News Corp to retain stations each owned in excess of the 35 per cent limit. (Kunz 2007: 66–74; McChesney 2004: 252–297; see chapter seven).

Broadcasting

Once the FCC rules allowed, by raising limits on multiple station ownership from seven to twelve in 1984, all three US networks changed hands in 1986. Capital Cities acquired ABC, General Electric acquired RCA Corp including NBC, and CBS came under the effective control of Laurence Tisch and Loews Corp (Kunz 2007: 76–77). This followed a decade of falling profits as audiences declined, competition increased and advertising sales diminished. The networks responded to decreasing revenues and increasing production costs by developing new forms of cheap television, such as 'reality' shows, 'genre' news and 'magazine' shows, created to provide 'viewer-friendly infotainment and reduced overheads' (Andersen 1995: 22). Another response to growing competition was to increase self-promotion. Since the 1980s the number of programme promotions on US television has increased dramatically. ABC showed around 7,000 promos for its programmes in 1990, almost double the number produced a decade earlier (McAllister 2000). According to Elliot (1992), CBS ran approximately 8,000 self-promotional spots annually in the early 1990s, worth about $500 million dollars. Between 1991 and 1996 the four networks increased the time devoted to advertisements and promotions by over one minute per hour and two minutes, 20 seconds in the case of ABC. The Fox network averaged the highest daily amount at 16 minutes, 5 seconds

(McAllister 2000).[14] In 1994, NBC established a promotional unit called 'NBC 2000' which sought to expand opportunities for programme promotion by utilising a split screen at the end of the programme while the credits for the programme go by. This technique was quickly adopted by other US networks as well as by UK broadcasters, such as Channel Four.

However falling network audience shares limited the effectiveness of self-promotion on-air and encouraged networks to explore alternative ways of promoting their own shows through increased off-air advertising and through cross-promotional deals with other TV channels and with retailers (McAllister 1996: 144–145). The most significant cross-promotional deals, however, have been with advertisers. CBS and NBC began systematic cross-promotion with advertisers in 1989; ABC, initially resistant, acquiesced in 1996 after its acquisition by Walt Disney.

Along with ownership rule changes, the expiration of the Financial Interest and Syndication Rules in 1995 had a significant impact, allowing the vertical integration of broadcast networks with the major film studios. Disney acquired Capital Cities/ABC, creating vertical integration between ABC and Disney studios. CBS's merger with Viacom completed in 2000 integrated the network with Paramount Pictures, while in 2004 NBC and Universal combined. This gave the networks benefits of vertical integration already enjoyed by Fox, established in 1986 as part of News Corporation, and the UPN and WB (Warner Brothers) networks launched in 1995. Universal Pictures Network (UPN) was brought together with CBS under Viacom in 2000.

Viacom is a first tier media conglomerate with interests in film production, music, theme parks, video/DVD rentals, broadcasting and publishing. Brands include MTV Networks, VH1, Nickelodeon, Nick at Nite, Comedy Central, CMT: Country Music Television, Spike TV, TV Land, Logo and more than 130 networks around the world, BET Networks, Paramount Pictures, Paramount Home Entertainment, DreamWorks and Famous Music. CEO Sumner Redstone originally engineered a hostile takeover of Viacom in 1987 for $3.4 billion. Redstone outbid Barry Diller for Paramount (1994), swallowed Blockbuster Entertainment before merging with CBS, his largest deal, valued at $46 billion. On 31 December 2005 CBS was spun off as a separate publicly traded company, CBS Corporation, which took with it the UPN broadcast networks, Showtime cable, TV stations, radio, billboards, and publishing. However, Redstone controls both CBS Corp. and Viacom, as chairman and as majority owner of both companies' voting shares.

Controls on advertising and editorial in broadcasting. During the 1970s, regulatory concern over broadcast advertising increased.[15] The National Association of Broadcasters (NAB) drew up guidelines in response to FCC pressure (see Cole

and Oettinger 1978: 277). These recommended that advertising time total 12 minutes per hour on weekday programming and less than 10 minutes per hour for weekend programming. In the late 1970s the FCC began formal procedures to investigate the amount of commercial time on children's programmes, which had crept up, despite the rule. This process was abandoned under Mark Fowler's chairmanship (Kline 1995: 214–217). Such deregulatory signals led to the emergence of children's programme length commercials such as *He-Man and the Masters of the Universe* and *GI Joe*. These programmes served to promote pre-existing toy lines (McAllister 1996: 33–34; Kunkel, 1988; Kline 1995), giving way to more complex promotional programming generating branded characters and associated merchandise (Andersen 2000; McAllister 2000). Following FCC deregulation 'the wok towards cross-promotional linkages and providing narratives for toys was further completed' (Marshall 2002: 72). The NAB code, which set voluntary limits on advertising minutage was abandoned, at the insistence of the Federal Trade Commission, in the early 1980s (Bogart 2000: 76). This resulted in an increase in the number of television advertisements and advertising minutes, the latter increasing by half an hour per network in one year.[16] Up to 1984, FCC rules limited commercials to 16 minutes per hour, thus blocking the broadcasting of programme-length commercials (infomercials).[17] After 1984, infomercials became, with home shopping, the fastest growing programme services in cable TV (Andersen 1995: 31–32). Single-advertiser infomercials, which began life on cable channels, also gravitated to the networks, with the form itself increasingly adopted by mainstream advertisers.

Growing advertiser power has led to increasing promotional content in programmes, beyond spot advertising (Andersen and Strate 2000; McAllister 1996). One form has been advertiser syndication, whereby advertisers fund production costs in return for advertising spots (see Baker 1994:104–5). From the 1980s the close relationship between advertisers and network producers saw a return to practices which characterised the early years of broadcasting, where the advertiser as sponsor was able to extract editorial support within programmes. Such arrangements have made possible strategic product development and cross-media promotions as well as preferential terms of access for product distribution (Bogart 2000: xiv).

Digitalisation and multimedia

Cross-media promotion is inextricably linked to media technologies. The multiplication of media forms and the opportunities to re-present, repackage and repurpose content are key features of multimedia expansion and shifts

from analogue to digital media. So far our analysis has emphasised political, economic and organisational factors giving rise to CMP, not least to avoid the technological determinism that remains prevalent in academic and policy discourses (see Lister et al. 2009; Dovey 1996). However, multimedia expansion and digitalisation have profoundly shaped the conditions and forms of CMP today.

Technologies such as cable and satellite TV, VCRs and later digital media have created new outlets for media content. In particular, the commercial development of the Internet has led to considerable expansion in both scale and scope of cross-media promotion, at the same time as profoundly challenging the efficacy of regulating such activities. The Internet has greatly increased bi-media diversification, bringing formerly mono-media products into new cross-media promotional relationships and extending the synergistic capabilities and reach of multimedia conglomerates. Any media outlet with a web site is involved in complex forms of inter-media and cross-media promotion. The Internet has also facilitated combinations of speech and commerce which transgress traditional boundaries between editorial and advertising.

Commercial online activities grew rapidly after 1993 when the World Wide Web became accessible by means of a graphical user interface. Contrary to many predictions, such as Negroponte's that 'the monolithic empires of mass media are dissolving into an array of cottage industries' (1995: 57), 'old' media took to the web. The number of newspapers with online businesses worldwide grew from 496 in 1995 to 2,700 in 1998 of which 60 per cent were US based. Forty-seven of the top 50 US magazines had web sites by 1998, as well as 800 US broadcast TV stations and 151 cable channels (Schiller 2000: 99; see also Sparks 2004).

The extent to which multimedia conglomerates dominate media content services is contested and changing, but there is no doubt that most firms have invested heavily to exploit the opportunities for cross-promotion. Cross–promotion has been integral to strategies to leverage users from one media environment to another so as to build market share.[18] Media firms possess some of the hottest 'brands' in off-line media and so have leverage to get premium locations online. The web platform is perfectly suited to the strategies of synergy, brand-building, 'repurposing' of content and cross-selling already driving the large media and entertainment conglomerates (Schiller 2000: 99; Murdock and Golding 2005). Such companies have acted to retain their considerable advantages over rivals though investment and control of new media ventures while incurring huge losses to outspend and outlast competitors (McChesney 2000). The advantages arising from cross-media promotion are considerable and take various forms. Companies can advertise

web sites and Internet services at nominal rates across their other media. Such advertising on mass media is considered vital in building large enough audiences to make Internet services viable. Web services are also routinely displayed or referred to across editorial in television and print. Such promotion provides not only considerable cost-advantages but also the benefits of authority and relationships of trust which such editorial can command, for instance within television news programmes. On the web itself, companies can seamlessly promote associated web sites. In the US MSNBC has been heavily promoted within programmes on NBC and in cross-promotional deals with The Washington Post Company (Martinson 1999, 2001).

Content can reappear and be used in a variety of ways, tending towards operational alliances or integration of firms operating in traditionally separate sectors—such as print and broadcasting. Rights holders have followed the example of advertisers in seeking to push their brands (or 'key ideas') across as many platforms as possible. An important motivation for media diversification, too, has been the ability to cross-sell advertising across the various online and offline platforms.

The transition online, however, has not been automatic, and there have been spectacular business failures and huge financial losses incurred. New Century Network, a US based web site consisting of 140 newspapers run by nine of the largest newspaper chains was shut down in 1998, and by 1999 an estimated 120 newspapers had closed web sites, the key reason cited being failure to attract sufficient advertising revenue to finance them.

Normalisation of cross-media promotion

With the creation of online, 'branded' versions of offline media products, cross-promotion has become a pervasive business objective. Major media corporations view the Internet as a medium to exploit synergies between various media interests with cross-promotion as a norm (Thussu 2000: 235). The head of Warner Bros. Online stated in 1996: 'The best thing to do is to use your established media to build new media' (Herman and McChesney 1997: 123). In the absence of operational profitability, cross-promotion has functioned as a key rationale for such business strategies. The normalisation of CMP for online activity, as with film, has operated at the level of business strategy, marketing logic and professional ideology. Framed thus, discussion has focused on issues of promotional effectiveness and the dangers of brand values being damaged by poor web sites (similar to concerns about poor masthead programmes damaging prestigious magazines). More specifically, failure to exploit such cross-promotional opportunities has been widely

castigated in a discourse which not only normalises CMP but also views it as an imperative of integrated marketing practice (Waldman 1999).

As with other media, dependence on advertiser revenue has increased advertiser power. However the Internet provides some important differences in how this power is exercised and controlled (Goggin 2000; Herman and McChesney 1997; Schiller 2000). The erosion of boundaries between editorial and advertising is facilitated by the technical structure of the Internet as well as driven by the commercial interests of media companies, advertisers and the new promotional-retail-information hybrid Internet companies that have emerged. Reducing data to a common digital bitstream weakens the ability to apply legal distinctions, such as exist in other media between editorial and advertising, and facilitates the merging of protected speech and commerce (Schiller 2000: 72). Alongside the vastly increased capabilities for cross-media promotion, then, is the loss of capabilities for policing such activity, with profound consequences for the viability and justification of broader regulatory control of communications. Traditional distinctions between different media forms are less distinct and sustainable. The online newspaper is no longer distinguished, in the way the print version is, from other online content (Sparks 2000: 278, 2004), a factor increasing competition but also impacting on editorial content. Many writers have examined the consequences of the convergence of editorial content and commercial transactions online, arguing that the division which has operated as a norm in journalistic media for some 50 years is collapsing (Sparks 2000; Herman and McChesney 1997:128; W. Williams 1996).[19]

Conclusion

Cross-media promotion has become more pervasive and normalised. However it is also contested and to varying degrees constrained by regulation and within different media cultures and practices. This book examines the nature of these constraints and the influence of critical perspectives. The next chapter considers how the 'problems' of cross-media promotion are identified according to different ways of thinking about the media. For some, the problems raised are principally ones of fair competition between firms. However, other approaches focus on concerns about the quality of media speech or raise more system-wide concerns about the effects of media commercialism. Across the various media traditions, too, different kinds of concerns are mobilised in respect to different cross-promotional activities. Earlier we distinguished three main modes of speech in which cross-promotion occurs: advertising, promotions and edito-

rial. One division is between cross-promotion within media content ('programme' content or 'editorial' content) and other cross-promotion 'outside' media content. 'Outside' here is often a matter of conventional designation, formatting or even user expectations and the shifting border between inside and outside, far from being a given, is often at issue and in flux in considering cross-promotion. However, the divisions between 'editorial', advertising and promotions matter, not least as different regulatory approaches govern these modes of speech. In addition, some of the key problems of cross-promotion concern the nature of disclosure of interest and the extent to which editorial and advertising are separated and identifiable as such. Another underlying division concerning CMP is between factual content and fiction, or 'news media' and 'entertainment'. Again, such divisions remain important in regulation as well as media practice and media analysis.

The ability to cross-promote products and services has been a powerful incentive driving media integration. In the United States, where this dynamic is most advanced, the results have been increasingly sophisticated and systematic marketing efforts, more media promotion, and more surreptitious advertising as promotional material burrows into editorial content. As it does so it raises critical concerns about the integrity of news and information, the diversity of ideas and imagery across the media, creative and journalistic autonomy, user power/empowerment, and about the consolidation of corporate media power.

Notes

1. 'Merchantainment' has been defined as 'a combination of merchandising and entertainment' by Dave Lauren, son of Ralph Lauren, speaking at the Comdex computer trade show on 14 Nov. 2000. Mr. Lauren used the term in the context of promoting Polo.com, the fashionware company's new web site (Schofield 2000).

2. Andersen (2000) cites Time Warner's use of *Dawson's Creek* as a regular television vehicle for promoting acts signed to Warner Bros. Music.

3. Croteau and Hoynes (2003, 2006) describe this as horizontal integration, but following Hesmondhalgh (2007) and others I consider it useful to distinguish horizontal, vertical and multisectoral/multimedia integration. This avoids any confusion between horizontal ownership/integration, meaning concentration in the same sector, and integration across different media sectors.

4. A conglomerate is a collection of firms or operations dealing in different products or services that is subject to central ownership and control.

5. The term itself derives from biology where 'synergism' is defined as 'the action of two or more substances or organisms to achieve an effect of which each is individually incapable' (Alger 1998: 144).

6. Negus's 'cultural economy' analysis also displaces corporate power, substituting the relative indeterminacy of group dynamics and asserting agency over structure. However, no regulatory framework bears on the synergy examined, a factor which aligns the analysis, however inadvertently, with corporate deregulatory strategies. Aside from quoting Bagdikian (1989), Negus does not engage with the sustained critique of concentration and corporate control which he caricatures as mechanistic, totalizing and rationalist.

7. In the UK Sadler (1991) examined such practices as intra-firm discounting of advertising rates (see chapter six).

8. In 1975, the US Federal Court overturned an earlier FCC rule restricting cable channels from showing movies of less than two years old (Wasco 1994: 74). For a summary of US television expansion see Tunstall and Machin (1999).

9. For a detailed examination see Baker (1994) and Soley (2002). See also Leiss et al. (1997); Mattelart (1991); Bagdikian (1997); Curran (1986); Wernick (1990); McQuail (1992).

10. When the Act was introduced communications media subject to it were radio, telephony and the telegraph.

11. FCC rules forbade more than seven holdings in each broadcast service (AM, FM and television) up to a possible maximum of 21. These limits were raised in 1985 to 12 stations of each type and shortly afterwards to 21 stations. The rules were revised again in 2003.

12. As one branch of US competition law, the FCC also contributed to a move away from vigorously pursuing anti-trust cases (Alger 1998). Antitrust law enforcement is undertaken by the Bureau of Competition of the Federal Trade Commission (FTC) and the Antitrust Division of the Department of Justice and, indirectly, by the Federal Communications Commission exercising its powers in media matters.

13. Section 202 (c) (1) of the Telecom Act directed the FCC to modify its rules to eliminate the numerical limit on the number of broadcast television stations a person or entity could own nationwide and to increase the audience reach cap on such ownership from 25 percent to 35 percent of television households.

14. McAllister adds that this is likely to be an underestimate since much media content not coded as 'promotion' may have been influenced by entertainment marketing.

15. Various US agencies regulate the advertising industry; for a summary see Croteau and Hoynes (2003: 112–113).

16. According to Auletta (1992: 563), the decision of the networks to run even more ads in the early 1990s in order to combat declining earnings, with increases from four per cent (ABC) to eight per cent (NBC, CBS), 'altered the psychology of the marketplace, shifting leverage to advertisers' faced with less scarcity of network advertising time.

17. In 1984 the FCC adopted a Revision of Programming and Commercialization Policies, Ascertainment Requirements, and Progam Log Requirements for Commercial Television Stations, 98 FCC 2d 1076. This abolished guidelines of a maximum of 16 commercial minutes per hour. In 1990 concern about commercialisation led to new legislation limiting stations to 10.5 minutes per hour of children's programming on weekends and 12 minutes on weekdays (Baker 1994: 178 n).

18. On the advantages for traditional media developing online services see Herman and McChesney (1997) and McChesney (2000).

19. Examples of editorial/commercial convergence include the practice of payment for search result listings (Williams, W. 1996) and advertorials in search sites (Riedman 2001).

Media Paradigms
and Promotional Speech

Part 1: Paradigms of Media, Democracy and Policy

What is the problem with cross-media promotion? The answer depends on the value framework or paradigm in which the problem is conceived. Different frameworks give rise to different articulations, or constructions, of the problems of CMP and propose different remedies to tackle them. This chapter examines how cross-media promotion is articulated within the main political philosophical traditions concerning the media. Other chapters examine the formation of specific media policies; this chapter draws selectively on policy positions in order to illustrate how different paradigms construct and evaluate CMP. Section one introduces the main paradigms while section two addresses the treatment of cross-promotion in each one.

Liberal democracy

Liberal theory of the press holds that the primary democratic role of the media is to oversee the State. This task requires that the media are 'free' from State interference. The theory supports a free-market economic model particularly powerful in the United States and encapsulated in the 'marketplace of ideas' formulation of the US Supreme Court (Baker 1989).[1] But it can also give rise to justifications for state action to protect pluralism and diversity of opinion.

Central to the evaluation of CMP considered below are judgements concerning speech rights; who may exercise them, what restrictions may be placed on speech and by whom, what measures and what conditions are necessary to protect speech. Also vital are arguments concerning the levels of protection that should be granted to different kinds of expression, in particular political, artistic and commercial speech. To begin it is necessary to review the liberal paradigm of media freedom. The question of whether the beneficiaries of the right of freedom of expression are speakers, recipients, editors, journalists, media proprietors or corporations remains the subject of intense legal and

political contestation (Baker 1989; Barendt 1987; Feldman 1993; Gibbons 1992). The question must first be understood and examined historically. Freedom of the press emerged as the guarantor of freedom of expression, within liberal democratic theory. As McQuail (1987: 123) states:

> From the seventeenth century onwards, in Europe and its colonies, the newspaper (or similar print publications) was widely seen as either a tool for political liberation and social/economic progress, or a legitimate means of opposition to established orders of power (often both at the same time).

Freedom of expression is a foundational value of democratic political systems and constitutionally enshrined in most, while some jurisdictions, notably the US and Germany, provide specific constitutional protection to media freedom. Article 10 of the European Convention on Human Rights (ECHR) guarantees 'freedom of expression and information, without interference by public authorities and regardless of frontiers' subject to certain restrictions, and this in turn provides the basis for media and information law within the Council of Europe (CoE 1996, 1997, 2000; Voorhoof 1995; Lange and Van Loon 1991). Different justifications for a free speech principle carry divergent implications for the scope of legal protection (Barendt 1987: 7). The argument from truth, espoused by Mill (1998 [1859]), is that truth arises from free circulation of ideas and opinions. In turn this has been used to underpin 'marketplace of ideas' approaches that have seen free competition as the prerequisite for the circulation of truth. In absolutist and libertarian versions this argues for the media to be free from all restraint by the State.[2] However, as Feldman (1993: 585) states 'political liberalism requires a degree of control over the operation of markets in order to protect liberal values against market-expressed preferences'. Justifications *for* state intervention and regulation derive mainly from arguments for democracy. In order to secure a consensus of policy, free speech is required so that there might be the greatest opportunity for differing points of view to be aired and for sufficient information to be available as a basis for making decisions (Gibbons 1998: 24). It is a test for democracy that the public has ongoing access to information on the basis for decisions and circumstances of decisions taken by those elected to govern. By contrast, an absolutist position on freedom of expression denies the State any legitimate powers to control or regulate speech.

The debate on the true character of freedom of expression is also an aspect of long-running controversy as to whether political freedom is only a 'negative' freedom from state control or comprises positive freedoms and rights (Barendt 1987: 78). Contained in Article 10 ECHR, for instance, is the implied duty for public authorities to act to ensure conditions for exercising the right of freedom of expression, including sustaining facilities and resources for freedom of

expression and information (Voorhoof 1995; Foley et al. 1994).[3] The claim to positive action has arisen in particular in the European policy context and is related to the 'general evolution and "socialising" of the European Convention's rights and freedoms' (Voorhoof 1995: 54), for instance the emphasis on states' positive duties in respect of privacy or protecting the right to life. It arises out of the strengthening and elaboration of the democratic basis for freedom of speech, namely the rights of recipients to receive a necessary range of ideas and opinions. Politically it is also based on the social market, public welfare principles which also shaped European broadcasting regulation. The European Convention on Human Rights, drawn up in 1950 and subsequently ratified by CoE member states, specifically acknowledges in Article 10 states' rights to licence and regulate broadcasting.[4]

In the twentieth century, liberalism faced imperatives to resolve for each medium the inherent tensions and contradictions between economic and political freedom, between market freedom and ensuring that media support democratic processes (see Murdock 1992b). Different political systems favoured different solutions depending on the leading values requiring protection, market conditions and power interests shaping policy at any one time. The two main responses came to be recognised as 'social responsibility' and 'social market'. The 'social responsibility' model was best articulated by the Hutchins Commission on Freedom of the Press in 1947 in the United States (Peterson 1963). This in turn influenced the 1947–1949 Royal Commission on the Press in Britain (O'Malley 1997; Curran 2000). Both combined a critique of market failure in the press with promotion of media professionalism. For Curran (1996: 99):

> The cult of professionalism became a way of reconciling market flaws with the traditional conception of the democratic role of the media. It asserted journalists' commitment to higher goals—neutrality, detachment, and a commitment to truth. It involved the adoption of certain procedures for verifying facts, drawing on different sources, presenting rival interpretations. In this way, the pluralism of opinion and information, once secured through the clash of adversaries in the free market, could be recreated through the 'internal pluralism' of monopolistic media.

This 'Anglo-American' concept rejected a purely libertarian view of the press as unrestricted freedom for publishers. In part, a response to mounting criticisms of concentrated ownership and narrow business control of editorial agendas in the US press, the Hutchins Commission also drew upon the model of broadcasting regulation. It proposed that the press should become more like 'common carriers' for diverse opinions, should be subject to a stronger code of practice than the industry had created of its own accord, and should be monitored by a new independent agency. The Commission thus accepted a role for

government in supplementing a privately owned media, but its defining boundary was that no economic restrictions should be placed on private enterprise.

The alternative 'social market' model, developed in several European countries, justified state intervention in markets on behalf of democratic objectives, in particular pluralism of voice and, later, cultural diversity. In addition to public service broadcasting, the main forms of social market intervention have been press subsidies and grants and subsidies for other media and cultural industries. According to social market perspectives market competition cannot guarantee the conditions for a democratic media culture. This view was trenchantly argued by the UK Conservative government when it justified maintaining 'special media ownership rules' to prevent media concentration against a strengthening lobby calling for these to be liberalised. In *Media Ownership: The Government's Proposals* (Dept. of National Heritage 1995: 3, 16), it justified rules 'to provide safeguards necessary to maintain diversity and plurality' arguing:

> Television, radio and the press have a unique role in the free expression of ideas and opinion, and thus in the democratic process. The main objective must therefore be to secure a plurality of sources of information and opinion, and a plurality of editorial control over them.

Neoliberalism

Neoliberalism defines the view that social development should proceed according to the dictates of the market, with the minimum of government involvement. Modern 'free market' media theory combines libertarianism with neoclassical economic theory of markets. The free market view (or 'market model', Croteau and Hoynes 2006) has been ascendant. A neoliberal paradigm of free market competition, dominant structurally and ideologically in the US from the 1980s, has increasingly taken the form of an international standard, influencing European and in particular UK communications policy.

The core features of neoliberal economic theory are a belief in the efficacy of markets and of market competition to provide the best and most desirable mechanisms for satisfying consumer wants. For Adam Smith (1776), market competition ensures that the best quality goods are produced at the lowest prices. The search for market share ensures that producers adopt the most economically efficient means of production and deployment of labour. The marketplace is conceived as a space in which individuals enter into voluntary transactions, and where the inherently conflicting interests of producers and consumers are resolved to the benefit of both parties. In neo-classical theory

'[u]nder perfect competition economic resources are allocated between different goods and services in precisely the quantities which consumers wish (their desires expressed by the price they are prepared to pay on the market)' (Whish 1989: 4). Under perfect competition four conditions pertain: together with allocative efficiency, described above, there is productive efficiency: goods will be produced at the lowest possible cost. Third, price will not rise above marginal cost (in contrast to monopolists' ability to retain high prices) and fourth, competitive markets will encourage innovation and product development, thus maximising consumer benefits.

For Adam Smith, the state should provide those services which individuals or companies found it unprofitable to provide, such as external defence, internal security, national education and roads. Smith also recommended public intervention in the sphere of culture to increase public knowledge and generate quality entertainment (Golding and Murdock 1996: 18). With the exception of such public, non-market goods, Adam Smith famously argued against state involvement in market competition but did so on the grounds that the state can only bring about an outcome less desirable than that resulting from unregulated self-seeking (Caporaso and Levine 1992: 201). Libertarians go further in arguing that the state has no purpose interfering in any way in the integrity and freedom of economic transactions carried out between individuals.

Libertarianism

Libertarianism combines the political concept of natural, inviolable rights and individual self-determination with an assertion of property rights. For libertarian economists such as Nozick (1974) property rights are accorded the same status as rights to personal integrity and any attempt by the state to regulate these according to principles of social justice is condemned (see also Feldman 1993:13). In the political sphere libertarianism conceives rights as claims to liberty and autonomy and the state as an inherently repressive force. As Curran and Seaton (2003) show, libertarianism's antipathy to state-media involvement has influenced positions across both 'left' and 'right' of the political spectrum, and so problematises any neat political schema.[5] Libertarian arguments, often instrumentally advanced by corporations (Keane 1991: 89), have laid siege to state supported media structures such as public service broadcasting, and, far more selectively, state involvement in media and communications. More widely, certain forms of 'left' libertarianism have also challenged the basis for state regulation and intervention, in particular supporting media cultures around the Internet and new communications media.

Here strains of 'radical' capitalist entrepreneurialism merge with both anti-statist and participatory democracy arguments. Finally, postmodernism and libertarianism have been mutually influencing, not least in challenging the normative basis for media policy shared by both liberal democratic and critical political economy approaches.

Consumer welfare

A consumer welfare paradigm can be distinguished from neoliberalism as one that gives greater weight to market intervention to protect or safeguards the interests of consumers. One of the difficulties of identifying consumer rights as a paradigm is that it is a highly inflected and mobile discourse. The appeal to consumer welfare is inherent in the claims of all the discourses considered, albeit in distinct forms and with divergent consequences. Neoliberal economics is predicated on and justified by the argument that market mechanisms best secure consumer welfare. Nevertheless, consumer welfare has provided the basis for a growing body of legal protection as well as rationales for policy including that of communications and information. A paradigm of consumer welfare can be delineated by the degree to which it provides substantive provision for consumer welfare and protection, taking account of the form and quality of information for consumers to exercise informed choice in markets. This identifies the need for property rights and economic power to be exercised within a framework of rules and behaviour which protects consumers. It recognises that consumers require particular resources, such as reliable and sufficient information, for market transactions. Consumer protection is therefore concerned with issues of accuracy, fairness and access to information, which arise in many forms of promotional media speech.

Postmodernism

Postmodernism also has a particular interest in consumers and consumption, not least in the ways that the choice of goods comes to be governed by sign-values rather than use-values (Warde 1994). Postmodern culture is perceived as synonymous with the culture of consumer society by theorists who share the assumption that 'the immanent logic of the consumer capitalist society leads towards postmodernism' (Featherstone 1991: 15). Postmodernism, however, is a term for a complex and highly varied set of intellectual concerns and arguments, aesthetic practices and political affiliations. It is therefore difficult and usually reductive to discern a distinct political trajectory in postmodernism itself. Hall identifies a 'postmodernism of resistance' which seeks to decon-

struct modernism and resist 'the status quo', and a postmodernism of reaction 'which repudiates the former to celebrate the latter' (Foster 1985: xii). Eagleton (1990: 373-374), more convincingly, if no less reductively, argues that:

> much postmodernist culture is both radical and conservative, iconoclastic and incorporated in the same breath . . . because of a contradiction between the economic and cultural forms of late capitalist society, or more simply between the capitalist economy and bourgeois culture.

A major postmodernist theme is the impossibility or foreclosure of the Enlightenment project, predicated on rationality, coherent (bourgeois) subjectivity and master narratives, either of positivism, scientism, liberalism or Marxist liberation. Postmodernism is also identified with examining the repercussions of the epistemological break it proposes with Western theories of representation, both political and aesthetic.

Postmodernism challenges, and sometimes collapses, distinctions and oppositions perceived as 'modernist', such as between high culture and popular culture, thus reconfiguring more longstanding debates on the relationship between culture and commerce as well as populism and elitism, the role of criticism and of intellectuals (see Foster 1985; Garnham 2000; McGuigan 1992). In addition, postmodernism, influenced by and relating to semiotic, poststructuralist, critical linguistics and other theories of language and communication, challenges many of the normative values and legal-philosophical assumptions governing other media paradigms. Postmodernist epistemology deconstructs, in some cases eradicates, the divisions between real and unreal (or hyperreal), between image and reality. Two features are particularly important for my discussion. First, as Andersen (1995: 93) notes, many of the visual and cultural phenomena described by postmodernists 'are manifestations of promotional modes of discourse in contemporary culture'. Second, the demarcations between different kinds of speech, for instance between editorial and advertising, independent and 'interested' speech, are challenged on both ontological grounds and, to the extent the term applies, on 'normative' grounds as nostalgic hankerings for a failed 'modernist' project of rationalist, 'public sphere' exchanges in the sphere of communications.

Amongst the key issues, then, are the challenges postmodernist theory mounts against the analytical and normative divisions within media speech made in other discourses. Another is a political as well as analytical argument concerning the degree to which postmodernists offer an uncritical, if not celebratory, account of consumer culture based on aesthetics, one which 'relinquishes the quest to understand the forces, power, motivations, and processes that underlie these symbolic surfaces' (Andersen 1995: 116). I address further aspects of this in considering the relationships between postmod-

ernist accounts, media systems, deregulatory policies and the corporate strategies of media corporations.

Critical Political Economy

Critical political economy mounts a critique of liberal democratic media theory and of the capitalist market relations on which liberalism is contingent. Shaped by Marx's critique of capitalism, the Western Marxist critique of commodification, reification and the 'culture industry' (Adorno and Horkheimer 1979 [1944]), and by theories of 'strong', participatory democracy, political economy criticises the capitalist market system for its failure to deliver economic fairness, social justice or the basis for a democratic polity (McChesney 1998; Mosco 1996; Murdock and Golding 2005).[6] In place of the sovereign individual exercising free choice in the market, critical political economists 'follow Marx in shifting attention from the realm of exchange to the organization of property and production' (Murdock and Golding 2005: 62). Political economy begins with an analysis of how capitalism structures and circumscribes the exercise of social and economic power. It therefore addresses how market power operates against principles of free and freely informed exchange. A core feature of political economy approaches has been the analysis and critique of the increasing concentration of corporate media ownership, a process seen an integral to the logic of capitalism and so requiring not simply anti-monopoly measures by the state but transformation of the economic system (McChesney 1998, 1999).

For Murdock and Golding (2005: 61) Critical political economy approaches are *holistic*, seeing the economy as interrelated with political, social and cultural life, rather than as a separate domain. They are *historical*, paying close attention to long-term changes in the role of state, corporations and media in culture. They are 'centrally concerned with the balance between private enterprise and public intervention'. Finally, 'and perhaps most importantly of all', they go beyond 'technical issues of efficiency' to engage with basic moral questions of justice, equity and the public good'.

For liberal democracy individuals must have access to a wide range of ideas and opinions in order to exercise their will and judgement as citizens, albeit to different degrees according to the democratic theory espoused (see Baker 2002). In the liberal legal tradition freedoms collide, notably speech rights, and carefully circumscribed constraints upon speech may be tolerated. However, while there are fundamental contradictions and inconsistencies in the regulatory treatment of different media and the protection of speech rights, the paradigm is based on principles of non-interference by the state in the

exercise of free speech. In response to monopolisation and abuse of property rights, liberal democracy favours the media professionalism/social responsibility model and industry self-regulation. Market failures, notably concentration of ownership, which endanger the democratic process, may be further tackled through sectoral regulation or general competition law. As Mosco states:

> (N)eo-classicists tend to view corporate concentration as an addressable aberration. Institutionalists see it as more deeply embedded in capitalism but correctable through state intervention (e.g. anti-trust enforcement and independent regulation). In its analysis of monopoly capitalism, Marxian political economy views concentration as a logical consequence of capitalist development and an indicator of crisis. (Mosco 1996: 58)

From the critical political economy paradigm, Curran (1996: 92–95) set out six reasons to challenge the belief that 'the free market produces a media system which responds to and expresses the views of the people'. First, 'market dominance by oligopolies has reduced media diversity, audience choice and public control' (92). Second, rising capitalisation restricts entry to the market, creating a zone of influence where 'dominant economic forces have a privileged position' (94). Third, the 'consumer representation' thesis ignores the decoupling of the link between the media and political representation which has marked the transformation of the mass media since the formulation of such accounts in the nineteenth century. Fourth, the claim by liberal pluralists that 'media controllers subordinate their ideological commitments to the imperatives of the market is only partly true' (95). Fifth, the concept of consumer sovereignty ignores the variety and complexity of influences which shape media content, notably in large, bureaucratised media organisations. Sixth, the idealised notion of market democracy ignores the structuring influence of advertising in commercial broadcasting and the press, which Curran describes elsewhere as a 'licensing' power (Curran 1977, 1996). I will draw upon this critique in the next section in order to consider some shared tendencies and problems arising from the various paradigms I have described.

Part 2: Paradigms on Cross-Media Promotion

What then is the status of cross-media promotion in the discourses considered above and what relationships exist between them in their treatment of CMP? My concern in this section is to consider how CMP is evaluated and contested in different discourses; how and in what ways, it is constituted as an object of discourse, what normative assumptions govern its usage, and in what chain of significations it is linked.

Cross-media promotion is conceived in distinct ways with each of the main paradigms I have outlined: liberal democratic, neoliberal, consumer welfare, libertarian, critical political economic and postmodern. However I have also highlighted overlapping configurations that apply to CMP. Liberal democratic and political economy approaches share normative concerns about the relationship between media and democracy and political philosophical justifications for state intervention to ensure the conditions for democratic media. Liberal democracy shares with the neoliberal competition paradigm a belief that market abuse and failure are not fatally systemic and are addressable through regulation which can provide the best basis for the protection of media democracy, for the former, and the pragmatic balancing of the rights of producers and consumers, for the latter. Liberal democracy and critical political economy offer a critique of CMP, on both distinct and shared grounds. Following an examination of CMP in the various discourses, I will argue that both liberal democratic and political economy approaches share a hierarchical valuation of political speech which has led to tendencies in both to neglect and displace cross-media promotion from their accounts. The ways in which key paradigms problematise CMP and propose remedies is summarised in table 2.1 below.

Table 2.1: Cross-Media Promotion: Critical Matrix

	Competition (neoliberal)	Consumer welfare	Liberal democratic	Critical political economy
Key concerns/ description	Fair competition (consumer benefit)	Consumer protection	Editorial integrity	Systemic problems media power
Evaluating Cross-media promotion	Effect on competition	Value to consumer transparecny	Editorial integrity quality (and diverse of information)	Commercial speech commercialisation commodification
Regulation (Preferred remedies)	Market regulation plus (general) competition regulation of economic activities between firms	Competition regulation plus consumer protection	Professional self-regulation (co-regulation); public service	Structural regulation enforced codes

Liberal democracy

There are several different ways in which CMP may be problematised for liberal democrats. There are concerns which arise directly from the threat to the democratic role of the media and which focus on abuses or problems in the exercising of political speech. There are concerns which arise from the threat to journalistic integrity and so to the social responsibility model as a whole. Underlying each of these are concerns, at least latent, about the abuse of media power by editorial content which is distorted by partiality arising from political or economic interests in ways which are not transparent to the citizen and so are capable of giving rise to undue influence. A different set of concerns focuses on the threat to principles of market competition from behaviour, including CMP, which threatens diversity of ideas and opinion. Cross-promotion may strengthen firms' market power in ways which may threaten editorial diversity and limit access to the widest range of information, ideas and opinion vital for democracy.

CMP forms part of those corporate media communications that may undermine fulfilment of the checking function espoused in the 'watchdog theory' of the press. While, from its classical origins that theory focuses on state abuse, there is broad consensus that the media should and does expose corporate wrongdoing, and this in turn forms an important part of the promotion, and mythologising, of investigative journalism. As Baker states (1998: 325):

> A plausible policy goal is to create a press that will maximally "check" or expose abuses of power regardless of whether the abuser is public or private, governmental or corporate.

The failure to expose, or at least tendency to neglect, abuses of power within the groups of companies or interests of media conglomerates has implications for the broader conception of the checking function, which it undermines. If media are reporting on matters of direct economic interest to the owners of that media outlet there are risks of unfairness, partiality, distortion and omission arising from the 'interested' nature of the relationship. With much CMP such risks are further increased by the very intentionality of the promotional behaviour regardless of the form it takes. Yet concern has focused much more on suppression of information arising from corporate conflicts of interest than on the promotion of firms' allied interests.

As indicated in my earlier discussion, the liberal principle of press freedom protects commercial speech when fulfilling a distinct 'press' function, at least as traditionally conceived. Liberal theory understands that much media speech is purely commercial and less worthy of protection, but it eschews measures to limit speech rights where the benefits of restricting protection for

commercial speech are outweighed by the risks of curtailing freedom of expression and the exercise of political speech. Along this faultline, CMP may give rise to particular concerns, against which liberal theory proposes significantly modest and limited action in the case of the press, while justifying stronger 'positive' requirements for broadcasting. Cross-media promotion is problematic then because it exposes the 'interested' nature of commercial media speech and the exercising of considerable power by the holders of property rights to such speech in ways which undermine the 'marketplace of ideas' theory in which the media are the canvas or screen on which society scripts its deliberative conversations.

The neo-Marxist, political economy tradition analyses and challenges the exercise of corporate power. This critique, together with the evidence and exposure of proprietorial or corporate power from journalists themselves, has influenced those modifications in liberal thinking which propose media professionalism and 'internal pluralism' as ways of strengthening democratic objectives within the market-model. But this modification of liberal theory is itself threatened by CMP. As Sánchez-Tabernero et al. show (1993: 169) amongst the implications for journalists of monopolisation of the media is the reduction in control and independence which accompanies the rise in corporate control of media speech. Indeed, as this book discusses, CMP has been a motivation for many such corporate mergers, acquisitions and alliances. I have highlighted concerns arising from the watchdog model and social responsibility model, the third main area, drawing on economic theory, is the threat of market failure arising from monopolies, in particular that of concentrated market power on the marketplace of ideas. Here classical liberalism is identified by the restricted scope of its proposed remedies.

Scope and rationale for regulation of CMP. Modern liberal thinking has, until recently at least, held that that market competition alone could not guarantee the conditions for democratic media. For instance, the UK Conservative Government's report, Media *Ownership: The Government's Proposals* asserted that there was a continuing case for specific regulations governing media ownership beyond those applied by general competition law, before going on to argue that there was need to liberalise existing ownership regulation both within and between the different media sectors.

As chapter six considers in more detail, during the period from the early 1980s, when CMP was identified as one component of increasingly rapid processes of vertical, horizontal and multi-sectoral concentration, to the mid-1990s, it was also generally acknowledged that competition law was not sufficient on its own to tackle the public policy issues that arose. It is important to note, though, that the claim advanced by the Government in 1995 focused on

the informational and political speech role of the media. Elsewhere the report (DNH 1995: 5) asserts that:

> Broadcasters in particular use a powerful and instant form of mass communication, delivered through a limited number of outlets, which are in a strong position to inform and influence public opinion and to help set the agenda for public debate, and may also have an effect (for good or ill) on the outlook and behaviour of individuals.

Here, clearly the broader influence of entertainment is acknowledged and incorporated into the policy rationale, but the justification remains focused on the protection of political speech and rational 'public debate'. It is the unique power of media to influence opinion that justifies special ownership rules. Consequently the system of law and regulation must support broader public policy initiatives beyond the narrow concerns of basic competition law.

An important, and complex, assertion of liberal values is found in the *Enquiry into Standards of Cross Media Promotion* (Sadler 1991) produced by John Sadler at the behest of the Secretary of State for Trade and Industry. The *Enquiry* was justified on the grounds that competition regulation alone could not be relied on to eliminate the risk of improper CMP by media companies. In keeping with a tradition of UK policy making described as 'makeshift' and haphazard, Sadler was asked to assess what level and form of cross-media promotion was 'proper'.[7]

Sadler (1991: 9) considered that 'cross promotion is a normal and widely used commercial practice [. . .]Any business selling a number of different but related products will try to use each of its products to promote the sales of the others'. However while cross-promotion was 'normal' in markets, special concerns arose in respect of media cross-promotion. For Sadler, these included considerations of consumer choice, of pluralism and diversity of the media, of freedom of expression, of fair trading and fair competition. He concluded that the discriminatory use of advertising rates should be prevented, together with 'abuses' arising from CMP in editorial. Sadler's proposals exemplify liberal democratic concerns. He proposed strengthened press self-regulation through a code of ethics to prevent abuses. Drawing on a consumer rights/welfare paradigm he further proposed that newspapers should disclose more explicitly their cross media and other commercial interests since:

> (T)he present degree of disclosure by newspapers of their other commercial interests may not be sufficient to enable a large enough proportion of readers to adopt the same critical approach to editorial copy as they do to advertising copy, where the advertisers' interests are obvious (Sadler 1991: 37).

This proposal draws on two other key rationales. Consumers, Sadler argued, have little defence against increasingly covert manipulation of editorial information for commercial purposes. As an earlier submission to the *Enquiry* put it (Sadler 1991: 27):

> This was not only against the interests of consumers but could also distort competition between media companies and enable them unduly to influence political debate in their economic interest.

Secondly Sadler identified market failures arising from 'improper cross media promotion,' which neither competition law nor market mechanisms alone was capable of rectifying: 'I am not convinced that a sufficient number of readers will identify partisan reporting and, as a result, choose to switch to other newspapers to prevent this problem' (Sadler 1991: 38). Sadler, then, identified a broad range of concerns arising from the *behaviour* of CMP, for journalistic integrity and the interests of recipients, and from the *outcome* of CMP as a potential to distort competition and so threaten the operation of the market-mechanism to ensure diversity of ownership and pluralism of ideas and opinion. Amongst these, concern to ensure editorial and journalistic integrity defines the main contours of the liberal democratic paradigm.

Neoliberal responses to cross-media promotion

While media concentration and mergers have increasingly been subject to competition regulation, there is almost no UK or EC competition case law that has explicitly addressed cross-media promotion.[8] Within economic literature, a report by NERA, commissioned by and appended to the Sadler *Enquiry*, remains one of the few documents to attempt to apply economic principles of competition law in a sustained manner to cross-media promotion.[9] I consider the report and the circumstances of its production in more detail in chapter four. Here, I will merely select some illustrative arguments. The report sums up the grounds for challenging CMP according to competition law principles (NERA 1991: 128–129):

> Since it has exclusive access to certain "unpriced" inputs of the kind described above [favourable editorial coverage and preferential allocation of advertising space] and to other inputs at marginal costs rather than market price, which in certain circumstances may be higher [e.g. advertising], an integrated firm enjoys an absolute cost advantage over non-integrated firms in the downstream market. If this competitive advantage is sufficiently large as to discourage non-integrated firms from entering the market, then vertical integration may have an adverse effect on social welfare.

The report acknowledged the potential economic advantage to News International arising from its ability to cross-promote Sky satellite television in its national newspaper titles, although it went on to say 'the size of this potential advantage, however, is small in comparison with other factors in the television market' (Sadler 1991: 131).[10] In their study of convergence Baldwin et al. (1996: 401) highlight the potential economic benefits of cross-promotion for broadband networks:

> A vertically integrated network will not be permitted to deny access to competitive programming, deny its products to competitors, or discriminate in the conditions of affiliation or price. But a vertically integrated broadband network can promote its owned content and services heavily, to the neglect of others. Promotion is critical because of the difficulties a subscriber may have in choosing and finding content in the plethora of options available on a digital broadband system. Of course, any program, network, or information service can buy time for cross promotion, but if the system uses unsold advertising availabilities for promotion of its owned content, it has a promotional cost advantage. The full service network could also favor a new owned network by packaging it with another very popular network at a discounted price.

Competition law is generally concerned 'to prevent the avoidable prevention, restriction or distortion of competition by firms' (Bishop and Walker 1999: ix). In contrast, utilities regulation frequently aims to foster both economic and social objectives. However, in a survey of EC Competition law, Jeremy Lever QC states that the 'public interest' as grounds for regulatory intervention is being increasingly superseded by 'a more disciplined application of economic principles' (Bishop and Walker 1999: viii). There is a large and growing literature concerning the application of competition law to communications regulation (Collins and Murroni 1996; Marsden and Verhulst 1999; Doyle 2002a; Venturelli 1998; Levy 1999). Competition law promises in important ways to answer calls for anti-monopoly measures, and the record of DGIV of the European Commission in respect of media mergers has been both highly variable and compelling. At the same time, competition law recognises only some of the issues raised by CMP, while ignoring concerns raised about pluralism, editorial independence, communication rights and abuse of power of commercial speech.

From a purely economic perspective, the achievement of economies of scale and scope makes sense. Their achievement is also recognised as a powerful dynamic driving communications markets and tending towards oligopolist structures (Doyle 2002b; Hills and Michalis 1997). Such tendencies and practices are only problematised within dominant economic/competition law perspectives when they give rise to monopolistic practices (Whish 1989; NERA 1991). In fact, one of the underlying contradictions of competition law is the

penalising of market power arising as a result of firms' success in securing market share. Within neoliberal economics there is no settled position on concentration and monopoly rights. First, and particularly relevant to the media field, the granting of monopoly rights to intellectual property and patents is both integrated with and inherently at odds with competition models, since it protects property rights but restricts market freedom (Beesley 1996). Second, there are many pro-concentration arguments including welfare maximising benefits for consumers arising from the pooling of resources in production, product development and retailing, for instance.

The neoliberal paradigm has been further popularised through pro-market discourses concerning new communications media, especially the Internet. For instance, *The Guardian*'s then New Media Editor, Simon Waldman (1999) admonishes us/them:

> Media owners must promote their websites using their publications or broadcast outlets. If you don't do it, you are throwing away one of your main advantages. Yet, it is remarkable how many sites are poorly promoted by their titles.

While certain mergers such as AOL-Time Warner completed in January 2001, generated intense critical debate, the market logic underlying 'synergy' and CMP is increasingly presented as unproblematic, as giving rise to none of the concerns raised, for instance, by Sadler. Policy makers are likely to distort rapidly evolving markets if they intervene (DTI/DCMS 1998). This rationale is, of course, supported from another perspective by free speech arguments against economic regulation of the press. Behavioural competition law has come to be preferred to sectoral structural regulation as the dominant paradigm for media policy in the UK, Europe and United States (chapter six). This is a complex and increasingly contested issue in communications policy. Critics argue that it shifts media policy from conceiving media monopoly and concentration as an intrinsic problem to be tackled, to determinations based on the contestability of markets. The latter, as formulated in EC competition law, defines the principal objectives as preventing abuse of a dominant market position or barriers to entry into markets but not of tackling media concentration *per se*.

Consumer welfare

Consumer welfare forms the discernible basis for a branch of laws and regulations relevant to CMP including explicit consumer protection measures, fair trading, trade descriptions, advertising and sales promotion regulation (examined in chapter six). This paradigm generates concerns that consumers may be

misled about the nature of goods and services offered to them. The consumer welfare paradigm also offers justification and models for disclosure of information and transparency (considered further below). The contested borders between editorial and advertising content are also spaces where consumer welfare and liberal democratic paradigms meet. To separate these is somewhat artificial since regulatory bodies generally incorporate and mix rationales, and both advertising and editorial codes apply to publishers.[11] Respecting freedom of expression for editorial content, most consumer welfare remedies have relied on self-regulation by publishers and media professionals rather than legal or administrative enforcement. However, it is possible to differentiate consumer welfare concerns about CMP which focus on the formal degree of disclosure of commercially interested speech, the nature and implications of advertising in promotional speech and the possible adverse effects of CMP on consumer power.

Libertarianism

Libertarianism challenges interference in the exercise of speech rights. The significance of libertarian positions for this discussion are first, that they do not give grounds for problematising CMP and, more generally, refuse legal-regulatory supervision. Second, libertarianism has been an increasingly significant component of communications policy, not least in the extension of free speech arguments to electronic media (Schiller 2000). Of the key paradigms examined, libertarianism and postmodernism, in general, both perceive CMP as phenomena which do not call for regulatory responses. Libertarianism rejects regulation, while postmodernism variously discounts, challenges or problematises any separation of promotional from non-promotional speech as the basis for regulatory interventions.

Postmodernism

Promotions in and of media are so ubiquitous that Andrew Wernick in *Promotional Culture* (1990) is surely right to speak of a 'vortex of publicity'. Wernick applies the concept of intertextuality to describe a chain of promotional signs—linked by commercial motivation—through which media products, advertising and non-advertising content are combined in a web of promotion. Wernick's postmodernist discourse of intertextuality provides a powerful account of the complex diffusion of promotional signs and transformation of textual meanings. For Wernick the boundary or division between non-advertising content and advertising is erased by this intertextuality, whereby the editorial copy is as

promotional as advertising and occurs in a media product which is itself both a vehicle of promotional messages and a privileged site for its own promotion. Wernick is careful not to collapse the distinction between ad-based and non-advertising material altogether. Instead, he argues varying levels of economic dependence on advertising in different branches of the culture industry mean that the extent of ideological/aesthetic assimilation of the commodity form is uneven:

> In general, we can say that the impact of any channel's ad-carrying role on the fashioning of its non-advertising contents is proportional to the extent of its dependence on such revenue (Wernick, 1990: 100).

This is a view shared by political economic analyses of advertising influence (Curran 1986, 1977; Baker 1994). However, for Wernick (1990: 100) such distinctions are ultimately reduced to a question of intensity, so that the culture industry:

> can thus be construed as one vast promotional vehicle: a functionally interdependent complex within which the line between what is incidental as advertising and what is ostensibly its primary content, as information and entertainment, is reduced at most to a matter of level and degree.

Wernick concludes (1990: 121):

> It is as if we are in a hall of mirrors. Each promotional message refers us to a commodity which is itself the site of another promotion. And so on, in an endless dance whose only point is to circulate the circulation of something else.

For Wernick the promotion universe is inescapable, and it envelops and incorporates 'critical' discourse, which is just one more promotional and self-promotional articulation. In a rather ironic parallel to Adorno and Hork-heimer's modernist essay 'The Culture Industry: Enlightenment as Mass Deception' (1979 [1944]), the position of the critic is both established by the discourse and cancelled out within it. Further, the promotional universe Wernick describes is not subject to regulation. In that more fundamental sense, this postmodernist account, while critical, is arguably aligned with the instrumental interests of corporations operating within and extending the promotional 'vortex'. Common to other postmodernist accounts, Wernick offers an acquiescent analysis complicit with, even celebratory of, the fascinating 'vortex' he describes.

Postmodernist writers address other aspects of intertextuality, especially in regard to popular cultural texts and in advertising. One focus is on the forms of bricolage and pastiche, raids and reconfigurations of genres, themes, symbols and all manner of content that arises in postmodern art and is an increas-

ingly pervasive feature of mainstream popular cultural forms. Another focus is upon the pleasure and participation of audiences in intertextual play (Olson 1987). Intertextuality, since Aristophanes at least, has been deeply embedded in artistic discourses and popular entertainment, evincing the pleasure of parody and pastiche, of recognition and shared knowledge, or alternatively deployed as a strategy of *Verfremdung* (Demetz 1962). In her insightful account of intertextual strategies in media and advertising Andersen (1995: 33) criticises the way in which 'the theoretical emphasis on audience participation through intertextual play . . . overlooks the importance of intertextuality as a commercial strategy'. Further, the consequence, if not the intention, of postmodernist accounts of intertextuality such as Wernick's is to render cross-media promotion irretrievable as a meaningful object for regulation.

Critical political economy

Critical political economists including Bagdikian (1997, 2000), Herman and McChesney (1997), McChesney (1999), Wasco (1994) have analysed key features of corporate consolidation, mergers and acquisitions that have given rise to extensive cross-promotional activity. Absent from most critical analyses into the early 1990s, strategies of CMP have been identified as central to media conglomeration in more recent literature (Croteau and Hoynes 2001, 2006). Amongst the earliest detailed accounts is Turow (1992a, 1992b), who examines the influence and adoption of synergy and related strategies by US media firms. The earlier neglect of CMP has been redressed by critical scholars. Cross-promotion now forms a prominent place in both mainstream and critical accounts of contemporary media, especially in entertainment and films. Cross-promotion across all media has been examined most extensively by McAllister (1996, 2000, 2002, 2005). Meehan's (1991, 2005) work on synergy marketing in films, television and merchandise has encouraged a thriving body of research on commercial intertextuality in entertainment media (see chapter three). There has certainly been increasing attention to forms of media integration by radical scholars, and so it may be argued that CPE has engaged with contemporary promotional practices as these have become more significant. However, the manner in which CMP has been neglected is still relevant in understanding both the analysis of 'problems' of CMP, and remedies, today. In addition, the literature remains heavily weighted to US scholarship, with consequent continuing neglect of CMP in the UK and other media systems.

This book argues that critical political economy (CPE) is best placed to develop a critique. However it is important to trace how CMP has been sub-

sumed in CPE accounts of media, tendencies which are less prevalent but still important today. This relates to the second area, and major challenge, that of formulating critiques of CMP to influence practice, public understanding, policy reform and regulation. While phenomena of the commodification of media and information are central to critical accounts of media power, I want to argue that normative arguments tend to concentrate on democratic, political speech matters to the detriment of adequate consideration of the exercise of media power in commercially interested speech. The more significant neglect occurs in the way in which critical political economists have generated critiques and from these formulated rationales and proposals for policy reform. CMP is framed in discussions of media ownership that trace the problems of market power and media power arising from ownership structures and behaviour. A second focus is on the erosion of media independence arising from corporate and proprietorial influence and the implications this has for pluralism. The third focus considers CMP as an element of more general processes of commodification and consumerism (Schiller 1989). A central task for political economy of communications has been to analyse the increasing concentration of corporate media ownership as 'a process flowing from the logic of the market' (McChesney 1998: 6). For instance, Schiller (1989) and Herman and McChesney (1997) examine the emerging patterns of vertical, horizontal, multi-sectoral and transnational expansion.[12] Herman and McChesney (1997: 104) describe a global media market dominated by 'ten or so vertically integrated media conglomerates':

> These firms operate in oligopolistic markets with substantial barriers to entry. They compete vigorously on a non-price basis, but their competition is softened not only by their common interests as oligopolists, but also by a vast array of joint ventures, strategic alliances, and cross-ownership among the leading firms.

They analyse how, beyond distinct cost savings, conglomeration and integration provide a source of profitability from 'the exploitation of new opportunities for cross-selling, cross-promotion, and privileged access' (Herman and McChesney 1997: 54). Rather than being welfare maximising, social or 'real', they argue such gains are 'private and pecuniary' (Herman and McChesney 1997: 54; Herman 1999: 46). In addition to exploitation of such 'synergies' there is increasing use of joint ventures amongst the largest global media firms. Their critique of such processes is that far from resting on neoliberal models of competitive markets, 'the 'synergies' of recent mergers rest on and enhance monopoly power' (Herman and McChesney 1997: 57; Bagdikian 2000: xvii). This political economy critique challenges the 'internal' market correction proposed by neoliberal economists and liberal democrats. Political economists

thus radically rework the critique of monopolisation articulated in the competition regulation paradigm by identifying systemic problems of media power.

Cross-media promotion is also identified within a broader critique of the commercialisation of news, and the rise of 'newszak' (Franklin 1997) and 'tabloidization' (McChesney 1997; Sparks and Tulloch 2000). More fundamentally, CMP transgresses the boundaries maintained by the model of the media professional, notably in respect of truth, independence, objectivity and impartiality, or at least 'transparency' of partiality. As Randall (1996: 93) states: 'These new ethics flow from an unwritten contract that should always exist between newspapers and their readers in a free society: every story and feature in the paper is there as a result of decisions made free of any political, commercial or non-commercial pressure'. In editorial cross-media promotion the owner 'usurps' the role assigned to the 'media professional', thus undermining the basis for modern liberalism to resolve, as it must, private ownership and media democracy.

As this study examines, efforts to grapple with the increasingly global reach of 'synergy' arising from multi-sectoral media ownership have led to a more explicit and diverse range of concerns being articulated, combining problems of market power and media power and synthesising and reworking the concerns of other paradigms. How this work can help to provide a more satisfactory account of CMP will be addressed especially in chapter nine. Here, the focus is on identifying the manner and significance of the displacement and neglect of CMP within the critical political economy tradition.

There are various ways in which CMP has been identified, and, I will argue, subsumed within political economy analyses. CMP is sometimes doubly subsumed under the issue of media ownership. First, CMP is only one of many components of media monopolisation and concentration. Second, in efforts to challenge deregulation and construct alternative media systems, proposals to limit media ownership largely 'resolve' the problem of cross-media promotion. Furthermore, political economic critiques often share with liberal democratic ones a focus on the political speech functions of media and on citizenship rationales. I will consider illustrative examples of each of these approaches below.

In *Megamedia* (1998), Dean Alger (1998:144) introduces his discussion of synergy by quoting an ABC radio executive who states, 'What synergy has done for us, particularly here in Los Angeles, with the fact that there's [Disney–ABC owned] KABC-TV, Disneyland, *Los Angeles* magazine, the Disney movies, and three radio stations is, it's a great opportunity to cross-promote each vehicle and really help each other'. For Alger (1998: 144) 'the simplest of

benefits from conglomerate ownership of media—and a more modest factor skewing economic competition—is the abundant opportunities for cross-promotion of megamedia products and services'. He then goes on to argue (1998:145) that the 'conglomerate capacities and synergy system become more profoundly distortive of . . . competition' in the exercise of preferential treatment by integrated corporations, favouring linked firms, or simply shutting out external competition as Time Warner's New York cable system did to alternative music channel, The Box, and to Murdoch's competitor channel to CNN, Fox News. Alger's approach illustrates a tendency to identify but then fail to examine the phenomenon of CMP. Part of the explanation lies in Alger's adherence to a 'marketplace of ideas' approach which circumscribes both his critique and reform proposals. Alger recommends a strengthened role for 'independent' public media, with a strengthening and expansion of anti-trust law beyond its narrow(ing) 'economic' framework to encompass a broader political, free speech and welfare rationale for preventing (further) concentration.

Alfonso Sánchez-Tabernero et al.'s Media Concentration in Europe (1993) is a thorough analysis and evaluation of the dynamic processes of concentration then rapidly reshaping Western European media. The report considers the increase of 'synergy' in several places and quotes one of the earliest studies by Bernard Guillou, who pointed out in 1984 that the emergence of the 'multimedia publisher' was influenced not only by financial logic but also by the opportunity to dominate the editorial function.[13] However Sánchez-Tabernero et al. make only two references to CMP. The first highlights how, arising from conglomeration:

> Managers may find that certain launches of "products" or acquisitions are more successful and profitable; moreover they may achieve certain synergies in terms of advertising, distribution, financing, cross promotion and management, and may therefore increase the profitability of each medium (Sánchez-Tabernero et al. 1993:163).

Here the authors point out that in actuality such benefits have not always been realised (see also Herman and McChesney 1997; Doyle 2002a).[14] In the other instance, Sánchez-Tabernero et al. refer to an interview with the owner of a Greek television channel who states that the five publishers who control the company are likely to promote it, not only through advertisements in their publications but through the provision of news and reports. Following this single example they state 'the effects of such cross promotion are more profound in some countries than in others, but these can, in most instances, merely be attributed to the level of concentration in the country in question' (Sánchez-Tabernero et al. 1993: 170). Here, characteristic of other accounts,

cross-media promotion is included in the 'empirical' evidence of conglomeration in communications markets but not examined either in greater depth or related to normative accounts, where present, of media democracy and power.

Further, cross-media promotion has been neglected in critical policy responses to media concentration. In evidence to the Sadler *Enquiry*, Mike Smith and Tim Gopsill for the TUC, the Campaign for Press and Broadcasting Freedom and Norman Buchan MP all argued that any remedial measures aimed at cross-promotion could only have very limited effect while cross-ownership remained so prevalent. This was, arguably, a fundamental and necessary critique of the limited terms of reference constructed by the government and further delimited by Sadler himself (see chapter six). The enquiry also occurred during a period when structural controls on cross-media ownership were being increasingly challenged and undermined, adding urgency to the charge. Nevertheless, in hindsight, some opportunity was missed to develop a more substantive critique of CMP, from the displacement of critique of commercial speech abuses to that of structures of ownership.

Hierarchisation of political speech

In various essays in the 1990s one of the UK's pre-eminent critical scholars Graham Murdock (1990, 1992a, 1992b, 2000) examined the consequences of changes in the organisation and regulation of communications industries for the realisation of a diverse and democratic culture. His work includes an outstanding critical-historical account of promotional speech and its regulation in US and UK media (Murdock 1992a), which remains one of the very few such analyses by a British academic. His consideration of 'the cultural resources for effective citizenship' (Murdock 1992b: 40) is informed by an expansive vision of media diversity that includes not only diversity of information and ideas but also imagery and so integrates political and cultural expression. Yet in his essay 'Redrawing the Map of the Communications Industries: Concentration and Ownership in the Era of Privatization,' Murdock (1990) provides an illustrative example of the way in which the hierarchisation of political speech has shaped political economy approaches to CMP. Murdock (1990: 5) identifies the 'growing interpenetration between old and new media markets as major players in established sectors move into emerging areas which offer additional opportunities to exploit their resources' and the underlying rationale as one of achieving greater 'synergy', 'so that the activity in one sector can facilitate activity in another' (Murdock 1990: 6). For Murdock, concentration of power by owners serves to limit the diversity of 'publicly available information and debate' necessary for democracy. First, 'the fact that many of

the leading communications companies command interests that span a range of key media sectors and operate across the major world markets gives them an unprecedented degree of potential control over contemporary cultural life' (Murdock 1990: 6). Second, privatisation is leading to an erosion of the countervailing power of public cultural institutions. Third, privately owned media are becoming both more concentrated and more homogenised, limiting the range and diversity of voices heard.

Drawing on his distinction between industrial, service and communications conglomerates, arising out of the relevant 'core' activity in each case, he cites examples of corporate control and abuse of ownership power. First, he describes industrial conglomerates' use of media to advance 'their social and political' ambitions, noting that such concerns go back to the early part of the century when such abuses first became recognised as a trend. Second, he describes service conglomerates' use of 'synergy', such as Berlusconi's announcement in 1988 of his intention to cross-promote on his television channels goods sold in the Standa department store chain which Fininvest had recently acquired. In contradistinction to 'political' abuses by industrial conglomerates, such synergies are for Murdock (1990: 8) 'purely commercial decisions, but by promoting multiplicity over diversity they have a pertinent effect on the range of information and imagery in the public domain'.

Analyses of media concentration must themselves be examined and situated historically. This is vital if any critique is to avoid simply charging researchers with neglecting phenomena that either occurred, or at least intensified, after the period under investigation. It is important, as Murdock (1992a) himself emphasises, to recognise the sometimes long historical trajectory of the processes of conglomeration, while also examining the forces determining the intensification of such corporate consolidation in the more recent period.[15] In addition, my charge concerns not just neglect of CMP by critics, but the organisation of a dominant discourse within political economy which shapes the way CMP is neglected or displaced. I am concerned to trace and examine the neglect of CMP which arises from the normative basis for much political economy critique. McChesney (1998: 8) argues that political economy 'can probably be distinguished from all other forms of communication research by its explicit commitment to participatory democracy'. Political economy draws upon classical democratic theory's claim that democracy is predicated on an informed participating citizenry, to assert that such political culture can only be generated by a diverse, democratised media system. Likewise Murdock (1990: 15), argues that the contradiction between private media ownership and the model of citizenship presupposed by the political system requires adoption of an alternative policy approach involving (stronger) regula-

tion of the new multi-media concerns and the development of 'novel forms of public initiative and institution'. However, returning to his earlier formulation of conglomerate abuses, it is clear that one kind of abuse (industrial conglomerates' pursuit of corporate interest) distorts political speech and so threatens democracy directly, while in the case of 'synergy' (service conglomeration) the interest is commercial rather than political and so the threat is to 'diversity', rather than in any direct sense to democracy. Murdock (1990: 15) concludes that media concentration is 'a major issue' facing those 'interested in the future of communications as an essential resource for developing and deepening democracy'. Notwithstanding the intrinsic value of this argument for democracy, I want to argue that the privileging of political speech and the role of the media in ensuring access to ideas and opinions prevents an adequate analysis of the exercise of commercial speech in the media and significantly delimits the effective grounds for justifying and developing regulatory action. In his contribution to *The Cross Media Revolution: Ownership and Control*, Bill Robinson (1995: 54) argues that:

> For many media products, the special concerns about pluralism do not apply, but ordinary competition policy can be used to achieve the desired aims

One of the principal aims of this book is to reconsider that hierarchisation and address if and how abuses arising from cross promotion and commercially interested speech might be subject to greater public policy scrutiny and regulatory control than hitherto, drawing conclusions from regulation, practice and analysis to date.

Political speech and entertainment media

The most persuasive and critical account of cross-media promotion—critical political economy—has nevertheless tended to privilege the political speech role of the media in critical-normative accounts of concentration of ownership and the extension of corporate media power. In this way political economy approaches share with liberal democratic/human rights based approaches a hierarchical valuation of speech leading to arguments for democratisation of the media and policies for reform which have tended to neglect important issues arising from CMP. Liberal discourse has traditionally tended to focus on (vertical) state–citizen relations of political speech to the relative neglect of (horizontal) matters, such as corporate communications and commercial speech. In contrast, political economy approaches argue that, in most liberal democratic states at least, corporate media power poses a greater threat to democratic processes than state control. However, for both, normative argu-

ments for reform have largely remained within a framework of political speech and information, derived from classic liberal theory.

Cross-media promotion has a problematic status within the various paradigms examined in this chapter. It combines and also transgresses divisions between political/ informational communication and entertainment. One of the important challenges is to broaden the conception of the political to encompass practices which do not 'reveal' political-democratic concerns, narrowly conceived, but which nevertheless demonstrate problems of media power and of media commercialism, which a broader critical theory and polity need to address. This, in turn connects to a set of debates about the relationship between politics and entertainment in media and communications studies.

Divisions arise between studies of media economics and production and studies of consumption, and more broadly between political economy and cultural studies approaches, in particular those influenced by postmodernism and cultural populism (see Frith 1996; Golding and Ferguson 1996; McGuigan 1992; Curran 2002). Such oppositions have been interrogated and deconstructed, notably by feminist scholars, not least in critiques of Habermas's theory of the public sphere (see Calhoun 1997; Curran 1996; Keane 1998: 157–189). Criticism has been made of both the privileging of rational discourse in Habermas's model and the positing of a centred, rational subject as the agent of communicative exchange. Here I want to focus more narrowly on the relationship between entertainment and the political speech role of the media. Curran (1996: 102) cites as one of five limitations of the classical liberal model of freedom of expression the omission of entertainment, 'because it does not conform to a classic liberal conception of rational exchange'. The status of entertainment has also informed wider debates concerning the public sphere. McGuigan (1998: 98) notes the 'tantalizing brevity' of Garnham's remark in 'The Media and the Public Sphere' (1997) that entertainment is 'a crucial and neglected area of media and cultural studies research', and goes on to highlight the fact that most of the actual research about the entertainment content of the media 'usually operates in a very different space from research that is grounded in a problematic of the public sphere'. As I hope to demonstrate through this study, CMP occurs on the boundaries of politics and entertainment and transgresses these just as it transgresses divisions between editorial and advertising and between independent and commercially 'interested' speech. Following from this, my book goes beyond arguing simply absence/omission in consideration of entertainment to argue that the outcome of the existing hierarchical valuation of 'political speech', shared by liberal rights and political economy paradigms, fails to account satisfactorily

for the consequences and implications of cross-media promotion exercised across the informational and entertainment fields of communications practice. Developing this argument below, particularly in chapter seven, I will justify expanding the scope of a critique of media democracy from the political/public sphere in order to adequately assess problems of corporate media power and recombine critical accounts of commercial speech with the political speech underpinnings of 'public sphere' theory.

Conclusion

During the early 1990s when cross-media promotion was first specifically addressed as a policy issue in UK regulatory space, it was notably done so within an unstable assemblage of discourses ranging from liberal rights to neo-liberal economics. At the same time, *both* the legal and economic discourses of competition law, which have come to dominate policy, and the neo-Marxist criticisms of media concentration have neglected to analyse and address CMP. In the case of the former this has arisen partly from the scope and procedures of 'general' competition regulation of market dominance in place of the 'sector specific' regulation which formerly drew upon various cultural, social and public policy rationales. In the case of critical political economy, a normative discourse of participatory democracy, requiring media diversity and limitations on ownership, has, until very recently, neglected to examine what it otherwise drew upon for evidential support, namely an articulation and critique of the actual practices of CMP.

Cross-media promotion is (no more than) one component of processes of media convergence and corporate concentration well established, particularly in the United States, and extending on a global scale. Yet, I hope to show that analysis of the phenomena and critical consideration of actual and possible regulatory frameworks, point to the need to reconceptualise both the regulation of media expression and the beleaguered discourses of citizen and consumer which underpin current regulatory rationales.

Notes

1. Baker (1989) provides a detailed, critical discussion of marketplace of ideas theory. This was enunciated by US Supreme Court Justice Holmes in *Abrams v. U*, who argued that all truths are relative and can only be judged 'in the competition of the market' [250 US 616, 630-1 (1919)].

2. Seaton (1998) argues that Mill's argument can be interpreted as supporting pro-active measures by the state to secure diversity and so ensure the conditions for freedom of expression.

3. Feldman's (1993: 606) account of US press freedom concludes 'it is still essentially a negative rather than a positive right [. . .] it limits the range of circumstances and ways in which it is legitimate for public authorities to interfere with free expression. It usually makes no obligations on the State to make available the facilities and materials which people need in order to take advantage of the freedom'.

4. The eighteen larger Western European states ratified the European Convention in the 1950s except France, Switzerland and Greece (1974), Portugal (1978), Spain (1979) and Finland (1990).

5. Curran and Seaton (1997: 356) distinguish four main approaches to media policy: traditional public service, free market, social market and radical public service. These approaches are defined according to a division between advocates of free market and supporters of public service. In addition, the four approaches are traversed by another key division of opinion between paternalistic and libertarian approaches to media law. Arising from the twin axes of free market–controlled market, and paternalism–libertarianism are a 'complex mosaic' of public policy positions.

6. Critical political economy (CPE) is the more accurate term to distinguish the tradition examined above which challenges mainstream, orthodox economics, but 'political economy' or in places CPE is used for the sake of brevity. For a detailed introduction to the tradition, see Mosco (1996, 2009) and Mosco and Reddick (1997).

7. Hitchens (1995: 624) describes the history of cross-media ownership policy making in the UK thus: 'The collection of opinions; the lack of empirical study; the inclusion of cross media ownership often as an afterthought; the failure to consider in any depth the design of the regulatory structure; and the lack of comparative material are all common features of broadcasting policy-making'. For Curran (1995: 36) the UK media regulatory system 'is not the product of a coherent strategy but rather the makeshift result of different media histories, different philosophies and different industrial pressures'.

8. Barendt (1993: 135) states in reference to Sadler's recommendation for self-regulation, that 'in principle, this is a subject which should be covered by competition law'.

9. Brief discussions of the implications of CMP for competition are found in Doyle (2002: 32). The ITC's analysis of effects of CMP on competition is examined in chapter seven.

10. Elsewhere, NERA's report (1991:127) states that it is 'difficult to identify potential scope economies from a single firm providing both newspapers and television services, other than the common use of news gathering services and, perhaps, some benefit from cross-media promotion'. Given that the report was explicitly commissioned as part of a review of just such kinds of CMP the brevity, and hence evasiveness, of this statement suggests that beneath the language of economic science lie the political and ideological inflections of a liberalising policy agenda.

11. In the UK, publishers are bound by Clause 1.2j of the British Codes of Advertising and Sales Practice to distinguish editorial from advertising. However, while advertising (commercial speech) is subject to statutory laws, media law does not place any substantive restrictions on editorial cross-promotion or on promotional speech in non-broadcast content.

12. Mosco (1996) describes how research on media concentration confronts an increasingly difficult task of examining the growing integration of media businesses across traditional industry and technology divisions.

13. 'This evolution of the editorial function and the appearance of new media which multiply the possibilities of distribution have just put all their weight behind the notion of a multimedia group. These are not simple conglomerates moved by a financial logic but they look to dominate this editorial function with the aim of benefiting from the synergy between the different media and assuring in this way long term profitability from their investments' Bernard Guillou (1984: 131).

14. Keane (1991: 84), in a discussion of advertising, addresses the problem of 'self-promoting giants' such as Time Warner which 'having commissioned one of its journalists to write a novel, could then publish the book and market it through a Time Warner book club, review it in Time Warner magazines, and make it into a Time Warner movie, which in turn could be the source of further reviews and interviews and feature stories before being broadcast on Time Warner cable television'. For Keane, however, this 'trend is sometimes exaggerated by its critics', such as Herbert Schiller.

15. Anthony Smith (1991:11) writes of the 'heightened interest [in an 'era of privatization'] in the way media enterprises operate, in their growing interlinkages, and in the commercial judgements that underlie them'.

Cross-Media Promotion
in Media Industries

Commercial Intertextuality: Cross-Promotion in Entertainment Media

Cross-promoting a single concept across various media is most evident in the synergistic strategies adopted for entertainment content. For integrated entertainment businesses success depends on the promotion and circulation of intellectual properties across media outlets. Major film releases are cross-promoted, as well as cross-referenced, through magazines, newspapers, broadcast content and online, and connected to an often extensive array of interlinked media products such as computer games, interactive websites as well as spin-off merchandising. The global consolidation of media and entertainment industries has favoured the creation of 'intertextual' cultural commodities (Meehan 1991; Marshall 2002, 2004), 'content brands' such as Harry Potter that 'travel between and provide a context for the consumption of a number of goods or media products' (Arvidsson 2006: 75). This chapter examines cross-promotion of entertainment media and situates this within the wider context of flows of texts, brands, concepts and content across multiple media platforms and multiple sites of consumption and engagement. The chapter also engages with different perspectives towards commercial intertextuality, in particular political economic and culturalist approaches. The economic, as Murdock (1989: 230) observes, 'is a necessary starting point for [cultural] analysis but not a destination'. To make full sense of cross-promotional practices we need to examine industrial organisation and production; symbolic meaning and textuality; reception, consumption and use. In short, we need the contributions of both political economy and cultural studies. If much can be gained by bringing various analytical tools into relationship and adopting more comprehensive and holistic accounts, there are also important tensions and differences that persist across the range of perspectives, as we will examine.

Film Promotion and Synergy

Studies of major commercial films, in particular, show the close relationship between film production, promotion and licensing. The major 'Hollywood' film studies are now a fully integrated part of a much larger, diversified entertainment industry producing content 'software', products and services (Wasco 1994; Schatz 1997). For Maltby (1998: 6)

> The major Hollywood corporations are now equally involved in the production and distribution of a chain of interrelated cultural products: books, television shows, records, toys, games, videos, T-shirts, magazines, as well as tie-ins and merchandizing arrangements with the entire panoply of consumer goods.

Marketing costs for major film releases often exceed production costs (McAllister 2000). Costly promotional efforts are undertaken with the aim of increasing sales of the film across all windows of exposure and increasing sales of associated products. The sale of licensed toys, computer games and other merchandise helps to promote the overall brand and enhance box office takings and revenue from DVD and other sales windows. These are rightly examined as mechanisms of control in which purposeful activity is undertaken to maximise revenues, principally through consumer spending. Critical political economic perspectives on cross-promotion engage with the consequences of these efforts both for specific cultural productions and exchange and in regard to the system-wide implications of corporate cross-promotion.

Such critique is not dependent on the 'success' of these activities. While there is a correlation between levels of investment in promotions and popularity, measured by consumer spending, so that the greatest promotional effort is expended on event films and major brand franchises, success remains notoriously unpredictable as the litany of costly failures such as *Cutthroat Island* (1996) demonstrates. Critics are therefore right to challenge 'control' accounts which imply corporate omnipotence and to draw attention to the different forms of risk and unpredictability attending cultural production (Hesmondhalgh 2007: 18–20). Cultural commodities serve to varying degrees as marketers of taste and 'distinction' (Bourdieu 1984), marking out socially situated identities and allegiances, and these relationships and investments can be highly volatile and changeable as the cultural values associated with symbolic goods change. Yet, corporate marketing, cross-promotion and public relations activity are the principal means of generating consumer demand and managing the risks of assuring profitable returns on investment. Extensive promotion and cross-promotion, while risky in economic terms, is a standard means to build awareness and demand to try to ensure the success of major releases. To be successful, releases depend on 'a complex web of information sites: radio,

spots, theatrical trailers, various sorts of television promotions, billboards, product tie-ins, and increasingly the Internet (Telotte 2003: 38). A celebrated cult hit, *The Blair Witch Project* (1999), which was promoted through an innovative Web strategy, was also supported by a $20 million marketing strategy, using print and TV advertising to encourage participation in the website (Telotte 2003; Marshall 2002).

Any account of media industries would be seriously flawed if it failed to address the nature of risks that underlie the unpredictability and high level of failure of ideas, products, firms and operations. This provides a vital corrective to 'control' accounts and encourages a more nuanced reading, alert to the contingencies of cultural flows. But it also sharpens analysis of risk-reducing strategies, of efforts to manage consumption profitably though the resources allocated as well as to sustain brand affiliation, cultural value and identification amongst target audiences.

The risks of promotion, for instance, include the lack of control over the circulation of opinions that may influence consumption decisions critics, journalists, word of mouth, and increasingly, Internet-aided communications. Products such as films are 'cross-referenced' (Marshall 2002) in a variety of other media through editorial (entertainment news, previews and reviews) as well as controlled communications (advertising) and mixed forms (competitions and give-aways). As Hesmondhalgh (2007: 19) notes, 'even if Company A actually owns Company B . . . they can't quite control the kind of publicity the text is likely to get because it is difficult to predict how critics, journalists, radio and television producers, presenters, and so on are likely to evaluate texts'. Risk reduction strategies include controlled use of marketing communications and public relations. Instrumental economic/political power may sometimes also be used, for instance in 1999 Fox dropped film advertising in the *Hollywood Reporter* in retaliation (allegedly) for negative comments about its film *Fight Club*. In addition, intra-firm cross-promotion serves to co-ordinate and manage communications.

The market environment for entertainment products carries risks arising from competition at each stage of creation, production, distribution, use and consumption. Competition is dynamic at each 'stage'; the risks are interconnected and can multiply. Risk reduction strategies involve efforts to create more binding relationships between collaborating operations to mitigate risks of competition from others that threaten value creation. One such strategy is corporate integration (chapter one). However the benefits of this strategy may well be offset by disbenefits. If synergy benefits appear uncertain, investors may resist integration at any stage. Diversification may have a range of negative effects including increasing the debt to earnings ratio, loss of management

focus on 'core' business operation, negative impacts on the operational effec-
tiveness and organisational culture. Another strategy is joint ventures and tie-
in deals with independent firms or subsidiaries. This last strategy is particularly
important in entertainment marketing. Key tie-in partners include advertisers,
manufacturers, wholesalers and retailers.

Film Marketing and Cross-Promotion

Film marketing and merchandising has a history as old as film itself. The
'blockbuster' film strategy developed in the 1950s was fully established by the
1960s (Schatz 1997; Maltby 1998). From the 1980s the predominant model of
synergy shifted from a contract-by-contract process to an increasingly sophisti-
cated combination of intra-firm, joint venture and licensing arrangements.
Before the 1980s, writes Meehan (2005: 90):

> The producer of a television series had to make individual deals with independent
> companies—a film studio, book publisher, comic book publisher, local television
> stations or cable channel, etc.—to move a property across multiple media venues. By
> the advent of transindustrialism, everything was already in-house, and each original
> property was designed to feed those in-house operations.

The blockbuster hits and economic recovery of the 1970s led to a wave of
mergers and acquisitions in the late 1980s and 1990s as the 'new Hollywood'
model of diversified conglomerate ownership came to dominate. The 1990s
witnessed a regeneration of the studio system, which dominated through
'vertical integration' of production and distribution in the 1920-1940s, but
now in a 'reconfigured' form, through conglomerate ownership and 'tight
diversification' (Schatz 1997: 86-87).

Film has also been cross-promoted in other media almost from its birth in
the 1890s. Public relations tactics and publicity stunts were developed in the
early years of cinema, together with product placement in films, star endorse-
ments in commercials and other forms of value-transfer of Hollywood glamour
(see chapter eight). Disney created extensive marketing and merchandising
from the late 1920s, marketing Mickey Mouse toys from the early 1930s,
during which period of Depression there was nevertheless 'an intensification
and rationalization of the process through which films were linked to con-
sumer goods' (deCordova 1994: 204). However, with notable exceptions such
as Disney, there was little studio-organised merchandising until the 1960s
(Wasco 1994). Since the 1990s, cross-merchandising, synergistic promotion
and million-dollar placement deals have become the norm in Hollywood
(Abramovich 2001; McAllister 2000; Wasco 1994). Schatz (1997: 80) dates the

'real breakthrough' as occurring in 1975 with the release of *Jaws*. This innovative summer release was accompanied by an unprecedented saturation marketing campaign and a vast array of tie-in merchandising (see also Gomery 1998: 51).

Blockbusters are expensive to make and to promote. There was a ten-fold increase in average costs for producing and marketing a mainstream film from $7.5 million in 1971 to $75.6 million in 1997 (McAllister 2000: 107). In 1995 the average cost of 212 Hollywood movies was $50 million of which $17.7 million was spent on marketing alone (Schatz 1997), and by 1997 marketing of wide-release, 'event' films averaged about $25 million for advertising (McAllister 2000: 103). These costs raise the risk-reward quotient, leading to spectacular losses but, with notable creative exceptions, ensuring that only large firms can generate the investment and bear the attendant risks. Cross-media promotion, then, functions alongside high entry barriers and other economic and promotional benefits of synergy to limit competition. Rising production and marketing costs have also been key drivers in encouraging cross-promotion and product placement deals.

Film has become the premium product for generating content for use in other media and in merchandising. As the essential 'Ur text' for extensive media franchises, blockbuster movies have also made the film studios key holdings for media conglomerates (Schatz 1997: 75). This has also prompted a huge increase in marketing, especially targeted at achieving high 'first run' attendance and 'buzz' amongst key publics, as the basis for stimulating interest in global markets. To achieve this, companies have significantly increased their expenditure on paid-advertising as well as seeking cross-promotional partners. Such deals have provided additional, usually 'free', advertising and generated sophisticated targeting and branding strategies. For Universal's *The Lost World* (1997) $30 million was spent on advertising and marketing, but an estimated $250 million worth of advertising was generated through tie-in deals with Burger King, Mercedes-Benz, and General Mills (McAllister 2000: 105).

Disney remains the lead model for merchandising, licensing and tie-in deals. In 1987, the year Disney opened its first retail store, an estimated 3,000 companies were manufacturing 14,000 Disney-licensed products (Wasco 1994). By 2000, Disney had 590 retail stores and Time Warner 160. For the *Lion King* released in 1994, Disney developed a new parade at Disneyland in addition to extensive licensing and cross-promotion, for instance with Burger King, with whom it concluded a ten-year deal. The returns to Disney of such 'unified cultural control across all media lines' were estimated at $1 billion in profits over two to three years (Hofmeister 1994). The release of the live-action

101 Dalmations in 1996 was accompanied by seventeen thousand Dalmation-related product lines (Schatz 1997: 92). As Disney CEO Michael Eisner put it (cited in Andersen 2000: 7):

> The Disney stores promote the consumer products, which promote the theme park, which promote the TV shows. The TV shows promote the company.

Multimedia

The Internet has become an increasingly important site for promotion and cross-promotion. It is also a dynamic arena in which corporate strategies to manage promotions meet a variety of challenges from illegal downloading to various fan/user activities. The major cultural producers have invested heavily in promotion via websites. Marshall (2002: 77) describes the advance promotion via 'countdown clocks' for *Star Wars Episode 1: The Phantom Menace* (1999), and the 'downloading frenzy' that greeted the online release of a promotional trailer. Major film releases have dedicated websites, cross-promoted from parent company sites, and these contain an increasing range of materials from trailers to production information and cast interviews, interactive games, competitions, activities and merchandise. Games are often pre-released, such as that for Spielberg's *AI* (2001) launched three months before the film release. Sony cross-promoted the *Da Vinci Code* through a microsite on Google, available only to Google account subscribers, who were required to solve a daily puzzle for prizes during a 24-day campaign. Such marketing is especially extensive for content aimed at children. The Internet also allows entertainment companies to sell merchandise such as toys and collector's items directly via websites (Marshall 2002: 77). In 2009 all Warner Brothers content was brought together under a revamped WB.com, where alongside archives, trailers and interactive content, visitors can purchase any of the more than 2,000 film and TV titles currently available.

Sometimes the event movie is the source for multimedia strategies and merchandise (*Toy Story*), in other cases the film is linked to other content such as books or comics (*Spiderman; Batman*). Computer games have joined the expanding list of content sources for multimedia strategies. *Tomb Raider* (2001) and the *Resident Evil* series all began as computer games.

Media firms have used their networks or worked with cross-promotional partners to distribute content across mobile, PDA and other platforms. In 2007, News Corp. teamed up with Sprint to deliver promos, streaming videos, games and more for the sixth season of *24* to Sprint's mobile phone subscribers. Multiplying promotions so that they encourage connected purchases and

consumption requires considerable strategic planning by businesses. Economic value is realised by imposing sufficient unity on activities that they are mutually supporting. This process involves the co-ordination of retail activities, promotional activities and the creation of coherent symbolic meaning across intellectual properties. One kind of unity is that of a brand; another is that of a text and allied 'texts'. The processes of symbolic meaning making and economic value making are closely interconnected.

Textual Strategies and Concepts

Commercial intertextuality

In her analysis of Warner's 1989 film *Batman* Eileen Meehan coined the term 'commercial intertext' to describe the process by which synergistic corporate owners move a brand across film, music, computer game, print, merchandising and toy outlets. A commercial intertext describes the various media products and merchandise spun off from an original creative work. The term marks Meehan's insistence that analysts should anchor critical appreciation of texts within a political-economic analysis of corporate structures and strategies. Appearing in a collection of essays on *Batman*, Meehan called for analysis of the *Batman* text, intertext, fandom and audiences found there 'to be supplemented by an economic analysis of corporate structure, market structure and interpenetrating industries. These conditions of production select, frame and shape both *Batman* as a commercial text and the product line that constitutes its commercial intertext' (Meehan 1991: 49).

Intertextuality has been used to describe how any given text 'implies or calls forth other texts' (Marshall 2002: 70). The concept is derived from literary theory and originates in poststructuralist accounts, such as that of Kristeva (1980). It is often used to refer to the inclusion in texts of borrowings or references to other texts, but within poststructuralist thought it means something quite other than the conscious appropriation of texts by an author. 'The fundamental concept of intertextuality', argues Allen (2005):

> is that no text, much as it might like to appear so, is original and unique-in-itself; rather it is a tissue of inevitable, and to an extent unwitting, references to and quotations from other texts. These in turn condition its meaning; the text is an intervention in a cultural system. Intertextuality is therefore a very useful concept . . . as it concerns the study of cultural sign systems generally.

The notion of authorship as creation and origination founded on a controlling individual subjectivity, 'created as coherent unity by the author' (Couldry

2000: 74) is challenged in two main ways. Any text, whatever its claim to originality, is constructed through a web of borrowings and references to other texts. Each text, argued Barthes (1977), is shaped by the already written and already read. Any text then is inherently intertextual. Second, meaning does not inhere in texts, it is relational, shaped by the interaction of texts with readers. As Couldry (2000: 74) writes, 'For Barthes, the site of textual order was not 'the author's text' but the textual culture as a whole and . . . the practices of actual readers'. Likewise, Julia Kristeva refers to texts in terms of two main axes: the horizontal axis connecting the author to reader; the vertical axis connecting the text to other texts. Every text and each reading are connected to wider cultural codes (Kristeva 1980). However, meaning is structured and ordered in texts, even if by no means fixed. The degree to which producers or readers 'make meaning' underlies critical debates and divisions concerning the 'active audience' and fan/user agency. Such debates are particularly relevant in efforts to assess and critique 'commercial intertextuality' and corporate strategies.

Meehan (1991) invites attention to the strategic production of intertextuality by cultural producers. Her account may be viewed as an engagement with and riposte to those accounts of intertextuality that emphasise active construction by audiences; an intertext in which we position ourselves 'to construct different readings of the film and [position] the film and its intertext to suit our own particular purposes' (48). Against such celebratory accounts, Meehan highlights the shaping agency of corporate strategy and the construction of an integrated sales campaign: 'text, intertext and audiences are simultaneously commodity, product line, and consumer' (61). This is a decidedly non-poststructuralist reading of intertextuality; intentionality arising from corporate authorship is certainly asserted. The central concept is of the *Batman* film as a 'commercial text and the product line that constitutes its commercial intertext'. However another meaning of intertextuality is invoked, whereby the 1989 film is 'the major text' which 'ricochets back in cultural memory to Bob Kane's original vision . . . [and] all the intervening Bat-texts'. There is then a 'complex web of cross references', but these are harnessed by Time Warner to build a promotional campaign around both the film and its lengthy back catalogue of Batman comics, television and film versions and licensed products. Warner Communications acquired the rights to the character when it bought DC Comics. The franchise continued with *The Dark Knight* (2008), which by February 2009 had grossed more than $1 billion worldwide at the box office alone.

The notion of a central text from which a commercial intertext emanates is adopted by scholars using a variety of different terms. Schatz (1997) used the

concept of an 'Ur' text, a foundational text, from which other texts are produced. Proffitt et al. (2007) use the term 'megatext'. Such megatexts are most often entertainment films with other texts 'constructed off the back of the film event' (Couldry 2000: 69). *Star Wars: the Phantom Menace* (Lucasfilms 1999) is connected to other types of text—publicity narratives, the books of the film, the countless merchandising images, the computer games (The Phantom Menace and Racer) and so on. For Couldry (2000: 70):

> If we place *The Phantom Menace* in its own wider context (the Star Wars series, all the associated fan literatures and practices, the whole history of cross-marketed merchandise-saturated Hollywood blockbuster films), it is clear that we need to understand not one discrete text but a vast space of more or less interconnected texts, and how that space is ordered.

This usage is broader than Meehan's. It certainly includes corporate intertextuality: 'Certain types of inter-textual connection are specifically promoted [. . . for instance] merchandising extensions . . .' . However, Couldry conceives of texts as being arranged in a 'space', in turn allowing for the conception of this space being negotiated and in various ways contested. Critical (CPE) scholarship highlights the corporate generation of texts and ordering of meanings to serve corporate goals. Cultural analysts tend to place greater emphasis on active reading, the construction and appropriation of meanings by 'readers', and increasingly on fan agency and the reappropriation of corporate texts. Couldry's analysis is usefully synthesising, encouraging consideration of the ordering of textual space by corporations but allowing for consideration of the incomplete, changeable, negotiated and contested nature of such commercial intertexts. In turn this allows for a critical political economy that is alert to contradictions within cultural production and exchange and can draw on the insights of cultural theory (see Hesmondhalgh 2007; Murdock and Golding 2005). The proliferation of forms and sites of 'audience' or 'prosumer' (Toffler 1970) (producer-consumer) activities online also requires appreciation of the contradictions of participatory 'fan' cultures (Hills 2002; Jenkins 2006; Marshall 2004).

Just as risk in cultural production requires a more nuanced reading of economic power, so too symbolic power must be understood as constituted in a 'space' shaped by interaction, not merely action. Far from diminishing critical accounts this strengthens the claim to attend to the power dynamics structuring textual space, the manner in which economic structures, imperatives of commodification and corporate interests impose constraints on such space and the manner and extent to which these are negotiated and contested. This relative openness can then serve to sharpen critical accounts of corporate strategies to impose order (or proprietary control) over symbolic meanings.

If there is a dynamic between corporate control and fan agency, 'control' and 'chaos', this should serve as a starting point for analysis of the nature of such control and the contradictions surrounding intertextual commodities in any given instance. Intertextuality, argues Marshall (2002: 70) is 'the exchange process of cultural knowledge that flows back and forth between the audience and the individual text as the audience member injects other sources into the text. The industry's role is to provide the related material for that injection'.

Signification

Alongside (inter)textuality, analysts of (cross) promotion draw on concepts from semiotics, narrative analysis, branding and marketing. Ono and Buescher (2001) develop the concept of cipher in their analysis of Disney's *Pochahontas* (1995). Drawing on the Hungarian literary critic Lukács, as well as Saussure, a cipher means an empty (free-floating) signifier, which can then be filled up with various meanings. The Disney Corporation, they argue, refashioned the figure and story of the American Indian Pocahontas, detaching it from its historic associations to events in seventeenth-century Virginia and creating instead a set of associations and themes that could resonate commercially with contemporary audiences, including romance, ecology and environmentalism.[1] This provided a sign-vehicle that was adaptable across a range of tie-in merchandise. A cipher is 'the mechanism by which commodity culture thematises concepts, such as *Pocahontas*, and via this process, markets myriad products to consumers' (Ono and Buescher 2001: 24).

The cipher concept is valuable in addressing how corporations fashion commodity signs. Such analysis highlights the work of symbolic meaning construction, in this case appropriation and refashioning of Pocahontas, drained of alternative sets of meanings. The concept of cipher is also valuable in addressing the breadth of significations, not simple iteration, that can arise. The cipher attains taken-for grantedness when it, itself, becomes the referent for each new product associated with it. It also allows variation, such as the 50 Pocahontas dolls Mattel produced, at the time its largest line of dolls ever associated with a film (33). Each product is therefore a 'buy in' to the larger cultural phenomenon of Pocahontas: 'a cipher is a figure through which various commodities with multiple exchange values are marketed, *and* it is a social concept that circulates like a commodity' (26). But if this is a textual 'environment' shaped by corporate production, it is also shaped by discourses such as that of critics, commentators and 'adult' fan readings.

The cipher is a central signifier that provides semiotic coherence to a 'brand' in its many manifestations. In contrast to the 'academic' terms (inter-

textuality, cipher) branding and marketing is the main discourse of industry. Studios seek to 'extend properties way beyond the films themselves. Today, they look at the brand as a whole to see how they can create a holistic approach—through film, TV, DVD and direct-to-video' (Facenda 2005). The economic imperative to transform hits into megabrands (Wolf 1999) is accompanied by the need to build semiotic and communicative coherence. Synergy strategies require effort to impose unity onto production, licensing and marketing activities, by promoting and attempting to manage the symbolic as well as material properties of products, and environments in which the brand is experienced.

Harry Potter and corporate magic

Harry Potter has been a phenomenally successful 'megabrand' that also exemplifies broader trends in entertainment and marketing: the development of a franchise based on publishing content, the rise of character licensing, as well as increasingly sophisticated and competitive tie-in marketing. JK Rowling's Harry Potter books have been phenomenally successful. Since the publication of *Harry Potter and the Philosopher's Stone* in 1997, global sales of the seven books in the series exceeded 400 million worldwide by 2008 (*The Guardian* 2008). Harry Potter transformed the fortunes of Rowling's UK publisher, Bloomsbury, but also came at an important moment for Time Warner. While her initial publishing contract granted Bloomsbury exclusive rights in the UK, Rowling retained rights over other markets and retained both the film and merchandising rights to her novel. After a fierce bidding war, in 1998, Warner Brothers (a subsidiary of Time Warner) secured these rights to the first two books for an undisclosed amount, thought to be around $1 million. By the time the first film was released in 2001, Time Warner had merged with the Internet firm AOL, which acquired the media conglomerate for $166 billion. AOL's acquisition was announced in January 2000. The merger was completed and formally approved in January 2001; however key divisions were established and operational from May 2000. The merger created a conglomerate twice as large as its nearest rival Viacom and promised a fusion of 'old' and 'new' media that would usher in an Internet revolution. Time Warner gave AOL access to rich content and cable distribution to match its online resources and offered a brand position in markets worth considerably more than its physical assets (Auletta 2002; McChesney 2004). This was the apotheosis of synergy hype. But with inflated claims came attendant dangers as the ability of the new company to realise synergy benefits came under intense scrutiny from business analysts.

Time Warner executives made much of their acquisition of Harry Potter to demonstrate the conglomerate's abilities to realise synergistic opportunities across their various platforms and corporate divisions. In fact, the newly merged conglomerate failed to impress investors; many were concerned about its huge debt-to-earnings ratio. The company suffered a series of crises and write-downs in value for acquisitions as well as from the various repercussions of the dot.com stock crash (2000–2002), the aftermath of 9/11, and the worldwide advertising recession. In the third quarter of 2001, AOL Time Warner reported a net loss of $996m, 10 per cent greater than in the same period of 2000 (*The Economist* 2001a). By January 2002 AOL-TW had lost more than half of its market capitalisation and by July had fallen to $13 a share, down from $71.25 for AOL pre-merger. In its first year the company shed more than eight thousand jobs (Auletta 2001). A merger that had been seen as emblematic of online convergence was increasingly viewed as one of the worst in corporate history. Having made a net profit of $4.3 bn. in 2007, TW fell into the red in 2008, reporting a decline in advertising revenue compounded by a writedown of the value of its cable, publishing and Internet businesses (Clark 2009). By May 2009, with a recession eroding online advertising revenues on which AOL depended, and with a significant drop in subscription revenue, Time Warner finally announced a split from AOL. Having failed to find partners to realise the assets of AOL, Time Warner announced it would concentrate on its core business of creating and distributing branded content on both traditional and digital platforms.

Facing pressure from investors to give the company a narrower focus, TW hived off its cable business and then AOL itself (95 per cent owned by TW with Google owning 5 per cent), completing the split in December 2009. Advantages such as intrafirm cross-promotion were ultimately outweighed by the underlying economics of the business units and the need to reassure investors of 'management focus' during a recessionary period. The de-merger highlights the need to assess carefully the economic and strategic value of online integration. Yet, journalistic announcements of the death of synergy remain premature, as inflated as the hype they countered (see McChesney 2004). Time Warner announced a significant fall in profits in 2008 before the de-merger, yet the period 2001–2007 gave investors plenty to cheer. TW also continued its global expansion and acquisitions, buying 31 per cent of Central European Media Enterprise Group (CME) for $241.5 million in May 2009. While TM's mixed fortunes highlight the need for a more nuanced account of synergy benefits, the company remains the largest global media conglomerate, and principles of synergy and cross-promotion remain central to the firm's strategy. Nevertheless the de-merger serves as a reminder that cross-

promotional logics can support but do not outweigh the underlying require-
ments of profitability for commercial operations.

In 2001 AOL-TW offered a then unrivalled combination of print, audio-
visual, games and other content together with cable and online distribution. It
reached over 147m subscribers directly through TV and Internet channels
(including Warner Cable, HBO, the WB Network and AOL) and retained
enormous market power over the carriage of its content (Warner Music
Group, Warner Brothers films and television, and Time Inc) by others. When
it merged, Time was the world's largest magazine publisher; Time Warner
cable was the second largest in the US; Turner Broadcasting generated the
highest cable revenues, HBO was the leading pay-TV channel, the company's
film and music divisions were amongst the top global companies while AOL,
the leading US ISP, delivered twice as much mail as the US Postal Service. As
Waetjen and Gibson (2007: 7) describe '[p]ossibilities for corporate synergies
seemed endless: new media brands could be developed into a myriad of prod-
ucts and hyped through the countless windows of the AOL Time Warner
empire'.

The Harry Potter franchise played a vital role in demonstrating the bene-
fits of corporate synergy and in realising the growth projections and profit
margins desperately sought by senior managers. In January 2002 Richard
Parsons, who replaced Gerald Levin as CEO that May, announced to investors
an end to 'over-promising', in the midst of a major writedown in the com-
pany's value (approaching $60 million). Yet he also 'made much of the incre-
mental revenue that could be wrung out of AOL Time Warner by the better
cross-promotion of its assets' (Teather 2002).

The film release of *Harry Potter and the Philosopher's Stone* (*Sorcerer's Stone* in
the US) was the biggest test of the much-hyped merger claims and was pre-
sented by TW executives as confirmation that cross-promotional synergies
could be achieved. Richard Parsons, then AOLTW's co-chief operating officer,
cited Harry Potter as a prime example of an asset 'driving synergy both ways',
'we use the different platforms to drive the movie, and the movie to drive
business across the platforms' (*The Economist* 2001b). Following a gradually
escalating marketing campaign, the film was released in November 2001, two
months after the terrorist attack on the Twin Towers, and constituted 'the
indispensable brand anchor for AOL-TW's intricate publicity and sales strat-
egy' (Murray 2002). The Warner Brothers film was a huge box-office success,
with revenues of $974.7 million, ranking it fourth amongst the highest gross-
ing films worldwide. Such a strong opening box office is recognised as an
important 'launch site' for franchise development (Schatz 1997) and Harry

Potter broke existing box office records in its weekend openings in both the US and UK (US$93.2m and GBP£16m, respectively).

Altogether the first four Harry Potter films grossed more than $3.5 billion (£1.7bn) worldwide. With the success of *Harry Potter and the Order of the Phoenix*, Warner Bros. Pictures' Harry Potter films became the top-grossing motion picture franchise in history (Time Warner 2007b).[2]

Corporate synergy and cross-promotion. The promotion of Harry Potter extends far beyond Time Warner. A writer and publishing house was the 'content generator' (Galligan 2004), and book promotion, retail and merchandising involved an array of commercial and non-commercial actors. But TW certainly demonstrated corporate synergy and integration on a breathtaking scale across its various divisions. The soundtrack was recorded by Atlantic Records, a label from the Warner Brothers Music Group. Released in the US on 16 November, the film was featured on that week's cover of *Entertainment Weekly*, and an advance review, 'gushing' in praise, appeared in *Time* magazine, both from AOLTW's publishing division comprising over 160 titles (Teather 2002). AOLTW's TV networks 'constantly plugged the film' throughout November (*Investors Chronicle* 2001). *People* and *Time* ran successive taster stories about the film and its loyal fan base (Murray 2002). Meanwhile, the release was heavily promoted across AOL websites through competitions, games, sneak previews and advance bookings. AOL's online ticketing subsidiary, Moviefone, pre-sold a record number of advance tickets. AOL offered its 31 million US subscribers (representing half of US internet users at the time) the chance to win tickets for an advance screening, while in Britain AOL marketed itself to new subscribers with the offer of cinema tickets for the film (*The Economist* 2001b). The corporate strategy, in fact, focused not only on building profits directly from Harry Potter sales but also on driving new business across its services. The official Harry Potter website carried free trial promotions for Internet service provider AOL. The film was thus promoted online, though WB shops, HBO and other TV networks, magazines such as *Time*, *Entertainment Weekly* and *People*, all within the AOL-TW corporate family.

For the video release of the first film in 2003, Warner Brothers created a quiz game in which players were sent to some 90 worldwide partner sites to search for owls, with digital downloads such as screensavers for the winners. The game was promoted through teaser ads in *People* magazine, on AOL and elsewhere. Jim Wuthrich, VP-worldwide interactive marketing, Warner Bros., enthused: 'I don't think we could have done it without being part of the AOL Time Warner family. . . . We wouldn't have been able to afford the amount of cross promotion and significant support we received from the various divisions'.

Intrafirm advertising. In 2001 AOL Time Warner spent $468 million on intra-company advertising across its own media properties (up from just $14 million pre-merger). Intra-firm advertising represented 5.5% of the $8.5 billion AOL Time Warner reported in advertising and commerce revenue. Such advertising was unsurprisingly credited by TW executives as increasing ticket sales. The company exploited all its intra-firm windows to exhibit and promote the film. When it premiered on HBO *Sorcerer's Stone* was the second-highest rated film for the channel in 2002. More than $142.6 million was spent to advertise the first four Harry Potter films, the highest being $40 million on the second release, *Harry Potter and the Chamber of Secrets* (Nielsen 2007).

Merchandising and licensing. Merchandising is central to accounts of commercial intertexuality as it serves at once both commercial and promotional objectives. Licensing of film characters and the use of images and other intellectual property to secondary manufacturers created 'tie-in merchandise designed to cross-promote the Harry Potter brand and stoke consumer investment (both emotional and financial) in the phenomenon' (Murray 2002). Licensing involves formal agreements to permit third parties to make restricted use of intellectual property rights in exchange for fees. Beyond this are business relationships with other firms involved in the various aspects of supply, distri-bution, retail and promotion of wholly owned or licensed goods. Retailers such as Amazon.com (in profit for the first time in the last quarter of 2001) and shops are relied upon to promote and sell merchandise such as the Lego Hogwarts classroom set.

In the US alone an estimated $269.1 million was spent on advertising for Harry Potter merchandise (including books, films, DVDs and other promo-tional products) between 1998 and 2007. Harry Potter emerged in a period of renewed growth for character toys and merchandise. Re-enacted vintage comic book properties, including Spider-Man and The Hulk were amongst the strongest sellers in film exhibition and in stores appealing to teen and tween boys in particular. The Harry Potter brand has been associated with products ranging from bubble bath to electronic games, with an estimated $54 million spent in the US alone promoting Harry Potter products (excluding the books and films) between 2001–2007 (Nielsen 2007).

The largest merchandising deal for the first film was with Coca-Cola, which won exclusive rights to official sponsorship, a deal which brought opposition from a growing campaign against HFSS (high in fat, sugar or salt) food promotion to children (Hardy 2009). Coca-Cola paid a reported $150 million for exclusive global marketing rights. Coca-Cola, which announced an eighteen million dollar global literacy campaign, agreed not to feature the characters on its labels or drinking Coke in its ads.

TW executives stressed they would avoid over-exploitation of the brand. Karen McTier, EVP, domestic licensing, Warner Bros. Consumer Products, said 'From the beginning we established a "less is more approach." We hand-pick the right licensees by thoroughly reviewing their product line as well as their channels of distribution and relationships with retailers' (Masters 2003). Harry Potter fans were promised a film 'faithful to the book's tasteful mer-chandise, and a kinder, gentler, multi-million dollar marketing campaign' (Chihara 2003). Eighty-five licences were issued for products associated with the 2001 film, fewer than the 150 issued for *Batman* in 1989. Such a strategy also nurtured the long-term potential for Harry Potter (and created value from scarcity). The merchandising also grew with each book and film release. Mattel became the worldwide toy licensee for the literary characters. Games, action figures, cheap toys and expensive reproductions abounded, together with the Harry Potter Robe, Ice Pumpkin Slushie Maker, Hornby Hogwarts Express Train (see Galligan 2004).

In an ever more competitive environment, retailers seek to reduce risky innovation in favour of 'properties with endurance and multi-faceted plat-forms that offer franchise opportunities', hence sequels, books, interactive and TV based movies prove especially popular due to their established audiences and awareness levels (Facenda 2005). Such merchandising indicates too how synchronicity has replaced more sequential strategies of brand 'recycling'. According to Murray (2002):

> multiple product lines in numerous corporate divisions are promoted simultaneously, the synchronicity of product release being crucial to the success of the franchise as a whole. The release of individual products may be staggered, but the goal is for products to be available simultaneously so that they work in aggregate to drive consumer awareness of the umbrella brand.

Governed by strict, detailed guidelines from Warner Brothers Consumer Products (WBCP) the licensing strategy seeks to enable young consumers to share the 'magical' commodities found in Harry's wizarding world. The experi-ence of following Harry's introduction to the wizardry world was established, for instance, in the registration process for visitors to the official website. According to Waetjen and Gibson (2007:18) 'the firm's licensing strategy issues a series of invitations to young (and adult) consumers to journey into the wizarding world in order to assume the role of Harry and adopt his love of magical commodities as their own'.

Games. Hollywood's connections with computer games goes back to the forma-tion of the video game industry when cartoon and film characters were li-censed and when studies invested in games hardware and software companies.

Warner Brothers owned Atari, one of the earliest video game companies. Problems in the 1980s, including the failure of a video game based on the blockbuster *E.T.*, slowed developments, but by the 1990s video games were becoming integrated into Hollywood synergy strategies (see Wasco 1994: 210; Proffitt et al. 2007: 247). AOL struck a five-year deal in November 1999 with Electronic Arts (EA), to deliver online games and interactive entertainment. EA would have exclusive responsibility for content on AOL Games Channel and all games content on AOL. In 2000 a financial deal with Warner Bros. Consumer Products secured EA exclusive rights to develop, publish and distribute computer and video games based on the first four books and WB films. EA subsequently brought out a variety of games including Quidditch World Cup (generating revenues of $3.2 million by 2007). In 2009, Warner Bros. Interactive Entertainment, TT Games and Lego group announced a joint venture interactive game *Lego Harry Potter: Years 1–4*.

TV rights and cross-promotion. Another important set of relationships concerns the broadcasting rights to the audiovisual content. AOLTM realised value by trading the broadcast rights to the film worldwide. But if these relations indicate often fierce economic competition between firms, they also show the interlocking of interests amongst global media conglomerates that belie 'text book' accounts of healthy economic competition. Herman and McChesney (1997: 104) describe how the major global firms:

> operate in oligopolistic markets with substantial barriers to entry. They compete vigorously on a non-price basis, but their competition is softened not only by their common interests as oligopolists, but also by a vast array of joint ventures, strategic alliances, and cross-ownership among the leading firms.

Bagdikian (2004: 9) found a total of 1441 joint ventures between the dominant five US media conglomerates. Such business partnerships are evident throughout the Harry Potter franchise. The films were telecast on US television 366 times since 2002 on four cable networks (Disney, ABC Family, Cinemax and HBO) and one broadcast network (ABC) (Nielsen 2007). ABC Family, owned by Disney, bought the cable rights to the Harry Potter films, together with exclusive rights to other WB films, and the right to show the films on the ABC broadcast network, Disney Channel and its sister channels. Tom Zappala, a senior ABC executive, announced he would work with WB to help launch the theatrical release of *Harry Potter and the Half-Blood Prince* (in July 2009) by running a marathon of the first four films. According to *Variety*, '[t]hese cross-promotion strategies often draw more people into the multiplexes at the same time as they're adding to the Nielsen ratings of the older titles on the network'. During the network TV debut of the second film on ABC,

previously unseen footage surrounding the fourth film, *Harry Potter and the Goblet of Fire*, was presented as interstitials; viewers could also see a 13-minute special with additional footage from *Chamber of Secrets*. In the UK, BSkyB's deal with Warner Brothers gave it the rights to show the Harry Potter films on pay-TV, while the BBC paid for the terrestrial rights. As one commentator (*The Economist* 2001b) put it:

> The best vindication of the AOL/Time Warner union is not cross-promotion as much as sheer muscle. With a classy property like Harry Potter, it would be hard not to conjure up success. But, at over twice the size of its nearest rival, Viacom, AOL Time Warner has massive clout [giving it] market leverage in any negotiation over the delivery of its brands down others' pipes, or others' down its own.

Diane Nelson, senior vice-president of marketing, regarded Harry Potter as 'a bigger property than anything else we at Warner Bros. have seen [. . . .] we're nowhere near saturation point. The appetite is not a trend; it is a real ever-green property' (cited in Chihara 2003). The franchise assets were extended with the creation of a theme park The Wizarding World of Harry Potter (due to open in Florida in 2010), a joint venture between Warner Bros. Entertainment and Universal Orlando resort.

Assessment and critique. With such megabrands as Harry Potter, Time Warner has demonstrated its awesome ability to move and link content across its substantial holdings and various distribution platforms. Crucial to the success of each element, from achieving the burst of publicity surrounding film release to the building of market share for product merchandise, is cross-media promotion.

In the business pages, assessment of Time Warner's cross-promotion was overwhelmingly financial or strategic but only very rarely subject to any other kind of critique. Occasional disquiet was registered, such as when an article in the *Chicago Tribune* noted concerns that 'the AOL service's aggressive promotion of content from its corporate siblings has become obtrusive and might be harming AOL itself'. However, as this indicates the parameter was whether the strategy would 'work' in creating economic value and sustaining revenue streams. The same *Chicago Tribune* article highlighted 'cross-promotional successes' such as the 100,000 Time Inc subscriptions that AOL claimed to be generating each month and the 800,000 new AOL registrations arising from promotion in the company's magazines. Most reporting was descriptive or evaluated cross-promotional strategies in terms of investor interests. Where fans were addressed it was mainly within the framework of a question 'how much cross-promotion is too much?' measured by profitability, balanced over short-term and long-term calculations (Fine and Elkin 2002).

By contrast, a central critique advanced by some academic writers is that the filmic text and commercial intertext of Harry Potter strip out the critique of consumerism and of commodities as status symbols found in the books' rich discourses. As Murray (2002) writes:

> . . . the normalising of shopping as filmic activity in *Harry Potter and the Philosopher's Stone* is the eclipse of the book's checks on commodity fetishism: its very British sensitivity to class snubs for the large and impecunious Weasley family; the puzzled contempt Hogwarts initiates display for Muggle money; the gentle ribbing at children's obsession with branded sports goods. The casual browser in the Warner Bros store confronted with a plastic, light-up version of the Nimbus 2000 Quidditch broomstick understands that even the most avid authorial commitment to delimiting spin-off merchandise can try the media conglomerate's hand only so far.

For Waetjen and Gibson (2007: 5) the novels can be read as a politically engaged critique of 'class inequality, crass materialism and racial discrimination' while other aspects, such as Harry's exciting and admired consumption of gadgets provided a reading which TW 'activated' in its commercial appropriation of the Harry Potter universe. TW's reading 'subordinates Rowling's powerful missive against class inequality and elitism in favor of her contradictory but equally prominent celebration of the transformative magic of commodities' (Waetjen and Gibson 2007: 16).

Various commentators, then, have highlighted contradictions and tensions at the heart of the Harry Potter phenomenon. JK Rowling's books equate hyperconsumption with covetousness in two of the most despised characters in the book Dudley Dursley and Draco Malfoy (Blake 2002: 79). Waetjen and Gibson (2007:16) draw explicitly on the claim of post-structuralist literary theory that texts like the Harry Potter stories 'are invariably riddled with contradictory discourses, which can then be "activated" in diverse ways by readers, drawing on the symbolic resources available to them from their position within the wider social field'. They argue that an analogous relationship exists 'between literary works and the media corporations who acquire the film and merchandising rights to these works. . .'

In their account, contradictions towards consumption in Rowling's text opened space for AOL Time Warner to 'activate' a corporate reading in their elaboration of the Potter universe into a commercial intertext. This analysis is congruent with Couldry's call for examination of the ordering of intertextuality. A full appreciation of commercial intertextuality needs to take account of the complex interaction of forces and agents, not merely posit the corporation as a simple or singular agency. The influence and authority of JK Rowling is an important factor here (as in accounts of the influence of creative personnel such as directors, star actors, producers, writers and others on corporate media

production (Schatz 1997). Rowling is reported to have made efforts to 'protect her stories from becoming encrusted with marketing pitches and merchandisers' plugs' (Galligan 2004), although it was a battle she was reported to be losing (Kirkpatrick 2003), with endorsement of the theme park a sign of further capitulation. WB's licensees were discouraged (and in some case precluded) from linking merchandise directly to the books; Rowling's autonomy is also subject to negotiated contractual ties, contracts which also meant she received a share of the merchandising revenue. According to one source Rowling received a full 50 percent of TW's licensing revenue after expenses (Waetjen and Gibson 2007: 6–7).

We can justifiably focus on 'push' factors, such as corporate marketing, but a full account of the Harry Potter phenomenon also needs to incorporate 'pull' factors. Readership of the first book grew through exchanges amongst enthusiastic readers amidst an initially modest book marketing campaign by Bloomsbury in the UK. While the books and TW franchise were subsequently very heavily marketed, the products became immensely popular. An estimated 28 per cent of persons 12 years or old in the US have read one or more of the books, with 15 per cent having read all six. More than one quarter of Americans 12 years or older claim to have seen all of the previous Harry Potter movies. The audience for *Prisoner of Azkaban* and *Goblet of Fire* in the US comprised over 40 per cent of 2–17-year-olds. Moreover, Harry Potter has generated an online fan culture, ranging from auctions, lexicons and discussion groups through to fan fiction, including porn (Chihara 2001; Jenkins 2006).

The critique of cross-promotion is not that the franchise lacked popular appeal or merit. Rather, there are several areas of critical concern. First, is critique of the effects of saturation promotion and, second, of rampant commercialisation, much aimed at children. Opponents of that commercialisation call for restrictions on such 'push' marketing strategies. Third, the commercial text and intertext tend to sustain pro-consumption values and shrink the space made available for critique of such values. The Harry Potter books' promising opening up of heterodox discourses critiquing materialism is cancelled out by the commercial interest and a 'reading' that is powerfully 'amplified' by one giant transnational corporation (Waetjen and Gibson 2007: 22). Fourth, such promotional 'supernarratives', whatever their merit, carry costs if they serve to crowd out 'a more diverse imaginative entertainment landscape' (Andersen 2000: 7). Fifth, relatedly, the market power of synergistic marketing has implications beyond the purely economic where it impacts on the quality and diversity of media content.

Arguably the most powerful critical response is less a totalistic rejection than a critical alertness to the implications of such corporate media dominance, which in turn informs arguments to strengthen countervailing forces, including regulation. We can celebrate the creativity of the books, the films and even the pleasure derived from the countless allied products and merchandise. But we can also recognise the costs arising from the encounter between creativity and commerce. The promotion of Harry Potter demonstrates an awesome mobilisation of market power, media power and promotional power. Such immense market power and leverage, allied to cartelisation and risk-reduction, enhances the power of producers over consumers. AOL-TW exploited its capacity to market through an immense range of interconnected owned properties, using both designated advertising and editorial cross-promotion.

Cross-media promotion is the consequence, and desired outcome, of corporate integration. Conglomerates like Time Warner seek to package and promote their entertainment products across the fullest range of media platforms. The corollary of this intensive focus is the risk of a decrease in media products that are not suitable for cross-promotion. If promotion narrows to what Hoynes calls the 'promotionally friendly', then the range and diversity of cultural expression, especially in the amplified register of mass-marketed texts, risk being shrunken (see Croteau and Hoynes 2003: 44–46). It may be objected that to expect otherwise is naïve here, but we need to adopt a carefully historical and comparative view, capable of registering shifts in the nature and pattern of commercialisation, and in any case the critique is not undermined by not being realised.

Beyond the narrative arc: *The Matrix*

If some synergy strategies are iterative, reproducing and repeating a coherent brand across a variety of locations and outlets, an important variant are those strategies that develop the narrative, through 'transmedia storytelling' (Jenkins 2006). Such strategies encourage fans to acquire extensions from an original text, either as desirable additionality or with some kind of in-built 'necessity' for the fuller realisation and enjoyment of a complex, interlinking narrative. *The Matrix* (1999), exemplifies a strategy of developing an entertainment brand's narrative arc (Proffitt et al. 2007).

Time Warner used the Internet for promotion, then still a relatively new strategy. It produced an enhanced DVD, the first to sell over 1 million copies, which included a documentary *Making the Matrix* by (Time Warner's) HBO, as well as a DVD-ROM containing the screenplay and other writings. For the

sequel *The Matrix Reloaded*, which opened on 15 May 2003, Time Warner undertook an extensive marketing campaign, simultaneously releasing an animated series Animatrix and video game Enter the Matrix. Filmed at the same time as the movies, using motion-capture tools, the game offered a narrative extension rather than a mere repetition of scenes from the film, making it an integral part of the *Matrix* megatext. The video game was promoted through TW television ads, crafted to look like film trailers. AOL Online advertised extensively, promoting the game as the first to incorporate AOL Instant Messenger technology. Promotions for the game were run in DC comics, on HBO and Cinemax when the film trilogy aired, and in the DVD. The game provided a narrative expansion, focusing on the 'back story' and behaviour or secondary characters from the films (Proffitt et al. 2007: 246). Tie-in partners included Samsung (which became global marketing partner for the sequels, game and Animatrix DVD), Coca-Cola's Powerade, Heineken and Cadillac. Extensive advertising by partners cross-promoted the movie. The second sequel, *The Matrix Revolutions*, was released in November 2003 by which time there were over 1,100 'autonomous' *Matrix* fan sites.

As with Harry Potter, critics charge that the corporate intertext diminishes the contradictions of the text, although here the text is the original *Matrix* film itself. For Proffitt et al. (2007: 252)

> The critique of consumer culture found in the thought-provoking, esoteric inaugural *Matrix* was overwhelmed by its integration into a larger commodity intertextual flow that defined fandom as never complete and, in the case of the video game and cross-promotional advertising campaigns, placed real promotions for products in an environment that was originally critical of exactly this type of activity.

Brooker (2001) uses the concept of 'overflow' for the phenomenon of television audiences flowing from programmes to associated content sites of corporate or fan generated material. The websites for the popular television programme *Dawson's Creek* offer various narrative features not found within the television text, such as computer files and diaries of characters. Such 'commodified inter-textual flow' argue Proffitt et al. (242) 'is increasingly a necessary condition for loyal fans, if these fans desire to be "well rounded" in the narrative development of the brand'. This might be represented as a shift from additive strategies to merchandising strategies built upon lack, the creation of insufficiency at the level of narrative, or fan appreciation. Proffitt et al. describe the marketing of 'narratively necessary purchases' for Matrix fans (243); promotional videos, video games and the animated Animatrix series were all marketed to fans as must-have items, necessary in order to understand the complexity of the Matrix.

While the Matrix represents a particularly enigmatic fragmented transmedia story, aimed at encouraging a teen/adult audience to engage with a 'sophisticated' philosophical (postmodern) text, such transmedia flow is an increasingly prevalent strategy, moving audiences to different media to engage with interlinked content. For Proffitt et al. (2007: 242) '[t]he goal is to move fans from the original "text" to other texts such as narratively connected video games, Web sites, and DVD releases that do not just duplicate the original text but "advance" it'.

Critical Debates and Approaches

Critical (CPE) scholars emphasise not merely the profit–oriented promotional strategies of media conglomerates but the fact that such strategies shape and constrain the space for audiences to take and make meaning. Creativity is principally generated by corporations. For Proffitt et al. (2007: 252) fans are constituted by their participation in the flow of activity that the companies involved create; institutional structures and corporate goals 'circumscribe media practitioner and audience creativity more that expand it'.

More celebratory accounts arise from studies that emphasise fan agency and creativity. Fans 'repurpose' material in ways which can demonstrate creativity, self-expression, communication and even subversive readings and reconfigurations. Jenkins (2002: 157) describes an era of 'transmediality' whereby economic trends, favouring conglomerate integration, encourage 'the flow of images, ideas, and narratives across multiple media channels and demand more active modes of spectatorship'. Transmedia promotion 'presumes a more active spectator', following flows of intellectual properties across outlets and responding to marketing strategies that promote 'a sense of affiliation with and immersion in fictional worlds' (Jenkins 2002: 165). For Jenkins, the Matrix is a prototypical transmedial text inviting audiences into engagements that require puzzling out ambiguities, sharing readings and comparing notes across film, game, animation and web. Such immersive engagements are associated with pleasure, play and agency. By contrast, the critical account argues such pleasures are harnessed to and constrained by the commercial logic shaping the extension of cross-media texts.

Underlying critical debates is the spectrum of positions between defenders and critics of modern capitalist media production. Some cultural analysts are merely celebratory of commercial media provision, while others examine audience activity as posing challenges to corporate control. The complex interactions between companies seeking to encourage engagement while

policing brand values and intellectual property show this well. Marshall (2002: 74) provides a useful summary of the tensions and contradictions when he writes, '[w]hat is being played is an elaborate dance between the techniques of containing and servicing the desires of the 'audience', and the audience itself venturing into unserviced and uncommercial areas of cultural activity'. Such radical and ongoing changes in media highlight the need for a flexible, enquiring approach that is attendant to both macro changes and to specific configurations of power in the interaction of texts and audiences.

Time Warner, for instance, sent cease-and-desist orders against young Harry Potter fans whose (non-commercial) web pages were deemed to infringe its intellectual property rights. However, as Jenkins (2006: 169, 185-191) shows corporations, including Time Warner, have adopted various, contradictory stances in their efforts to negotiate the 'value, and threat, posed by fan participation'.

The Harry Potter and Matrix megabrands illustrate the growing sophistication in cross-media strategies. Both are also examples of major corporations using a proliferation of platforms for content distribution, marketing and cross-promotion. A key feature in each is increasing interactivity, although with corporate efforts to direct and constrain interactivity for commercial ends. While media corporations still rely on traditional licensing revenues, digital and globally distributed technologies such as the Internet, DVDs, video game consoles, and mobile media such as cell phones have greatly expanded marketing possibilities and thus potential manifestations of the corporate text.

The key value of Couldry's concept of 'textual environments' is that it encourages us to examine the ordering of textual space as well as its multiplication. An earlier related concept is that of a 'reading formation' which for Bennett and Woollacott (1987) is the process through which particular texts and particular readers come to be ordered in relation to each other. Drawing together the various accounts in this chapter, we can identify an axis of control from commercial intertexts (and corporate readings) through to autonomous intertexts of fans and critics. Intertextuality is structured by but by no means entirely 'controlled' by corporations. Rather, the textual environment includes various kinds of discourse from corporate to the discourses of critics and commentators, intergroup and interpersonal communication. Here we can conceive of a vertical axis of corporate communications and a horizontal axis of more or less autonomous communications which intersect. Cultural analysts have traced the multiple sites of textual production and shown that these can be influential, creative and powerful. Both CPE and cultural studies provide a valuable corrective lens. Together these are needed to trace the increasing complexity and implications of textual proliferation. However

against tendencies to inflate the agency of fans, critical scholarship highlights that control over symbolic meaning and over textual proliferation remains concentrated in the hands of the major content producers whose cross-promotional activities generate critical concern.

Notes

1. *Pocahontas* also served to reposition Disney's image in Latin American markets whose strategic importance was underscored by ABC/ESPN that year (Wayne 2003: 95).

2. *Harry Potter and the Order of the Phoenix* brought in $140 million in its opening five days in the US and $330 million worldwide in the opening weekend, the largest worldwide opening in Warner Bros. history (Time Warner 2007a). In Europe, the film was the largest box-office opening weekend in France and Germany for 2007, and the second largest opening weekend of all time in the UK.

Cross-Promotion in News Media

Cross-media promotion in news media generates the most disquiet of all forms of cross-promotion. It may be a form of editorial-for-hire, undermining the independence and editorial integrity of news. The synergistic promotion of entertainment media in news programmes shrinks the space for other news content and undermines news values. However, a positive case can also be made for some forms of cross-promotion, especially as news media platforms proliferate. Cross-promoting news services and other ways of accessing news or cross-promoting a documentary programme that investigates public affairs issues in more detail may all be justified, not least in the context of declining audiences for news. This chapter then explores the dynamics and evolving forms of cross-promotion in news media and considers a range of critical perspectives. Cross-promotion in news media is bound up with two broader processes: convergence and commercialism. The first section outlines these themes before examining cross-promotional practices in news media.

Forms of Promotion

A useful starting point is to consider the promotional dimensions of media products. With the concept of 'promotional reflexivity' Wernick (1990) identifies self-promotion as an integral feature of mass media goods; 'the product which [the media industries] have to advertise is a privileged site for the advertisement of itself' (Wernick 1990:101). Newspaper mastheads and cover pages act as promotions of themselves and of contents or sections inside. Wernick describes this form of self-promotion as 'hooking', where the cover or presence of the media seeks to attract and 'hook' the reader/audience. As media forms converge the varieties of self- and cross-promotion multiply, but distinctive forms of promotion have developed in print, broadcasting and online media. Taking print newspapers first, three main forms of promotion can be distinguished.

i. Self-promotion

Newspapers promote content distributed within the sections and pages of the physical edition of the paper. This may be editorial items or sections and supplements. Alternatively, competitions, give-aways and forms of cross-promotion inside the paper may be promoted. Papers also promote content and sections appearing on other days such as regular features (sport, media, law, education), job sections and supplements (weekend magazine section, TV guides, etc.).

ii. Intra-firm cross-promotion of allied media

Papers promote allied newspapers owned by the same company (intra-firm promotion), although this is generally restricted to non-rivalrous companion papers such as dailies promoting a linked Sunday paper. Such cross-promotion is usually separated and delineated from editorial content and set in the format of advertising matter and in spaces and sizes otherwise used for third-party advertising. However, such promotion may also be more integrated textually or graphically or both. Promotional appeals may be set as strap lines or splashes, which are integrated into the visual layout of the pages on which they appear so that the delineation between editorial content and promotional material is blurred. In the UK this occurs more extensively, but not exclusively, in the popular 'tabloid' press. Papers have cross-promoted other co-owned media such as television services (see chapter six) and all major papers now cross-promote their online content.

iii. Promotion of goods and services

Newspapers promote a wide range of non-newspaper goods through promotional offers and reader deals. These usually involve joint promotion of goods and services in which the newspaper has negotiated deals with third-party companies. For instance, the *Telegraph*, a UK quality newspaper, generated sales of £15 million from over 400 reader offers made during 1996 (Mitchell 1996). Such deals may be intra-firm or involve some degree of ownership interest between the newspaper and the other party. Usually, such promotions are displayed in advertising format, however competitions and give-away promotions take more hybrid forms, appearing embedded in editorial.[1] In October 1998, the film *Titanic* was released on video and heavily promoted across all titles of News International, a UK subsidiary of News Corporation. The film was co-produced by Paramount and Twentieth Century Fox, owned by News Corporation. *Titanic*, the highest grossing film in the 20th century,

had already been the focus of massive synergistic cross-promotion and generated a 'virtual industry' of promotions and merchandise (Croteau and Hoynes 2006: 118-120). For the video release, in addition to extensive advertising and a tie-in competition, *The Times* (10 October) produced a 40-page souvenir record of newspaper accounts of the disaster. *The News of the World* (25 October) ran a three-page tribute including a 'reproduction' cover dated April 21, 1912, and featured a competition on the cover and inside pages. *The Sun* ran competitions and promoted the release heavily in seven consecutive editions between 16 and 23 October.[2]

Self-promotion has also been an integral aspect of the 'flow' of television and radio broadcasting and takes increasingly sophisticated forms (chapter seven). Increasing competition amongst suppliers has encouraged an expansion of all kinds of self-promotion, from trailers for upcoming programmes to channel branding and corporate idents. Promotion for allied channels and services has also increased. In 1999, ABC aired more than 7000 promotions for its own programmes (McAllister (2000:111). According to Hart and Hollar (2005):

> During the May 2004 'sweeps' period (when advertising rates are set based on audience share), *TV Guide* counted over 117 minutes of NBC promotions on the *Today* show. CBS's *Early Show*, which runs an hour less than *Today*, had just over 107 minutes, while ABC's *Good Morning America* (GMA) came in last with just under 36 minutes of self-promotion. Former morning show producer Steve Friedman told the magazine that 'it's inevitable that a morning show or a magazine show will do these segments,' adding: 'You'd be a fool not to do it. It's a business'.

Similar research in the UK found that in 2005, 63 per cent of TV spots were self-promotional with one-third cross-promotional of which most (76%) were for allied TV channels or programmes on these channels (Ofcom 2005b: 12).

Over the last few decades, attention has focused on various, emergent forms of cross-media promotion in news, which now co-exist. In the 1980s and 1990s attention was focused on two main forms: newspaper cross-promotion of allied media, and cross-promotion of allied channels and programming in broadcast programmes. In the UK cross-promotion in Rupert Murdoch's newspapers of Murdoch-owned Sky TV was the focus of a government inquiry in 1989 (see chapters five and six). From the late 1990s to the present, multimedia integration and cross-promotion has been the increasing focus of attention. With the Internet and the expansion of digital media, CMP takes an increasing variety of forms.

News cross-promotion and convergence

The blurring of boundaries between 'old' and 'new' media technologies has occurred gradually over the last thirty years. Convergence has arisen at the level of technology, markets, regulation, programme content and media consumption. There is increasing cross-media production, which Erdal (2007: 52) defines as 'production of content for more than one media platform with the same producer or organization'. News output from many providers is increasingly multimedia. The expansion of digital and network technologies in the 1990s facilitated the creation of multimedia production, increased opportunities to publish content that was available to those with Internet access, and encouraged new forms of convergent communications. Broadcast news has expanded to cover not only television, radio and teletext, but web and mobile phones, as well as integration with print (Erdal 2007). Traditionally print-based publishers who have expanded online, increasingly incorporate audiovisual content (produced by themselves or acquired) alongside text and still images. News media have thus become increasingly convergent. So too, the integration of news production for old and new media has become a ubiquitous form of convergence. In the US, Media General's Tampa News Centre in Florida, launched in March 2000, established a converged news operation offering an influential model of cross-platform consolidation across print, TV and radio (see Dupagne and Garrison 2006; Corrigan 2004). Convergence in this context refers to 'some combination of technologies, products, staffs and geography among the previously distinct provinces of print, television and online media' (Singer 2004: 3; Huang and Heider 2007). One vision of economic convergence has been that of a single business that would operate across multiple platforms with cost-savings from a shared news operation and revenues from ads sold across multiple media. The cross-promotional value of sharing and presenting content across platforms has been viewed as a means of increasing advertising revenues, although Dupagne and Garrison (2006: 239) summarise the views of sceptics who point to the failures of many ventures to realise significant economic benefits from corporate integration. Yet, undoubtedly, web capabilities have facilitated what Bell Canada Enterprises Chairman Jean Monty calls the 'the possibility of cross-selling, cross-promoting and repurposing' (Sparks et al. 2006).

Different critical approaches tend to privilege different dimensions of convergence. The technological basis of convergence is digitalisation, allowing text, vision and sound from sources such as television footage and radio to be recombined and published on a variety of platforms. However, newsroom convergence is by no means only a matter of technological convergence. Convergence is multidimensional, encompassing a variety of different eco-

nomic, market, institutional, operational and cultural processes. Murdock (2000) usefully delineates three convergence processes: the convergence of cultural forms, as formerly distinct forms of expression can be combined and recomposed; the convergence of communication systems, as different platforms can carry the same kind of services; and the convergence of corporate ownership. Technological convergence remains the most manifest dimension but to understand the implications, and policy debates, the term needs unpacking. In particular, critical political economists highlight the importance of human agency in both corporate strategies of consolidation and acquiescence by policy-makers and regulators to permit these. Of most relevance for this chapter is the emphasis on institutional practices and cultures in shaping how convergence is realised.

Media Commercialism

Cross-promotional activities need to be understood in the context of a broader set of changes affecting news media. The underlying trends have been growing commercial pressures and increasing commercialisation (Croteau and Hoynes 2006; Hallin and Mancini 2004) especially but not only across ad-dependent, privately owned media. However, these take different forms across media sectors and firms. Media organisations are shaped by the complex interaction of political, economic, technological, social and cultural influence as well as by each institution's historically determined rules (McQuail 1992: 82–98). CMP constitutes a specific set of behaviours and practices that need to be understood in the context of factors shaping media production and consumption and within the broader context of convergence processes. In particular, cross-promotion in news activates different sets of values about media production, content and performance. The logic of marketing and promotion meets concerns about news values mobilised by professionals on their own behalf and directly or indirectly on behalf of consumers. Which values and practices prevail tends to be determined at an institutional level, within firms and even within divisions or teams, although this is heavily influenced by wider market conditions and by the adoption and acceptance of practices in the relevant media sector.

In commercial media news must either make a profit or be cross-subsidised from other business operations. The business models for newspapers and free-to-air broadcasting have both been challenged by falling demand, rising costs and growing competition from 'free' news outlets, for instance content aggregators like Google and Yahoo. The major opportunity and

economic incentive are to drive audiences and advertisers across more than one platform—print, broadcasting, online, mobile, etc. in order to command market share, reduce costs and maximise the value of content. For many journalists and critics, it has been corporate demands for high returns on investment that have eviscerated news provision, cutting costs beyond a level to sustain quality, independent and investigative news (McChesney 2007: 95–98). Conglomeration has led to increased bottom-line pressures in sections of the media, such as news divisions, that tended, historically, to be partially insulated from them. In the United States broadcast news became a major public source of information during the Second World War, and from the late 1940s the three major networks invested heavily in their news divisions to provide international, national and local news coverage. By the 1990s all the national broadcast networks were in the hands of major entertainment and multimedia conglomerates. GE owned NBC; Westinghouse Electric bought CBS in 1995, from billionaire investor Laurence Tisch who acquired it in 1986. Westinghouse then consolidated CBS with entertainment conglomerate Viacom. Capital Cities bought the ABC Network in 1986 and then in 1995 Disney took over Capital Cities-ABC. According to Croteau and Hoynes (2003: 46) the 'loudest warnings about the impact of conglomeration have come from within the news industry, in part because some news media have traditionally been sheltered from the full pressure of profit making'.

Today, the model of advertiser financed news is in profound crisis and, many suggest, terminal decline. In the US commercial system, the combined pressures of profit expectations by corporate owners and the loss of audiences and advertising revenue to 'new' media have led to a frantic search for a viable and profitable business model for news. Rising costs, growing competition from other ad-carrying media have increased media dependence on advertisers. News media have offered attractive packages to secure advertising finance, including editorial placement. Advertisers have also sought, and obtained, promotional opportunities across media, including news. More broadly, attracting advertisers and the audiences sought by advertisers has limited the nature and range of news content. According to McChesney (2004:83), 'Pressure to shape stories to suit advertisers and owners is not new, and much of the professional code has attempted to minimize it. But corporate management has been grinding away at news divisions to play commercial ball'. Commercial integration of news by third-party advertisers has occurred alongside that of owners. The commercial penetration of news, McChesney argues, has taken two main forms:

1. Commercial interests produce or directly penetrate the news itself, corrupting integrity.
2. Journalists use their privileges to report favourably on their owners' commercial ventures or investments.

Writing shortly before Disney's takeover of Capital Cities/ ABC Marc Gunther (1995) reported the growing belief that 'many more reporters will be forced to engage in a kind of journalistic incest when covering their corporate parents and siblings. If nothing else, that will fuel second-guessing of news judgments, suspicions about the hidden agendas of news outlets and questions about journalists' independence and credibility'.

US newspapers

The 'firewall' separating 'Church' and 'State', that is separating editorial from advertiser or corporate interests is a central trope structuring debate about US journalism (see Bagdikian 1997). The firewall concept provides a normative standard for critique while spotlighting profound economic, structural and behavioural changes in journalistic media, especially news journalism. The US press is characterised by a high degree of concentration in local markets. Chain ownership of newspapers originated in the first wave of consolidation at the end of the 19th century. Over the past 30 years, with newspaper circulation generally flat or declining, the pressure to become more market driven has intensified (Campbell 2000; Squires 1994; Hickey 1998; McChesney 2004). The processes of commodification and their resulting forms in newspapers are certainly not new (Baldasty 1992). The first ethics codes for news were established in the 1920s, partly in reaction to the excesses of sensationalist 'yellow journalism' (McManus 1994: 201). But it was from the 1960s that one of the most successful newspaper chains, Gannett, became a market leader after adopting new technologies, reducing staff costs and introducing 'market-driven journalism' (McManus 1994). Under Al Neuharth, Gannett secured stockholder investment to fund aggressive expansion, generating profits considerably higher than most traditional newspaper owners were achieving, through a strategy of acquiring monopoly papers and increasing advertising rates (Squires 1994; McManus 1994: 202).

From the 1970s stockholders have come to expect high profits from newspapers held by publicly listed companies. According to critics, many corporate investors do not share the principles of public service which shaped the uneasy balance between business and journalistic imperatives and which created the historically brief 'provisional resolution' between owner intervention and

journalistic autonomy (Hallin 2000: 220). In 1997, 162 dailies out of 1,509 changed hands with total transactions reaching a record $6.23 billion. With rising purchase prices, the chain owners, often heavily debt-laden, demanded efficiency savings to maintain stock price (Hickey 1998). Journalistic professionalism, it is argued, survived largely in an economic context where profit margins of 5-7 per cent were acceptable, before returns of 15-20 per cent were expected (Squires 1994: 72-102; Hallin 2000: 222-3).[3]

Conglomerate ownership has also shifted the balance further from editorial autonomy to commercialism including cross-promotion (Bagdikian 1997; Hardt 2000).[4] Accompanying the growing influence of business strategies in editorial content has been a shift in journalistic culture and professional outlook, responding in part to the economic pressures, uncertainty about the future of newspapers and exigencies of fierce competition. Auletta (1998) captures the characteristic ambivalence of many professionals, quoting a *Chicago Tribune* bureau chief who justifies 'better communication between business and editorial' but warns 'I would be very troubled if I saw advertising guys talking to my reporters'.

Breaching the firewall. In December 1999, the *Los Angeles Times* printed a 32,000-word report by staff journalist David Shaw (1999), which severely criticised senior executives. Simultaneously, the paper gave a renewed commitment to the effect that '[i]f the editorial mission and the commercial interests of the Times conflict, editorial integrity will always come first' (*Los Angeles Times* 1999). The action which prompted this unprecedented *mea culpa* was the publication on October 10 of a 164-page magazine supplement devoted to Staples sports arena in Los Angeles. The *LA Times*, a founding partner in the arena, did not reveal to its readers, or many staff journalists, that the $2 million the supplement raised in advertising would be split between the paper and the sports centre. The supplement formed part of an elaborate profit-boosting deal put together by the paper's publisher, Kathryn Downing (a former law book publisher, employed at the paper for only six months), who later apologised for her 'fundamental misunderstanding' of newspaper ethics. This incident was the culmination of a longer process. In June 1995, the paper's owner, Times Mirror, hired Mark Willes as CEO, a former executive at food giant General Mills, who earned the title Cap'n Crunch for his vigorous cost-cutting methods. Willes stated his aim was to 'blow up' the wall separating the newsroom from the business side of the paper. By 1998 Willes had secured significant backing from some staff journalists (Rappleye 1998), although after the Staples incident 300 journalists signed a petition calling for a thorough review of all financial relationships that might comprise the paper's 'editorial heritage'. Interviewed in 1998, Willes argued that the firewall was a 'phoney

issue' because publishers had always had the ability to jump it, and he cited instead the need for 'standards' of editorial integrity. Willes survived only another year and the fortunes of the LA Times continued to slide with changes of ownership and cut-backs failing to reverse its long-term decline in circulation. In addition to cross-promoting its website there are frequent cross-promotions with co-owned KTLA (Channel 5) local TV news channel.

Broadcast news

The acquisition of broadcast news operations by major entertainment conglomerates has been an important factor in erosion of the firewall. News divisions have been placed under the same pressure as other divisions to deliver a common rate of profit. Returns of 20–30 per cent have been demanded from divisions that have previously achieved 5–10 per cent operating profits. Increased expenses for 'star' TV news anchors, investment in hi-tech equipment (for instance for weather reporting) on the one hand have been accompanied by intensifying efforts to drive down costs (see Alger 1998; Bagdikian 2000; Bennett 2008; McChesney 2008). This is manifested in management pressure to maximise revenues as well as to reduce costs and so includes internal pressures for greater accommodation with advertisers, just as external pressure from advertisers increases. A Project for Excellence in Journalism (PEJ 2002), report on local TV news found evidence of routine pressure from advertisers on editorial. In a survey of 118 news directors more than half, 53 per cent, reported advertiser pressure to suppress negative stories or to run positive ones (PEJ 2002: 2). Sponsors intervened most often to try to secure favourable coverage, but 18 per cent of news directors reported that sponsors had tried to prevent them from covering stories, a problem most acute in small markets. The report concluded: 'What emerged was the sense that the relentless push by advertisers and sales departments inevitably yields small concessions from beleaguered news directors. Even without overt pressure news directors may feel obliged to compromise just to keep their jobs'.

Together these factors alter US news in several ways. McAllister (2005: 212) notes the increasing stress on 'ratings-friendly' news as well as pressure to avoid criticism of advertisers and corporate owners. 'This context also influences journalism toward more coverage of commercial activities and to serve as a promotional outlet for advertisers and corporate owners' (McAllister 2005: 212). A growing number of critics find the commercial voice dominating news in the US, especially in the highly competitive FTA television market, governed by ratings. Advertisers demand more promotion than the typical (and increasingly avoidable) spot advert.

Convergence: newspapers, broadcasting and online

In addition to the editorial–advertising 'firewall', several other walls have come down, sometimes physically, as news operations converged. In 1995, the Chicago Tribune Co. converted its Washington office into a joint facility for print, TV, radio and online (Auletta 1998). But a greater influence on cross-media promotion have been the combined alliances between print, broadcasting and online operations. An essential difference has been that while online expansion for offline media such as newspapers has been mainly governed by businesses themselves, mergers between newspapers and broadcast outlets remain subject to cross-media ownership rules as well as general competition regulation. Joint ownership of a local broadcast station and newspaper has generally been prohibited under FCC cross-ownership rules, and FCC efforts in 2003 to eliminate most of the remaining restrictions were rebutted. Hence many cross-media arrangements have been alliances or joint ventures, with ownership rules being an important, if by no means the sole, factor here.

When the Washington Post Company announced its alliance with MSNBC and NBC in 1999, the scope of which surprised many in the industry (Martinson 2001), it was keen to stress that editorial independence would be fiercely maintained. Leonard Downie, Executive Editor of the *Post*, said, '[i]t's important to remember that nobody bought anyone else', arguing '[t]his is an alliance and a cooperative effort. We are an independent news organisation working together' (Martinson 1999). Two years on, Martinson (2001: 58) noted that when the NBC news anchor broke a story that would appear on the front page of the *Washington Post*, 'few people bat an eyelid':

> Alliances between print, television and online media have become so common in the US that the occasional use of an early evening news—or an online partner—to sell a newspaper story has become a common, if not standard, procedure. (Martinson 2001: 58; see also Hoyt 2000)

The deal involved both the *Washington Post* and *Newsweek* in twice-daily news conference calls with MSNBC. However integration of MSNBC with the magazine was much greater than for the newspaper where, 'there has been none of the collaborative ventures that mark the *Newsweek* venture, both on the editorial and business side' (Martinson 2001: 58). Differences arose partly from the deal itself and from the fact that the *Post*, unlike *Newsweek*, aimed to be a leading online (as well as off-line) source of news. The defence of editorial integrity illustrated here indicates the durable appeal of normative rules determining different components of the media system but also the powerful centripetal forces towards inter-media and intra-firm promotion.

Newspaper-TV convergence. Tie-ups between newspapers and television news have increased dramatically since the early 1990s. This has occurred under shared corporate ownership but also through strategic alliances between independent companies. One of the most commonly found forms such integration takes is cross-promotion. Dailey et al. (2005) define newspaper-TV convergence as a series of activities involving interaction between partners, and the authors posit a five stage 'convergence continuum' reflecting an increasing degree of interaction and cooperation. These are cross-promotion, cloning, coopetition [a fusion of cooperation and competition], content sharing and full convergence. Cross-promotion is thus conceived as the basic, foundational stage of interaction. Lowrey (2004) modified the continuum to focus on three stages: content partnering, procedural partnering (involving shared planning, scheduling and story preparation) and structural partnering (new work structures for completing the job). Yet, Lowrey too found that most partnerships focused on cross-promotion. Content sharing was undertaken by about half, while very few engaged in structural partnering. Other researchers have found that most print-TV news convergence has focused on two areas— content sharing and cross-promotion (see Dailey et al. 2005). Such cross-promotion might involve publishing or broadcasting a partner's logo on a regular basis or having a designated person appear on the partner's newscast to promote stories in tomorrow's newspaper (40–41). A survey of editors at 30 US newspapers in 2004 found that a 'small group of newspapers appears to be relatively committed to promoting their stories on their partner's broadcasts', however, the majority were not taking advantage of the cross-promotion opportunities, and gave little attention to promoting their partners' content' (43). Such researchers, however, offer a descriptive account bereft of any critical scrutiny of convergence practices, including CMP. As Deuze (2004: 140) notes, the 'convergence continuum' implies a linear process towards fuller convergence and presumes an unproblematic consensus about the meaning (and desirability) of such convergence.[5] Yet even the director of the News Centre at Tampa, Florida, Forrest Carr, describing how 'each platform frequently publishes, 'refers' or pushes to its partners', acknowledged that some readers, viewers and users found such corporate cross-promotion to be annoying and stated 'we are revisiting how, when, and where we do this' (Carr 2002). For Compton (2004: 6, 97–136), who provides a critical survey of the repurposing of news in US and Canadian media, 'corporate and promotional convergence' threatens independent newsgathering.

European research: convergence and integration of news √

In her study of UK media companies in the late 1990s, Doyle (2002a) found considerable scepticism as to whether integrating broadcasting and newspaper publishing would offer any substantial synergy benefits. For most managers 'the *only* special advantage of cross-owning television and newspapers appears to be the opportunity to cross-promote products' (Doyle 2002a: 116). While multimedia ('diagonal') expansion across television and newspapers created some economic benefits for individual firms and shareholders, Doyle argued the evidence to date did not show that general economic gains, used to justify liberalisation of cross-ownership rules, were realised. Some cross-ownership combinations did provide synergies and cost-efficiencies (at least defined by narrowly economic criteria). In particular, the expansion from print to electronic publishing enabled content to be shared or repurposed. However Doyle (2002a: 78) argues that there was little economic benefit arising from combined ownership of television broadcasting and newspaper publishing, a finding that flatly contradicted the main argument put forward in favour of deregulation of cross-ownership rules. 'Diagonal' integration (such as between print publications and broadcasting) failed to bring about claimed efficiencies, economies of scale or other economic benefits. Nevertheless, Doyle suggested such benefits were more likely to be realised with increasing multimedia convergence. In fact it was anticipated technological change that was a key driver of 'diagonal' integration. Likewise, Sánchez-Tabernero and Carvajal (2002) found that diversified media companies pursued a range of synergy strategies, including: content sharing, cross-promotion, advertising, commercialization, marketing co-ordination to share information, and integration of production structures (see Carvajal and García Avilés 2008: 454).

In the US news media convergence has often involved strategic alliances or mergers between newspapers and cable TV stations. By contrast, online convergence in the UK has tended to be an internal process linking print or broadcast newsrooms online within the same organisation. A key factor has been the UK's cross-ownership rules that prevent newspaper companies from controlling TV or radio stations (Thurman and Lupton 2008). By contrast, most Western European governments have allowed their public service broadcasters to expand their activities on new digital platforms (Bardoel and d'Haenens 2008). In both the US and UK news companies are increasing their online operations, with increasing use of video alongside text and still images (Thurman and Luton 2008).

Editorial Cross-Promotion in News Media

Three main forms of news cross-promotion can be distinguished analytically:

1. coverage of the business affairs and interests of parent companies
2. coverage of the entertainment products and services of parent groups
3. coverage of allied media platforms, products and services

While these certainly overlap they have tended to engage different research foci and attract rather different kinds of critique. If the first is for some a litmus test of corporate influence and editorial integrity, the other two are sometimes tolerated as facets of market-driven media. Entertainment cross-promotion may be normalised as marketing, or accepted, sometimes with resignation, as 'soft' news. The cross-promotion of other content, channels, platforms or services is viewed by most practitioners and academics as a business imperative, and increasingly normalised.

'Covering ourselves'

Corporate cross-promotion has a corollary: suppressing information deemed to damage the interests of corporate media owners. As Gitlin (1997: 8) suggests, the most insidious form of censorship in commercial media is self-censorship. Journalists and creative workers quickly get to know where boundaries lie, what stories are likely to be suppressed, frowned upon by senior editors and executives, or otherwise damaging for career advancement. A survey of US journalists and news executives (Pew Research Centre 2000) found that a quarter of journalists purposely avoided newsworthy stories, while nearly as many admitted they had softened the tone of stories, in order to benefit the interests of their news organizations. Some 41 per cent had engaged in either or both of these practices. More than one-third (35%) said that news that would hurt the financial interests of a news organization would often or sometimes go unreported. In particular, over half of investigative reporters questioned said newsworthy stories were often or sometimes ignored because they conflicted with the economic interests of the parent organisation. More than six in ten (61%) judged that corporate owners exerted at least a fair amount of influence on editorial decisions. While those surveyed admitted that journalists might sometimes *wrongly* suspect stories were killed because of conflicts of interest, when the stories in question simply lacked merit, nevertheless one in five reported receiving criticism from bosses for stories deemed to be damaging to the company's financial interests. Overall, some three

quarters judged the impact of buyouts of news divisions by diversified con-glomerates to be negative (71% of national and 75% of local journalists). Jackson et al. (2003) note that 'journalists who resist pressure from up-stairs—whether that means a pushy publisher's office or a mega-corporate HQ—face consequences up to and including the loss of their jobs. Readers and viewers may never learn that a reporter was fired or demoted or moved off the beat. Nor will they be aware of the stories that go untold as a result'. Infamous examples of corporate suppression include Disney-owned ABC's refusal to air a report investigating employment practices at Disneyland (Soley 2002). In 1999 investigative business journalist Kim Masters was not invited to appear on any Disney-owned news outlets to discuss her unauthorized biography of Disney CEO Michael Eisner. Eisner was alleged to have pressured Random House, which previously published Eisner's autobiography, to drop Masters' book (Seitz 2000).

A more general instance of information suppression has been the failure to cover media policy and regulation stories to bring these matters to the attention of general readers in news pages rather than specialist, and largely, uncritical reporting in the business pages. Price (1998) highlights the failure of US corporate media to cover the 1996 Telecommunications Act (see also Gitlin 1997: 9–10), while Gilens and Hertzman (2000) found media compa-nies skewed their coverage to their corporate policy interests.[6] Similarly, a study of editorial and opinion coverage of several major mergers in the Cana-dian communications sector found only one item critical of a deal that in-volved the paper it was printed in (Hackett and Gruneau 2000: 5–10). The researchers found that 'the majority of the coverage tended to be uncritical, to focus on convergence as a technological inevitability, and to frame the issues as an economic concern or as one involving powerful and interesting individuals' (Hackett and Uzelman 2003: 336).

Corporate self-promotion and cross-promotion in editorial. A study by the US organi-sation Project for Excellence in Journalism (PEJ 2001) found that media outlets tend to cover their parent companies' products much more than those of others. The study found that the TV networks' morning magazine news programmes featured more stories about their own parent company's products than they did about any other single company. At the time of the study CBS was owned by Viacom, whose vast holdings included MTV, Simon & Schuster book publishers, Paramount studios, the UPN network and more. CBS was nearly twice as likely to carry Viacom products as ABC and NBC combined. Such coverage ranged from interviews with contestants on CBS reality TV shows to interviews with the stars of Paramount movies. In a study of 20 days

coverage in 2001, CBS aired 82 product stories on *The Early Show*, more than a quarter of which (27%) involved Viacom products.

Each of the three main networks is now owned by vast entertainment conglomerates. ABC is owned by Disney, whose holdings include Disney Studios, Miramax, 80% of ESPN, *Talk* magazine and much more. NBC is owned by General Electric which also owns CNBC and co-owns MSNBC. In 2009 CBS Corporation and The Walt Disney Company, two of the largest media conglomerates in the world, also dominate television news. They own and operate TV stations that reach more than 60% of the country's population (WGAE 2007).

The PEJ study demonstrated that ownership matters, finding a strong correlation between corporate links and editorial cross-promotion. Each company gave coverage to the products of its competitors, but each morning show carried more stories about their own parent company's wares than they did about any other company, especially their media competitors.

Table 2. Corporate cross-promotion on US network television morning shows (June and October 2001)

	ABC	CBS	NBC
AOL/TIME WARNER	4.2%	7.3%	8.1%
DISNEY	21.1	4.9	2.3
VIACOM	7.0	26.8	9.3
NBC/GE	1.4	0	11.6
COMBINATION W/NO PARENT	0	8.5	3.5
OTHER	66.2	52.4	65.1
TOTAL	100.0	100.0	100.0

(Source: Pew Research Centre, Project for Excellence in Journalism 2001)

Hackett and Uzelman (2003: 336) report the findings of Canadian researchers that the *Vancouver Sun* gave more favourable coverage to its owner Hollinger and less favourable coverage of competitor media companies (Gutstein et al. 1998: 39-44). The PEJ study also found that corporate links were disclosed to viewers only in a minority of cases, commenting: 'In the age of synergy, such cross promotion may not raise as many eyebrows as it would have some years ago. Yet what is surprising by any measure is how rarely the parent relationship is disclosed'.

In June 2001 the study found that only 11 per cent of all stories about products connected to a parent company disclosed the corporate relationship. In October the disclosure rate increased considerably, mainly due to promo-

tion of new entertainment programmes for the fall. However, routine disclosure in news stories was exceptional. As Seitz (2000) shows, most of these US outlets do not have policies regarding disclosure of corporate ownership or related conflicts of interest in their news coverage (cited in McAllister 2005: 213).

Disclosure patterns vary across companies, across different divisions and within journalistic beats (see also chapter five), According to Seitz (2000) news divisions of all the media giants routinely disclosed conflict of interest when reporting on the parent company's stock prices and corporate business activities. In some cases news divisions 'hit the parent harder than their competitors, just to prove their independence'. Such instances included MSNBC's aggressive coverage of Microsoft founder Bill Gates' antitrust cases and CNN and *Time* magazine's reporting in 1999–2000 on the details of the AOL-Time Warner merger. Regarding intra-company entertainment products, however, disclosure patterns vary considerably across news organisations. According to Seitz (2000: 1):

> Fox News Channel tips viewers to conflict of interest simply by naming the division that produced whatever they're reporting on; since most of the company's divisions have the word 'Fox' in their name, disclosure is automatic. CNN often finds a way to disclose conflict of interest even when it's just doing an entertainment puff piece on a new Warner Bros. CD or movie, either in narration or through a graphic that reveals the name of the releasing company. But *Time* magazine, ABC and CBS News and the Murdoch-owned *New York Post* rarely disclose intra-corporate ties unless the story has some kind of obvious business angle.

Self-promotion in TV news programmes

A report by the Writers Guild of America, East (WGAE 2007), based on survey data from WGA members at CBS and ABC news outlets found less hard news, more 'infotainment' news, and more cross-promotions of outlets or products owned by the same company. It found there was less news output overall; fewer stories were covered and these were repeated more frequently, especially on co-owned stations.

The morning news shows feature heavy self-promotion. PEJ (2001) found there was a 'steady stream of self-promotions, many of them short, but so many of them constant'. In June 2001 NBC averaged 31 self-promotions a day, CBS 29 and ABC 25. *Good Morning America* averaged 15 minutes of promotion time per show—a full 18% of the newscast. A common form is trailing material that will appear later in prime time programmes. *Good Morning America*, for instance, ran segments of Diane Sawyer's interview with Nancy Reagan as a preview to the longer interview that would air on *Prime Time Thursday*.

Such plugging of proprietary news (exclusives) may well be defended as editorially justified. It may be defended as serving consumer interests (providing appropriate information to help viewers choose programmes of interest) and pro-social, citizen interests (where promotion seeks to build audiences for news content). What is apparent, however, is that corporate interests can skew news agendas in ways which can be detrimental regarding the criteria for news selection, the manner of news coverage, transparency, and the broader impact of corporate-inspired coverage on news coverage and news values. NBC *Nightly News* featured more than twice the amount of news coverage of the 2002 Winter Olympics than did the ABC *World News Tonight*, and nearly seven times more coverage than did CBS *Evening News*. NBC was the broadcaster of the Winter Olympics. According to ADT research, NBC's *Today* show devoted 544 minutes to the Olympics, more than for any other news story that year (cited in Jackson et al. 2003; McChesney 2004: 85). Jackson (2006) comments:

> The network that pays for the rights to broadcast the Olympic Games always happens to find the Olympics far more newsworthy than its network competitors. In 2004, according to the Tyndall Report's tally of network newscast coverage (8/28/04), NBC *Nightly News* devoted 106 minutes of news time to the Athens events; by comparison, ABC dedicated 34 minutes of news time, and CBS only 15. NBC executive producer Tom Touchet, who works on the *Today* show, felt no conflict, telling the *Atlanta Journal-Constitution* (8/14/04) that "his bosses haven't asked him to do anything he wasn't comfortable with".

Of greatest concern are instances of promotion which lack editorial justification and which are routinely non-disclosed. An example, cited by PEJ (2001), involved six plugs for a Martha Stewart cooking segment on the *Early Show*:

> The segment was sponsored by the K-Mart retail chain, which carries Stewart's exclusive line of clothing and housewares. And during the segment, Stewart and CBS host Jane Clayson took care to also plug Stewart's "Pies and Tarts" cookbook . . . CBS then referred viewers to CBS.com for more of Martha's recipes. That, in the end, made the segment for Stewart, K-Mart and CBS a five-point cross promotion.

The authors use the term 'meta-promotions' to describe such instances as a wedding feature on *GMA* and *Today* in which viewers chose a couple to be married at the end of a week of coverage featuring preparations. Such a meta-promotion promoted commercial wedding products, plugged throughout the broadcast, promoted interactivity via the network's website, while the segments were 'self-promotions for the most heavily plugged segment of all, the live TV wedding to come at the end of the week' (PEJ 2001).

One growing trend has been promoting that day's entertainment programmes in news programmes. Launched in 2001, CNN's *Headline News* routinely included the evening TV line-up at its various sister networks as part

of its news headlines and plugged upcoming movies on sister networks TNT, Turner Classic movies and the WB (Jensen 2001). When Jensen, an *LA Times* journalist, contacted CNN a spokesman denied such cross-promotion was policy but said Time Warner outlets would no longer be favoured over others. However, while *Headline News* did feature competitors' media, Jensen found evidence that the majority of headlines continued to favour AOL-Time Warner fare over competitors. Further, the cross-promotion between CNN itself and *Headline News* remained stated policy. *Headline News* executive vice president Teya Ryan said "We do have the intention of moving audiences back and forth between [CNN and *Headline News*]'. Jensen reports that MSNBC and Fox News Channel acknowledged that they also use their on-screen headlines to promote topics and guests for upcoming shows, but both stated that they did not promote other channels in their respective corporate empires.

Cross-promoting allied entertainment, in news programmes

When news divisions create stories promoting movies, CDs, books and other media products owned by their parent company, they engage in 'plugola', which McAllister (2002: 384) describes as occurring 'when a person responsible for including promotional material in a broadcast has a financial interest in the goods, or the group being promoted'. As we have seen, the ability to market and cross-promote entertainment brands has been a driving force for corporate integration. Broadcast news, newspapers and magazines are all enlisted to promote parent companies' film releases through entertainment features or tie in news features. News features on parent-owned TV entertainment shows have also become increasingly ubiquitous, critics argue. Hamilton (2004: 145) found that ABC's popular quiz *Who Wants to Be a Millionaire* 'was mentioned in 80.2% of the local news programs on ABC affiliates'.

In his study 'Selling *Survivor*', McAllister (2005) describes a round-table discussion on CBS's *The Early Show* of the previous night's *Survivor* episode. Panelists, including former *Survivor* participants commented in a weekly six-minute segment which aired throughout the series from its inception in 2000. Viewers were routinely encouraged to visit the CBS-*Survivor* website. Incorporated in the programme, news items and website were coverage and promotion of Pontiac's Aztec vehicle, sponsors of the show. Such forms of 'plugola' (McAllister 1999, 2005: 213), 'where a news story becomes publicity-based coverage of corporate holdings' have become increasingly common on the morning news magazines, primetime network news and local TV news.

The morning news magazine shows in the US have long mixed news and entertainment with a high proportion of 'soft' news and with human-interest stories and chat interspersed with headline news, but all are produced by news divisions. Studies indicate that commercial integration in news tended to be constrained by a countervailing defence of journalistic professionalism. Through the 1950s to 1970s TV news tended to be protected and guarded from within. In 1983 George Merlis, executive producer of CBS Morning News clashed with executives over his decision not to give extensive coverage to the final episode of CBS's M*A*S*H. (Boyer 1998 cited in McAllister 2005: 215). However the Church-State barrier has suffered a worrying thinning, if not collapse, according to critics. When a weather reporter on Good Morning America promoted ABC drama Push, Nevada, the drama producers acknowledged the stunt: they had hired actors to appear as the fictitious town's school hockey team alongside the reporter. However, 'instead of calling it a misleading hoax or a journalistic transgression, they called it an edgy promotional technique suggested by their marketing company' (Jackson et al. 2003). According to ABC, the news division at GMA was unaware of the nature of the stunt, although it made no effort to edit out the lengthy plug from later broadcasts.

CBS's Survivor, one of the first in a series of popular, event-based reality programmes, certainly had news value and salience and was covered by the news divisions of ABC, CBS and NBC. However, McAllister (2005: 216) found that CBS news programmes devoted five times as many stories to Survivor as its nearest competitor ABC, 108 compared to 21 for ABC and 15 for NBC between January and August 2000. Coverage also began months before the show aired and became a popular hit. Promotion increased for the second series in 2001 with 169 stories on CBS compared to 16 on NBC and 8 on ABC. CBS's Early Show became a 'virtual two-hour promotional spot' at times, with integrated stories, including lead news items, graphics and audio from the show and even days branded for instance as 'Survivor Wednesday'. Product placements for sponsors such as Doritos and Reebok also featured in the news coverage, extending their impact and audience profile. CBS cross-promoted Survivor on the Internet, notably CBS's website, and used many outlets owned by its Viacom parent including MTV, Paramount's Entertainment Tonight, and CBS's KCBS radio station in Los Angeles (Compton 2004: 135-6). The third series aired in the very different news environment following 9/11, and there was noticeably less coverage on news programmes, although interviews with the participants remained a staple of CBS's morning news programmes.

Criticism of the practice has also grown. CBS's news divisions were criticised for compromising editorial independence and news values following

parent corporation product tie-ins at CBS such as cross-promotion of *Survivor* and shows such as *Big Brother*. WGAE's members took particular exception to the requirement that they regularly write interviews with the previous night's *Survivor* or *Amazing Race* loser, stories about the 'real-life missing person' featured on that Sunday's episode of *Without a Trace*, and numerous feature stories incorporating syndicated daytime talk-show host Dr. Phil. CBS writers are sometimes pressured to use material from 'corporate partners' such as Simon & Schuster or politico.com before they go to other sources, who might be able to better speak to an issue.

WGA members at WABC-TV in New York recalled reporting on magician David Blaine's Manhattan underwater-living stunt each of the eight nights leading up the ABC primetime special in which he emerged from his bubble. In another instance, ABC Network Radio members were instructed to write about bets being placed on the upcoming *National Spelling Bee* before it aired as a primetime special on ABC. According to WGAE's report (2007: 15):

> Media conglomerates see their news operations as a great venue to cross-promote entertainment products with Disney particularly conspicuous in its use of cross-promotion: Several writers on ABC's *Good Morning America* reported that any domestic story without a crime component is expected to find a way to use a clip from the popular ABC television series *Desperate Housewives*.

The common finding amongst academic researchers too is that the major TV networks have promoted their other media goods and services though their news programmes (McAllister 2002; McChesney 2004). Entertainment conglomerates have exploited opportunities for synergistic promotion across their news outlets. Lee and Hwang (1997) found that after the merger of Time and Warner Brothers, *Time* magazine showed favouritism in coverage towards Time Warner products in both amount and position of coverage. Likewise, Gitlin (1997: 9) notes that *Time* devoted cover stories to Scott Turow, a Warner Brothers author, coinciding with the release of a movie *Presumed Innocent* based on his novel and ran a cover story of tornadoes the same week Warner Brothers' *Twister* opened in cinemas. *Time* magazine declared AOL Time Warner's movie *The Two Towers* a resounding hit before it was released. (Cover line: "Good Lord! *The Two Towers* Is Even Better Than the First Movie"— 12/2/02, cited in Jackson et al. 2003). In contrast, Gunther (1995) reports instances of intra-firm criticism, notably *Time* magazine's pieces critiquing variously Warner music and the WB network, following the merger. Yet his account, while showing that editorial independence was asserted post-merger, shows too evidence of corporate pressure on editorial. One senior *Time* writer states 'We put in things that made others in the company very uncomfortable, I learned later'. When it acquired NBC in 1986 General Electric showed little

regard for the news division's independence. According to former NBC News President Lawrence Grossman, GE's Chairman Jack Welch told him, 'Don't bend over backwards to go after us just because we own you' (Gunther 1995).

Disney acquired Capital Cities, the parent company for ABC television in 1996. Until then it had achieved only modest success in television with hits such as *The Golden Girls*. ABC provided a distribution outlet for Disney films and television programmes as well as a platform for cross-promotion across the conglomerate (McAllister 2000). ABC news played an increasing part in such synergistic marketing. Glaser (1998) describes ABC news coverage of the movie *Armegeddon*. Likewise ABC news promoted Disney's *Pearl Harbor*. In 2002 Disney used its Adventure park and other resources to promote the ABC primetime season, securing an estimated $8 million in free publicity from national and regional television, radio and print coverage of the ABC *Primetime Preview Weekend* (Hiestand 2003). A key criticism has thus been its tendency to reduce ABC news programmes at times 'to a publicity arm of the parent company' (Wayne 2003: 95). However, Gitlin (1997) cautions that movies routinely feature in news coverage, regardless of ownership links. In addition, while it is possible to accumulate examples of corporate cross-promotion, examples of critical reporting of a corporate parent's interests can also be found. The accumulation of anecdotal evidence cannot be substituted for rigorous, systematic research and this remains disappointingly thin. Where they exist, most studies indicate the presence of pro-corporate bias and CMP. Jung (2001) found CNN covered Time Warner's movies more frequently and reduced coverage of TW competitors after Time Warner became CNN's parent company.

Williams' (2002) study of news coverage of ABC, CBS, NBC and CNN examined how these networks covered the different segments of the industry that each company owned. Williams found ABC's coverage of *Shall We Dance* put out by Miramax, then a Disney subsidiary, was used in an ABC story about the rise of ballroom dancing in Japan. The majority of reports of CMP in news, however, have come from media campaigners or news professionals, with notable insights from those recently retired. How such corporate influences are exerted and incorporated into newsroom practices, in particular, needs further research work. This requires analysis of newsroom practices and cultures, management, external influences and interaction, and the flow of promotional materials, synergy strategies and communications across conglomerates. The opacity of intra-corporate dealings also makes this subject an imperative for research to inform policy-making. An example of such complexity and opacity is provided by FAIR (Jackson and Hart 2002). ABC News' Diane Sawyer claimed that her exclusive interview with Dr. Jerri Neilsen, a

doctor who detected her own breast cancer while in Antarctica and wrote a book about the experience, was the result of journalistic perseverance. However *TV Guide*'s J. Max Robins (3 October 2001) reported that Sawyer's supposed scoop might more plausibly be attributed to the fact that Neilsen's book was published by Talk/Miramax Books owned by the Disney Corporation. One of Robins' sources commented, 'Once you have a deal like that in place, it's a no-brainer that the TV piece will end up at ABC News. That's part of what Disney is paying for when Talk/Miramax spends a bundle on a hot property'. However, all parties gave routine denials. Diane Sawyer denied that ABC had any corporate advantage. Talk/Miramax claimed ABC offered the best deal for publicity, with the promise of three segments on ABC's *Good Morning America*. Yet, a sceptical Robins noted that NBC's *Today Show* with 2 million more viewers a day than its ABC rival, claimed to have offered five segments on *Today*, plus *Dateline*. As Jackson commented '[s]ounds more like horsetrading than journalism, doesn't it?'

News cross-promotion in UK media

Cross-promotion in UK newspapers is examined in greater detail in the next chapter through a case study. Compared to the US, however, cross-promotion in UK news media has attracted far less analysis and commentary from academics, journalists and media commentators. Conflicts of interest in reporting proprietors' business interests have, however, been a sustained concern, given the power and influence of the British press and concerns over media ownership and concentration. All the UK editors who gave evidence to the House of Lords Select Committee on Communications (2008), denied that they would be reticent about running a newsworthy story even if it might be damaging to their parent corporation. However, as the Committee's report drily noted, ex-editors were more forthcoming. Andrew Neil, who edited *The Sunday Times* from 1983 to 1994, stated that 'no newspaper group in this country, none, covers its own affairs well'. Neil described the direct pressure from the paper's owner, Rupert Murdoch, in 1994 to desist from the paper's investigations into alleged corruption by the Malaysian government, investigations which were threatening the business expansion of News Corporation's Star TV into Malaysia. Neil acknowledged that this pressure led to his resignation as editor (see also chapter five).

Arguments—Justifications and Criticisms

The normalisation of cross-media promotion

This chapter has examined various kinds of cross-media promotion and argued that these need to be understood in the context of larger processes reshaping media performance. At the heart of concern are those CMP practices which erode distinctions between editorial content and advertising or promotional speech. Here, according to writers occupying various liberal, radical and conservative positions, the professional ideology of journalistic integrity and social responsibility has been dangerously eroded. The criticisms of media commercialism are broad-ranging and include the merging of news and entertainment (infotainment), pandering to sensation and prurience, and irresponsible 'market-driven', 'ratings-led' journalism. Cross-media promotion arises here largely as one form of abuse of ownership whereby conflicts of interest are resolved in favour of corporations, sometimes through censorship, more usually through routine self-censorship by journalists and media workers. Within public sphere discourse entertainment cross-promotion is largely inconsequential (chapter two). By contrast, those US scholars analysing media commercialism have highlighted and criticised the masking of persuasive intent when content become more ad-like and ads more programme-like (McAllister 2000, 2005).

The principal defence to the charge of conflict of interest has been to provide reassurance that editorial integrity remains valued, as the examples cited above indicate. Addressing the conflict of interest arising from Disney's holdings, Michael Eisner asserted:

> I would prefer ABC not to cover Disney . . . I think it's inappropriate for Disney to be covered by Disney . . . By and large, the way to avoid conflict of interest is to, as best you can, not cover yourself. (Preston 2000)[7]

Two principal discourses are discernible in such defences, a discourse of journalistic norms and ethics, and a discourse of economic calculation of the 'value' of editorial independence. Often these are explicitly combined in practitioner discourses, so that the convergence of the latter with the former is offered as a guarantee of their durability. However, it is dangerous and reductive to infer which tendencies are motivating particular articulations without considering institutional, occupational, cultural, and psychological and other factors shaping specific utterances. Over two decades ago, Gans (1980) provided evidence that professional ideology amongst US journalists, especially news journalists, countered commercial influence exerted by owners, senior

business executives and senior editorial staff. McQuail (1992: 86) summarises
research into 'insider' experience by stating:

> Especially notable, perhaps, is the recurrent theme of independence; the emphasis on
> the need to maintain an essential autonomy and freedom of action so that the
> credibility and good faith of the media as well as personal integrity can be sustained.

Since the 1960s testimony from journalists and academics indicates that
commercial pressures on journalists have increased and that professional
ideology has shifted towards greater accommodation with commercial impera-
tives. Identifying the increasing acceptance of cross-media deals, Turow
(1992b: 702) suggests that the 'mandate of synergy', amongst conglomerates
carrying both news and entertainment, 'may be altering the norm that news-
workers separate their stories from the stories their advertisers tell'. For Bag-
dikian (1997: xxi) there has always been an 'inherent dilemma' for journalists
in news companies, but these have been exacerbated by conglomerate owner-
ship, especially as '[s]ome of the new owners find it bizarre that anyone would
question the propriety of ordering their employee-journalists to produce news
coverage designed to promote the owner's corporation'. According to Baker
(1994: 77) most news media attempt to maintain the public's belief that they
realise the professional norm of independence and try to cover up or minimise
any corporate or advertiser influence that does occur. This raises complex
issues for research and evaluation since it indicates both the influence of
norms, the pressure to sell influence to advertisers without letting the reader
(or wider public) know, unwillingness of executives and journalists to reveal
commercial influence (Gans 1980: 253), as well as the many ways such modifi-
cations may be psychologically internalised and rationalised by agents.

There is evidence that professional norms continue to exert influence by
their iteration in practitioner/publisher discourses. Since at least the begin-
ning of the 20th century, newspaper publishers realised that being known to
slant news in favour of advertisers injured the paper's reputation and hence its
ability to sell its product (Baker 1994: 77). Two years before the Staples inci-
dent at the LA Times, Mark Willes asserted, 'our franchise revolves around our
quality'. The paper's travel sector editor, Leslie Ward asserted: 'The minute
you start putting out a paper for the advertisers and not for the readers, you're
going to kill it' (Rappleye 1998: 6). Whatever the conviction shaping such
appeals to journalistic integrity, what such utterances disguise is precisely what
the Staples incident revealed, the effort to conceal the paper's interestedness
from readers (and in this case also from its own journalists).

Statements that corporate news divisions will not cut out competitors or crassly promote their own content are also made to validate self-regulation and avoid the threat of tougher media (or competition) regulation being imposed. During the 1990s, Gitlin (1997: 8–9) found evidence of news divisions striving to avoid the charge of bias in covering their parent companies. Gunther (1995) records several spirited defences by journalists and executives of editorial independence and claims to avoid corporate favouritism. Such defences are very important. In themselves they can influence work cultures and wider public cultures in which puffery is tolerated or challenged. Self-regulation at the individual or institutional levels is (self-evidently) amongst the most important and effective to influence practice. The evidence surveyed in this chapter, however, shows that self-regulation has often proved to be limited and insufficient in practice.

While many professionals willingly defend promotion as a business imperative that also benefits consumers, the charge of failure to disclose interests in editorial coverage is more challenging. However, various arguments to support non-disclosure have been put forward. One is that such disclosure would add needless editorial clutter. Another is that such disclosure would itself give a false impression to viewers.

CBS News President Heyward argued that for CBS News to disclose corporate links in feature stories about books or movies, 'would create a false implication about why we were running the story' (cited in Seitz 2000). Some journalists, however, argue that there is an even greater responsibility to explain the provenance of information, especially that relating to a corporate parent company. Frank Sesno, the Washington bureau chief for CNN, owned by AOL-Time Warner, asserted his news channel's 'obligation to explain the origin and potential conflict of interest in virtually any story we do'.

Criticisms

The failure to adequately disclose corporate interests is one key charge. The promotional function of such stories is often hidden from view (McAllister 2005: 213). However, a central critique is the displacement of public affairs news coverage required to sustain democracy. McAllister (2005: 223) argues that news stories on programmes such as *Survivor* do not encourage participation and engagement in social decision-making and are 'anti-democratic'. Such entertainment cross-promotion pushes other news stories and concerns off the news agenda. This connects to broader criticism, and indeed alarm, at the diminishing news hole on mainstream US TV. TV networks have decreased the amount of international news coverage and increased coverage of enter-

tainment and celebrity (Bogart 2000; McChesney 2004; Bennett 2008). McAllister's argument that cross-promotion displaces democratic news values is an important one, although not without difficulties. Why should 'hard' news be privileged? Is there less objection if corporate CMP comes at the expense of other entertainment or 'soft' news? What mix is appropriate and viable? How should the interests and preferences of consumers be recognised, especially in regard to the news salience of major film releases and 'event' programming?

There are also both citizen and consumer welfare arguments that can be made in favour of news cross-promotion. Intra-corporate promotion, can increase audience awareness for news as well as reduce marketing costs. Cross-promoting news services and news stories can have evident pro-social benefits if it helps to nurture news consumption. This applies to commercial media and the case for cross-promotion is arguably even stronger for public service media. Nevertheless there are also debits to set alongside credits here. As one journalist puts it, 'the same synergy that makes news organizations stronger, richer and more efficient also brings blurred lines and credibility issues. Some are self-inflicted—the product of carelessness or worse. Others are the invariable byproduct of being an arm of an entertainment company' (Seitz 2000: 1).

A modified argument is that democratic communications are damaged if these serve the instrumental economic interests of content providers. Accordingly, upholding editorial independence from the business interests of owners or advertisers provides important safeguards for consumers and citizens. Appeals to democratic values can be stretched, however, when extended to entertainment media. Arguably, a stronger criticism is based more directly on the power imbalances arising from media commercialisation. The immediate form this often takes is lack of transparency in declaring interests shaping the nature of news content (and selection). Cross-promotion can be acceptable where it is editorially justified, transparent and justified by value to viewers and viewer interest. Even here, however, there are further grounds to restrict cross-promotion. The first concerns market power. Market power, exercised as cross-promotion, can diminish the promotional space for alternative products. There is a social value loss when the logic of commercial promotion pervades news so that not only are parent-products promoted but competitors are ignored, even when popular. For instance Jackson and Hart (2002) argue:

> It's no secret that at a huge media conglomerate, one hand often washes the other: A Disney movie, for example, can count on promotional assistance from other Disney-owned properties. But what happens to Disney's competitors in that kind of media environment? One indication is the megacompany's treatment of the animated film "Shrek," produced by Disney rival DreamWorks. According to Inside.com (4/30/01), Radio Disney affiliates received the following instruction in the April 16 issue of their

in-house newsletter, "Ear All About It": "We are being asked not to align ourselves promotionally with this new release." At least five affiliates in Radio Disney's network . . . were ordered by top management to cancel previously scheduled promotional screenings of the film.

The problems of cross-promotion can be linked to a broader critique of media ownership concentration, as argued notably by Baker (2007: 41–53). 'Synergistic' product, argues Baker (2007: 47) 'can reduce net social value by causing the failure of even more valuable media products'; for instance, it can 'provoke a slight downward shift in the demand for alternative media products' that may cause 'the commercial failure of valued, previously profitable, media products'. The second rationale for restricting CMP arises from the system-wide effects of commercial promotion. Even if some viewers may benefit from and value commercial cross-promotion these benefits need to be weighed against disbenefits of increasing commercialisation of news, corporate commercial interests determining selectivity in news content and output, and intrusive promotion.

The commodity production of news has never been free of the exigencies of either profit-making or promotion. The infusion of commercial values into editorial decision-making has long excited critical commentary but the breadth of that criticism today across US scholars, journalists and commentators is remarkable and troubling. CMP in news editorial content is only one aspect of a broader shift towards media commercialism, but it is amongst the most important indicators of a downgrading of editorial independence in news.

Notes

1. In 1999, NI launched CurrantBun.com a 'free' Internet service in *The Sun* newspaper. The service was heavily cross-promoted on the *Sun's* cover inside pages. When relaunched as bun.com, *The Sun* ran a two-page spread on Tuesday 12 October, followed by a four-page pull-out supplement the next day. The Internet service was justified by the paper as attracting its target readers whose profile included lack of prior experience and access to the Internet.

2. See also *Private Eye* (1998) 'Readers of the *Times* weren't simply told about the film *Titanic* being released on video. They were provided with an extremely useful supplement to remind them of the momentous occasion. Of course the paper's enthusiasm for the disaster pic has nothing to do with the fact that its proprietor, News International, also owns 20th Century Fox, producer of . . . *Titanic*'.

3. Hallin (2000: 222) identifies a 'readership theory' of market-driven journalism which offers a different explanation to the 'stockholder theory' outlined above, especially in locating the forces shaping decline in readership largely outside the control of the newspaper industry.

4. Hardt (2000: 221) identifies corporate owners with a new 'patronage model' of the press where journalistic labour is viewed in terms of routinised technical tasks which 'cater to the entertainment interests of consumers, thereby satisfying the demands of advertisers for non-controversial contextual material to help maximise the impact of commercial messages'.

5. The wider debates on newsroom convergence are beyond the scope of this study, but Thurman and Lupton (2008) provide a useful summary regarding the UK, while Scott (2005) offers a critical perspective on the US.

6. According to Gunther (1995) ABC News' *Nightline* was a notable exception.

7. Kurtz (CJR 1997) describes how ABC's *Good Morning America* devoted most of its two-hour show to coverage of Disney's 25th anniversary, with key presenters offering enthusiastic promotion for Disneyland. There are several examples of corporate 'censorship' of stories at Disney owned ABC including ABC News's rejection of a report that poor screening had resulted in the company hiring paedophiles to work at its theme parks (Soley 2002: 232).

News International:
A Study of Editorial Cross-Promotion

Rupert Murdoch gets a mixed press: half of it he owns, the other half is bad. Now there's a surprise.

AA Gill (1998) *The Sunday Times* 22 November

That Murdoch-owned newspapers have been used as vehicles to promote News Corporation's other media and corporate interests is a largely accepted charge and commonplace observation. It appears in numerous academic works and student textbooks (Miller 1994: 25-26; Curran and Seaton 1997: 83; O'Malley 1994: 38; Tunstall 1996: 126; Keeble 2001: 114; O'Sullivan et al. 1998: 161). However, some scholars have objected that while there is evidence of such promotion, and numerous accounts by journalists themselves (for instance Evans 1994: xix), evidence remains largely anecdotal (Street 2001:133-139; see also Sadler 1991: 36). Others object that explanations of corporate or proprietorial influence have been both analytically weak and difficult to prove (McQuail 1992:119-120). In November 2007 Murdoch met members of the House of Lords Select Committee on Communications (2007) in New York; he 'insisted that there was no cross-promotion between his different businesses. He stated that *The Times* was slow to publish listings for Sky [television] programmes. He also stated that his own papers often give poor reviews of his programmes'.

This chapter examines evidence of cross-promotion in Murdoch's UK newspapers. It considers whether newspapers owned by News International (NI), a wholly owned subsidiary of News Corporation, cross-promoted Sky-Digital in which News Corp. had a 40 per cent controlling share. It investigates evidence of cross-media promotion of BSkyB in NI papers primarily though a comparative analysis of newspaper content in October–November 1998, when SkyDigital and ONdigital launched digital television services. These are, then, historical forms of cross-promotion in declining media forms. Murdoch's denial and coyness in 2007 concerning newspaper cross-promotion is in stark contrast to News Corp.'s promotion of synergies and integration

across digital media, in particular global satellite television and interactive services, and integrating online and offline media. In July 2005 News Corp. purchased Intermix Media, owner of Myspace.com, the fifth most-viewed Internet domain in the US for $580m (£332.85m). The social networking site, Murdoch announced, would drive traffic to his Fox TV sites. Like all the major media conglomerates, News Corporation has advanced CMP. But if promoting new services has been licit, subverting editorial independence to promote owners' corporate interests has not. Given this tension, it is of more than merely historical interest to trace how cross-promotion in newspapers has taken place and how it has been assessed by journalists themselves and critics alike.

According to Tunstall's definition Murdoch is an archetypal media mogul (1996: 85). He owns and operates media properties, is a risk-taking entrepreneur and has an 'idiosyncratic or eccentric management style, that may involve political motives'. Murdoch can also be considered a transitional figure, straddling what Tunstall describes as a gradual transition from the era of 'press lords' to 'entrepreneurial editors'. This is characterised by a shift from owners who privileged the political influence of newspaper ownership above business expansion to an entrepreneurial model in which profit maximization, corporate survival and appeasing shareholders are governing priorities. Barnett and Gaber (2001) endorse Tunstall's account, while emphasising that proprietorial influence on political journalism persists and that corporate political interests, for instance over communications regulation, continue to influence editorial. But they argue that '[a]s long as the *business* of journalism thrives and is successful, the content of journalism is less circumscribed than it was in the days of the highly politicised press lords' (61). They identify a qualified abdication of editorial control, circumscribed by owners' political viewpoints, but their discussion of owner influence (58–77) is framed almost entirely in respect of political communication. Against this, evidence of cross-promotion suggests that business interests, far from leading to a withdrawal of corporate influence on editorial, lead to an increase. Sustaining a division between political and 'business' interference prevents an adequate assessment of media power today.

News Corporation

While News Corporation is not the largest it can claim to be the most integrated global media corporation, owning a wide range of media interests that straddle the globe. Rupert Murdoch remains, in Bagdikian's (1989) phrase, 'the lord of the global village'. Herman and McChesney (1997: 70) argue that

News Corporation provides 'the archetype for the twenty-first century global media firm in many respects and it is the best case study for understanding global media firms' behaviour'. Murdoch is perceived by many as holding immense power, deployed ruthlessly to pursue his own interests, willing to sacrifice ethical, political and journalistic standards for profit, as a long list of former editors, competitors, critics and biographers attests. There are many, largely anecdotal, but well-documented accounts of Murdoch's direct proprietorial interference by journalists (Neil 1997; Evans 1994; Kiley 2001; Giles 1986) and academics (Street 2001: 133–137; Curran and Seaton 1997; Belfield et al. 1991; Williams 1996; Curran 1990; Hardy 2008a). Such 'demonisation' of Murdoch has undoubtedly had real effects, for instance, strengthening (and personalising) resistance from politicians and regulators to the corporate ambition of companies in which News Corp. has a stake (see Brown and Walsh 1999).[1] However, such personalisation also risks obscuring the systemic characteristics of corporate media activity.

Editorial values and newspaper independence ✓

When Sadler examined cross-promotion in the early 1990s (see chapter six) there were widely iterated assumptions that newspapers should be factual and fair in all their reporting. Two decades on, newspapers compete within and join to a multimedia system in which cross-promotion is more endemic and routine. It might be objected that what was perceived in the early 1990s as a problem of the loss of 'independent' and impartial speech in newspapers, is better understood as part of a wider process of multimedia convergence, competitive marketing, branding and increased promotional reflexivity across the media. For instance, News International (2000: 4) argued it was anomalous that it:

> cannot produce news programmes on licensed television services under the reassuring brand of The Times or its other titles. Meanwhile, News International and every other publisher are perfectly free to provide, via the Internet, streamed video material similar to a television service that is virtually unrestricted in respect of "masthead" and other television programming and advertising rules.

Murdoch told BSkyB's AGM (BSkyB 2000: 4), that '[a]llied to its TV-based interactive applications, BSkyB is developing a range of new media services with the aim of providing seamless content across all platforms'.[2] Such statements show corporate efforts to promote and capitalise on the extension and normalisation of cross-promotion.[3] In this chapter I will argue that newspapers remain an important medium for observing and analysing CMP but also that

the problematic of promotional speech has validity and relevance beyond newspapers.

Murdoch and proprietorial interference

Murdoch entered Fleet Street with the acquisition of the *News of the World* (hereafter *NoW*) (1968) and the *Sun* (1969). His bid for *The Times* in 1981, however, represented a more profound challenge to the political and social elite for whom Murdoch was an 'outsider' who had brought journalism into disrepute. That the take-over was not referred to the MMC was a source of considerable criticism. While it was conceivable that *The Times* was not a going concern (allowing the Secretary of State for Trade, John Biffen, to approve the merger without referral) this was far less certain regarding the *Sunday Times*, as its own journalists argued (Robertson 1983; Baistow 1985: 13). To assuage criticism, Murdoch agreed to eight conditions 'guaranteeing' the independence of his editors, which included the appointment of 'independent' national directors (Department of Trade 1981). Famously, Harold Evans, former *Sunday Times* editor, lasted only one year as editor of *The Times* before being sacked, responding with a critique of Murdoch as an interfering proprietor (Evans 1994; Shawcross 1997).

There is evidence that Murdoch has taken a keen, critical interest in many aspects of the editorial content and layout as well as the financial state of his newspapers (Neil 1997; Manning 2000: 88–89). Murdoch has interfered directly politically, written or rewritten leaders and other articles. Such interference declined somewhat in the later 1980s as Murdoch moved to Los Angeles and took much more direct control of US television and film interests and global media expansion (Snoddy 1998a). Murdoch led a management-imposed shift to the right at *The Times* and *Sunday Times* in the 1980s and in the 1990s shifted the *Sun* (and *NoW*) to support the Labour Party, much to the anger of some staff journalists (Neil 1997: xxiv).[4] Through a mixture of threats and cajoling, employing senior managers and editors sharing his outlook and rewarded for loyalty, Murdoch has deployed various means to exert influence. For instance, a survey of editorial coverage in 2003 found that the most influential of the 175 newspapers owned by News Corp. worldwide unanimously supported the invasion of Iraq by a 'coalition' of the US, UK and a few allies (Greenslade 2003). However, overt intervention is less common than more subtle alignments between the outlook of editors and their internalised awareness of Murdoch's political and other interests (Neil 1997). Manning (2000: 91–92) identifies three main ways in which power is exercised intentionally or instrumentally by proprietors and senior executives:

they may exercise power internally to ensure that their news organisations produce news formats or editorial regimes of which they approve; they may exercise and accumulate power externally through their exchanges with political elites; and they may consciously exploit the advantages which accrue with the structural positions of their organisations to further consolidate resources, and undermine rivals.

Manning (2000: 87–97) gives a valuable account of how Murdoch has exercised each type of opportunity, although he makes no direct reference to cross-promotion.[5] It is widely acknowledged that corporate interests dominate corporations such as News Corporation. These are often intertwined with political interests (for instance, Murdoch's support for Reagan and Thatcher also advanced favourable regulatory structures and decisions required for the expansion of his media businesses). In other cases, corporate economic interests have predominated over political ideology. When he acquired the left-leaning *Village Voice* newspaper in New York, Murdoch refused to renew the contract of the editor but permitted a non-conservative replacement to retain the paper's editorial stance relatively unchanged. Other key characteristics, also informing corporate culture, have been Murdoch's opposition to public service media, the BBC in particular (O'Malley 1994: 36–46; Barnett 1989), and to traditional rationales for media regulation, as well as wider, selective, opposition to 'the establishment' especially in the UK (see Horsman 1998; Shawcross 1997). Once again, this is a complex mix of instrumentalism and political conviction as the company has waged battles with regulators worldwide since it expanded from its Australian newspaper base in the 1960s. Before Sadler, claims that *The Times* carried articles criticising the BBC, and advocating its dismemberment, as part of a campaign to further Murdoch's commercial interests, were rejected by the papers independent directors (*The Times* 1985) but later research found that the 'editorial and reporting approach to broadcasting matters being pursued by News International was having a material effect on the opinions of readers' (Barnett 1989: 19):

> Whatever the editorial intentions, concentration of newspaper ownership is clearly capable of being exploited to promote the owners' interests elsewhere. Largely, it seems as a result of reading its newspapers, significant numbers of people hold views which are patently to News International's financial advantage.

Satellite Wars: News International, Sky and BSB (1988–1990)

British Satellite Broadcasting (BSB), a consortium initially made up of Pearson, Granada and Virgin Group was awarded the first DBS (direct broadcast-

ing satellite) licence by the IBA in December 1986, providing monopoly supply of three licensed channels for 15 years. Bypassing this regulatory arrangement, Rupert Murdoch announced in June 1988, that he would use leased-space on the Luxembourg-registered Astra satellite to launch four channels for the UK. Sky launched on schedule on 5 February 1989, initially to very poor take-up and with losses reaching £2 million per week by mid-year. BSB launched in April 1990 (March for cable subscribers), a delay of seven months from its target date, as a result mainly of technical and supply problems with the home receiving equipment, dubbed the 'squarial' (Horsman 1998: 44–45). Intense competition between BSB and Sky proved too costly for both; in November 1990 the companies merged in what was 'effectively a takeover' by Sky (Horsman 1998: 78, 67–84; Chippendale and Franks 1991: 280–319). But, in addition to market competition, BSB had pursued other means to challenge Sky.

Crying foul: BSB and cross-promotion

At BSB, according to Chippendale and Franks (1991), 'outrage' greeted the extensive editorial coverage given in all NI papers following Murdoch's announcement of Sky. Both the pervasive advertising of Sky in NI papers and perceived editorial bias prompted retaliatory advertising. BSB made a complaint to the Office of Fair Trading (OFT) about unfair Sky advertising, which was passed to the Advertising Standards Authority (ASA). Then, in December 1988, BSB commissioned the European Institute for the Media (EIM 1989) to produce an independent report which found disproportionate coverage of satellite TV in Murdoch's papers compared to other newspapers.[6]

BSB's campaign garnered criticism in Whitehall (Chippendale and Franks (1991: 210–21), but, in June 1989, further weight was given to the charges when Tim de Lisle, arts editor of the *Times*, resigned in protest after his page was remade without consultation to feature a prominent promotion for a production of *Carmen* being shown exclusively on Sky. This, de Lisle argued, undermined editorial independence and credibility (Sadler 1991; Chippendale and Franks 1991: 207–8). The *Times*'s NUJ chapel also complained to the OFT over the promotion of Sky in the paper's editorial columns, claiming this breached the undertakings on editorial independence Murdoch gave when he acquired the *Times*. With pressure mounting, NI papers agreed to take reports on Sky through the Press Association and *Sunday Times* editor Andrew Neil issued a staff memorandum on 'Guidelines for covering satellite TV'.

The coverage in NI papers of Sky television and its rival British Satellite Broadcasting (BSB) is widely cited as an unequivocal illustration of ownership

influence on editorial; for Evans (1994: xix) it demonstrated Murdoch's 'distain for independent journalism. His five newspapers, including *The Times* and *Sunday Times*, blatantly used their news columns to plug their proprietor's satellite programmes and undermine the competitor'. This cross-promotion gave rise to the Sadler *Enquiry* whose significance is examined in chapter six. The House of Lords Select Committee in 2008 described the studies conducted into Sky's satellite television launch in 1988/9 as amongst the 'few systematic studies of cross-promotion'.

The battle for digital \vee

In 1998, Sky, now BSkyB, was once again in competition with a service, ONdigital, approved and licensed by regulators and involving 'establishment' players, namely Channel 3 licence holders Granada Television and Carlton, confident of Government support (Hall 1998). Parallels between the contest for digital television in 1998 and satellite television in 1988 were not lost on commentators (Bennett 1998: 5). Yet there were key differences, as well as continuities, which shaped the conditions for cross-promotion. In 1988, Sky and BSB were in direct competition over technology, product, distribution, content, retail (customers) and revenue. It was a competition some believed only one provider could win (Chippendale and Franks 1991: 210-11; Fallon 1989). The losses for both were enormous, threatening to bankrupt News Corporation and risking zero return on the even larger investment made by media companies and banks in BSB. While Sky had secured 'first mover advantage' in 1988 (OFT 1996: 41), satellite was new and many consumers, as well as analysts, waited to compare both services and delayed investment in receiver equipment until performance and value were established. In 1998, Murdoch's ownership relationship had changed and the competitive position was altogether more complex.

Sky had been approximately 96% owned by News International plc, a UK subsidiary of News Corporation, ultimately controlled by Murdoch. News International's share of British Sky Broadcasting Sky (BSkyB), the company created from the merger of Sky and BSB in 1990, was 39.88% following a global offering of BSkyB's shares in December 1994.[7] News International held the controlling share of BSkyB, and Murdoch's own influence (and interest) had increased following the replacement of Sam Chisholm by Mark Booth and the strengthening of his daughter Elizabeth's position as head of programmes (Horsman 1998: 229). Assessing the precise level of control is problematic without a detailed analysis of the multiple, changing factors shaping corporate actions. For instance, BSkyB's Chairman until May 1998 was Gerry Robinson,

Chairman of Granada, involved in both joint initiatives and competitor services to Murdoch.[8] News International, nevertheless, held the balance of corporate power and had economic and strategic interests in the success of BSkyB.

In 1998, BSkyB was the main supplier of non-terrestrial television channels to the UK.[9] SkyDigital and ONdigital, together with cable companies, were in competition for subscribers over competing platforms and with competing, incompatible receiver technologies. The cost and lack of interoperability of equipment meant that domestic subscribers would invariably choose between the three 'platforms' available.

Murdoch had initially seen Sky as a free-to-air service funded by advertising, but the insistence of content providers, notably the US film studios, on encryption and the market success for pay-TV led to subscription becoming the main revenue source for satellite. This would remain the case for digital services and so subscriber competition remained crucial. However, the leading platform competitors were also programme providers for each other. BSkyB had been a partner in the winning consortium for the Digital Terrestrial Television (DTT) licence until the Independent Television Commission (ITC) ruled that BSkyB must withdraw as a condition of awarding the licence (Horsman 1998: 195–206). BSkyB would remain 'a leading programme supplier to ONdigital' (Snoddy 1998d). ONdigital secured rights to carry some of the most popular Sky channels as premium services, including Sky One, Sky Sports 1 and selected film channels. However, the ITC ruling meant BSkyB was a competitor, and many analysts subsequently charted the failure of ONdigital's business model from this decision.[10] Many factors, however, contributed to ONdigital/ITV Digital's demise including Government policy regarding the switch-off of analogue TV signals; poor programming offer and lower than anticipated consumer demand; poor reception for DTV and other technical problems; and highly competitive marketing and pricing strategies, especially following BSkyB's decision to give away digital set-top boxes in 1999.

By autumn 1998, few commentators were in doubt about the ferocity of competition between BSkyB and ONdigital. When asked if Sky Digital would crush its competitors, Mark Booth replied, 'I hope so' (Johnson 1998). In an interview in *The Times* Murdoch (1998: 43) asserted 'we are out to win', and decried the ITC's requirement that BSkyB supply programmes to its competitor when 'ONdigital is not required to supply its programmes to us, inasmuch as it has any'. Murdoch also articulated the strategic aim to brand Sky as the principal digital service: 'The SkyDigital launch has been terrific. It has succeeded in fixing in the public mind that digital and Sky are almost synonymous' (Murdoch 1998: 43). BSkyB had over 6.3 million subscribers who could

be encouraged to migrate to digital satellite (Horsman 1998: xvii). The need for new receiver equipment for Sky's digital service lowered one of the barriers to competitors entering the Pay TV market. However, BSkyB also had both a subscriber base and a sophisticated subscriber management system (SMS) while ONdigital had no subscriber base and no experience operating a Pay-TV system.

News International and SkyDigital: A Case Study of Cross-Promotion

This section investigates the hypothesis that corporate business interests influence the content of newspapers. It draws upon a study of newspaper coverage at the time of the launch of digital television in the UK which examined newspaper content over a two-month period from 1 October to 30 November 1998. NI papers are compared to competitor papers in their market segment, namely *The Times* and *Sunday Times* with the *Telegraph* and *Sunday Telegraph*, the *Sun* and *News of the World* with the *Mirror* and *Sunday Mirror*.[11] This period covers the launch of Sky Digital on 1 October and the launch of ONdigital on 15 November.

Analysing cross-promotion requires examining newspaper content other than editorial material, which, together with pictorial elements and paid-for advertising space, has tended to dominate studies (Gans 1980; McQuail 1977; Hansen et al. 1998). The case study comprises analysis of different kinds of newspaper data. These are:

1. Editorial content and forms of editorial promotion
2. Advertorials and special supplements
3. Newspaper listings of satellite, cable and digital terrestrial television channels and programmes.
4. Critics' choices and the review, preview and selection of highlighted programmes on satellite, cable and DTT in newspapers.
5. Advertising of Sky and ONdigital and self-promotional and cross-promotional newspaper advertising.

Advertorial supplements

In October-November 1998 the following supplements were carried:

1 Oct *The Times* 'Digital Times', 36-page
4 Oct *Sunday Times* 'Digital TV, Turning You on', 32-page

14 Nov *Sun* Sky Digital, 8-page

15 Nov *NoW* Sky Digital, 8-page 'Advertising Feature'

The supplements represent a significant financial outlay on promotion. None included any advertising other than for Sky Digital, so all costs were born either singly or jointly by NI and BSkyB. The significance of such expenditure is underscored by the reported fall in profits for the newspaper division of News Corporation in 1998, caused by price cuts and extra promotion for the *Sun*, and poor results in Australia, although *The Times* and *Sunday Times* 'increased advertising revenues and improved operating income' (Snoddy 1998g). The October supplements were clearly designed to promote take-up of digital satellite television amongst the predominantly ABC1 readership of the broadsheets. The November supplements coincided with the launch of ONdigital and promoted Sky against the competitor service amongst a predominantly C2DE readership. The supplements were promotional by design as well as execution and so provide the strongest evidence of corporate cross-promotion.[12]

The Sunday Times's 32-page pull-out magazine, 'Digital TV, Turning You on', comprised 15 articles together with a variety of comments and opinions on digital, mainly from industry figures. One article, 'Buyers Beware', set out the pros and cons of each digital service. SkyDigital had 7 pros against 3 cons, compared to ONdigital's 3 pros and 7 cons and cable's 5 pros and 3 cons. With advertising endorsements alongside favourable editorial, the supplement functioned as an advertorial but was not designated as such. *The Times's* 36-page colour supplement, *Digital Times*, was promoted in a flash on the front page of newspaper.[13] Produced 'in association with SkyDigital', it carried a series of articles by *Times* journalists. The supplement was promotional; it was clearly timed to promote the launch of Sky and seize editorial 'first-mover advantage' over rivals. At the same time, its editorial tone varied. Media correspondent, Raymond Snoddy, offered a characteristically balanced assessment of the 'rival' technologies, highlighting their common interest in promoting digital and their financial interdependence:

> Some of the links that bind the rivals are even more financially explicit. BSkyB, the satellite venture in which News International, the parent group of *The Times*, has a 40 per cent stake, is supplying ONdigital's three most important channels under contract—Sky One, Sky Movies and Sky Sports. (Snoddy 1998e: 27).

TV critic Paul Hoggart (1998: 35) bemoaned how '[u]nsightly dishes sprouted up across the land, as [Sky] subscribers discovered a huge new choice of cookery programmes'. Nevertheless, most articles were little more than promotional 'advertorial' copy for Sky such as 'Here's the deal'. In the centre spread, Fox

TV's cartoon character, Homer Simpson, was interviewed as 'the ideal television consumer to ask whether 200 channels of television will have an impact on the lives of the British people. *The Times* travelled to meet him . . .' (McLean 1998:18–19).

The supplement carried four pages of advertising for Sky Digital. With a two-page spread on the new channel line up and another dominated by display of Sky's electronic programme guide (EPG), nine of the 36 pages, a quarter, were exclusively promotional material for Sky. One non-promotional article, 'How Digital Television Works' (Hawkes 1998: 4–6) was accompanied by a large graphical spread displaying Sky's EPG. Non-Sky services such as Film Four and the BBC's digital services both had page-long articles, although in the latter, Snoddy endorsed (without acknowledging) BSkyB's corporate view that 'BBC News 24 causes a particular furore, as CNN and Sky News already provide exactly the same service' (Snoddy 1998e). The concentration on Sky was provided a veneer of editorial justification as the first digital service available. One article begins 'SkyDigital is first out of the launch blocks, beating ONdigital and cable. Here we look at its channel line-up'. The supplement thus combined elements that indicated journalistic integrity (the inclusion of articles by named *Times* journalists, and others including the Culture Minister, Chris Smith, on 'digital Britain'), alongside 'advertorial' endorsements and advertising.

The *Times* supplement was also notable in generating a rare complaint to the Advertising Standards Authority (ASA 1999). The complainant argued that the cover page flash ('How Digital TV Works. Free 36-Page Glossy Magazine') suggested that the supplement was unbiased and, 'questioned whether the advertisement should have made clear the magazine was sponsored by Sky Digital'. In its evidence, BSkyB said *The Times* was responsible for the content of the supplement, although BSkyB has supplied information and placed advertisements. *The Times* claimed the supplement was 'an editorial initiative and was an impartial guide to digital television' and justified not referring to Sky in the flash by claiming that the paper did not normally promote brands in front-page flashes. The complaint was not upheld, the ASA ruling that since BSkyB had not paid to influence the editorial of the supplement, *The Times* need not make clear their involvement in the front page flash. Only the summary adjudication is publicly available for assessment, but this takes no account of the implications of shared ownership on editorial content, nor of the way in which advertising might constitute a surrogate means of payment for editorial.

Both 'quality' press supplements gave readers generic information about DTV while providing a powerful and explicit promotional vehicle for SkyDigi-

tal. Promotion of Sky was naturalised by underscoring first-mover advantage and by highlighting the inherent benefits of Sky against other services. The supplements also provided a space for promotion, separate from the main newspaper sections, which was thereby legitimised in a way that successive pages of promotional copy in the newspaper would not be. This indicates a contrast with the tabloids. The promotion of Sky was much more explicit and promotional within the *Sun* itself (and to a lesser extent in the *NoW*). Several *Sun* articles, for example, were accompanied by graphical displays of Sky's logo. The purpose of the tabloid inserts was less to do with the legitimacy of the supplement as a space for promotional speech than with the value of heavy promotion to counter intensive promotion for ONdigital at the moment of its launch. Table 5.1 summarises key characteristics and differences in the four supplements.

Table 5.1: News International supplements on digital television (Oct–Nov 1998)

Paper, issue date and designation.	Total No. Pages	Editorial Pages	'Advertorial'	Pages with adverts	Articles ref. to ONdigital
The Times (1 Oct) Magazine 'in association with SkyDigital'	36	27[1]	5	4	3
Sunday Times (4 Oct) Magazine	32	24	4	4	2
Sun (14 Nov) 8-page 'Sun Sky TV special'	8	-	7	8[2]	0
News of the World (15 Nov) 'Advertising Feature'	8	-	7	8[2]	0

1. Includes cover page and graphic image pages
2. One full-page advert and 7 pages with 1/8 page advertising strip along bottom of page

The designation of content as editorial or 'advertorial' is necessarily somewhat imprecise. Here items have been identified as advertorial where the material consists solely of information or evaluation that promotes features of BSkyB services and which is displayed in a similar manner to editorial items and not separately designated as advertising by graphical or textual means. What table

5.1 shows are sharp differences between the market sectors, here 'quality' and popular press (see Sparks 1999), and similarities within each sector. The broadsheet supplements were primarily editorial but contained 'advertorial' elements; the latter were predominant in the shorter tabloid supplements.

On 15 November, the day ONdigital launched, The News of the World produced an 8-page pull-out supplement for Sky Digital, identified as an 'Advertising Feature' on each page. Although reference was made to competitors, there was no reference to ONdigital and no attempt to provide any indication about digital alternatives to Sky. Both tabloids led with 'reader' offers to switch to Sky. Both focused on describing the features and benefits of Sky so that promotional and editorial text was integrated and indistinguishable. By contrast, none of the non-NI sample papers carried special supplements for digital TV, although all devoted editorial space to cover it. The Mirror launched its 'NEW look TV magazine', The Look, on the same day as the Sun's new TV Guide (10 October 1998). The Sunday Mirror's magazine supplement, Personal, which included TV listings, carried a column on the 'Digital Revolution' in its Oct 4 issue explaining the three ways to receive DTV.

Listings sections

All national newspapers carry television listings which show programme times for the five terrestrial television services, regional variations for ITV and a selected range of non-terrestrial television channels as well as BBC and commercial radio.[14] Such listings appear alongside television reviews and previews, critics' choices, pictures and captions highlighting programmes, and advertisements, usually for programmes or channels. While considered separately for analytical purposes, the integration and interrelationship of these various elements is a significant element of cross-promotion and one examined further below in terms of promotional intertextuality. In the period October–November 1998, NI newspapers promoted BSkyB more heavily than competitor papers through their listings.

News International papers listed a significantly greater number of channels than comparable papers, with the exception of the NoW. On average NI papers carried two thirds more channels than comparable papers.[15] There are also some anomalies; for instance, MTV and VH1, both listed in the Sunday Times and often selected in 'Satellite Choice' are not included in The Times listings.

Table 5.2 Number of channels carried in newspaper listings sections
(October 1998)

Title	Main paper	Supplement
Times	29	34
Telegraph	20	16
Difference	+9	+18
Sun	39	50
Mirror	29	26
Difference	+10	+24
Sunday Times		30
Sunday Telegraph		9
Difference		+21
News of the World		7
Sunday Mirror		18
Difference		-11

The *Sun* redesigned its listings on 1 October, promoting its 'new-look SUN digital movie guide' (*The Sun* 1998e). Then, on 10 October, the *Sun* launched a 48-page free TV listings magazine, *The TV Mag*, carried in the Saturday issue and replacing its *TV Super Guide*. The magazine was itself previewed and heavily promoted across two *Sun* cover pages (9, 10 October) as a superior replacement for competitor listings magazines. The message was driven home by images of rival magazines with large red crosses over them and the *Sun*'s TV critic, Gary Bushell, posing by a burning dustbin to illustrate the headline 'Free Tomorrow/ Get our TV Mag and you can bin the rest' (*The Sun* 1998f). The *TV Mag* provided listings for 50 channels, the greatest number carried by any national newspaper.[16] The *Sun* already carried 39 channels in its regular weekday listings section, while its closest competitor, *The Mirror*, carried 29 in the main section and 26 in its Saturday magazine supplement, *The Look*.

Characteristics of listings

Most papers separated terrestrial channels (BBC1 and 2, Ch3-5, SC4, and regional variations) from satellite, cable or digital only channels. The latter

sometimes appeared on the same page but were separated by g
such as headings, rules or boxes. The exceptions are the *Sun* an
titles. *The Sunday Mirror* listed L!ve TV alongside terrestrial (
main section of paper, while all other satellite and cable cha
only in the *Sunday Mirror* magazine supplement, *Personal*. L!ve TV was a cable
venture of Mirror Group newspapers that was closed down in November 1999
by Trinity Mirror, formed from the merger of Trinity and Mirror Group
earlier that year. Featuring prominently in the Mirror newspapers but not
carried by any other (sample) newspaper, this is unequivocal evidence of the
use of listings to promote an associated company. [17]

The *Sun*'s magazine, *The TV Guide*, carried four pages of TV listings for
each day, with Sky One prominently featured alongside the main terrestrial
channels, despite its much smaller audience share. Sky One had an estimated
audience share of 1.5 per cent in 1998 (4.3 per cent in satellite or cable
households), the highest for a non-terrestrial channel.

NI papers devoted much greater coverage to non-terrestrial channels, the
majority of which were available only on BSkyB. The *NoW* was exceptional,
however, listing only seven non-terrestrial channels, (all available to Sky sub-
scribers). The absence of listing may be explained in part by the fact that most
readers of the *NoW*, also being *Sun*, readers might be expected to have the
Sun's TV guide. However, in contrast to all other papers the *NoW* did not
change either the layout or featured selection of channels between September
and December 1998.[18] The paper's listings coverage, then, refutes the hypothe-
sis that all NI papers were subject to systematic corporate control to maximise
all promotional opportunities, indicating instead editorial autonomy, or
possibly editorial inertia. Other factors would need to be considered in deter-
mining why the paper did not expand its listings section, including economic
calculations of the viability of additional pagination. However, the carriage of
only Sky channels in the *NoW* listing supports the broader conclusion that all
NI papers served actively to promote BSkyB.

Editorial justifications and readership interest

The common professional justification for television listings selection is that
here, as with editorial decisions in general, selection is based on serving reader
interests. Consequently, the selection of listings should be expected to corre-
spond with the media preferences of each paper's readership, such data being
available through companies' proprietorial research as well as from such
bodies as Broadcasters' Audience Research Board Ltd (BARB) and the Na-
tional Readership Survey (NRS). Table 5.3 (on the next page) shows satellite

and cable TV subscription levels averaged out across 1998 amongst the reader-ship of the eight newspapers sampled.

TABLE 5.3. Newspaper readership and satellite/cable subscription levels

Jan - Dec 1998

	Total newspaper readership	Subscription cable TV/ satellite TV	Readership as % of total population	Subscribers to sat/cable as % of total subscribers	Subscription to satellite/ cable as % of readers	Index
TOTAL	46,400,000	14,410,000	100.0	100	31.1	100
NRS Responses	37,071	10,370				
The Times	1,843,000	547,000	4.0	3.8	29.7	95.7
Daily Telegraph	2,348,000	604,000	5.1	4.2	25.7	82.8
The Sun	9,697,000	4,101,000	20.9	28.5	42.3	136.2
The Mirror	6,400,000	2,389,000	13.8	16.6	37.3	120.2
Sunday Times	3,466,000	1,085,000	7.5	7.5	31.3	100.8
Sunday Telegraph	2,108,000	579,000	4.5	4.0	27.5	88.4
News of the World	11,109,000	4,728,000	23.9	32.8	42.6	137.1
Sunday Mirror	6,354,000	2,547,000	13.7	17.7	40.1	129.1

(Source: National Readership Survey 1998)

Based on a sample of 37,071 people, the NRS survey estimated that 31.1% of UK adults over 15 received satellite or cable television in 1998. The data allow comparison between the share of subscribers in the total population (31.1%, index = 100) and the share of subscribers among the total readership of each newspaper. Differences between tabloids and broadsheets are evident. The tabloids have an average index of 130 compared to 92 for the broadsheets. The NoW had the highest percentage of satellite/ cable subscribers (42.6%) followed by the Sun (42.3%). For daily national newspapers as a whole, the

Financial Times had the highest percentage of satellite/cable subscribers (38.9%), but *The Times* (29.7%) had approximately twice as many (547,000 to 227,000), above *The Independent* (26.6%) and *Telegraph* (25.7%). The Sunday broadsheets had a higher percentage of subscribers than the dailies, the highest being *The Sunday Times* (31.3%). Amongst the tabloids, *The Sun* had the largest number of satellite/cable subscribers (4.1 million), while the much smaller *Daily Star* had a higher percentage (50.2%). The distribution across the sample of eight papers corresponds to that across newspapers as a whole. With two exceptions (*Financial Times*, *Daily Star*) NI newspapers had a slightly higher percentage of satellite/cable subscribers than competitors in their respective markets.

According to criteria of readership preference, we would expect to find greater listings coverage in tabloids compared to broadsheets and broadly comparable levels of coverage between papers in their respective markets. The magnitude of difference in listings described above suggests that readership preference does not satisfactorily explain variations between newspapers' listings coverage. The discrepancies amongst NI papers refute a hypothesis of 'strong' systematic corporate control. But the variations suggest that three of the four NI titles devoted significantly greater attention to television services in which there were 'intra-firm' corporate interests than non-NI papers.

Sky had another important advantage in that many of its channels were available on analogue satellite or cable and so established in television listings sections. Some of Carlton and Granada's channels were available on cable or satellite, but Carlton's new channels for ONdigital were not included in NI papers in 1998 nor in the sample papers. At the end of November, *New Media Markets* (1998) reported 'Newspapers slow to give ONdigital listings'. Only the *Express* carried listings for two of the three Carlton channels available only on ONdigital (Carlton World and Carlton Cinema; Carlton Kids was not listed). A spokesperson for NI was quoted as saying the company would wait for digital take-up to rise before listing the new channels (stating that most ONdigital channels were listed already since they were available either on Sky digital or analogue cable). ONdigital was reported to be negotiating with newspapers to secure greater coverage in weekend supplements.

Promoting digital TV

As well as providing TV schedules, listings also served a broader promotional function. Non-subscribers received a daily or weekly 'advertisement' for selected channels and platforms. The extensive coverage given to non-terrestrial television in 1998 is particularly significant in the context of low take-up of pay-TV and specifically digital services and viewing levels across non-terrestrial

channels.[19] Of course, one feature of newspaper coverage in October–
November 1998 is that all coverage of digital satellite and digital terrestrial
television was 'promotional' for the vast majority of readers of all newspapers
since subscription levels were then so low.[20] According to BARB, total non-
terrestrial viewing increased from 12.9 per cent in 1998 to 14 per cent in
1999. The number of homes with satellite was just over 4 million in October
1998 (4,107,000) with 2.8 million cable subscribers.[21]

Explanations that listings selections reflect readership interests or inde-
pendent editorial judgement are only partially true. Disparities in listings
coverage between competing papers can only be explained satisfactorily by
reference to different corporate interests in the selection and promotion of
channels.

Critics' choices and programme promotion

Throughout October–November 1998 television critics dealt almost exclu-
sively with the five main terrestrial channels. Non-terrestrial channels were
mentioned very frequently, but this was usually a passing reference rather than
a detailed review of specific programmes. This professional behaviour is largely
explained by the small reach of non-terrestrial channels. On the day Sky
Digital launched, the *Sun*'s TV critic, Gary Bushell (1998a), mused upon the
'daunting' prospects of digital for television reviewers, '[w]ith so much choice,
will there ever again be shows the whole country talks about'? For Bushell, and
others, the critic's role was to contribute to the common conversation of
television, and that meant the five terrestrial channels.

Television critics are prominent journalists on the paper, often displayed
photographically and with 'signature' by-lines incorporated into headlines.
This emphasises their status as 'trusted guides', expected to offer robustly
independent, but not necessarily impartial, assessment of programmes. Across
both elite and tabloid papers, there is a strong emphasis on the personality of
the reviewer, generated by personal anecdotes and an intimacy with the reader
established through self-referential modes of address. So, in addition to the
functional emphasis on terrestrial television in this period, the critics' role also
serves to militate against overt editorial promotion which would undermine
integrity and trust. At the same time, television writers in the Murdoch-owned
press often showed acute awareness of their position in negotiating corporate
interests and peer and reader perceptions of their integrity. After the main
television and radio reviewers, there are less prominent named critics and then
'anonymous' selections, that is, editorial selections without by-lines, as well as
photo captions and other graphic, photographic or textual means to feature

programme selections. Television sections and guides also include selections and reviews of forthcoming programmes. Here again there are both named and anonymous 'previewers'. According to Tunstall (1996: 187):

> Certainly the previewers collectively have some power to influence the size of audiences; research indicates very high readership of these recommendations. Nevertheless it is the reviewers who tend to carry the higher prestige within journalism.

Most papers used various means to highlight recommended viewing for satellite and cable viewers, adjacent to the listing of channel timetables. These are the data used for the analysis that follows. All sampled papers distinguished clearly between recommendations for the analogue terrestrial channels and channels available only to satellite, cable or DTV homes.

On weekdays *The Times'* 'Pick of the Day' selected terrestrial programmes only. However, *The Times* highlighted one satellite film each weekday issue with a picture caption listing the title, time and channel on which the film was broadcast. The Saturday edition of *The Times* included a 7-day television guide that carried a daily critic's choice column for satellite and cable. Here, named reviewers (there were three in October) would identify usually one programme. *The Sunday Times* provided a 7-day guide in its 'Culture' section. Here named reviewers, of which there were three during October 1998 selected programmes for Satellite Pick of the Day.

The Telegraph carried a film of the week selection and non-terrestrial selections by two named previewers. *The Sunday Telegraph*, by contrast, did not provide recommendations for satellite and cable with the exception of a picture caption in one issue (4 October 1998). *The Mirror* carried a column 'L!ve Choice' next to its L!ve TV listings which featured one or more programmes on the channel that evening. Its Saturday supplement, *The Look*, included Satellite Choice, which selected one programme for each day's viewing, and Satellite Movie Highlights, which identified films across the week. The latter selection was made on the basis of films only, with up to three selections on some days and none on others. *The Mirror*, whose weekday listings were small in comparison to the *Sun*, introduced a box into its terrestrial listings section promoting a particular programme on satellite, several of which promoted MTV (Europe). Another device was to use a single photographic image with picture caption to highlight programmes, usually films. No direct comparison can be made with channels available on ONdigital only, since the service did not begin until November 15, but the sample allows comparison of the range of channels cited and the incidence of BSkyB channels in critics' choices. Table 5.4 below shows the range of channels mentioned in each paper.

Table 5.4. Range of channels litsed for film recommendations

NEWSPAPER	TOTAL	NI channels	Non-NI channels	RANGE
Section/critic				
Times				
(Weekday) Satellite films	22	18	4	7
(Saturday) Satellite Films	29	26	3	6
Critics Choice L. Godfrey	28	19	9	5
Critics Choice T. Patrick	19	8	11	13
Critics Choice P. C. Peck	10	0	10	7
Telegraph				
Films of the week	6	6	0	3
Pick of Day C.McKay	20	11	9	9
Pick of Day S. Horsford	45	17	28	16
Sun				
(Sat Magazine) Film of the day	22	22	0	3
(Sat Magazine) Pick of the day	5	5	0	1
Mirror				
Satellite movie highlights	20	15	5	5
(The Look) Satellite Choice	29	19	10	10
Sunday Times				
M. James	45	37	8	7
D. Hutcheon	23	15	8	7
E. Porter	10	10	0	4
TOTAL	333	228	105	

The *Sun*'s TV magazine offered the smallest range of channels from its film of the day selection. However, the paper did offer a star rating for films across a wider range of channels, providing independent assessment as indicated by poor ratings for many films shown on BSkyB channels. For its general 'pick of the day' selection the *Sun*, again, had the most limited choice, citing only one channel Sky One. The *Mirror* concentrated on the leading BSkyB film channels but included two non-BSkyB channels. The paper's general choice covered a range of ten channels. As expected, individual preferences of identified critics are evident. For instance, in *The Times*, Louise Godfrey mainly provided

a sports selection, while T. Patrick usually selected from a wider range of entertainment channels. In the *Sunday Times*, Edward Porter, a film reviewer, usually selected a premiere of a recently released film. As Sky Box Office was then the only pay-per-view channel showing such films, such selection provides no evidence of individual or corporate preference for Sky channels. Likewise, many sports fixtures were unique to Sky Sports and so, in the absence of substitutes, the same is true. There are therefore many variables shaping critics' choices including the preferences of the reviewer appointed, their role and relationship with other reviewers, the relationship between columns and listings, and the size and format of the column. Nevertheless, critics' choice/selections may be examined for evidence that readers were more strongly directed towards channels in which papers had an economic interest.

Some non-NI papers provided a greater range of channels in critics' choices than NI papers. NI papers also promoted Sky channels more heavily through listings than comparable papers, although, once again, there is variation across NI titles. In *The Times* two critics' selections covered a wide range of channels. By contrast, the *Sun*'s coverage confirms evidence of proprietary promotional selection, based on the very narrow range of channels selected, all of which were wholly owned by BSkyB. NI papers carried more critics' choices (as well as channel listings) than comparable papers. This resulted in significant promotion for Sky television even though non-Sky channels were also featured.

Tunstall (1996: 187) argues that previewers and reviewers 'are left remarkably free to decide what they write and which programmes they write about', adding:

> Television writing is broadly regarded by newspaper editors as soft entertainment material; television previewers and reviewers are encouraged to develop a personal style which will be attractive to readers.

Critics' choices do confirm evidence of agency and autonomy in the case of the principal reviewers and identified previewers. The main TV critics reflexively signal their commitment to retaining the trust and confidence of readers. Yet we must distinguish between by-line reviewers and the more anonymous forms of selection and promotion (in picture captions and some 'pick of the day' selections). The latter, for instance in the *Sun*, show evidence of selections that lack range and demonstrate not journalistic 'freedom' but instead the corporate use of space to promote intra-firm channels.

Editorial content and cross-promotion √

As this study has shown, various resources can be used for cross-promotional purposes. Nevertheless, one of the most important and contested issues is the degree to which editorial content is used. Considerable difficulties arise, however, in identifying and defining the promotional components of editorial and in evaluating such content, particularly in ascribing motivation (Sadler 1991). A 'plug' may be defined as a favourable mention serving a promotional purpose that is not editorially justified. However, defining the conditions in which editorial content becomes promotional and assessing the validity of various explanations or justifications for such content are very difficult matters to determine objectively (see McManus 1994: 143–149).[22] Shoemaker and Reese (1996) identify five layers of influence on news content, from micro level (such as the ethics of media workers themselves) to macro level (ideological influences). Their third level is the influence of organisational imperatives of media institutions, including the pressures to shape content in accordance with owner interests. But as Hackett and Uzelman (2003: 333) point out, commercial and corporate interests have potential impact at each of the five levels.

Comparing editorial content across newspapers provides one way of identifying both quantitative and qualitative differences in coverage. We will compare four papers: the *Times* and *Telegraph* and the *Sun* and *Mirror*. The *Times* and *Telegraph* were compared by coding and analysing all items appearing in October–November 1998 in which a number of keywords appeared: BSkyB, ONdigital, News International, Carlton, Granada, Sky (including all references to Sky television, channels or services), digital television, digital terrestrial, digital satellite. Table 5.5 on the next page shows the frequency of keywords appearing in the *Times* and *Telegraph*.

In *The Times* media correspondents wrote a large number of items and these have been designated as news. In *The Telegraph* by contrast more media items appeared in the financial and business pages. Consequently the distribution of these items is less significant than the figures suggest. *The Telegraph* carried a higher number of articles on sports. The number of relevant items comprising reviews of sports was smaller than *The Times*, but *The Telegraph* carried more articles on the business aspects of sports as well as several special features on television and sport.

The Times carried more favourable items for BSkyB and News Corporation, fewer favourable items on ONdigital and more unfavourable items than *The Telegraph*. Overall, coverage in *The Telegraph* was more favourable towards ONdigital than *The Times*. However, the differences in editorial balance were small. In *The Times* only 15 per cent of items concerning BSkyB were unfavourable or mixed compared to 18 per cent in *The Telegraph*. Neither paper

gave extensive coverage to ONdigital, although *The Times* gave less. *The Telegraph* featured more favourable comments on DTT than *The Times*, but both carried critical comments.

In *The Times'* media reporting (notably by Snoddy) and in business and news reporting of News Corp.'s interest, there is evident effort to meet journalistic norms of independence and even-handedness. At the same time, there is some evidence to support the charge that *The Times* operated as a 'corporate newsletter' for Murdoch's interests (Brown 1998b). The volume of reports of corporate activities of News Corporation in the *Times* was higher than in the *Telegraph*. Such reports, while mainly factual and balanced, nevertheless served to promote News Corporation amongst key publics, namely investors and the city. However, the *Times* did carry critical reports and opinion on News Corporation.[23]

Table 5.5. Times - Telegraph analysis: occurance of keywords in editorial (October- November 1998)

	Times	Telegraph
Editorial (Keywords)		
Sky One	5	5
Sky Sports	25	27
Sky Premier	1	1
Sky Cinema	0	1
Sky Box Office	0	1
BSkyB	71	77
ONdigital	21	25
Sky Digital	5	6
SkyDigital	7	3
Digital Television	50	43
Satellite Television	22	18
Digital terrestrial	8	9
Digital satellite	7	3
News International	49	2
News Corporation	18	7
BBC	*546*	*570*
Channel Four	*124*	*139*
Channel Five	*35*	*43*
Film Four	*5*	*4*

(Source: Proquest database)[24]

For *Campaign*'s editor (Hatfield 1998b) 'Murdoch's cross-promotion created the football hype' promoting the creation of 'special sections' in NI and other newspapers. Here, it is particularly valuable to compare coverage in *The Times* and *Telegraph* in order to consider evidence that cross-ownership was a factor influencing sports reporting. Different kinds of mentions can be distinguished. First, there are references to fixtures on television. These often occur at the end of articles previewing single fixtures or in columns listing forthcoming events. The patterns of such coverage in the *Times* and *Telegraph* are similar. The next type is editorial references within articles. While most are passing references to Sky's coverage, there are other favourable references that are more gratuitous and less editorially justified. For example, a *Times* article on an amateur golf championship sponsored by *The Times* and to be broadcast by Sky describes how players will be 'exposed to the Cyclopean eye of the Sky Sports television camera'. This exhibits the characteristic identification of sports writers with Sky (itself not confined to NI journalists), but the 'plug' may also be editorially justified (rather than judged as gratuitous promotional embellishment) in highlighting the added pressure the amateurs face. Almost all such inclusions can be given some measure of editorial justification, but they nevertheless fulfil a promotional function and so the incidence of such references is significant. My analysis shows there were no significant differences in frequency between such references in sports reporting in *The Times* and *Telegraph*.

During October–November, *The Times* carried several articles, which, however editorially justified, cross-promoted BSkyB services. The Duchess of York's chat show on Sky One, *Sarah . . . Surviving Life* was favourably reviewed and reported (Midgley 1998). There were also celebrity articles, such as the 'Coldcall' to Julian Clary (Jackson 1998), which served to preview and explicitly promote a new entertainment programme on Sky.

Disclosure (declaration of ownership links)

Sadler (1991:1) recommended that the newspaper industry strengthen its code to require 'disclosure in the editorial content of newspapers of the owners' or associates' other media interests'. The Mirror group, in its evidence to Sadler (1991: 16) 'saw no objection to disclosure rules but added it did not want rules so tightly drawn that such statements would have to be made every time there was an item about a subject in which the proprietor had some interest'. It argued that unnecessary repetition would be likely to 'stifle readers' interest'. In his memorandum to staff (Sadler 1991: 78–79), *Sunday Times* editor, Andrew Neil included in his guidelines on covering satellite TV:

When it is germane to the story (i.e., the story's integrity demands that our readers should be told) it must be made clear that Sky TV is 'part of News International, owners of Times Newspapers'.

Neil's carefully worded statement limited the circumstances in which disclosure was required.[25]

In October–November 1998, there was considerable variation in disclosure patterns within NI papers. *The Times'* media correspondent Raymond Snoddy routinely provided full disclosure of ownership, irrespective of story length. For instance in a pre-launch article 'The Future Has Begun' on 25 September, Snoddy (1998c) followed a quote from Mark Booth, BSkyB's chief executive, ('this is the best digital platform in the world') with the statement 'The satellite company is 40 per cent owned by News International, the parent group of *The Times'*.[26] As the principal media correspondent and one under considerable peer scrutiny (see below), Snoddy had the highest rate of full disclosure of any *Times* journalist, albeit with occasional lapses (Snoddy 1998b). In the majority of references to BSkyB in *The Times*, however, no ownership disclosure was made. Disclosure occurred in media business or other corporate news stories but only exceptionally in sports or entertainment coverage (see table 5.6).

The majority of *Times* articles did not disclose News International's stake in BSkyB in articles mentioning the latter. It could be argued that the majority of NI readers would know that Sky was 'owned' by Rupert Murdoch, and that, in addition, routine disclosure of ownership would, as the *Mirror* had argued before Sadler, alienate readers. Support for the first claim comes from the fact that other papers did not routinely inform their readers of the ownership of Sky. However, the purpose of disclosure is not simply to inform readers of economic or other proprietorial interests, it is to remind and alert readers that such interests may affect particular coverage when such coverage arises. This is the sense in which Snoddy makes the ownership link explicit. It shows the journalist's awareness of the possibility of conflict of interest and of the requirements of journalistic integrity. It makes an implicit claim to speak in an unbiased manner and does so in a double articulation by alerting the reader to scrutinise the journalist's words at the moment the journalist identifies interests which might conceivably influence their account.

It has been argued that media correspondents have special requirements for disclosure of ownership since their reporting routinely and directly concerns their owners' corporate interests (Brown 1998a, Snoddy 1998a). However, the activities and corporate affairs of BSkyB certainly arose in other sections, notably sports, news and features where disclosure was exceptional. Of the 37 instances of full disclosure in *The Times*, 26 were by media or finan-

cial correspondents and only three by sports writers. Correlation with *The Telegraph* indicates a similar lack of disclosure: most references to Sky services occurred in sports sections and usually carried no reference to ownership. However, I have argued that there were special obligations on NI journalists to declare ownership links; it is evident that only in media and financial sections was this usually done.

Table 5.6

Disclosure of ownership link BSkyB - News Corporation

Author Type	TOTAL	Disclosure Full	Partial	None
THE TIMES				
1. Media correspondent	32	18	1	13
2. Business/finance correspondent	16	8	0	8
3. Sports correspondent	45	3	0	42
4. Television reviewer	7	0	1	6
5. Arts/culture reviewer	1	0	0	1
6. News/political correspondent	2	0	0	2
7. Freelance contributor	2	0	0	2
8. Editor/editorial	n/a	n/a	n/a	n/a
9. Other	10	2	1	7
10 Designation not given/ cited	23	6	1	16
	138	37	4	97
THE TELEGRAPH				
1. Media correspondent	9	2	0	7
2. Business/finance correspondent	45	12	1	32
3. Sports correspondent	70	2	2	66
4. Television reviewer	4	0	0	4
5. Arts/culture reviewer	1	0	0	1
6. News/political correspondent	2	0	0	2
7. Freelance contributor	n/a	n/a	n/a	n/a
8. Editor/editorial	2	0	0	2
9. Other	8	0	0	8
10 Designation not given/ cited	34	3	6	25
	175	19	9	147

Sun–Mirror analysis

There were fewer articles that include references to Sky or BSkyB in the *Sun* compared to the *Mirror* (in October *1998*). However, qualitative differences are pronounced, with significant integration of cross-promotional elements in the *Sun*'s editorial content. Sky's logo was used to accompany several stories. For instance, a picture displaying the Sky One logo accompanied an item by deputy TV editor, Jenny Eden, on Chris Evans' debut on Sky. The logo was repeatedly used also in constructed images (*Sun* 1998b), as graphic accompaniment to articles, and even in cartoons (7 Oct p8). Such use of Sky's logo made the separation between editorial and advertising less distinct, as the logo featured in BSkyB adverts as well as in third-party adverts for TV sales and rentals (Comet, Granada, Curry's).

In contrast to all the broadsheets, the *Sun* adopted the promotional language of advertising in editorial matter. This occurred within article text, but also in strap lines, splashes and other graphic/text elements. An example of the former is the extensive promotion for *The TV Mag* and for the release of *Titanic* on video. Daily, on page two, the Sky News logo was displayed to accompany 'Today's weather'. However there was negligible promotion for BSkyB in editorial items during the period with only 15 articles in the paper itself mentioning any BSkyB service. By contast, BSkyB or Sky was mentioned in 45 articles in *The Mirror*, while ONdigital was mentioned in six.

Coverage of Sky in the *Sun*'s main paper was favourable throughout. The only adverse comment made in October came, notably, from TV critic Gary Bushell (1998b) who described a televised football match (England vs. Bulgaria) as 'the worst thing on TV this side of *Sarah . . . Surviving Life*'. The *Mirror* carried more items unfavourable towards Sky and Murdoch (for instance, 'Murdoch Anger at Man United Probe' (Morris 1998). Given the fierce rivalry between tabloids (Sparks 1999) such criticism of competitors and their associated interests is routine. A notable example is the mock apology carried on 9 October ('Fergie: An Apology', *The Mirror* 1998b):

> It has been brought to our attention by Sky Television that the story on the front page of yesterday's Mirror revealing that the first [edition] of Fergie's new chat show *Sarah...Surviving Life* attracted a 'pitiful' audience of 10,000 was unfair and in bad taste. In fact it pulled in a staggering 12,000 viewers. We apologise for the distress this error may have caused.

During October, *The Mirror* offered a balanced assessment of the digital offerings. Its earlier coverage had highlighted weaknesses in ONdigital's offering compared to BSkyB ('TV Rivals Won't Reach for the Sky', *The Mirror* 1998a). Various articles on digital television identified the three main providers, in

contrast to *The Sun's* efforts to make digital synonymous with Sky. Only rarely was ownership disclosed in the *Sun*. A spread on digital television (*The Sun* 1998e) mentions ONdigital's owners, but the paper makes no reference to NI's ownership link with BSkyB. The *Mirror* occasionally indicated ownership, referring to Murdoch as 'Sky boss' (O'Carrol and McGurran 1998) in items concerning Murdoch/BSkyB's business concerns. However, there was no routine disclosure in most references to Sky or related terms. Aside from Eden's article, there was no mention of ONdigital in the *Sun's* editorial content.

Advertising √

Newspaper promotion occurred as part of major multimedia advertising campaigns by BSkyB and ONdigital.[27] On launch date, BSkyB took the entire *News at Ten* advertising break on ITV to promote SkyDigital, and its campaign made it the second largest television advertiser in October 1998. *The Times* and the *Sun* were two of the three highest spending and most advertised newspapers that year (Hatfield 1998c). Overall, NI papers did not display significantly higher levels of intrafirm advertising for SkyDigital during the launch month than BSkyB's advertising in competitor newspapers (see Table 5.7).

For SkyDigital's launch (1 October) two-page spread advertisements appeared across the national press. Thereafter the pattern of advertising is more complex. In October, *The Times* carried the equivalent of 10 broadsheet pages of advertising for SkyDigital, slightly less than that carried in the *Telegraph*. The *Mirror* carried more advertising for SkyDigital than the *Sun*. This may be explained by the desire to reach target markets amongst non-NI readers, but another significant factor is the promotional resources available within NI papers themselves. The higher rate of advertising in non-NI papers must also be understood in the context of the use of editorial promotion, especially in the tabloids. Overall, NI papers did not carry significantly higher levels of intrafirm advertising than BSkyB's advertising in competitor papers.

While this chapter examines intra-firm promotion, it should be noted that most media cross-promotion involves deals between the paper and third parties. Such promotions are determined by the value of the target market to marketers, the likely impact on sales and the estimated value of the tie-in in appealing to the newspaper's readers. For example, On November 15th 1998, the *NoW* ran a two-page spread on the Mitchell brothers, characters in BBC 1 soap *EastEnders*, featuring a tie-in offer for *EastEnders* videos. NI papers like others contain such tie-in promotions for other media company's products (such as Disney's *Mulan*). Even more significantly the *Sun* ran promotions for

ITV's gameshow *Who Wants to Be a Millionaire?* through September 1998, just as ITV's two largest companies prepared to launch ONdigital. The *Sun* offered a £1million prize in conjunction with sponsoring the programme. Ellis Watson, marketing director for the *Sun* and *NoW*, said: 'It's the biggest TV gameshow tie-in any brand has ever done. We've done it through helping each other with cross-media promotion' (Griffiths 1998). Finally, it is important to emphasise that NI is by no means the only proponent of cross-promotion in newspaper content. The *Mirror* and *Sunday Mirror* cross-promoted its owners' L!ve TV with all the resources deployed by News International and with even less editorial justification, given the very small audience share of the ailing cable channel.

In his lecture *Television Ownership and Editorial Control*, David Glencross (1996) highlighted various newspapers' cross-media interests while concluding that, compared to News International, their cross-promotion was 'pretty modest stuff'. In 1998 Associated Newspapers, owners of the *Daily Mail*, *Mail on Sunday* and London *Evening Standard* also had TV interests with a 20 per cent stake in Westcountry Television, ownership of the Performance channel (cable), and 80 per cent share of London cable service Channel One, a deal involving cross-promotion in the *Standard* (Williams, G. 1996: 29; Glencross 1996: 6). United News and Media (UNM), then owners of the *Express*

Table 5.7. Summary of Advertising for digital television in October 1998

Newspaper	Sky Digital				Sky channels/progs				Ondigital				Third Party for Sky Digital			
	FP	HP	QP	SM	FP	HP	QP	SM	FP	HP	QP	SM	FP	HP	QP	SM
Times	2	15	0	1					0	3	0	0	3	2	0	2
Times Supplement	4		7	1												
Telegraph	2	13	1	1			2		0	5	0	0	1	3	2	0
Sun	7	10	0	0	1	2	2	0	1	3	0	0	7	2	0	1
Mirror	10	12	0	0	0	3	3	0	0	3	0	0	7	2	1	0
News of the World	4	2	0	0	0	3	0	0	3	5	0	0	2	2	0	0
NoW Supplement	1															
Sunday Mirror	3	2	0	0	0	1	2	0	1	4	0	0	1	0	0	0

Codes: FP = Full Page; HP= Half page, QP = Quarter page, SM = Small (I.e.under quarter page), Third P other = Third party advertisment with prominent promotion for Sky Digital

newspapers, were one of the three major ITV companies. Although not directly involved in ONdigital, UNM was a shareholder in the new digital channel ITV2, which like ITV was initially only available on DTT. The *Daily Express*, which carried extensive listings, was the only daily paper to carry ONdigital's new channels from launch. The Express carried overt promotions for ONdigital in its listings pages. Unlike NI however, there was very little editorial coverage of either Sky or ONDigital during the period examined. The *Express's* TV columnist, Andrew Billen (1998), focused on Sky's services, to which he subscribed, and did not favour ONdigital, in contrast to the sub-editorial promotional copy. The BBC's Media Correspondent (Douglas 1999) rightly contrasted the independence of the *Express* with 'the way that most Murdoch titles proudly beat the drum for BSkyB'.

Summary of findings

Analysis of newspaper content in October–November 1998 shows that NI newspapers used a range of promotional resources to cross-promote Sky in ways that differ from comparable competitor papers. This is most apparent in the use of advertorial supplements but is also evident in the arrangement of listings and of critics' choices. In editorial, differences between the sample broadsheets were slight but show more extensive promotional content in NI papers and an editorial balance tilted in favour of BSkyB in contrast to greater even-handedness in non-NI papers. There are variations between broadsheets and tabloids, as might be expected, but also significant variations within newspapers, between different sections and journalistic briefs. Above all, it is in the more 'anonymous' sections of the papers, in layout, listings and previews, that cross-promotion is most evident.

Journalistic Reflection and Responses

The tensions between normative standards and real-life exigencies are usually resolved by journalists through a pragmatic acknowledgment of constraints and a sense, often ill-defined, of acceptable and unacceptable behaviour. Common to many accounts by journalists are two widely held beliefs, first, that owners are apt to seek to influence media content in accordance with their corporate interests and, second, that journalists, as Rob Brown (1998a) puts it 'always end up being economical with the truth about the media organisation that pays our monthly mortgage'.[28] There is also a tendency to avoid criticism that may be perceived as pious or which risks the charge of hypocrisy.

The significance of peer assessment by journalists is heightened by the mutual suspicion between journalists and academics that diminishes the influence

of academic efforts to probe journalistic ethics (Bromley 2000; Edgar 2000; Belsey and Chadwick 1992). The HarperCollins row provided one such incident, although Murdoch denied personal responsibility for the refusal to honour a contract to publish Chris Patten's account of the Hong Kong handover that criticised the Chinese authorities Murdoch was assiduously wooing to extend the reach of Star TV. *Private Eye* (1998a: 6) criticised Snoddy directly[29]:

> Meanwhile, many readers have asked if Raymond Snoddy, the *Times* media editor who so dismally failed to cover the Murdoch versus Patten story, is the same Raymond Snoddy who used to present Channel 4's *Hard News* which specialised in exposing cant, censorship and corruption in the Street of Shame.

Snoddy himself wrote a *Times* article (1998a), 'It's our job to tell the truth about the corp', which reflected upon conflict of interest and stated that '[n]o national newspaper in the UK covers its own affairs really well and owners of even the quite recent past have used their papers to promote their own interests and attack those of their rivals . . .'. Advocating 'simple facts . . . honestly told', Snoddy argued that the competitive nature of the newspaper industry and the fact that 'journalists who cannot get stories into their own papers have been known to ring *Private Eye*' meant that proprietors could not ensure control over the way in which their interests were reported. He acknowledged that such 'accidental safeguards' were insufficient and that 'as newspapers are now part of multimedia empires, there should be particular sensitivity over who controls what information' but also argued that as readers become more sophisticated, 'it will become a matter of credibility for newspapers to report more honestly on their own affairs'. Indicating such improvement, was the fact that '[m]ore newspapers are at least telling readers in the text of stories whether the company has a business interest in a news item'.

Such self-reflection is rare compared to criticism of conflicts of interest or journalistic failings by other journalists (see Porter 1998). But there are also variants of self-reflection amongst a broader range of journalists. During 1998, other NI journalists acknowledged and responded to critical (peer) scrutiny. When Channel Five delivered two bottles of wine to *Sunday Times* television critic AA Gill, he ostentatiously denounced the bribe, ignored the intended programme and criticised another Channel Five offering (Gill 1998a). In November Gill (1998b) reviewed a Channel Four documentary *The Real Rupert Murdoch*:

> I know a lot of you have been wondering whether or not I'll have the guts to review this programme in my characteristically bile-iferous manner. Well, I'm a professional

> journalist first, with standards and ethics So here goes. The Rupert Murdoch we
> were shown was frankly . . . Lord, is that the bottom of the page so soon?

Such self-consciousness was also exhibited in a *Sun* editorial in September (*The
Sun* 1998d) (which implied inaccurately that the paper had kept silent about
the BSkyB Manchester United bid):

> So far *The Sun* has kept quiet in its opinion column. That's because the rest of the
> media would say we are biased. *But now it is time to give soccer fans the facts.* Because we
> ARE biased—in favour of what's best for football [. . .]Anyone who thinks *The Sun*
> will now be biased in favour of Manchester United is either brain dead . . . Or the
> jealous editor of a rival paper. (Emphasis in original)

Richard Littlejohn (1998) also demonstrated heightened sensitivity, professing
his support for the BSkyB deal was genuine and not 'because I happen to write
for *The Sun* and present TV shows on Sky, which are both part of Rupert
Murdoch's empire'. But he also defended the *Sun*'s support for the bid, stating
'[i]t would be naïve in the extreme not to expect one part of a commercial
organisation to support a sister company', adding for further justification:

> You don't read a lot of criticism of Lord Hollick's Anglia and Meridian TV stations in
> his *Express* newspapers. The *Mirror* has never been known to dump a bucketload on its
> own televisions interests. The BBC shamelessly runs constant commercials for its
> various TV and radio programmes and assorted publishing and marketing activities.

Littlejohn appeals then to journalistic integrity and to a pragmatic realism in
which business influence is considered inevitable and unavoidable. These
examples show that journalistic integrity, however motivated, remains a salient
countervailing force. But this case study has shown that it also operates un-
evenly. The disclosure patterns that Snoddy exercised did not operate in all
such instances as he implies but rather in those sections where such journalis-
tic norms are maintained. Journalistic integrity, however much exhibited in
the examples above, is also at its weakest in those 'anonymous' sections of the
papers where channel choices, listings or promotional embellishments in
text/graphics provide compelling evidence of corporate cross-promotion. A
further factor is the degree to which journalistic integrity is itself counterbal-
anced by managerial-editorial control measures, from by-line deprivation
(Bevins 1992) up to actual or threatened loss of employment. For instance,
Matthew Parris, sacked from *The Sun* in November 1998 following his 'outing'
of Trade Secretary Peter Mandelson, had previously been fired by Sky after
writing an article for *The Times* criticising the idea of 24-hour news coverage
(*The Telegraph* 1998).

Finally, both journalistic and corporate behaviour are influenced by the
complex interplay of interests, presentation and external pressures and scru-

tiny. Murdoch's interests and the integrity of his papers' journalism was under particular scrutiny. SkyDigital was launched the month after Murdoch's bid for Manchester United had generated considerable criticism, and during the period when the bid was being examined by the MMC. Brown (1998b) argues that, 'the adverse coverage of HarperCollins–Chris Patten feud in rival titles . . . has forced the proprietor of *The Times* to let his own media commentators operate on a slightly looser leash—for a while, anyway'. *The Sun* also had a new editor establishing himself (Greenslade 1998). Murdoch also faced a charge of predatory pricing of the *Times* from critics seeking to amend the Competition Bill. In the glare of the immediate policy context as well as in the shadow of earlier cross-promotion of Sky, there were some corporate incentives to avoid damaging controversy. This helps to explain the complex patterns of coverage we have examined but also enhances the significance of the cross-promotion that occurred.

Conclusion

[A]lliances between television and newspaper companies are a logical and natural product of the economic and technological dynamics of the industry and will allow a healthy interchange of skills and creativity for the benefit of the consumer.
Department of National Heritage (1995:19)

Political information and opinion are privileged in the liberal and radical (political economic) critique of media concentration and of proprietorial intervention. Corporate interests affecting media content matter because such interests can threaten the democratic role of the media. But entertainment content as such does not raise democratic concerns. In critical discourses of tabloidization (Franklin 1997), entertainment signals the dissolution (and substitution) of political information and opinion, the conversion of news into entertainment.[30] Yet, corporate influence *within* entertainment content is generally neglected in such accounts. Liberal discourses on journalistic ethics also tend to concentrate on professional conduct, and individual capacities, rather than structural constraints and so engage with the consequences but not the dynamics of corporate influence on media content, including entertainment content.

While references to cross-promotion of Sky in Murdoch's British newspapers are commonplace, these also tend to be generalised, anecdotal and unsupported by evidence. Such references do draw attention to cross-promotion and to corporate/proprietorial interests beyond news. But cross-promotion is often framed within discussions of ownership where it exemplifies a broader

pattern of proprietorial interference or corporate editorial control whose significance is that of the consequences for democracy (see, for instance, Keeble 2001: 113–114). Instead, cross-promotion needs to be examined directly in terms of the nature of corporate commercial influence on media content and the extension of commercial speech within contemporary media practice.

This chapter has examined newspaper content in order to test the hypothesis that corporate business interests shape content. This is the justification for analysing newspaper content rather than a broader sociological or ethnographic investigation of journalistic behaviour (although both are necessary for a full explanation of the dynamics of cross-promotion; see Hackett and Uzelman 2003). The study shows evidence of corporate cross-promotion in NI papers. However the hypothesis of 'strong' corporate control, meaning the systematic deployment of promotional resources, is only partly supported and must be modified. There is evidence that promotional resources were not deployed fully and consistently across NI titles, so that the NoW, the paper with the largest readership, devoted less space to all varieties of promotion than other NI papers. There is also evidence of journalistic autonomy in instances of criticism of Sky in NI papers. Nevertheless the analysis of editorial content indicates a tendency for NI papers to favour Sky. Moreover, all NI papers tolerated forms of explicit editorial cross-promotion. Here, the most unequivocal evidence of cross-promotion is the use and content of advertorial supplements deployed across all four NI titles.

There is some evidence of the countervailing force of journalistic standards. However, there is unevenness within as well as across papers. The strong identification amongst NI editors and journalists with Sky, characteristic of the 1988–1991 period was less evident in the post-Sadler environment (Snoddy 2003). However, while news, media, business and financial journalists in the broadsheets tended to offer a high degree of impartiality (and disclosure of ownership interests), there is evidence of close identification with, and promotion of, BSkyB by sports and entertainment journalists. In the case of television reviewers, retaining trust and credibility with the reader appears to act as an important countervailing force. Journalists' perceptions of being scrutinised by peers or critics also act as a countervailing force. Such characteristics of professional behaviour and variations between types of newspapers, while significant in understanding CMP, have been commonly found in other studies of British journalism (Franklin 1997; Tunstall 1996). While the broadsheet news journalism examined gives some support to liberal views of news journalists' professional values (Gans 1980; Schudson 2000), the deployment of promotional resources beyond editorial, which such studies ignore, reveals

quite different patterns of control. Moreover, even in editorial, differences between papers are best understood in terms of Curran's (1990:120) concept of 'licensed autonomy' whereby journalists may exercise independence 'in a form that conforms to the requirements of their employing organisation'.

I have argued that it is important to look beyond news content and editorial material, to content that is usually neglected in analysis, such as listings, reviews and critics choices. This also means attending to areas of newspapers characterised by greater anonymity. There is greater textual anonymity, for instance, in the organisation of listings and in unauthored television selections. There is also the anonymity of material produced by designers and sub-editors such as pictures (picture captions), graphics (such as the use of Sky's logo), strap lines, splashes and other promotional resources. This material is most prevalent and characteristic in the tabloids, but it is also a feature of the listings, critics' choices and related sections of broadsheets to a greater extent than other sections, particularly the main news and editorial sections, as well as being a key feature of the advertorial supplements. Listings and review sections show evidence of promotional resources as well as being spaces where countervailing forces of journalistic integrity are diminished by greater anonymity than in text inscribed with the 'signature' of an individual journalist.[31]

Harold Evans (1994: xxvii) commented that 'Murdoch, under pressure, would subordinate editorial independence to his other commercial interests'. Against such charges the key defences are those of editorial independence, journalistic integrity, competitor/peer scrutiny and the vital need to retain consumer trust. Our study has shown that editorial autonomy and journalistic integrity retain salience but that they are also overridden. Such cross promotion has consequences for economic competition since Sky had a privileged site for non-advertising promotion in NI papers which ONdigital was not able to match. Cross-promotion has consequences for the quality of editorial, in this case the degree to which editorial favoured Sky over ONdigital. It has consequences as commercial speech is extended and interests affecting media information or opinion are disguised, or at least unacknowledged. And it has consequences if media power can be strengthened by deploying promotional resources in ever more intensive ways to cross-promote intra-firm interests against those of competitors, as News International did in 1998.

Notes

1. Opposition to proposals set out in Communications Bill (2002) and introduced in the Communications Act 2003, allowing Murdoch to own Channel Five television is discussed in chapter seven.

2. Wasco (1994: 60) cites earlier references to News Corporations' underlying philosophy that all media are one' (News Corporation Limited, Annual Report 1987: 54).

3. In 2003 the *Financial Times* reported on News Corporations 'unabashed cross-promotion' of *American Idol*. Local Fox stations ran 'soft features' on the network television show, while the *New York Post* devoted several pages to the competition, and a film was commissioned by 20th Century Fox. News Corp's Chairman, Peter Chernin defended such corporate synergies as 'common sense', '[w]here you get into trouble is if you try to institutionalise it. There are tremendous synergies between these businesses but they should not be overstated' (Burt and Larse 2003).

4. For a summary account see Barnett and **Gaber** 2001:27-29; 66. On Murdoch's relations with News Labour see Freedman (2003: 158-9, 2008).

5. See also Street (2001: 124-144).

6. The EIM report and News International's (1989) rebuttal are examined in Hardy (2004).

7. The other shareholders were Pathé (12.71%), Granada Group plc (6.48%) and BSB Holdings Limited (13.96%) (OFT 1996: 153).

8. Granada sold its 6.5 per cent stake in BSkyB for £429 million on 13 October 1998, shortly before ONdigital's launch, retaining an indirect holding in BSkyB of 4.3 per cent through its 33.55 per cent stake in BSB Holdings (Potter 1998; Snoddy1998f).

9. 50 per cent of non-terrestrial viewing in the first quarter of 1996 was of BSkyB channels, 100% in the case of film channels. Source: OFT 1996.

10. Former Granada Chief Executive Steve Morrison argued (Revoir 2003) that as soon as the ITC ousted BSkyB from the Consortium 'it became the enemy and it was much bigger . . . We should have got out'.

11. For a guide to the UK press in the 1990s, see Sparks 1999; Rooney 2000; Curran and Seaton 2003.

12. BSkyB had already sought to counter its down-market image during the 1990s and target more 'discerning consumers' (Morley 1995: 315; Brunsdon 1991).

13. The Oct 1 cover page also featured an advert for SkyDigital, referring readers to the screening times of SkyDigital's terrestrial television advertising that evening.

14. The 1990 Broadcasting Act relaxed restrictions on programme listings in newspapers and periodicals. Change was introduced on 1 March 1991 when copyright holders BBC and IPC were required under section 176 of Act to allow listings information to be published by others up to a week ahead of programmes, subject to payment of a negotiable fee (see Copyright tribunal 1992; MMC 1992: 118). For Christmas 1991 several newspapers produced 'free' listings supplements for the first time (MMC 1992:94).

15. Of the total number of channel mentions, 63 per cent were in NI papers compared to 37 per cent in non-NI papers. Across the sample as a whole the average number of channels listed was 26, while NI papers carried an average of 33 against 19 in non-NI papers (or 75 per cent more on average).

16. Sky Box Office 1-4 is calculated as one channel, although it comprised four PPV films broadcast at different times across various channels. While this minimises differences in the total 'channels' carried, it enables more fair and accurate comparison of the number of separate programme services listed in each newspaper.

17. L!ve TV attracted notoriety but small audiences, with 0.1 per cent estimated audience share in 1998 (ITC 1999c), the minimum registered. The Mirror also gave prominence to MTV

Europe, a 50 per cent joint venture with Viacom. On 9 October, it produced a four-page supplement covering the MTV Music Awards.

18. The paper changed its weekly listing in the 6 Sept issue to reflect changes in Sky's film channels, as did other newspapers. The layout was not changed again in 1998.

19. In October 1998, terrestrial channels had an 86.9 per cent share of viewing in all UK TV households, non-terrestial share was 13.1 per cent. Within cable and satellite homes Sky 1 was the most popular non-terrestrial channel with 4.3 per cent share of viewing (but the channel had only 1 per share of viewing in all households). In cable and satellite homes Sky 1 was followed by Cartoon Network (2.4), Sky Premier (2.2), UK Gold (2.2), Sky Sports 1 (2.1), Nickeodeon (2.0), Living (1.8), Sky Movie Max (1.4) Sky Sports 2 (1.2) and MTV (1.0). All other channels had less than one per cent share including Sky Sports 3, Sky Cinema, Sky News, Sky Travel and Sky Soap. For further details see BARB (Broadcasters' Audience Research Board) Monthly Multi-Channel Viewing Summary 1992-2009, available at http://www.barb.co.uk/report/monthlyViewingSummaryOverview?_s=4.

20. Both BARB and Taylor Nelson Sofres plc, which produced television viewing figures for the ITC (1998i), did not include DTT in viewing figures until 1999. The sample from which BARB calculated audience size was small (under 5,000), making figures for non-terrestrial television particularly unreliable. Yet, even in multichannel homes, actual viewing share for non-terrestrial channels was very small compared to terrestrial channels.

21. BARB calculated the total number of homes with satellite or cable television as 7,094,000 in December 1998. The NRS data estimated the number of adults aged 15+ with access to satellite/ cable TV subscriptions at home as 14,410,000.

22. McManus (1994) distinguishes four types of journalistic objectivity norm violations: personal biases of journalists, 'the self-interest of the media firm' and allied interests, self-interest of societal elites outside the media firm, corporate parent and major investors , and human error. Violations may reflect one or more, but McManus acknowledges the difficulty , even in detailed studies, of pinpointing causes.

23. In September 1998 *The Times* reported criticism of BSkyB's bid for Manchester United. In contrast, *The Sun's* coverage of the BSkyB bid was explicitly promotional, with headlines such as 'Gold Trafford' (*Sun* 1998a) 'Skyly delighted' (*Sun* 1998b) and 'Thanks a Billion' (*Sun* 1998c) with only brief references to criticism ('not all fans were quite so sure about the mega-deal'.

24. The number of references in editorial content to the BBC, Channel Four, Channel 5 and Channel Four's subscription channel, Film Four, are included for purposes of comparison with coverage of the rival digital television services.

25. Neil (1996: 374) stated in (inaccurate) self-justification that he 'had effectively banned reporting of Sky so that there would be no conflict of interest'. His memorandum, issued on 6 September 1989, came after acknowledging growing political opposition (Neil 1996:373). Neil's guidelines were a calculated public rebuttal to the charge of bias and carefully utilised the assertion of professional standards to suggest that concern about abuses was misplaced.

26. While the actual form of words varies slightly such disclosure is identified as 'full' in my analysis.

27. The agency assigned to handle ONdigital's £40m account, Abbott Mead Vickers BBDO, Britain's largest, resigned in August (Hatfield 1998a).

28. Brown, writing about the HarperCollins Row, argued that Murdoch went beyond usual proprietorial/ media company behaviour (i.e., preventing his resident media pundits from washing dirty linen in public) by distorting or suppressing negative coverage of shady regimes where, according to Brown, he calculated that doing so would help him expand his media empire.

29. *Private Eye* (1998c: 12) later described Snoddy as 'a man who combines a twitching sanctimoniousness about journalistic standards with an ungrudging admiration for great newspaper proprietors such as Robert Maxwell and Rupert Murdoch'.

30. For a valuable cultural studies critique of 'tabloidization' discourses see Turner (1999). Sparks and Tulloch (2000) offer a useful collection of analytical and empirical studies.

31. Editorials, while conventionally anonymous, have much greater prominence and, in the quality press in particular, are expected to demonstrate high editorial standards. In contrast to the 1988-1990 period when NI used editorials and leader articles to promote Sky, there was no such usage in 1998.

Media Policy and Regulation

Changes in UK Policy and Regulation: An Overview

Introduction

For his *Enquiry into Standards of Cross Media Promotion* (1991), John Sadler arranged correspondence with several British embassies, including the United States, West Germany, France, Italy, Canada and Australia, and the permanent representative to the European Community. From the responses received he concluded that none of the countries had introduced specific measures governing cross-media promotion.[1] In the years since, no detailed study of the regulation of cross-media promotion has been carried out either at national or supranational level or comparatively. The aim of this chapter is to describe and analyse the ways in which cross-media promotion has been constituted as an object of policy and addressed in regulation. The chapter traces how cross-media promotion has been subject to regulation. The first part describes how CMP has been addressed and constrained in regulations governing media ownership, newspapers and advertising (with broadcasting dealt with more fully in chapter seven). The second part examines the Sadler *Enquiry* as a key moment in which CMP became an explicit object of policy. Part three situates responses to CMP in the wider context of shifts in policy, notably towards more neoliberal, deregulatory approaches.

Cross-Promotion as an Object of Regulation

Cross-media promotion has been subject to policy and regulation only to very a limited extent. In the UK cross-media promotion became an explicit regulatory issue in the late 1980s with the Sadler *Enquiry*. Since then the issue has been addressed in the regulation of cross-promotion by television broadcasters. That topic is outlined here but examined more fully in chapter seven. Cross-promotion has arisen as a topic in a variety of policy debates over the last two decades but is subject to very limited regulation outside of the specific rules on

broadcasting. However, various kinds of regulation have served, historically, to constrain cross-promotion. In particular, rules on media ownership limited the scope for intra-firm CMP.

To investigate only regulations explicitly governing cross-media promotion would be unsatisfactory for several reasons. First, the practices of cross-media promotion are broad, encompassing promotional behaviour in editorial, advertising, sponsorship and their complex combination. Second, the relevant regulatory frameworks are diverse. CMP concerns each of the three main types of regulation governing the media: structural, behavioural and content regulation (Feintuck and Varney 2006:56) and occurs at the intersection of these. Third, instead of positing CMP as an object and then investigating its occurrences, it is necessary to examine how CMP comes to be constituted as a regulatory issue within different regulatory structures and discourses. It is also necessary to examine how various kinds of cross-media promotional practices are made subject to regulation and the conditions under which this occurs.

Media Ownership and Cross-ownership

Structural regulation refers to ownership rules, which usually set limits on ownership with a given market, and licensing or other rules governing who is eligible to provide a media service. Content regulation concerns requirements or limitations on what can be communicated. Behavioural regulation 'generally serves to limit how property held can be used in relation to its impact on actual or potential competitors' (Feintuck and Varney 2006: 68) and is usually characterised as competition regulation ('anti-trust' regulation in the US).

Media industries have tended to be regulated differently in accordance with the technology and industry concerned, and so governed by 'sector specific' rules. Such rules remain but there has been a shift towards the application of 'general' regulations such as general competition rules. In regard to 'sector-specific' media regulation, CMP is usually constrained by structural regulation of ownership, in particular cross-media ownership, by content regulation, such as the regulation of impartiality and treatment of commercial interests in broadcasting, and by the regulation of advertising and sponsorship. Of the 'general' regulations affecting media, competition law and consumer protection regulations are the most relevant for CMP, but other aspect of the general legal framework of public and private law also have bearing (Daintith 1998). According to Goldberg et al. (1998a) media regulation is characterised by a greater diversity of institutions and instruments used than any other form of regulatory activity (see also Collins and Murroni 1996).

Structural regulation of media ownership has been a crucial factor in determining the conditions and scope for cross-media promotion. As well as granting licensing powers to television regulators (Gibbons 1998: 150-178), successive UK governments have also restricted diversification through ownership rules. Newspapers remain subject to rules on concentration of ownership (discussed below). Broadcasting has been organised via systems of licensing, the rules for which have been established through Acts of Parliament. Broadcasting legislation has set rules on who may own and provide broadcasting services, limits on ownership and rules governing cross-media ownership, in particular between newspaper publishers and broadcast licensees.

The 1990 Broadcasting Act introduced specific quantitative rules governing mono-media concentration and cross-media interests. Previously, broadcasting legislation conferred broad discretionary powers on the regulator to secure adequate competition between programme contractors. The 1981 Broadcasting Act did, however, impose restrictions on cross-ownership of radio and television and created powers to prohibit newspaper shareholdings in television contractors where that would be contrary to the public interest (Gibbons 1998: 220, 211-212; Barendt and Hitchens 2000: 248). Under the 1990 Act national newspapers were allowed to own up to 20 per cent of a licence in each category of national radio, terrestrial television and domestic satellite broadcasting. Cross-ownership became a more significant and controversial issue after the 1990 Act set rules that failed to restrict Murdoch's joint ownership of Sky and News International newspapers, since Sky, a non-domestic satellite service, fell outside the rules. During the 1990s other papers formed the British Media Industry Group (BMIG) to lobby for relaxation of the rules on cross-ownership that prevented them from building integrated multimedia groups. The 1996 Broadcasting Act further relaxed the rules on cross-media holdings, removing many of the upper limits, and introduced new licences for digital broadcasting. The Act prevented newspaper owners with a national market share of 20% or more from controlling a Channel 3 or channel 5 licence or national or local radio licence and limited their cross-media interests in the latter to 20%. Such newspaper groups could, however, control other licences for 'local delivery services, licensable programme services, satellite television services, restricted service licences, digital multiplex services and digital programme services for both television and radio' (Department of National Heritage 1997: 5). Mergers were now permitted between newspaper, radio, television and new digital media companies, while ownership limits between satellite, cable and terrestrial broadcasters were removed.

The Communications Act 2003 represented a further liberalisation of ownership rules. The Communications Act allowed the creation of a single

ITV and removed restrictions on foreign ownership of broadcasting. However, pro-market deregulation was balanced by a social-market defence of public service broadcasting, a newspaper merger policy that required public interest considerations to be assessed, and the maintenance of some cross-media ownership rules (Curran and Seaton 2010).

UK Press Regulation

Beyond legal restrictions, publishing is largely governed by a self-regulatory system. Industry-led, this has survived by changing and reacting to often intense criticisms of most of its incarnations, with the principal aim of protecting the newspaper and periodical industries from statutory regulation (see Robertson 1983; Curran 1995b).

There have also been specific competition rules governing newspaper mergers since the introduction of the 1973 Fair Trading Act (FTA) as well as the special provisions on cross-media ownership. Under the terms of the FTA, the consent of the secretary of state was required for mergers or acquisitions giving rise to a combined daily circulation of 500,000. The secretary of state was required to receive a favourable report for the merger from the Competition Commission (which replaced the Monopolies and Mergers Commission on 1 April 1999), except in cases where the newspaper was not economic as a going concern. The exercising of such powers proved highly controversial when Ministers approved the sale of *The Times* and *Sunday Times* to Murdoch in 1981 without referral to the MMC, with many analysts disagreeing that the *Sunday Times* was not a going concern (Robertson 1983; Kuhn 2007: 91–92; Feintuck and Varney 2006:129–135). The newspaper merger regime has since been revised, most recently by the Communications Act 2003 (sections 373-389), which repealed the FTA and amended the Enterprise Act 2002. This increased the scope for newspaper consolidation but retained mechanisms to prevent mergers on grounds of plurality and public interest. Under the so-called 'plurality test', public interests considerations on newspaper mergers are:

1. the need for accurate presentation of news in newspapers
2. the need for free expression of opinion in the newspapers involved in the merger
3. the need for, to the extent that is reasonable and practicable, a sufficient plurality of views expressed in newspapers as a whole in each market for newspapers in the UK or part of the UK

Overall, the regulatory system has failed to prevent increasing concentration in the national and especially local and regional press (Curran and Seaton 2010; Feintuck and Varney 2006; Williams, G. 1996; Franklin and Murphy 1997).

In addition to formal legal controls, the regulatory system comprises other elements such as professional scrutiny through journalism reviews, industry periodicals and the wider press.[2] These constitute what may be described as 'soft' regulation, that is non-formal mechanisms that seek to influence and enhance professional behaviour. The general evolution and performance of British press self-regulation are beyond the scope of this study (see Gibbons 1998; Munro 1997), but I will briefly examine how far CMP has arisen as an object of UK press policy.

Industry self-regulation was established grudgingly and belatedly in 1953 following government support for the recommendation by the first Royal Commission on the Press (1947–49) that a General Council of the Press should be established, voluntarily, by industry (O'Malley 1997: 130). Contributors to the Commission, such as the backbench MP Michael Foot, saw the process in relation to attempts in the United States, notably the Hutchins Commission in 1947, to tackle abuses through social responsibility. However, Foot, with other Labour MPs, was also concerned about concentration in the film industry and hoped the Commission would recommend rules on cross-ownership (O'Malley 1997: 133). While it was not until the 1974–77 Commission that cross-media interests were systematically addressed, and together with other recommendations subsequently ignored, the first Royal Commission did consider evidence of the influence of advertisers on editorial content. This included the use of supplements 'where the editorial material was designed to comment on and create interest in the advertisements' (Royal Commission on the Press 1949: 142). It also heard evidence of the lack of independent criticism of films and theatre in local newspapers where journalists felt compelled to write favourable reviews because of the large part played by theatre and cinema advertising in the local paper (RCP 1949: 141). The Commission (RCP 1949: 107) acknowledged the criticism of those who:

> sought to show that the ownership of newspapers by large commercial undertakings, the effective control of which was concentrated in the hands of a small number of individuals, resulted in commercial considerations and the political policies of the chief proprietors taking precedence over considerations of good journalism and public interest.

But it concluded that the 'direct influence of advertisers is negligible' and the British press remained 'completely independent of outside financial interests' (RCP 1949: 149). The Commission did recommend, however, that all papers owned by chains 'should be required by law to carry on the front page a for-

mula clearly indicating their common ownership.' (RCP 1949: 163). The Second Royal Commission 1961–62 went further, recommending that 'an obligation should be laid on all proprietors to carry on the front page of each newspaper the name of the company or individual in ultimate control of that newspaper'. However, this measure of transparency was proposed in the context of considerable ambivalence concerning concentration of ownership, as the Commission balanced political pressure, pragmatism and economic arguments favouring consolidation ('strong units are essential to a healthy Press') against the risks to the public interest. The Second Royal Commission's compromise recommendation was for a Press Amalgamations court to scrutinise future press concentrations. Significantly, however, responding to the changing structure of the industry and cross-media ownership of newspapers and television, such as Thomson Scottish Associates' ownership of newspapers, including *The Scotsman*, and Scottish Television, the Commission concluded that it was 'contrary to the public interest for such companies to be controlled by newspaper undertakings' (RCP 1962: 78; 148–151).

Each Royal Commission identified the growing influence of cross-media and multi-sectoral ownership on editorial, the influence of advertisers on the economics and editorial of the press, as well as more diffuse pressures of commercialisation. In this context, it is significant that neither the Press Council, nor the Press Complaints Commission which replaced it in 1991, felt under sufficient pressure, notwithstanding three Royal Commissions and other public policy interventions, to introduce rules governing commercial influence. In fact, for more than thirty years, the Press Council resisted introducing a written code of practice, producing instead a digest in 1985 of its decisions between 1953–84, *Principles for the Press* (Paul 1985; for a critique see Robertson 1982; Gibbons 1998). The Press Council did adjudicate on a variety of matters concerning advertising in newspapers and periodicals. In a series of decisions it affirmed that editorial and advertising matter must be clearly distinguishable and dealt with the prominence and adequacy of such identifications. However the Council's adjudications concerned third-party advertising and only exceptionally addressed self- and cross-promotion by newspapers themselves or promotion of their allied commercial interests. In one adjudication, the publication by a morning paper of an editorial 'puff' for its associated evening paper was deemed acceptable on the grounds that this could not possibly have misled readers. In another adjudication the Council deplored the unethical conduct of a newspaper that inserted its own printing department's advertisement in an advertising feature 'when it well knew that another firm, which had not been invited to advertise, had undertaken the printing for the enterprise being advertised' (Paul 1985: 9).

The Press Complaints Commission and codes of practice

The Press Complaints Commission code was introduced in 1991 and has been revised several times thereafter, most recently in 2009 (PCC 2009). The code states general principles concerning accuracy, including the avoidance of 'inaccurate, misleading or distorted material'. It states that '[n]ewspapers, while free to be partisan, must distinguish clearly between comment, conjecture and fact'. The code also has specific restrictions on financial journalism, affecting how financial information is used and reported. Beyond these general principles and specific measures, nothing in the code regulates any of the practices deployed in cross-media promotion, or any aspects of commercial influence over editorial. The requirement that newspapers should report fairly and accurately the outcome of defamation cases to which they are party, does acknowledge, although only in this limited context, problems arising from newspapers covering their own interests and affairs.

In contrast to the PCC code, the National Union of Journalists' code prohibits acceptance by journalists of bribes or other inducements.[3] It states, more comprehensively, that 'a journalist shall not lend himself/herself to the distortion or suppression of the truth because of advertising or other considerations.' The code also prevents a journalist from endorsing 'by way of statement, voice or appearance any commercial product or service save for promotion of his/her own work or of the medium by which he/she is employed' (Rule 13; see Frost 2000: 250, 151-2). As Frost points out (2000: 150), while the PCC code is concerned primarily with published material, the NUJ code is concerned with journalists' behaviour. The latter's mechanisms for enforcement include sanctions up to expulsion from the union.[4] The NUJ's code illustrates Harris's (1992) observation that journalists' codes, in contrast to proprietors' ones, often highlight the need for reporters to maintain journalistic integrity and resist being influenced by commercial pressures, such as fear of offending advertisers. As well as seeking to regulate journalists' behaviour such clauses are also designed to help journalists resist pressure from proprietors.[5] But Harris goes on to note that '[i]t is the limited powers that most professional bodies have to enforce their codes which throws into question the public benefits of having codes of conduct, at least of the non-statutory kind' (Harris 1992). Indeed, the failure of effective mechanisms for enforcement of press self-regulation has been the focus of sustained criticism (Robertson 1983; O'Malley and Soley 2000).

In 1991, shortly before the PCC drew up its first code, the Sadler *Enquiry* recommended that a code of practice on cross-media promotion should be incorporated into both the PCC code and the British Code of Advertising

Practice. His report (Sadler 1991: 1-2) stated this should cover both advertising and editorial content and contain provisions relating to:

(i) access to and prices for advertising space
(ii) the distinction of advertisements from editorial copy and disclosure in advertisements of ownership links;
(iii) disclosure in the editorial content of newspapers of their owner's or associates' other media interests;
(iv) the application of professional journalistic standards to editorial content concerning matters in which the newspaper or an associate has an interest

Four bodies representing newspapers and periodical publishers did produce a *Cross-Media Promotion Code* in 1994 (Newspapers Publishers Association et al. 1994) although this did not add to existing provisions except in encouraging all publishers to produce individual in-house guidelines. None of the *Enquiry*'s recommendations was adopted by the PCC in its code. Through the PCC code, largely comprising measures adopted when a response to political flak and criticism was unavoidable, the industry has been successful in evading measures to restrict, or indeed articulate and problematise, cross-media promotion.

Europe–Codes of Conduct and Journalistic Integrity

The role of professional self-regulation, and in particular the independence and integrity of journalists and editors, has been most explicitly espoused in European policy by the Council of Europe. In addition, the International Federation of Journalists (IFJ) and its European section, the European Group of Journalists (EGJ) has done much to promote journalistic standards and protection. The Council, in its aims to balance state responsibility for encouraging ethical and responsible journalism with the dangers of State interference with media freedoms, prefers the profession to elaborate its own codes of conduct to regulate its activities (CoE 1993). Measures to secure journalistic integrity through self-regulation are seen as vital in achieving social responsibility, 'internal pluralism' and freedom from undue commercial influence. The Council recognises that media concentration may reduce choice and limit individuals' rights to freedom of expression. At the same time, the Council has not proposed special regulation for control of press concentrations, considering that such regulations may be incompatible with fundamental right of

freedom of expression. The alternative view that states have an obligation under Article 10 to ensure the conditions for pluralism and diversity, including limiting media concentration, has been elaborated within Council deliberations but not endorsed in specific policy by the intergovernmental Council of Ministers (see Vorhoof 1995).

One of the earliest Council of Europe policy statements on the media, Recommendation 747 on Press Concentrations (CoE 1975), called for various measures including drafting a model statute for newspaper editorial staff (at the European level). The European Parliament went further, adopting in February 1990 a resolution calling for a special legislative framework on media mergers and take-overs to ensure, *inter alia*, that journalistic ethics were protected and that freedom of expression for all those working in the media was safeguarded. There is then a wide-ranging, but formally weak, European regulatory framework supporting self-regulation of the media via codes of conduct which seek to maintain journalistic standards and independence from both political and commercial influence. But cross-media promotion, as such, has not been explicitly addressed or made subject to such measures.

UK Advertising Regulation

Like the Press Council, the Advertising Standards Authority (ASA) was established by the advertising industry mainly to resist the threat of statutory controls.[6] The Committee of Advertising Practice (CAP) was established in 1961 and produced a code based on the International Code of Advertising Practice, first published by the International Chamber of Commerce (ICC) in 1937. The code, covering non-broadcast media, has since been revised several times (Hardy 2009). It was extended to cover direct marketing (from 1992), non-broadcast electronic media (from 1995) including CD-ROMs, the Internet, and more recently SMS text messages. The CAP brings together twenty trade bodies, including the Newspaper Publishers Association, to draw up the codes. The ASA, at least half of whose members are required to be independent of advertiser interests, supervises the CAP and enforces the codes.

The success of the ASA relative to press self-regulation is widely acknowledged. The ASA's codes are much more detailed, while resting on core principles to ensure that advertising is 'legal, decent, honest and truthful'. The ASA has stronger enforcement powers than the PCC including trading sanctions, de-recognition by the relevant professional association and withdrawal of financial incentives by trade, professional or media organisations, and adverse publicity arising from adjudications. Further, under the Control of Misleading

Advertisements Regulations 1988 (amended 2003), designed to comply with the 1984 EC Directive on Misleading Advertisements, the Director General of Fair Trading may obtain a court injunction against offenders, underpinning the regulatory system with 'backstop' legal powers. Above all, however, the differences lie in the higher level of industry support and compliance than has been the case across the press (see Robertson 1983; Feintuck 1999:152). The ASA is also subject to supervisory jurisdiction though judicial review procedures, although as Lidbetter and others point out, the courts have generally deferred to bodies which they regard as having expertise in a given area (See Barendt and Hitchens 2000: 213; Feintuck 1999: 153).

The framework in which advertisers, agencies and media must operate is a mixture of voluntary and statutory regulation. The ASA now deals with most paid advertisements and marketing communications, but it operates within a wider framework of domestic and international law and alongside various other regulatory agencies such as trading standards. More than 170 Acts of Parliament directly affect advertising, with some 235 regulations and statutes affecting broadcast advertising in England and Wales alone (Hardy 2009).

The British Codes of Advertising and Sales Promotion

The codes set out both general requirements and specific rules governing advertising and sales promotions. The advertising code requires that advertisements 'are designed and presented in such a way that they can be easily distinguished from editorial' (23.1). Section 23.1 principally concerns advertorials. 23.2 states:

> Features, announcements or promotions that are disseminated in exchange for a payment or other reciprocal arrangement should comply with the Codes if their content is controlled by the advertisers.

This formulation is significant since it protects media generated editorial from the code unless it takes the form of advertising. The Sales Promotion Code covers 'advertisement promotions' requiring that these should be easily distinguished from editorial (41.1). The codes, then, prohibit cross-media promotion only in so far as it is surreptitious advertising and then only in so far as it accords to general content requirements governing advertisements. At this intersection of advertising and editorial, the codes themselves offer no clear definitions governing their separation.

Since the creation of commercial television in 1955 broadcast advertising had been the responsibility of the relevant statutory regulator. The 2003 Communications Act gave powers to a new regulator, the Office of Commu-

nications, known as Ofcom. Within a year of operation regulation of broad-cast advertising largely passed from Ofcom to the ASA. The Communications Act (2003) had required Ofcom to review whether its functions could be effectively secured by self-regulation rather than statutory oversight. Following a short consultation, Ofcom approved this approach, arguing it would provide consumers with a 'one-stop-shop' for complaints and be better able to handle convergence issues raised by the growth of digital communications. This was a not a straightforward transfer of powers, however, but rather a 'co-regulatory' arrangement, involving statutory and voluntary elements, between Ofcom, the ASA and BCAP, the broadcasting section of CAP. Ofcom has delegated its statutory powers over the content of broadcast advertisements to the ASA which deals with all complaints, but Ofcom remains ultimately responsible for regulating advertisements on television and radio services. Ofcom also retains direct control over important matters such as the amount and scheduling of advertisements, sponsorship and teleshopping.

The Sadler *Enquiry*

John Sadler's *Enquiry into Standards of Cross Media Promotion* (1991) has been neglected.[7] Major studies of UK media policy in the period omit it (Snoddy 1992; O'Malley 1994; Negrine 1994; Goodwin 1998). Steven Barnett, who gave evidence, acknowledges its significance (Barnett and Curry 1994: 128–132), and there are brief references in legal and policy studies (Gibbons 1998; Barendt and Hitchens 2000; Feintuck 1999), but no detailed assessment has been made. Yet the *Enquiry* concerned matters which are recognised as central to media policy during this period and beyond: cross-media ownership; the purpose, behaviour and financing of the BBC; press regulation; and more broadly the implications of convergence and of paradigm shifts in the govern-ance of communications. This section attempts to redress the neglect by examining the *Enquiry*, placing it in the wider context of changes in media and policy and arguing that it has continuing relevance for an otherwise trans-formed multimedia landscape.

The *Enquiry* was established to investigate the cross-promotion of Sky by News International newspapers. Announcing the *Enquiry* in December 1989 the Secretary of State for Trade and Industry, Nicholas Ridley, explained:

> How media companies promote their interests in media services and products raises questions of standards of behaviour which go wider than those which can be addressed by the Director General of Fair Trading using competition legislation.

This acknowledged that editorial conduct was not adequately addressed by general competition law, an argument amplified by Sadler. But it also provided a justification for the curtailment of OFT investigations into cross- media ownership. Gordon Borrie, Director General of Fair Trading (DGFT), was poised to refer Murdoch's alleged anti-competitive practices to the Monopolies and Mergers Commission (MMC) (Sadler 1991: 5) and was perceived as a serious threat by News Corporation (Stelzer 2003).[8] Ridley announced that as a result of the Sadler *Enquiry*, the DGFT had decided not to pursue any further investigation. According to Sadler (2002), Ridley applied pressure to a reluctant Borrie to withdraw.[9] The decision to hold an enquiry also ensured that cross-media ownership did not result in MMC recommendations during passage of the 1989 Broadcasting Bill.

The origins of the *Enquiry* lay in BSB's complaints to the OFT about Murdoch's cross-promotion of Sky (chapter five). However, to the consternation of BBC executives, the enquiry was expanded to consider the BBC's on-air promotion of its magazines. Understanding this shift to the BBC requires consideration of the interaction of factions within government, the interests and effectiveness of various policy actors, the commercial expansion of the BBC, changes in market conditions and the conduct of the *Enquiry* itself. Timing was a key factor. The *Enquiry* began in January 1990 and by October had completed evidence on the issues relating to BSB-Sky. Altogether, Sadler received responses from 40 interested parties.[10] Then in November, BSB and Sky announced their merger during a five-day hiatus of regulatory scrutiny, and with the sufficient, if tacit, approval of the outgoing Prime Minister Margaret Thatcher (Tunstall and Machin 1999: 166–168). Sadler subsequently acknowledged the merger 'took the heat out of the issue' (Sadler 2002). A *Guardian* leader article (1991), using imagery from the Gulf War, described Sadler's report as 'a lonely scud missile' seeking a new target as it returned to a 'different landscape'.

Conducting the *Enquiry*

The way in which the *Enquiry* was conceived and conducted made it particularly susceptible to following an agenda set by commercial interests against the BBC. According to Sadler (2002) the *Enquiry* had two 'rounds', a fact-finding phase, followed by meetings with the principal parties. This followed common MMC practice to invite interested parties to consider matters of concern within the terms of reference set. However, cross-media promotion lacked the economic and socio-legal parameters guiding most competition investigations. For Sadler, cross-promotion was a normal and widely used commercial prac-

tice. So while special concerns arose in media markets, determining when such practices became 'improper' proved difficult. Some, such as the provision of advertising to third parties, certainly could be addressed in accordance with general principles of competition and fair-trading. Other principles, including disclosure, could be derived from existing consumer law, such as foods and medicines labeling. However, cross-media promotion lacked what Daintith (1998: 359) calls 'legal substance', that is 'the existence, at the time when policy is being formulated [of] relevant bodies of substantive law, whose adaptation or development may provide one means of achieving the objective at hand'.

BBC commercial expansion

On 1 March the BBC Director General, Michael Checkland, criticised the inclusion of the BBC in the enquiry as a part of an exceptional, wide-ranging attack on government policy, citing it amongst several instances where the BBC's efforts to supplement its licence fee income would be hampered (Henry 1990; Brown 1990; Barnett and Curry 1994: 120–121). Building BBC Enterprises was a key objective for Checkland, and its director James Arnold Baker produced a five-year plan known internally as 'the dash for growth' (Barnett and Curry 1994: 130–142). The magazines division of Enterprises produced the Radio Times, published since 1923, which was responsible for £78m of the division's £88m turnover in 1989/1990. From the late 1980s, however, the listings monopoly, and so the division's profits, was under renewed threat. In response, the BBC launched twelve consumer magazines between 1987 and 1990. As Barnett and Curry state (1994: 131) '[t]he principal problem with this strategy was that no-one had defined adequately the purposes of Enterprises, or its relationship with the rest of the BBC'. The lack of clear boundaries on expansion and clear distinction between public service and commercial activities influenced consideration of the more specific issue of BBC cross-promotion.[11] Commercial publishers, some of whom, like Reed, had interests in rival satellite services, led the charge. Reed argued that the BBC's on-air promotion of its magazines gave those titles an enormous and unfair commercial advantage over competing magazines. The BBC could benefit from extensive and exclusive on-air promotion, and from savings on marketing and advertising production costs not enjoyed by competitors. In accepting the publishers' main arguments Sadler established a superficial coherence in the application of principles to all three CMP issues which masked more profound differences.[12] Sadler drew on the principle, established for newspapers, that there should be 'little if any discrimination in favour of

associates and against competitors in access to and prices charged for advertising space or air time' (1991: 60).[13] Applied to the BBC, however, this would require either that the BBC took third party advertising, or that it ceased to 'advertise' its products altogether, or (as the government briefly proposed in 1992) that the BBC should announce relevant competitor products when mentioning its own. Sadler's criticisms were widely shared and were broadly endorsed by the subsequent MMC investigation, but Sadler judged the BBC in terms of commercial market competition and ignored considerations of public service broadcasting, asserting, rather stiffly, that the public interest was a matter for the MMC.[14]

The shift of focus to the BBC caused difficulties for the unions, academics and others who were united in opposition to Sky's cross-promotion (Gopsill 1991).[15] For Steven Barnett of the Broadcasting Research Unit, the BBC served the public interest by reinvesting commercial revenues into programme making. However, Nicholas Garnham judged the BBC's promotion of magazines to be a clear example of unfair competitive practice, recommending that the BBC should advertise only through other media outlets. The TUC urged that the BBC should be adequately funded through the licence fee but added that only the *Radio Times* should be promoted on-air and cited the risks to competition and BBC impartiality arising from promotion of magazines, such as *Fast Forward*, not directly related to programmes.'[16]

Sadler enabled the interests of competing commercial publishers to coalesce against the threat posed by the BBC's commercial activities.[17] The *Enquiry* comes near the start of a period from 1988 in which commercial companies challenged the BBC in both domestic and European courts, relying on competition law to override the protected position of PSB. The two most powerful, well-resourced opponents, NI and the BBC, never formally engaged with one another in the *Enquiry* itself, although the BBC had been a target of criticism in NI papers though the 1980s (Barnett 1989; O'Malley 1994; Barnett and Curry 1994: 114–5, 125; Keane 1991). However, it is not difficult to see the tactical benefits for NI of not seeking to open a public front against the BBC while defending itself assiduously before Sadler. Irwin Stelzer (2003), who led NI's team, confirmed that he recommended in private conversation that Sadler address BBC cross-promotion even though this never featured in NI's formal submissions.

Responses and aftermath

Sadler submitted his report on 10 January 1991. However, it was not until 12 March that Peter Lilley responded for the government.[18] The period from

1987 to 1993 has been described as a peak of activity concerning press regula-tion (O'Malley and Soley 2000). Calcutt (1990) had recommended that the press should be given 'one final chance to prove that voluntary self regulation can be made to work', but that the Press Council be replaced by a Press Com-plaints Commission which would be 'specifically charged with adjudicating on complaints of press malpractice'. The government accepted the committee's recommendation that the press should have 12 months to establish the PCC, with a review of its performance after 18 months of operation, reiterating its reluctance to introduce a statutory framework but indicating that only effective self-regulation could prevent this occurring (a position supported by the oppo-sition Labour Party).[19] Sadler's recommendations for a fairly modest extension of self-regulation did not raise serious problems for the Government and were accepted by Lilley.[20]

Sadler's recommendation that the BBC should be referred to the MMC posed a greater presentational and policy challenge. As the government feared, some press reports highlighted the contradictions for government policy arising from the report. A *Guardian* (1991) leader stated:

> The (sponsoring) Home Office, which has devoted many waking hours to exhorting the BBC to raise more revenue commercially, must now see those efforts put up for Monopolies and Mergers judgement. No wonder the DTI has sat on Sadler for months, pondering a report about rather small things which, in fact, asks a very big question ['How do we want to run and finance our public broadcasting service?'].

After discussions between officials and ministers in both departments, it was agreed that Lilley would announce a six-week consultation. In his March statement, Lilley gave a carefully appreciative but non-committal response to the Sadler report. The BBC chairman and Director General held meetings with Baker immediately after the report was published, and then on 16 May 1991, Lilley announced his decision to refer the BBC to the MMC. The outcome was undoubtedly uncomfortable for the Home Office, although Kenneth Baker, who replaced Hurd in November 1990, was even more critical of his department's protectionist BBC stance (Baker 1993). Further, since the DGFT could act without ministerial approval, it was risky to oppose a refer-ence expected to occur anyway. Even within the DTI there was concern that the government would be seen as soft on Murdoch while coming down hard against the BBC. How far the DTI sought to use Sadler to advance its influ-ence over broadcasting policy is unclear, but it provided Lilley, an ardent Thatcherite, with the opportunity to show that the BBC should not escape from competition principles and that anti-competitive practices would be tackled wherever they arose.

Sadler's recommendations on the BBC prompted ministerial intervention and an investigation, while his proposals for the press were largely ignored.[21] The different regulatory traditions and structures of the press and broadcasting are key underlying factors here, as are the variable strength and mobilisation of policy actors. Another factor was the different regulatory resources available in each case. The MMC could draw on competition powers and its embedded institutional autonomy (Stirton and Lodge 2002) to assess cross-promotion. The PCC lacked regulatory resources but was also unwilling to exercise those it possessed.

On 16 May 1991, Lilley announced his decision to call on the newspaper industry to draw up a code of practice and noted 'encouraging indications from the industry itself that it is willing to draw up a code'. In fact, nothing was produced until 1994, when a *Cross-Media Promotion Code* was approved by the Newspaper Publishers' Association (1994), the Newspaper Society, the Periodical Publishers Association and their equivalent bodies in Scotland. Trade Secretary Neil Hamilton announced its publication to Parliament on 18th May 1994 (Newspaper Society 1994).

The code was a careful effort in minimising obligations. It added nothing to existing rules for press or advertising and merely encouraged publishers to draw up individual in-house guidelines. On the key matter of editorial disclosure it stated that 'substantial news and comment in a publication referring to an associate should normally include a statement about any relevant ownership link'. This fell short of Sadler's recommendation that newspapers should publish at regular intervals a list of significant media interests of its associates (Sadler 1991: 40). The PCC code itself was not amended, although it has been modified on other issues, notably privacy, when pressure built to do so. The industry's response confirms broader critical accounts of UK press self-regulation as acting principally to ensure self-regulation survived, strengthening rules only when unavoidable (Petley 1997, 1999; O'Malley and Soley 2000). Only governmental pressure could have secured Sadler's recommendation and this was not forthcoming.

Investigating broadcasters' promotion

The MMC dismissed broadcasters' promotions on commercial television as economically insignificant, after adopting a controversial interpretation of the relationship between the ITV companies, the IBA and the ITC[22]. Consequently, the MMC followed Sadler in directing its attention to the BBC, and it concurred that BBC promotions distorted competition in certain sections of the consumer magazine market, namely television listings, gardening, and food

and cookery (MMC 1992; Barendt 1993: 135).[23] It recommended prohibiting in-programme mentions and 'moving' trails, while allowing still trails (i.e. single photographic images with voice-over) provided these did not include 'persuasion, endorsement or selling'.

Having found against the BBC, the MMC stated that suitable undertakings drawn up between the DGFT and BBC might be substituted for its own recommendations. However, Neil Hamilton called on the DGFT to secure undertakings from the BBC, favouring this approach over that of a Code of Practice then being devised by the BBC and ITC, which he considered would not be an 'effective sanction' (DTI 1992). The undertakings were drawn up and signed by Will Wyatt, Managing Director of BBC Television, on 4th November, two days before the minister's deadline. The BBC agreed to use only still trails, limited in 'style and duration' and linked in content to the preceding programme, except for the *Radio Times*. The BBC committed not to exceed seven minutes of television promotions for its magazines each week.

Under Prime Minister John Major (1990-97), government attacks on the BBC subsided and with it pressure on Enterprises (Barnett and Curry 1994:133). In addition to the undertakings, the BBC was already reducing its range of magazines. However, new commercial initiatives, including the launch of World Service Television and UK Gold, the first of several commercial joint ventures, were given explicit government support in the 1994 White Paper, *The Future of the BBC* (Goodwin 1998: 133-138). By the late 1990s, the BBC faced renewed criticism from commercial competitors. One, the British Internet Publishers' Alliance (BIPA) referred back to Sadler, but this is rare acknowledgement of influence on later policy debates. The main legacy of Sadler has been the broader mobilisation of commercial rivals to challenge BBC promotion as anti-competitive and unfair use of a dominant market position. In contrast, commercial publishers and broadcasters have been reluctant to establish CMP self-regulation that impinges on their editorial behaviour and judgement.

Left arguments and analysis

In the period of the *Enquiry*, the Labour Party, the TUC media committee, media trade unions and media reform groups, such as the Campaign for Press and Broadcasting Freedom, shared a common opposition to media concentration and advocated public service values in mass communications. Their responses, both during and after the *Enquiry*, are important in understanding why cross-promotion did not emerge as a policy issue.

Broadly, the position of the left was that the salient issue was cross-ownership. This shaped responses to the *Enquiry* and critical reaction to the report but it also had wider implications for policy demands. In their evidence, Mike Smith (TUC) and Tim Gopsill (NUJ), the CPBF and Norman Buchan MP all argued that any remedial measures aimed at cross-promotion could only have very limited effect while cross-ownership remained so prevalent.[24] This was, arguably, a fundamental and necessary critique of the limited terms of reference constructed by the government and further delimited by Sadler himself. Nevertheless, in hindsight, the opportunity was missed to develop a more substantive critique of cross-media promotion itself; instead, critique of commercial speech abuses was displaced. In the second reading debate on the Broadcasting Bill (Hansard 1989), Labour's Home Office spokesperson, Roy Hattersley, stated:

> I take this opportunity to make clear Labour Members' absolute commitment to greater diversity of media ownership. I make it clear that to us the problem of media ownership is not simply cross-promotion—newspapers plugging their own television channels, which is the subject of the inquiry that was announced last week—but cross-ownership. We should have a general reference to the [MMC] on the concentration of media ownership in fewer hands.[25]

The TUC argued that cross-promotion was a symptom of the 'fundamental problem' of cross-ownership (TUC 1991a:1; see also Sadler 1991: 25).[26] Nevertheless, Sadler adopted in weakened form proposals advanced by the TUC and others such as the media company Pearson (Sadler 1991: 17) on disclosure of interests. The TUC proposals were drawn by Head of Press Mike Smith, a former reporter, and Tim Gopsill, editor of *The Journalist*.[27] A TUC media committee meeting in March 1991 noted that Sadler's recommendations on disclosure were 'much in line with the TUC's evidence and if effectively enforced could ensure greater public awareness of the concentration of media ownership' (TUC 1991a: 3). By this time the immediate legislative battle over ownership was over. Disclosure measures were seen as a useful means of generating critical media literacy about ownership (TUC 1991a: 3). While no substitute for structural regulation, disclosure was identified as a useful, if modest, measure in its own right. Disclosure requirements could both educate readers and act as a countervailing influence to corporate interests on editorial decisions.

In the 1990s, as multimedia integration increased and government policy shifted from tackling media concentration to promoting 'convergence', it might be expected that the demand for disclosure would be pursued. As opinion shifted towards a more 'pragmatic' acceptance of increasing media concentration, it might be expected that disclosure would retain saliency as a

modest, behavioural regulatory measure. However, this did not occur. After Sadler, neither restricting cross-media promotion nor the remedies of disclosure were sustained as explicit policy demands by the unions, campaigners or academics until the end of the decade.[28] When cross-media promotion arose as a regulatory issue in the late 1990s, principally concerning digital television services and the BBC, it did so through the agency of commercial companies where it was framed almost exclusively as an economic competition issue (see Hardy 2004).

The Sadler *Enquiry* opened up explicit policy consideration of cross-promotion during a period of multimedia expansion. Some of its contradictions are evident in Ridley's initial justification for holding an independent enquiry. Ridley's acknowledgment that the issues raised went beyond competition legislation allowed cross-promotion to be addressed across existing regulatory approaches and paradigms. At the same time, his justification masked a tactical decision to divert issues of ownership and CMP from legislative scrutiny. The *Enquiry* itself was incrementalist and reactive. In dealing with the BBC, Sadler adopted an economic competition approach, while failing to conduct market analysis. Yet, in the case of newspaper cross-promotion, Sadler adopted a more complex, compound perspective drawing on the paradigms of liberal democracy (editorial integrity and independence), consumer welfare (transparency and disclosure) and competition. In each case, Sadler identified market failures requiring regulatory responses. But, while the BBC should be legally constrained in the interests of market competition, Sadler recommended self-regulation for newspapers because market competition could not be relied upon either to prevent abuses or to safeguard non-economic values of editorial propriety.

In the absence of legal or regulatory antecedents concerning cross-promotion, media industries were invited to define the field. This led the *Enquiry* towards a critical evaluation of the BBC along competition lines. However, the same openness also meant that editorial as well as economic behaviour was addressed. Sadler reported that cross-media integration might give rise to editorial abuses in addition to anti-competitive abuses. Since competition itself could not be relied upon, and competition regulation did not encompass editorial, there was a need for editorial standards to be separately enforced. Sadler recommended self-regulation, in line with government press policy. Nevertheless the proposals themselves pose insistent questions about the adequacy of regulatory systems that lack safeguards concerning cross-media promotion and commercial speech. That such questions could be avoided indicates the unwillingness of government to challenge press power,

the political strength of market actors, as well as the failure of media reformers to pursue demands for the Sadler recommendations to be acted upon.

From Concentration to Convergence

There is a ready and broadly accurate answer to the question why has CMP not emerged as an object of media policy in the period of multimedia expansion from the 1990s. Liberalisation policies, established by Western governments since the 1980s have led to the weakening of structural, behavioural and content regulation which served to constrain CMP and the favouring of market solutions over regulatory interventions. Yet key elements of older regulatory paradigms have persisted, even if this has meant survival through transformations and hybridising accommodations, as has occurred in Western European public service broadcasting systems. Politicians and regulators have also been forced to respond to new concerns in a rapidly evolving media scene, including those arising from the results of earlier liberalisation, by deploying a combination of regulatory tools. New problems arising from the commercial development of digital media and from technological and market convergence have led to burgeoning regulation. 'Deregulation' often results in both new layers and added complexity of regulation. In particular, McQuail and Siune (1992) highlight the importance of describing changes to media regulation as liberalising re-regulation as opposed to deregulation (McQuail and Siune 1992; Humphreys 1996). So the question of CMP is worth considering more carefully. In chapter seven I examine how CMP has been addressed in UK broadcasting regulation; here, drawing on broader studies of policy change I highlight key factors which have shaped the treatment of CMP (see Hardy 2008a; Goldberg et al. 1998a; MacLeod 1996; Sánchez-Tabernero et al. 1993; Hoffmann-Riem 1996; Humphreys 1996; McQuail and Siune 1998).

A common theme in accounts of Western media policy is the shift from what Winseck calls legislated divergence to 'convergence' policies (Winseck 1998). While change has occurred unevenly, a dominant trend has been increasing cross-media ownership. Convergence of firms, industries and markets has been stimulated by technological developments—digitalisation and technological convergence—and assisted by generally favourable regulatory responses to consolidation and cross-media ownership. Goldberg et al. (1998a: 2) whilst seeking to avoid a technological determinist account nevertheless argue that technological developments 'have encouraged consolidation through alliances between different companies, each trying to dominate emerging markets and to achieve a synergy of different but interdependent

parts of the market such as telecommunications, broadcasting and information technology' (Goldberg et al. 1998a: 2).

The gradual removal of technical and regulatory barriers in broadcasting encouraged new investors to enter the market (Leys 2001). Some were new entrants to media; others were media companies, 'seeking to diversify into other fields of activity in the pursuit of different markets, economies of scale, the exploitation of synergies between media sectors, the spreading of business risk, and so on' (Humphreys 1996: 202). Newspaper publishers were amongst the most important media owners to diversify both in terms of structural changes and as one of the key actors shaping government policies towards liberalisation. Humphreys (1996) identifies the main factors shaping this development in Western Europe. In the early 1980s mono-media press expansion was limited by regulation of ownership and by both low-growth but fiercely competitive markets. Diversification allowed risks to be spread. It also allowed companies to seek some 'future proofing' through acquiring electronic media interests. Press interests shared a 'defensive-offensive' motivation, fearing the loss of vital revenue from advertising to new media, notably cable and satellite, and of their share of the information market (Dyson and Humphreys 1990: 18). In addition, increased profitability from new technology and increased advertising revenues during the 1980s gave some press groups greater financial capacity to expand. Another key reason given for this development has been the achievement of 'synergy'. As Meier and Trappel (1998: 52) state:

> Since monomedia concentration has reached its limits in national markets, one could argue that a strategy for achieving synergies may be one of the most promising means of growth for large media companies. Therefore, mergers, acquisitions, joint ventures and strategic alliances play a role in cross-media concentration.

It is this process of cross-media integration and 'synergy' that has given rise to the conditions for cross-promotion. However, accounts of 'synergy' as a goal of consolidation vary significantly in their treatment. Dyson and Humphreys (1990: 18) describe companies' pursuit of 'trans-media synergy', using 'ownership of publishing, film, video, electronics and broadcasting interests to extract maximum creative value from a few top quality creative assets'. The consequence 'has been a rush to strategic acquisitions, mergers and joint ventures' (1990: 18). For Humphreys (1996) synergy refers to the possibility that editorial, journalistic and news-gathering tasks, expertise and resources, and other media-specific activities, could be shared. Gibbons (1999:168) highlights the leverage of cross-subsidies or technical expertise arising from CMO which raises concerns over media pluralism. While some accounts of cross-media integration, such as Humphreys above, ignore cross-promotion as a core

objective, others suggest it has been a key driver of corporate strategy (Doyle 1999). However, Doyle concludes from her study of trading performances of UK media companies following the 1996 Broadcasting Act, and interviews with senior managers, that 'there is no evidence to suggest that cross-ownership of television and newspapers is economically desirable' (Doyle 1999: 150). Aside from some 'back-office' efficiency savings, '[t]he only special advantage of cross-owning television and newspapers is the opportunity to cross-promote products' (Doyle 1999: 150). Doyle's argument is essentially that the UK government responded to considerable industry pressure to deregulate and masked its capitulation to service the commercial ambitions of media sectors with justifications based on 'convergence':

> Whereas deregulation of cross-ownership could otherwise have been clearly recognised as a response to special pleading from influential media owners, 'convergence' provided Ministers and policy-makers with a convenient and much more respectable argument for change—namely, that domestic companies should be allowed to avail of the 'obvious and natural' cross-synergies between newspaper publishing and broadcasting. (Doyle 1999: 153)

Ownership and paradigm shifts in regulation

From the early 1980s policy-makers and analysts began to anticipate the future convergence of communications industries and consider which models of regulation were most appropriate. During this period there was considerable focus on the 'vulnerable values' and 'novel conditions' (Blumler 1992) in Western public service broadcasting (Dyson et al. 1988; Ferguson, 1986, 1991; McQuail and Siune 1986; Siune and Treutszchler 1992; Petley and Romano 1993). Dyson and Humphreys (1990) identified as key trends in European communications policy, challenges to the legitimacy of 'public service' principles and provision; the displacement of a cultural by an economic conception of communication; the internationalization and diversification of business operations; the impact of technological innovation (including undermining scarcity rationales for broadcasting regulation); ideological changes including political frustration with the performance of public-service operators.[29] Such debates intensified in the 1990s as governments began to radically reshape communications regulation. In the European Union, the Bangemann report (EC 1994) was influential in arguing that Europe should develop a strong commercial communications market capable of competing worldwide. To achieve this, national rules on media concentration and cross-ownership should be swept away and broadcasting liberalised to facilitate the creation of large companies capable of financing and building the information infrastructure required for Europe's economic growth. Mapping these changes scholars

have argued that paradigmatic shifts in communications regulation have occurred from the 1980s (Hoffmann-Riem 1996; Van Cuilenburg and McQuail 2002; see Hardy 2008a: 141-2). This has involved a shift from broader public policy considerations towards limited intervention on economic and consumer welfare grounds; market mechanisms, industry self-regulation and general competition regulation have been favoured, with content regulation limited mainly to broadcast media; intervention on behalf of social-cultural goals and citizenship has been disfavoured with a growing presumption against 'interference' with market mechanisms.

In the UK, deregulation and the shift towards market liberalisation intensified from the early 1980s, but there have also been some significant, although less effective, countervailing political and institutional forces rendering the process protracted and uneven (O'Malley 1994; Goodwin 1998; Barnett and Curry 1994; Graham et al. 1998; Gibbons 1998). These developments also need to be understood in an extra-media context in particular in the ascendancy of neoliberalism shaping political and policy responses, and the decline of a liberal corporatist settlement shaping broadcasting and other sectors of the economy (Curran and Leys 2000). Indeed, deregulation cannot be properly understood by examining factors internal to the regulation of television, or even communication industries, but only in this broader context. Such an approach underlies Horwitz's (1989) exemplary account of the Reagan era reforms of broadcasting and telecommunications.

In the UK, market competition and self-regulation were favoured (at least ideologically if often not concretely) over interventionist 'command and control' regulation. A broader shift towards regulatory rationality, whose various components were endorsed from radically opposed political perspectives, thus deepened the crisis of legitimation for an older 'public interest' regulatory paradigm in communications. National governments have favoured the convergence, consolidation and integration of communication companies (Cavallin 1998). Processes of digitalisation and technological convergence, while complex and uneven, have undoubtedly influenced the weakening of sectoral regulation and command and control measures (such as entry control) which have underpinned broadcasting regulation (Flew 2002). Technological changes, it is argued, have undermined the rationales (scarcity; market failure), desirability and capacity of sectoral regulation, in particular content regulation.[30] In addition policy and governance are shifting from national governments to supranational institutions such as the European Union and World Trade Organisation. International trade agreements are 'moving the locus of media governance from national, discretionary and industry-specific forms of

regulation, towards internationalized, legally binding and generic forms of media governance' (Flew 2002: 119).

Communications policy under Labour

In June 2001, Labour secured the second term in office that had been a key goal of Tony Blair's programme of 'modernisation'. Blair committed Labour to 'moving beyond the solutions of the old left and the new right' (cited in Heffernan 2001: 19). Yet while the values of old Labour were marginalised, Labour adopted the Thatcherite inheritance in many policy areas, including communications. Policy was predicated on a vision of the convergence and market-led expansion of communications services (Freedman 2008; Hardy 2008b). Labour favoured market competition as best able to achieve pro-social benefits and secure many of the objectives of traditional communications policy, such as pluralism and diversity. As the 1998 Green Paper put it (DTI/DCMS 1998: 10):

> The regulatory structure should seek to allow markets to develop organically, while providing the necessary protection for consumers and business. The Government will seek to provide a structure which reflects market realities and will seek to distort them as little as possible.

Aside from the review of BBC funding and commercial activities, cross-promotion did not arise as a topic in government policy documents or debates until the passage of the Communications Bill when concerns were raised about future cross-media promotion between Sky and a Murdoch-owned Channel Five. However, the shift towards pro-convergence policies favouring multimedia integration involved an implicit, if not always explicit, normalisation of cross-promotion. This is clearest in the 1998 Green Paper, *Regulating Communications*. Scottish Media Group (SMG) was praised as a company whose multi-sectoral integration provided advertisers with 'a full range of advertising vehicles, from the local newspaper and specialist magazine, to prime-time advertising on the ITV network. This can be adapted to suit a wide range of client needs' (DTI/DCM 1998: 49). Elsewhere the paper enthused that 'Granada is also active in linking themed channels to publications' (A.31).

From 2001, during the process that led to the Communications Act 2003, CMP did re-emerge briefly as regulatory issue. While it did not appear explicitly in any official documents and draft legislation after the 1998 Green Paper,[31] it did emerge as a topic, formulated in two main ways, during the passage of the Bill. First, commercial publishers, rival media companies and various media commentators increased pressure for restrictions on BBC cross-promotion, a key demand within broader calls to curb BBC expansion. In

December 2002, Tessa Jowell announced a review of BBCi (formerly BBC Online). This followed the review of BBC News 24 and engaged the same agenda of assessing the market impact of BBC activities, but now issues of cross-promotion were more central. Second, the government's proposal, subsequently adopted, to relax the 1990 cross-ownership rules for Channel Five would remove the legislative barrier preventing Murdoch's News Corporation from purchasing Channel Five. Amongst the fierce debate around the so-called 'Murdoch clause', was concern that Murdoch could use Five to cross-promote BSkyB's channels, strengthening his grip on UK media and the digital 'gateway'. *Guardian* journalist, and longstanding Murdoch critic, Polly Toynbee (2003: 24) warned that Channel Five would be 'invaluable' to Murdoch: 'He could buy up sports rights for both terrestrial and satellite, outbidding all-comers, cross-promoting across his newspapers and two TV platforms. With Murdoch behind it, Channel 5 could destroy ITV as it is unshackled by ITV's public service obligations'. In *The Times*, Ray Snoddy (2003) reported concerns that Murdoch's control of Five would 'create unprecedented media power'. He went on '[i]t might although the theory sees Five, which at the moment has an audience share of just over 6 per cent and 80 per cent national coverage, mainly as a promotional vehicle for Sky.'[32]

Labour peer, Lord Puttnam, who chaired the joint Parliamentary Committee which scrutinised the Draft Communications Bill, led a rebellion of peers opposed to liberalisation of cross-media ownership laws. Signalling his intentions in March 2003, he stated that the Committee was 'never able to get any sensible answer' from ministers when questioning them about their motives for introducing the so-called 'Murdoch clause'. They also displayed a 'willful refusal' to discuss the thorny issue of cross-media promotion (Wells and Perkins 2003). Steven Barnett, who had given evidence to the Sadler Enquiry, organised letters signed by five senior academics that appeared in the *Financial Times* (Barnett et al. 2003a, 2003b; Burt 2003a).[33] Faced with mounting opposition, the government responded. Tessa Jowell warned that rules on cross-media promotion might have to be revisited if, in future, Five was used as a promotional vehicle for Sky (Snoddy 2003). In a newspaper interview (Burrell 2003:7) she stated:

> We would, if it were necessary, ask Ofcom to look again at cross-promotion in order to ensure that a newspaper proprietor could not abuse their position through the advertising outlets of channel Five.

Widely reported as a warning that 'she would introduce new rules to prevent [Murdoch] promoting his other interests', Jowell's statement explicitly acknowledged only abuses concerning advertising supply and indicated no

prohibitions on publicising cross-media interests, or editorial promotion. She stated that the public service obligations would be tightened if Five's market share increased to the point where it became a serious competitor to ITV. These comments, designed to reassure opponents and safeguard the bill's proposals, were accompanied by a robust defence of consolidation; takeover of Five by a large media group such as News Corporation, would be 'good and progressive' (Burrell 2003: 7).[34]

While, the BBC and Murdoch received most attention, other consideration was given to cross-promotion. The author addressed CMP in submissions and lobbying, including meetings with Tessa Jowell, members of the Joint Committee, MPs and Peers (CPBF 2000, 2001a, 2001b). In *The Guardian* Tambini (2003) referred to regulators' 'struggle to keep up with aggressive cross-media promotion', citing this as one of several aspects of regulation needing 'more updating than is provided in the bill'. Janet Goldsmith (2003) of Universal Studios Network, one of the contributors to the ITC consultation on cross-promotion (see chapter seven), argued in the *Financial Times* that CMP was an outstanding issue that OFCOM must address. During 2002–3, then, various efforts were made to reintroduce CMP as a regulatory issue. Apart from attacks on the BBC, however, no corporate media or advertising interest advocated sectoral regulations governing CMP. Amongst non-corporate policy actors, efforts were made to (re)establish CMP as a critical issue, and these had some influence on sympathetic politicians. This occurred in the context of broader efforts to reassert public interest considerations at the heart of media regulation. Significantly, however, throughout the government did not explicitly acknowledge CMP as a regulatory issue.

Competition regulation

Competition law has become an increasingly important instrument of media regulation, especially at EC level. In the absence of specific legislation for the regulation of media concentration (Harcourt 1996, 2005; Doyle 2002a; Humphreys 1996; Kaitatzi-Whitlock 1996; Collins 1994; Sarikakis 2004), the European Commission has relied increasingly on the competition provisions of the Treaty of Rome (see Hardy 2008a). EC competition regulation has so far not addressed CMP, either directly as a substantive issue in its own right or in assessing market power in respect of mergers and acquisitions.

Through the licensing of broadcasting and controls on newspaper concentration the UK, like other Western European states, has operated a system of structural controls governing vertical, horizontal and cross-sectoral integration. Up to the early 1990s policy reflected a political consensus that general com-

petition law was insufficient as an instrument to meet public policy objectives in regard to the media, in particular pluralism, diversity and quality. The 1990 Broadcasting Act introduced new sectoral rules on ownership and gave the ITC specific quasi-competition powers. The Competition Act 1998 which incorporated much of EC competition law into domestic law (see Taylor 1999; Feintuck and Varney 2006) retained the stricter regime which applies to newspaper mergers than general mergers. The newspaper regime was subsequently amended by the Enterprise Act 2002 and then in 2003 by the Communications Act increasing the scope for newspaper consolidation but retaining mechanisms to prevent mergers on grounds of plurality and public interest.

Outside of the period of activity which led to the Sadler *Enquiry* and MMC investigation (1988-1992), CMP has not been addressed in any substantive way by general competition authorities in the UK, only by communications regulators in respect of digital TV cross-promotion (chapter seven). The lengthy investigation of the pay TV market by the Office of Fair Trading (OFT) in particular, highlights how CMP has been neglected. In December 1995 the OFT launched an enquiry into BSkyB examining its position in the market (Aitman 1996: 479; Goldberg et al. 1998b). Aitman (1996) found that the OFT failed to address several of the main causes of BSkyB's dominance; to his own list may be added cross-promotion. The OFT addressed cross-promotion but only in respect of investigating whether cross-promotion of channels by BSkyB was used as a means of compelling cable operators to carry new channels. Some cable companies had complained that BSkyB's cross-promotion of its channels acted as an inducement on them to take channel bundles (so called 'full line forcing'), the source of their principal complaint regarding BSkyB's wholesale practices. They argued that cross-promotion created an expectation among cable customers that they could receive promoted channels and that this 'could place cable operators under undue pressure to take all BSkyB channels' (OFT 1996: 15), replicating the anti-competitive effect of full line forcing. BSkyB refuted the charge, stating that cable operators were not forced to take all BSkyB's channels. Secondly, BSkyB challenged as 'highly discriminatory' and 'completely unacceptable' the suggestion that cable operators should be able to block out promotions for channels not carried by them (OFT 1996: 109) This would allow 'a distributor to demand that he should alter the nature and characteristics of another producer's product in his favour but to the detriment of the producer's interest' (OFT 1996: 109). The OFT accepted BSkyB's argument, concluding that the evidence available, itself largely derived from BSkyB, did not support the complaint.

The OFT's approach to the cable companies' complaint meant that it did not directly address cross-promotion of premium channels by Sky. The complaint, by cable companies representing 53% of the market, that they faced pressure to carry Sky Sports 2 because of cross-promotion of the channel on Sky Sports 1 (OFT 1996: 78) was not addressed. More significantly the definition of the relevant market itself, as the Pay TV market, limited from the outset consideration of wider aspects of market power. Only Pearson, in its evidence to the review identified News International's newspapers as one of six factors accounting for BSkyB's market dominance, namely 'BSkyB's ability to cross-promote its channels within its package and provide market support through its newspaper links' (OFT 1996: 66). Five years on from Sadler, the OFT applied a more rigorous competition regulation approach but one framed within a much narrower, and ironically more mono-media, conception of the relevant market. The OFT report neglected to address matters that had triggered Sadler five years earlier, namely, the cross-promotion in newspapers of allied television interests. Despite the residual sector-specific components in UK competition law, cross-media promotion has not been addressed by general competition authorities since the early 1990s.

There is no doubt that EC and UK competition regulation is capable of addressing cross-promotion. Beyond the significance that competition regulation has not done so lies a broader critical debate about the adequacy of competition regulation as a substitute for sectoral regulation (Doyle 2002a; Humphreys 2000: 90). In assessing market power through economic considerations, competition law is unable to grasp more complex operations of cultural or symbolic power which regulation of media pluralism has traditionally sought to address. Some recognition that economic considerations are insufficient to address issues of pluralism and editorial is reflected in the public interest tests established for UK media mergers. The Enterprise Act 2002, as amended by the Communications Act 2003, recognises the power of the secretary of state to refer media mergers to both Ofcom and the Competition Commission to report on the 'public interest' issues, and grants the minister powers to interfere in the merger on such grounds (Feintuck and Varney 2006: 95). In this way, UK competition regulation makes some provision for departures from economic analysis. However the lack of cases makes it hard to estimate the extent to which 'public interest' considerations will apply (Feintuck and Varney 2006: 98–100) and no such case has moved beyond the important but narrow considerations for pluralism and diversity set out in the tests to address CMP.

Conclusion

Regulatory responses to CMP in 1988–2008 can only be properly understood in the broader context of the legal, institutional and ideational development of UK media policy. The latter has been contradictory, fragmented and haphazard. Liberal press theory has influenced lack of policy, integration and coherence (Seymour-Ure 1987; Curran 1995) and non-decision making (Hitchens 1995). Explanations for the historically divergent regulation of press and broadcasting (Curran and Seaton 2010) are integral to explaining the regulatory treatment of CMP. Successive UK governments have been reluctant to be seen to interfere with editorial freedom. Yet concerns about owner and advertiser influence have shaped governance of public service broadcasting and generated detailed regulation of content and advertising in commercial broadcasting. Regulation of advertising expanded into new media but acknowledged as its boundary principles of freedom of expression governing media speech. CMP, in particular embedded promotional speech, has remained largely unformed on the contested regulatory borders between editorial and advertising. Cross-media promotion was constrained by media ownership rules, but as regulation has shifted towards competition regulation CMP has not been recognised within legislation or determinations of market power. CMP has lacked 'legal substance' (Daintith 1998). This legal, but also institutional and ideational, 'lack' has shaped the way in which CMP has been addressed in an era of re-regulation and convergence. One key area where CMP has been addressed, however, has been in broadcasting regulation, and this is examined in the next chapter before broader conclusions are offered about the regulatory treatment of CMP.

Notes

1. Sadler (2002) acknowledged this was a limited 'fishing expedition'; 'if there had been a whale around I'd have done something more'.

2. See Bunton (2000) on the regulatory role of journalism reviews in the United States.

3. The NUJ first adopted a 'Code of Professional Conduct' in 1936, being one of the first professions internationally to develop such codes. See O'Malley 1997; Frost 2000: 224–225.

4. Robertson and Nicol (1982) note the weakness in enforcement of the NUJ Code. This has been further exacerbated by widespread de-recognition of the union and erosion of the NUJ's power in the workplace.

5. While the NUJ and PCC codes are both brief, other European codes are more detailed and some, like Sweden's which covers press and broadcasting, include detailed rules in the category of editorial advertising alone (see www.uta.fi/ethicnet/sweden.html). The Swedish

code states that nothing should be published among editorial material that is not motivated by journalistic purpose and that 'Newspapers'/ Broadcasting companies' advertisements for their own products and services as well as own arrangements shall be presented as advertisements' (trans. Tiina Laitila).

6. This followed the report of the Moloney Committee (Final Report of the Committee on Consumer Protection, Cmnd 1781 (1962); See Munro 1997: 9).

7. This section summarises a more detailed, unpublished study of the Sadler *Enquiry* in Hardy (2004a).

8. Sadler (2002) argues that the DGFT 'wanted to get [NI] before the Monopolies Commission on one pretext or another' and saw in BSB's complaint the possibility to do so.

9. Sadler (2002) recalls that Murdoch 'sent his tanks up Downing Street [. . .]what emerged was a means of heading off an MMC investigation'.

10. Sadler also held meetings with government and regulatory bodies.

11. See Born and Prosser (2001).

12. Sadler told the MMC (1992) that he considered the BBC to be in a 'monopoly position' and that the key issue was 'denial of access' in the refusal to supply advertising space.

13. Sadler's other two principles were 'disclosure of media interests' and 'journalistic freedom from undue [corporate] pressure'.

14. The BBC defended its commercial activities as compatible with its public service role. It justified the promotions on the grounds of negligible market(ing) impact, their informational as opposed to 'advertising' role, the special nature of the magazines, and the efficacy of BBC editorial controls.

15. As the TUC (1991b) put it, 'what started as an inquiry into cross promotion within the Murdoch empire ended as an attack on BBC funding'.

16. In a letter to Lilley the TUC (1991c) stated, 'The solution is not for the BBC to drift into advertising which could result in an extension of commercially funded advertising'. Writing to media union general secretaries it stated (1991b) the BBC should 'not be forced into competitive funding ventures'.

17. In evidence to the MMC (1992), Sadler acknowledged there might have been 'collusion' amongst publishers, but added, 'the fact that there were at least four magazine groups saying virtually the same thing to me I think added a bit of weight, and in respect of different markets'. Asked to comment on Reed's broadcasting interests influencing the company's argument against the BBC, he replied: 'The showers of sparks from the grinding axes would have almost set light to the DTI'.

18. Lilley had replaced Ridley in July 1989 following the latter's resignation following criticism of anti-German remarks (see Young 1993: 572).

19. In *The Times* Waddington (1990) wrote '[i]f this last chance is spurned' those arguing for statutory controls 'will be impossible to resist'.

20. A Home Office Memo on 7 March 1991 states: '[a]s regards the direct implications of this extension for press freedom, we should avoid any serious difficulty if (unlike with Calcutt) we do not start pressurising the industry. DTI's consultation period would allow them to size up the idea, and maybe come to terms with it under Lord McGregor's leadership. It might not work, but given our rather delicate relations with the press it seems the only

sensible course. And if the whole code became statutory for Calcutt reasons in due course, no obvious harm would arise in the cross-promotion context'.

21. Gibbons (1998:226) notes the 'complete lack of enthusiasm', by industry and government to implement a self-regulatory code. However he fails to mention the 1994 Code, as do later scholars who draw mainly on Gibbons' account (Barendt and Hitchens 2000).

22. The MMC argued that the IBA and ITC (between 1991–1993) were the 'broadcaster' of ITV and of BSkyB's licensed transmissions. Since the ITC did not supply any of the goods publicised during such broadcasting of ITV or BSKYB the MMC judged that neither fell into the terms of reference set by the DGFT (1992:15). The ITC criticised this formulation as a 'legal fiction' (MMC 1992: 76). The MMCs definition excluded the actual suppliers of services, namely the TV companies, but did reveal the limited extent of cross-promotion by ITV in the early 1990s.

23. In two sectors, listings and gardening, the distortion had no adverse effects on the public interest, although the MMC considered this was likely to arise in the absence of 'suitable constraints' on promotions. The judgement rested on calculations of market dominance, since the BBC's share of the food and cookery market was 90% as against 43% for general gardening and 32% for television listings (MMC 1992).

24. The CPBF is a UK civil society organisation, established in 1979, that campaigns for a more democratic, accountable and pluralistic media (see www.cpbf.org.uk; Hackett and Carroll 2006).

25. In the same speech, Hattersley criticised the government for its failure to extend the rules restricting cross-ownership of newspapers and television to satellite services.

26. The TUC activity on Sadler was amongst the last such media policy initiatives before it was reorganised. Under the new General Secretary, John Monks, the TUC ceded policy, including the media, to the relevant unions and consortia, such as the Federation of Entertainment Unions. The TUC, with Labour, also shifted concern from structural media reform to strategies for improving communication effectiveness and media relations (Smith 2002).

27. Sadler (2002) could not recall precisely where disclosure proposals originated. Other policy actors, such as the Association of Media Independents, made similar proposals, although it is unclear how many were made in response to questions from Sadler.

28. For instance, cross-promotion was not addressed throughout the public hearings that accompanied Clive Soley's MP's Freedom and Responsibility of the Press Bill (1992), except by the TUC who said the bill failed to deal with 'broader questions of concern . . . such as cross media promotion and ownership' (Jempson 1993:160; O'Malley and Soley 2000).

29. In line with the present study, the authors argued that communications policies in Western Europe cannot be accounted for as the outcome of 'technological or market determinism', instead '[a] more detailed study of the responses of international institutions and of national policy networks reveals a much more complex picture' (Dyson and Humphreys 1990: 29).

30. The House of Commons Selection Committee on Culture Media Sport argued that while positive content regulation could be maintained through PSB, negative content regulation would become impossible. See POST (2001: 63–64).

31. CMP is, of course, affected by provisions on media ownership, competition regulation, regulation of broadcast advertising and the removal of restrictions on advertising agencies

owning broadcasting licenses. The Communications Bill grants OFCOM similar powers to regulate advertising as set out in the 1990 Act but provides for co-regulation of broadcast advertising to be introduced.

32. In the same article, Snoddy quoted Barry Diller's attack on the Communications Bill in his speech at the NAB conference: '[c]onglomerates buy eyeballs. That's it. They leverage their producing power to drive content, their distributional power to drive new services and their promotional power to literally obliterate competitors'.

33. A former BSB press officer, Chris McLaughlin (2003) wrote to the *Financial Times* arguing against Murdoch ownership of Channel Five, stating that 'the line should have been drawn in 1988 not 2003'.

34. Mimi Turner in *Hollywood Reporter* 4 June 2003 noted 'Jowell's comments are likely to be read as a bid to appease the concerns of parliamentary colleagues in the House of Lords'

Convergence and Cross-Promotion in Digital Television

This chapter examines the growing complexity of cross-promotion in UK television and evaluates efforts to address and revise its regulation over the last decade. Programme promotion has always been an integral part of the 'flow' of broadcast output (Williams 1974). It was accepted as normal behaviour by broadcasters and remained largely unregulated outside of general rules on programme content. As UK broadcasting expanded, limited cross-media promotion between the public service broadcaster's two channels BBC1 and 2 was incorporated as an acceptable practice of programme promotion, providing information of interest and benefit to viewers. However, if the provision of programme information has been seen as enhancing consumer welfare, 'promotion' of commercial services has been treated differently. Principles of editorial integrity and the separation of editorial and advertising informed regulatory rules which have acted upon broadcasters' promotion of their related goods and services, affecting what could be promoted, where and in what form.

Cross-promotion in UK Television

The cross-promotion of goods and services in which broadcasters have an economic interest has been regulated according to such factors as the 'place' of promotion (whether within programmes, in 'promotional time', in designated advertising time), the character of the product or good promoted, and the characteristics of the promotion itself. Three main types of promotion need to be distinguished as these have been subject to different regulatory treatment.

(i) Programme trails and announcements

These have been treated as broadcaster's content and subject to general rules on programme content and scheduling. There have been restrictions on the amount of time devoted to promos between programmes.

(ii) Promotion of commercial services and products

The promotion and cross-promotion of commercial services have been heavily regulated as this chapter shows.

(iii) In-programme promotion

There have also been strict rules prohibiting commercial references in programmes. This is considered more fully in chapter eight, which examines product placement and product integration.

This chapter examines how these regulatory arrangements were problematised by the expansion of multichannel television, multimedia output, and cross-platform promotions.

Regulating broadcasters' promotion of commercial goods

The Independent Broadcasting Authority (IBA; 1972–1990), which replaced the ITA in 1972, addressed growing commercial pressures including broadcasters' promotion of their own or associated commercial products and services. In 1977 the Annan Committee approved the IBA's recently published guidance on 'indirect advertising', which addressed, along with such issues as third-party sponsorship appearing in programmes (for instance, trackside banners in sports programmes), 'the promotion of products, such as books, which are the spin-off of television programmes' (Annan 1977: 169). The Committee said the IBA's guidelines were less successful at dealing with 'clandestine advertising'.

Annan considered a case of what would be called 'plugola' in the United States, concerning a pop music programme on London Weekend Television packaged by a television producer in collaboration with recording artists 'who seemed in effect to be invited to buy time on the programme' (Annan 1977:169). Thus, the committee noted that 'such programmes could lead to the public being misled into watching programmes which in effect were elaborate advertisements for commercial interests'. It concluded '[i]t may be necessary to ensure in future legislation that programmes are not used to promote the private business interests of their producers' (Annan 1977:169). The

subsequent White Paper, issued by the Home Office in 1978, rejected the Annan Committee's recommendations (Home Office 1978: 55-56) but identified a general question that arose from its report: 'Are there adequate safeguards to ensure that the programme contractors (whether for television or local radio) do not abuse the monopoly position which their contracts confer on them to further their other interests by unfair means'? It recommended that the IBA should keep these matters under review while acknowledging that the matter was wider than the Authority's responsibilities for broadcasting.

As the ITCA pointed out in evidence to the Annan Committee (Annan 1977), ITV was 'founded on diversification out of other industries such as newspapers, cinema and the theatre'. From its inception, various media and non-media interests invested in commercial television including television rental companies and hardware manufacturers as well as those involved in 'software' and talent from theatre, film and other entertainment industries (Seymour-Ure 1991). These patterns of financial involvement are particularly important since television was always intimately related to entertainment ('show business') and other media, drawing in personnel and performances from theatre, music hall or newspapers. With varying degrees of intensity and intentionality television promoted other media, just as appearance on television became a promotional asset to exploit elsewhere. From the outset there were complex forms of promotional reflexivity concerning broadcasters' commercial interests. Such promotion was restricted by structural and content regulation, although section 4 (6) (b) of the Television Act 1954 specifically permitted 'review of literary, artistic or other publications or productions including current entertainment' in programmes, as well as 'factual portrayals of doings, happening, places or things' provided there was no 'undue element of advertisement' in the latter.

Most of the ITV franchises were owned by companies with other media and non-media interests, but there was limited cross-promotion of broadcasters' own commercial goods and services. While financial investment in ITV and diversification enabled complex intra-firm interests to evolve, especially from the 1970s, various factors constrained their development: market structure limited incentives; professional culture upheld public service values and programming over marketing; and regulatory constraints on editorial, sponsorship and advertising restricted cross-promotion and prevented it acting as a significant incentive for diversification.

Since its creation, ITV has been mostly dependent on advertising revenue for its income (Henry 1986). Granted monopoly rights over television advertising in their franchise areas, by the time the franchises were reallocated in 1967

commercial television had become highly profitable, despite the Government's introduction of a variable levy on profits in 1963. However, slower growth in advertising and growing industrial unrest were factors in a downturn at the end of the 1960s when, between 1969–70 revenue fell by 12 per cent (Seymour-Ure 1992).[1]

Programme sales remained the second largest income source even when, in the 1990s, sponsorship income increased as a proportion of total income. Income from publications, audio-visual or other merchandise, or licensing (other than programmes) remained very small by comparison, only starting to increase significantly in the 1990s. Describing the period 1968–1980, Potter (1989: 192) writes:

> Except for a relatively small supplementary income from the profits of its programme journal [*TV Times*], from the sale of programmes overseas and from investments, ITV is dependent for its existence on the sale of airtime to advertisers . . .

Such revenue levels also reflected the fact that the ITV companies generally preferred to share risks through licensing agreements in which they would obtain royalties from sales of books, records and other merchandise produced by other companies. Nevertheless, from the 1970s cross-promotion of goods produced or licensed by television companies started to increase. Describing UK television as a whole, Seymour-Ure (1991: 144) states:

> By the early 1970s mixed-media tie-ins and marketing of records, TV series and books were well developed and would increase. They had a major international dimension, as TV programmes were made for overseas markets, books were packaged for mass readership, feature articles were syndicated worldwide. They ranged from the modest puffing of his travel book by a visiting American author on Radio 4 to the screening of pre-launch films about the making of big-budget movies such as *Gandhi*. Little in these practices was new but they became endemic.

For ITV the main object of cross-media promotion was *TV Times* magazine. The first issue came out in 22 Sept 1955 and a year later circulation had grown to one million (Sendall 1982: 126). ITAP, the wholly owned publishing arm of the ITV companies, published *TV Times* and produced annuals, books and other one-off publications featuring programmes and stars. Aside from *TV Times* itself, these products contributed only very modestly to ITV revenues, but they were cross-promoted through stills at the end of programmes, voice-overs, as well as in-programme mentions. *TV Times* was eventually sold to Reed International in June 1989.[2] Part of the sale arrangements was that from 1989 to 1992 each ITV company undertook to provide seven minutes each week of promotion for *TV Times* and another magazine, *Look-in!* During this period, promotional trails for *TV Times* reached some 30 a week (MMC 1992: 23).

Examining ITV finances in 1991, the MMC (1992) calculated that only Thames (£600,000) and Central (£350,000) generated sales of any significant size from goods that they or their associates supplied. However, the MMC estimated gross revenue (including royalty income) of £3 million for the whole commercial TV sector, based on gross sales revenue of £20m for goods supplied (compared to £144 million for BBC) (MMC 1992: 26).

The cross-media promotion of broadcasters' commercial products was first explicitly addressed by the Sadler Enquiry (Sadler 1991), which led to an investigation by the Monopolies and Mergers Commission (MMC 1992). In its report, Television Broadcast Services, the MMC (1992) found that the promotion of broadcasters' goods and services on commercial television was economically insignificant[3] (in contrast to that of the BBC), although it stated (MMC 1992: 3):

> What has emerged more generally, however, is the need for broadcasters to distinguish between the provision of information about products that is useful to viewers but does not attempt to persuade them to make a purchase, and paid-for advertising of products that has a persuasive aim. It is clear to us that this is an issue that is likely to grow in significance as the television broadcasting industry, and its links with other commercial activities such as publishing, becomes more complex.

The Independent Television Commission (ITC), established by the 1990 Broadcasting Act, allowed only ancillary material to be promoted at the end of programmes (1997c). So-called 'programme-related materials' such as fact-sheets, that were provided for the benefit of viewers, usually on a cost-only basis, could be mentioned between, or at the end of, programmes. Promotion of broadcasters' commercial products and services was only permitted within allowable advertising time, known as 'minutage', that was subject to restrictions across the day, day-parts and in clock hours of broadcasting. Such intra-firm promotion, then, had to be weighed against realizing value by selling the allocated time for third-party advertising. In-programme promotion was prohibited. References to commercial products or services could be made in programmes but only where these were informational rather than promotional, editorially justified, and not unduly prominent.

If programme promotion was largely normalised and cross-promotion of broadcasters' other commercial interests strictly circumscribed, the 1990s brought a combination of new challenges to problematise these arrangements. The regulatory framework came under growing pressure as the forms and varieties of CMP multiplied and their strategic importance increased. With the advent of cable, satellite and later digital television, multichannel broadcasters and platform-operators cross-promoted programmes, channels, suites of channels, platforms and digital services in which they had economic or strategic

interests. This gave rise, principally, to complaints from rival broadcasters or platform operators about the actual or potential impact on competition from cross-promotion. By the late 1990s, the ITC was forced to confront problems arising from increasing competition among broadcasters and delivery platforms, and intensifying on-screen promotions.

Changes in UK television ✓

Chapter one described the factors giving rise to increasing cross-media promotion in the US media system. The same underlying processes leading to increasing promotion and cross-promotion are discernible in the UK, but, of course, broadcasting from its inception developed very differently in each country. In the UK, commercial broadcasting began thirty years after the US, as part of a public service system with considerable structural, content and behavioural regulatory oversight.[4] The system of commercial broadcasting introduced in 1954 was one of strictly regulated competition between ITV and BBC. The launch of Channel 4 in 1982 introduced further competition for audiences but from within a system of public service obligations and detailed rules to minimise the perceived adverse effects of competition. From the 1970s public service systems across Western Europe faced up to various, unprecedented pressures (Blumler 1992) that arose as governments sanctioned a massive expansion of television across Europe, organised, for the most part along commercial rather than public service lines (Dyson et al. 1988; Siune and Treutzschler 1992; Humphreys 1996; Dahlgren 2000; Hardy 2008a). This allowed competitors into formerly monopolistic or tightly regulated systems.[5]

Under the Conservatives (1979–1997), UK broadcasting policy favoured increasing competition, embracing new technologies of cable, and satellite in the 1980s and digitalisation of television in the 1990s (Goodwin 1998). The cable television services introduced in the 1980s were relatively insignificant in audience share but provided investment opportunities for capital and were subject to new 'light touch' regulation.[6] BSkyB's satellite service, also subject to minimal regulation, introduced much more significant competition for the terrestrial broadcasters. Audiences for the two main terrestrial channels declined sharply during the 1990s as competition increased from satellite, a revived cable television industry and a strongly performing fifth terrestrial channel, Channel 5. As in the US, increasing competition led broadcasters to devote more marketing effort to attracting and retaining audiences. Competition for revenue encouraged diversification into multiple sources of income, including merchandising and multimedia expansion. Competition also in-

creased pressures to accommodate intra-firm as well as advertisers' interests in programming, content, and integrated or cross-marketing.

Television promotion \/

When UK television began, broadcast for limited hours per day, so-called interludes were filled with sequences filmed from a static camera designed to provide a soothing pause between programmes (Meech 1999).[7] Television also incorporated the promotional patterns of radio, with 'announcers' informing viewers of the next programme by voice over images. Programme promotion became gradually more sophisticated as competition grew between the BBC and ITV. With the creation of BBC 2, the BBC began what may be considered *cross-media* promotion, trailing and announcing the schedule of programmes on the other channel. And, from 1982 the ITV companies were required by statutory law to cross-promote Channel Four by making programme announcements and carrying trails and promos. However, most programme promotion remained directed at forthcoming programmes on the same channel (known as 'trails').

Two basic types of on-air promotion can be distinguished: topical or 'tune-in' promotion and image promotion. According to Eastman et al. (2002: 5–6):

> Most network and television promotion is tied to the daily content of individual series episodes and news stories. Networks refer to these tune-in promos as topicals or episodics [. . .] In contrast, promotion and advertising that focus on the overall qualities of a station, system or network, not tied to any day's individual episodes or news stories, are image promotions.

Already, by the mid-1990s, the break between programmes (known as the 'junction') had been transformed. One element, of growing importance, was channel branding and self-promotion. By 1998 all the major UK broadcasters had either rebranded themselves (or launched) in the two years before digital television services began (Meech 1999: 39). A study of promotions running across the five terrestrial channels and Sky One on selected dates in August 2000 (see table 7.1.) found that Sky ran almost three times as many as any terrestrial broadcaster.

Table 7.1

Number of promos shown per day (0900–midnight) in August 2000

Date	8	11	12	13	Average
BBC1	43	67	37	50	49
BBC2	74	65	41	36	54
ITV60	65	41	54	55	

C4	61	68	32	42	51
C5	60	58	35	48	50
Sky One	133	140	135	145	138

(Source Peaktime. Adapted from data in Carter 2000: 16-17)

While most of these promotions were for programmes (appearing on the same or associated channels), Sky and the BBC carried a significant proportion of promotions for their other media activities. On 8 August, Sky carried 65 promotions for other Sky channels and services out of a total of 133. The BBC promoted activities ranging from online services to radio, merchandise and BBC News 24. ITV, Channel Four and Channel Five put greater emphasis on programme over 'corporate' promotion, but both ITV and Channel Four extensively promoted their digital television services. Research conducted by the Billett Consultancy found that ITV in London devoted an average of two minutes per hour in peaktime to programme promotions.[8] Channel Four analysed peak hour promotions in channels (see table 7.2.) in one randomly selected week as follows:

Table 7.2 Peak hour promotions (28 April–4 May 2001)

Channel	Average in peak hours (in seconds)
BBC1	101
BBC2	53
ITV	108
Ch4	108
C5	83
Sky One	250

(Source: Channel Four 2001)

In television, identifiers (or IDs) refer to short segments scheduled during programme breaks to distinguish the start and end periods for advertisements (as required by the regulator). Channel 5, which began broadcasting in 1997, introduced a multicoloured line as a separator, as well as introducing to terrestrial television a 'dog' (digital on-screen graphic), a miniature translucent logo that remains on screen at all times (except advertising breaks) acting as a station signifier (Meech 1999: 40). Other types of channel promotion include 'specials' such as Sky Sports' 90-second promotion for its football coverage in 1997–1998.

Professionalism and marketing ethos

The teams creating promos and trailers 'have traditionally been disparaged by observers as [producing] formulaic hack work which is mass-produced to order' (Meech 1999:40). During the 1990s, however, the status of the various professionals involved was enhanced and followed the trajectory of professionalisation occurring earlier in related fields of marketing, advertising and public relations. Professionals involved in promotion, marketing and design in all electronic media have a lead body PROMAXBDA, bringing together PROMAX, the association for promotion and marketing professionals working in broadcast media and the Broadcast Designers' Association (BDA). In 2009, PROMAXBDA represented over 3,000 companies and individuals in over 70 countries, with a number of regional and country-wide branches including PROMAX UK established in 1989, now with over 700 members. PROMAX organises events and training, hosts annual awards and acts to promote 'the role marketing, promotion and design play in the value of media across content platforms' (PROMAXBDA 2009).

Technology, in particular, the development of sophisticated computer graphics and digital editing software has also been a factor in enhancing the form and profile of promotions. Technological innovation helped firms overcome various resource constraints, influencing both creative work and organisational structures. There has been a move to enhance in-house teams as well as to outsource work to specialist design and production agencies (Eastman 2002: 52; Meech 1999) With enhanced resources, some promotions are now produced to the standard and budget of premium television drama and advertising. The changing status of promotions is clearly evident in the case of ITV. Before 1998 programme promotions were the responsibility of each company in the ITV network, subsequently on-air promotions were centrally planned and produced by a new network promotions unit which, by 2000, had 35 employees (Carter 2000: 16–17). Television promotions were increasingly sophisticated, planned according to the same principles as major marketing and advertising campaigns. Promotions have their own target television ratings (TVRs), and it has become common to devise a creative brief, marketing and media planning strategy for each programme promoted. These developments have occurred across broadcasting. According to Sky One's creative director, Andi Granger (quoted in Carter 2000: 16–17):

> The worlds of on-air promotions and advertising have never been closer. Broadcasters are adopting advertising and media planning techniques and now employ copywriters in-house and talk of brand development of their programmes.

Digital and 'content streaming' \/

The marketing 'imperative' preexisted the technological and market developments associated with the Internet and digital broadcasting, but the latter generated increased scope and opportunity for cross-promotion. In May 2001, *Broadcast* discussed how broadcasters were following the example of advertisers in seeking to push their brands (or 'key ideas') across as many platforms as possible in order to extract the maximum potential from them. A good illustration of such 'content streaming' (Murray 2001) across platforms is Channel Four's highly successful *Big Brother*, produced by Endemol. Contestants, filmed around the clock in a specially constructed house, were selected for eviction by housemates and voted out each week by viewers' poll. For the first series in 2000, in addition to programmes on Channel Four, viewers could watch 'live' coverage on Channel Four's website. The *Financial Times* (Ward 2001a) reported 7.5 million page impressions when 'nasty' Nick Bateman left the house. For the second series new features included text messaging and bulletins on partner radio stations. With the launch of digital channel E4 in 2001, viewers could watch live coverage of the *Big Brother* house, with extensive cross-promotion across the two channels. Highlighting the significance of exploiting intellectual property across different platforms, Endemol's managing director, Peter Bazalgelle, stated that the TV show was only the first 'window' of exposure, with merchandising, video and book sales, and text messaging taking equal precedence to the show. Significantly such revenue also increased profits and leverage for the independent company itself, which retained rights to develop the brand, encouraging extensive and rapid cross-promotion. As a powerful 'independent', Endemol, a Dutch-owned multimedia company, retained rights to exploit the brand and so seek ways of maximising profits during its 'window' on commercial television.[9]

Normalisation

Since the creation of commercial television there has always been a movement of personnel between broadcasting sectors. Where this previously served to strengthen 'public service' values, notably as ITV recruited BBC personnel, from the 1980s there has been a counter movement, establishing an increasingly common set of practices and approaches across television between promotion professionals who have growing influence within broadcasting organisations.[10] Commercial broadcasters headhunted senior advertising and marketing figures and sought US promotional and marketing experience to strengthen the branding and competitive position of UK channels. In May 2001, just as the ITC began its review of cross-promotion, *Broadcast* reported

that Discovery Networks Europe was the third multichannel broadcaster recently to hire a senior marketing guru, stating '[t]he common ground between [Advertising and television industries] is becoming increasingly apparent. Each wants to create consumer loyalty by pushing creative work across different platforms'. The same article reported that ITV Network Centre had approached 10 senior advertising executives in its search for a new chief Executive (Ellery 2001).[11] Flextech's Managing Director Lisa Opie confirmed her plans to bring BBC Worldwide and Flextech (joint owners of UKTV) 'together under one brand, enabling more cross-promotion and signposting' (Burt 2003b). As part of the broader shift from PSB values to marketisation in broadcasting (Leys 2001) there has been a discernible shift towards the normalisation of marketing, and within that cross-promotion, in the last decade, although this remains uneven and has generally occurred later in Britain than in the United States.

The ITC Review of Cross-Promotion

The Independent Television Commission (ITC) was established by the 1990 Broadcasting Act to regulate commercial television. The 1990 Act did not confer on the ITC any specific powers regarding cross-media promotion with one notable exception. Section 37 authorised the ITC to require Channel 3 licensees and Channel 4 to promote each other's programmes.[12] The government intended the ITC to regulate with a 'lighter touch' than its predecessor. Nevertheless, the code making provisions of the ITC set out in statute 'largely reflect those applying to its predecessor' (Prosser 1997: 264). Further, as Goodwin (1998: 93-122) shows, the combination of legislative concessions and the ITC's use of its discretionary powers made the regulator stronger in key areas, such as Channel 3 licence allocation, than had been outlined in the White Paper (Home Office 1988). Many of the new codes initially drew on the IBA's rules, but the ITC undertook extensive rule-making during its lifetime. Between 1991-2003 ITC licensees were subject to a variety of codes and guidance, chiefly the ITC's Programme Code, Code of Advertising Standards and Practice, Code of Programme Sponsorship and Rules on the Amount and Scheduling of Advertising.[13] Periodically revised and amended, the codes set out rules governing advertising content, the separation of programmes and advertising, sponsorship of programmes, surreptitious advertising and product placement. The ITC's codes also implemented the rules on advertising and sponsorship found in the EC Television Directive and the Council of Europe Convention on Transfrontier Television (Barendt and Hitchens, 2000: 214).

The ITC had a statutory obligation to ensure that advertisements and pro-gramme promotions were clearly distinguishable as such and recognisably separate from the programmes. Advertising was defined broadly as 'any item of publicity inserted in breaks in or between programmes, whether in return for payment or not, including publicity by licensees themselves' (ITC 1998c, Rule 4). Any advertisement or item of publicity by licensees was subject to the code irrespective of the particular form it took. However broadcasters' programme announcements were not included in the calculation of advertising time ('minutage') permitted across day parts.

Cross-media promotion re-emerged as an explicit regulatory issue in the late 1990s in the context of increasing competition amongst broadcasting network and service providers. It arose to a limited extent in the investigation of BSkyB's relations with cable television companies (chapter six). However, it was the licensing arrangements and development of digital services, following the 1996 Broadcasting Act, which brought new pressures and opportunities for cross-promotion between analogue and digital services.

The television market and cross-promotion (1999–2001)

This section summarises the television market and forms of cross-promotion in the period of the ITC review. It also identifies market factors influencing industry arguments concerning CMP.[14] The overall share of viewing in mul-tichannel homes in 2001 is set out in table 7.3 below.

Table 7.3 Share of viewing in multichannel homes

BBC	28.6%
ITV	20.9%
BSkyB	14.8%
Flextech	6.0%
Time Warner	4.4%

Source: ITC (2002d).

Note: viewing share calculated on the basis of channels in which the company has at least a 50 per cent share.

BBC ∨

After the regulatory scrutiny of 1990–1992, BBC cross-promotion of maga-zines and other commercial products continued under stricter conditions. However, the launch of new public service digital channels, the successful development of the BBC's commercial ventures and its online services led to

increasingly vocal and organised criticism from industry and renewed regulatory attention. The BBC invested heavily in its online service (Leys 2001: 134). By 2001 4.8 million people had used the BBC's interactive services (BBC 2001a). For Richard Tait (2003), the BBC's online dominance 'infuriated' newspaper publishers whose own sites were still losing money, and he identified a 'political downside' for the BBC as newspapers that normally supported the BBC made common cause with traditionally hostile papers such as News International's.

The BBC had adopted a stance of platform neutrality and successfully lobbied government to ensure adequate terms for carriage of its public service digital channels on all digital platforms. From 1998, the BBC promoted digital television generically and heavily promoted its expanding range of public service digital channels and radio services. The BBC was restricted (mainly under its fair trading guidelines) in promoting its commercial digital channels, but promotion of digital public services was unrestricted. A marketing plan in 2001 stated: 'across the first 12 months from launch of the new TV services we anticipate that each person will have seen an average of up to 100 promotions about the BBC's digital services and how to get them' (BBC 2001a: 7). According to its 2003 Annual Report (BBC 2003: 81), BBC on-air promotion of its magazines totalled 3 hours, 10 minutes and 30 seconds between 1 April 2002 and 31 March 2003 (compared to 2 hours, 25 minutes and 30 seconds in 2001/2). The weekly average was 3 minutes 40 seconds, up from 2 minutes 45 seconds the previous year. Total on-air promotion for all BBC commercial products totalled 4 hours, 38 minutes (5 minutes, 20 seconds per week on average) almost unchanged from the previous year.

As the BBC expanded its online services, there was increasing mention of BBC websites within and between programmes. One particular concern, for critics, was the lack of separation between the BBC's main public service site (bbc.co.uk) and its commercial website (beeb.com). Following the Davies Committee's recommendation (DCMS 1999), the government appointed auditors KPMG to review BBC fair trading including measures to ensure that commercial online activities were not unfairly subsidised or promoted by the BBC's publicly-funded activities, and commissioned competition law expert Professor Richard Whish to review the fair trading procedures. The BBC stated in its 1999/2000 annual report (BBC 2000) that it had addressed 'the question of fairness of links between the BBC's publicly-funded and commercial online services':

> It is important that users should have access to the whole of the BBC's online offering, but this must be balanced against the need to avoid unfair cross-promotion. Accordingly the Committee, approved, during the year, a policy whereby the BBC

does not trail beeb.com on its broadcast public services, and requires its public service website also to link to non-BBC e-commerce guides.

The full nature of the debate on the BBC's expansion is beyond the scope of this chapter (see Born and Prosser 2001; Born 2004; Currie and Siner 1999) but the BBC's promotional activities had important bearing on market behaviour and policy debate.[15] For critics, allowing the BBC to extend its market power would reduce competition and could not be justified according to narrow 'market failure' rationales whereby the BBC should provide only those public services that the market, left to itself, would not provide. While the precise competition and market conditions change, the essential charge remains: the BBC's market dominance unfairly constricts the market. For defenders, the BBC is a market intervention that is justified by the public benefit that arises and by the provision of content and services that the market left to itself will tend to undersupply (see Hardy 2004b). The BBC itself argued that the public was served by a globally powerful and successful BBC expanding domestic public service provision beyond traditional media, cross-subsidised by commercial activities.

Cross-promotion was a subsidiary, although important, element of this debate. The BBC argued cross-promotion of commercial interests was carefully regulated, while cross-promotion of new public service programmes and services was justified in providing information and helpful guidance for viewers and encouraging take-up. For critics, the BBC was using brand values and market power to distort various product markets and obtaining a promotional (airtime) subsidy which its competitors were forced to bear as a business cost. The Davies Committee (1999: 169) noted in its review of correspondence that there was 'much concern expressed about unfair competition–particularly cross-promotion of BBC services through the various media'. A new organisation, the British Internet Publishers' Alliance (BIPA), challenged the BBC's expansion into online services as anti-competitive.[16] Publishing group IPC (2000) sought government action against 'the unfair advantage given to Worldwide by its free access to airtime for cross-promotion'. On-screen promotion '[g]ives their brands airtime, inaccessible to others, in a uncluttered, non-commercial environment' and conferred a 'public service status to purely commercial products'. However, other industry groups attacks were tempered by the desire to avoid restrictive regulation and instead to enjoy cross-promotional advantages enjoyed by the BBC. Paul Brown, Chief Executive of Commercial Radio Companies Association (CRCA), argued (*Broadcast* 2002):

> There's no point in us, however offended and angry we may be, bleating on about what the BBC can do. It's far better for us to try to persuade the government that we should be able to do the same thing.

ITV, Channel Four and Channel 5 ✓

ITV's audience share was declining through the 1990s, as it has continued to do since (ITV1's audience share fell from 24 per cent in 2002 to 19 per cent in 2007). ITV responded to complaints from advertisers and shareholder concerns by making a series of pledges and setting ambitious audience targets.[17] However, most commentators believed the problems were structural rather than cyclical as competitor services eroded ITV's audience. The advertising recession, growing in 1999 and acute in 2001, also eroded revenues, all but wiping out ITV companies' profits from their main analogue channel, ITV1. As one industry report put it (Baxter 2001: 34) 'For companies such as Granada Media Group Ltd and Carlton Communications PLC, having to derive nearly 70% of their revenue from a struggling advertising market is extremely uncomfortable'. The main way in which terrestrial commercial broadcasters sought to diversify revenues for their television operations from advertising revenue (beyond sponsorship) was through subscription-based pay television.

The formation of ONdigital by Carlton and Granada, and Granada's earlier joint satellite venture with BSkyB, have already been described. By April 2002, Carlton and Granada's digital ambitions had ended in costly failure following a series of earlier restructuring efforts.[18] For instance, Carlton Cinema and Carlton Food Network (rebranded Taste following a deal with Sainsbury's) posted losses of £11.2m for the six months to March 2001 and in August Taste was axed. However, with the creation of new digital offerings (ITV2 and later ITV3 and 4) the strategic role of cross-media promotion on ITV was transformed. The three largest ITV companies were also significant multimedia companies. Granada's ownership interests included ONdigital, Granada Sky Broadcasting, shopping channels (Shop!) and online (G-wizz). Granada's merchandising operation, Granada Media Productions, signed three major deals in 1998 with video, music and book publishers worth £10 million over five years. Granada also acquired educational book publisher, Letts Education, to develop print, multimedia, TV and online applications.

Channel Four, responsible for selling its own advertising following the 1990 Act, grew successfully. Channel Four's businesses, other than the terrestrial service itself, notably E4 and Film Four, accounted for four per cent of revenue in 2000/1 but were expected to rise to 10 per cent the following year (Reid 2001:18).[19] Channel Four had been innovative in developing programme related materials as well as in cross-promoting its films. From 1999 the channel ran heavy promotions for its Film Four subscription channel, including a series of 90-second trailers and joint programming on Channel Four itself. E4, aimed at a lucrative youth audience, was used for first runs of successful US series

(*ER*, *Friends*) and for linked featuring of television events such as *Big Brother* in 2001.

Launched in 1997, Channel 5 achieved steady growth, securing in 2000 nearly five per cent share of viewing and five per cent of net advertising revenues. Channel 5 has been used for innovative forms of sponsorship and advertiser-financed programming (the Pepsi Chart) but was not involved in significant cross-promotion except for its Internet services.

BSkyB √

The volume of promotions on Sky One has been described above. With analogue and then digital satellite, BSkyB promoted its platform, subscription packages, channels and programmes, although subject to restrictions laid down by the ITC. BSkyB carried US channels in which self- and cross-promotions were more extensive than UK channels. News Corporation's joint ownership of Fox and BSkyB, as well other global television interests, meant there were more direct forms of influence of marketing on BSkyB's services (through personnel, products and through the fiercely competitive and commercial orientation of the company). When the ITC began its review in 2001, BSkyB was clearly winning the platform war for digital television, but the business had made heavy losses since 1999 when BSkyB, preempting ONdigital, started to give away digital set-top boxes. In May 2001 it reported losses of £365.3 million for the first 9 months of the financial year, including a £40m exceptional charge for Open, its loss-making interactive e-commerce service. Cross-promotion was a minor component of industry and regulatory concerns about BSkyB's dominant position and of the technical gateways to services which could be used in anti-competitive ways to sustain market power. There was greater concern about the lack of prominence for public service channels on the Electronic Programme Guide (EPG) and access for non-proprietary, third party interactive services.

Cable

Since the 1990 Act there had been significant consolidation in the cable industry. Two US companies, ntl and Telewest, owned all but 6 of 136 operational franchises. Concentration arose in part to manage the huge investment and repositioning of cable for digital. The cable companies remained programme distributors rather than providers, but were actively involved in cross-promoting their telecommunications services and Internet and interactive services.

The ITC and regulatory intervention

In October 1998 the ITC issued a *Consolidated Statement of ITC Rules on Cross-promotion of Digital Television Services* (ITC 1998g). The immediate trigger for the *Statement* was the promotion on ITV of the new digital terrestrial service ONdigital owned jointly by Carlton and Granada television and the promotion of SkyDigital launched that month. The *Statement* set conditions for cross-promotion of digital services outside of designated advertising minutage, addressing in particular how analogue terrestrial licensees could promote their associated digital services. Licensees could promote their 'qualifying service' (digital versions of each analogue channel) and their other services carried on the same multiplex. Promotion of any other digital television services had to be included in advertising minutage. This meant that broadcasters would have to make an economic calculation whether to use part of their total allotted advertising time for their own promotions instead of selling the airtime to third party advertisers (see NERA 1991). Licensees 'may refer incidentally to the availability of other digital programme services but may not single out any such service for specific promotion' (ITC 1998g). Digital terrestrial or digital satellite programme service providers were permitted to cross-promote their own services, but other promotions including 'cross-promotion contradeals' had to be included within advertising minutage.

The rules built upon the ITC's existing approach to advertising by competing broadcasters (ITC 1992), which was based on a distinction between generic advertising of services and so-called 'call-to-action' advertising 'promoting particular programmes at particular times on the competing services'. Broadcasters' refusal of generic advertising would generally be regarded as 'unreasonable discrimination'. However, the ITC allowed cable operators to opt out of carrying 'call-to-action' promotions for BSkyB's pay-per-view (PPV) services and substitute instead BSkyB generic promotions (ITC 1997a). In doing so, the ITC identified that 'call-to-action' promotions 'could be anti-competitive' (ITC 1997b). In March, the ITC (1999d) upheld a complaint from BSkyB of unreasonable discrimination in the refusal by ITV to accept a SkyDigital advertisement mentioning ' . . . football on Monday nights'. BSkyB argued that it had been discriminated against because some ITV companies had previously run an advertisement by ONdigital for the Tyson-Botha boxing match which contained an even more specific reference 'Saturday January 16th live and free only with ONdigital'. Six weeks after publication of the Consolidated Statement (ITC 1998g), the ITC ordered the withdrawal of all current promotions for digital terrestrial television running on ITV, stating they were 'denigratory to the satellite television platform' (ITC 1998k). It required that all future promotions for digital terrestrial television (DTT) be submitted to

the Broadcast Advertising Clearance Centre (now Clearcast) for approval before transmission.

The review of cross-promotion, long promised (ITC 1998a), was finally undertaken in May 2001 when the ITC issued a *Consultation Paper on Cross-Promotion in Commercial Television* (2001a). The initial five-week consultation period was extended to six, but then, exceptionally, a second consultation was launched in October and the final rules and guidelines were not published until 15 January 2002. According to the ITC's Director of Strategy, Economics and Finance, Robin Foster, these would 'allow broadcasters greater flexibility to promote digital channels than ever before' (ITC 2002b). The ITC gave four reasons for the timing of the review (ITC 2001a: 2–3):

1. Viewer complaints about advertising 'clutter' had increased.
2. Recent 'issues' required a review of the 1998 *Consolidated Statement*.
3. Promotion of digital services would help the timetable for digital switchover.
4. The current ITC rules needed reviewing as part of 'the ongoing process of modernising and streamlining regulation'.

The main reason, as Ofcom later acknowledged, was the competition concerns that arose primarily from the cross-promotion of ITV Digital by ITV; ITV's 'unique ability to cross-promote a specific digital retail TV service could have an impact on competition in the retail pay-TV market, i.e., the market where Sky, cable and ITV Digital were competing for subscribers' (Ofcom 2006: 7). The 'recent issues' included ITV's announced rebranding of ONdigital as ITV Digital and the consolidation of the ITV brand across terrestrial and digital television and the Internet. By April talks had also broken down between ITV and BSkyB over carriage of ITV channels on Sky Digital (ITV Sport, launched in August, would never be carried on Sky).[20] The ITC was also considering a complaint from ITV Digital concerning Sky's 'constant cross promotions (through promotions, screen views and voiceover) of interactive services not available to DTT viewers' (Carlton, Granada and ITV Digital 2001: 10). Long promised since 1998, the ITC review had been put aside as a 'difficult issue', but action was now unavoidable.[21]

The government's digital television policy was another key factor. DTT was perceived as the platform which would be the natural successor to free-to-air analogue, although BSkyB urged the government to base its digital strategy on digital satellite (BSkyB 2000) and, with others, asserted that favouring DTT might breach EC trade rules. DTT was vital in attracting viewers who did not wish to subscribe to digital satellite or cable services if the 'switch-off' of ana-

logue spectrum, then set for 2010, was to be achieved. Yet the government adopted a formal stance of platform neutrality, allowing markets to determine the success of competing pay-services (see Freedman 2003: 178–181). The policy contradictions here could be resolved if, as the government expected, competition would flourish and all platforms would become economically viable.

In a speech to the Royal Television Society, Culture Secretary Chris Smith (1999) announced two tests of availability and affordability that had to be met before switch-off. He also drew attention to another key element of policy: the promotion of digital television technology and services, urging broadcasters to begin a 'conversation with the public on what digital television as a whole has to offer. Not this package versus that package. But what it means altogether' (Smith 1999). Smith called on the ITC, OFTEL and OFT to provide joint advice on options to ensure the digital television market did not develop so as either to 'inhibit competition' or 'set unnecessary barriers for consumers to access new services'. Their advice, published in November (ITC, OFTEL, OFT 2000) was to leave digital take-up to market forces. As part of its undertakings, the ITC agreed to:

> Review its rules on cross-promotion. One of the aims of that review will be to simplify the rules on cross-promotion of digital television by broadcasters. This should help to increase awareness of the potential benefits from digital television. The ITC would aim to involve the BBC in the exercise.

Industry also responded. In March 2001, ONdigital convened a meeting attended by all UK terrestrial broadcasters, together with manufacturers, retailers and industry bodies who agreed to launch a campaign to promote DTT. The government also drew up an action plan on digital TV, which included a pre-Christmas publicity campaign aimed at retailers and consumers.

The ITC review then arose from contradictory pressures towards regulatory promotion and prohibition. The government wished digital television to be actively cross-promoted by all terrestrial broadcasters, albeit without distorting competition. Although the government and ITC favoured only 'generic' promotion of digital television services, stimulating consumer demand was a key objective. Cross-promotion was addressed because of pressures to relax restrictions, as well as to restrict promotions, mainly on competition grounds. The review did not include the BBC (although the BBC itself responded[22]), further evidence for many of the inadequacy of outdated regulatory and sectoral demarcations for converging industries. Instead, the government established a separate review of BBC fair trading in October 2000. The report by Richard Whish (2001) concluded that the BBC had more rigorous safeguards on fair trading than any comparable media organisation, much to the

chagrin of the British Internet Publishers' Alliance (BIPA 2002) and commercial broadcasters campaigning for restrictions on burgeoning BBC cross-promotion.

Responses to the consultation

Table 7.4 (below) records the respondents to the ITC's two consultations. Formal submissions to public consultations provide only one visible and often highly 'constructed' part of the process of influencing regulation.[23] The process of bargaining between interests is usually opaque in regulatory processes and has long been a feature of 'private interest' governance in television regulation (Dyson et al. 1988). The major policy actors, notably ITV companies and BSkyB, had privileged, private and routinised access available to them. Nevertheless, formal submissions can provide an important guide to policy actors' interests and can be used to assess their respective influence on regulatory outcomes. For resource-poor groups, formal consultations provide an important means of access to the policy process.

The ITC described the first consultation as an 'extensive sounding of industry views' (ITC 2001b). It was certainly little more. Only the CPBF and Public Voice represented non-industry contributions, both from public interest media groups. With 22 responses the first consultation was comparable to others, such as on digital TV (29 responses) and masthead programming (13).[24] The response was considerably less, however, than on issues of concern to more stakeholders such as regionalism and ITV (over 70 responses) or the advertising code revisions (over 300), both occurring in 2000.

Table 4 Responses to the ITC consultations on cross-promotion

First Consultation	Second Consultation
Attheraces	
British Broadcasting Corporation (BBC)*	BBC
British Sky Broadcasting (BSkyB)*	(BSkyB)*
Campaign for Press and Broadcasting Freedom*	CPBF*
Carlton, Granada and ITV Digital*	Carlton, Granada, ITV Network, ITV Digital
Carlton Cinema	
Channel 4*	Channel 4
Channel 5*	Channel 5
Discovery Networks Europe*	
Dungate, Arthur	
Hallmark Channel*	

Table continued on the next page.

Incorporated Society of British Advertisers*	ISBA
Institute for Practitioners in Advertising*	
Institute of Direct Marketing	
Independent Television News (ITN)	ITN
ITV Network*	
Music Television (MTV)	MTV
ntl	ntl*
Public Voice *	
Scottish Media Group (SMG)*	
Taste	
Telewest*	Telewest
Turner*	Turner
UKTV	
Universal Studios Network (USN)*	USN

Note: An asterisk identifies those submitting non-confidential written submissions made available by the ITC.

All industry respondents were careful to acknowledge the importance of editorial integrity. Such unanimity, however, must be contextualised. No industry respondent favoured any extension of regulatory controls over programme content. Instead, in line with responses on Labour's communications policy (see David Graham and Associates 2001), they favoured greater self-regulation. Broadcasters presented themselves as responsible (self) regulators who could best determine the complex, context-specific matter of when particular promotions were editorially justifiable. Such claims may be contrasted with the unattributed views of senior figures in broadcasting and advertising quoted in a DCMS commissioned report, *Out of the Box*, who saw the further integration of advertising and editorial as both increasingly inevitable and desirable (David Graham and Associates 2000).

All respondents agreed that viewers benefited from information about programmes scheduled later on the same channel and in future time periods. Both terrestrial and pay-TV broadcasters argued that consumer power and advertiser power provided sufficient restraint on promotions to motivate self-regulation, with no beneficial role for 'external' regulation. Consumer preferences imposed constraints on clutter and encouraged quality, while advertisers' interests influenced the available space and environment for promotions. Both forces, it was argued, acted to ensure that the viewing experience was free from undue promotional clutter.[25]

Any additional regulation, industry agreed, should be competition based, with several calling for this to be the sole criteria (Turner, BSkyB, NTL). There was, however, little unanimity concerning the competitive position itself. Responses were divided, predictably, along the lines of inter-firm competition and economic interests. The principal antagonists, ITV (in particular, Carlton and Granada) and BSkyB, both asserted market power analyses which justified restrictions on their competitors' cross-promotion but not on their own. Defining the relevant market as the market for television advertising made Granada and Carlton dominant. In contrast, identifying Pay TV and free-to air television as separate markets, meant that BSkyB had demonstrable market power in Pay-TV.[26]

Review Outcomes

The ITC proposed changes to the rules on cross-promotion in four main areas: programme breaks, in-programme, advertising, and digital services and platforms.

(1) Programme breaks

The ITC had introduced a 20-second limit on programme promotions in centre breaks in 2000 when it revised the Rules on the Amount and Scheduling of Advertising (RASA). Initially the ITC proposed a 90-second limit for promotions (outside of allowed advertising airtime) in peak time for channels 3, 4 and 5 only. In the second consultation, it abandoned this proposal in favour of a 'watching brief', retaining the centre break limit but now restricting this to channels 3, 4, and 5. The final rule allowed ITC licensees to promote programmes, events or strands or related services (such as a website) between programmes. To qualify the promoted service had to be 'provided' by the broadcaster, defined by possession of at least 30 per cent of the shares or voting power. Such promotions should 'provide information of value to viewers and should avoid creating significant viewer annoyance' (ITC 2002a: 8). In addition, Channels 3, 4 and 5 could not give 'an excessive amount of airtime to a particular channel, service or suite of channels/services' (Rules 3.a) nor mention prices of products or services (Rules 3.f).

(2) In programmes

The final rules stated:

The primary place for cross-promotions and other promotions is within promotional airtime and not programmes. In-programme promotions should not compromise the editorial integrity of the programmes within which they are placed by any means, or lead to advertising substituting for programme content.

In-programme mentions 'must provide information likely to be of value to the viewers of the programme containing the promotion' and 'must not constitute a call to make a specific purchase'. The final rules, as proposed by the BBC, allowed '[m]entions of and visual references to interactive features which might enhance viewer enjoyment of the *current* and *upcoming* programmes on the same or related channels' (Rule 6). In addition, filmed promotional trails (originally prohibited) could now be carried in 'multi-item programmes' of over one-hour duration (such as sports programmes). Finally, the ITC clarified that the in-programme rules would not apply to end-credits.

(3) Cross-promotion in advertising breaks

No changes were made to the rules on cross-promotions in advertising minutage; the ITC reaffirmed its position on the grounds for refusing paid advertising from competing broadcasters for particular events or series (so-called 'call-to-action' promotions).

(4) Digital services and platforms

The ITC proposed to liberalise the rules set out in the *Consolidated Statement* (ITC 1998g). Instead of being limited to promotion of their simulcasts and channels on gifted capacity (i.e., ITV 2), ITV could now promote any channel or related service. The promoting channel must have a 30 per cent ownership share in the promoted service, but the rules allowed for non-financial arrangements for the promotion on the ITV Network of ITV branded programmes. This allowed common promotions to be carried across the ITV network for channels such as ITV Sport in which only Carlton and Granada had controlling interests. Announcing the new rules, the ITC (2002a:1) stated:

> Our overall aim throughout this process has been to achieve a balance between supporting the real benefits for viewers that cross-promotions can bring, especially in the new multi-channel digital environment, and the disbenefits that arise if cross-promotions are excessive, affect editorial integrity by misusing programme time for advertising, or threaten fair and effective competition

For cross-promotion of programmes and related services, then, the outcome was significant liberalisation. By contrast, the rules on platform promotion were not significantly relaxed to meet ITV's demands. Channels 3, 4 and 5

were prohibited from making specific promotions (outside advertising time) for any particular platform service provider (Rule 3.b). [27]

Analysis

The ITC clearly articulated rationales based on competition, consumer welfare and editorial integrity. However, the new rules indicated a shift from editorial to competition-based rationales. The justification for regulatory action arose from the identification of three perceived problems ('disbenefits'). The amount and intensity of cross-promotions may cause 'clutter', detracting from viewer enjoyment; cross-promotion may cause confusion in distinguishing between advertising and editorial content; and, cross-promotion may affect competition between service providers. The three disbenefits then articulate regulatory rationales based on consumer welfare, editorial integrity, and competition. These 'disbenefits' had to be weighed against three benefits of cross-promotion: viewer information about programmes, channels and services; information about digital to aid switch-off; and promotion to facilitate expansion of new services such as interactive television.

The ITC's case was weakened by lack of evidential support (see ISBA 2001: 4). The one empirical claim made in the first consultation paper, that viewer annoyance at 'clutter' had increased, was not substantiated but rather moderated in the second. The ITC now claimed that it had evidence that viewer complaints had decreased. However such evidence remained impressionistic and internal. The ITC conducted no research nor drew explicitly upon any available third-party research for the review. [28]

Although viewer annoyance and editorial integrity determined some of the rules, the principal justification for differential restrictions on cross-promotion was the effect on competition. The ITC's competition analysis began by defining the market for 'promotional impacts' and took this to be the total television market. This corresponded closely to BSkyB's definition since audience share (on advertiser-financed and subscription services) was used as a measure of promotional reach. Audience share and reach, taken together, provided a 'good proxy' for the share of 'promotional impacts' (ITC 2001b: 8). This approach, however, conflates two different values. One concerns economic indices of market power; the other concerns the qualitative nature of promotion and its influence on viewers. The assumption is that quantitative measures can serve as a proxy for qualitative measures (influence); production (promotional airtime) can act as a proxy for consumption ('impact'). The other effect of this approach is to displace qualitative concerns about cross-promotions by channels other than those with significant market share. Fur-

thermore, the measure is that of overall channel share not programme share. A very different assessment of impact would arise from taking account of the actual audience segment and considering the level of substitutability of similar programmes for this audience profile (see OFTEL 1997).

In-programme promotions

While promising a 'watching brief', the ITC rules allowed greater scope for in-programme promotions and followed changes already made regarding commercial references in programmes. The ban on commercial promotion in programmes remained, so that advertising or product selling in programmes was prohibited (Gibbons 1998: 193–204). Under the 1998 Programme Code 'ancillary' products including magazines, information packs, and specific merchandise (music, videos and books) could be promoted in end credits or after programmes provided they were not featured in television advertising within six weeks of the programme or series (Section 10.3). Only material or activities related to social action could be mentioned within programmes themselves. In November 2000, the ITC (2000d) published new guidance, allowing 'details of products to be given within programmes where they are relevant and helpful to viewers but these must stop short of becoming promotional or selling messages'. Website addresses could now be included in programmes provided they were, and appeared to viewers to be, 'entirely independent of the site and . . . not seen to be acting as a conduit for the sale or promotion of goods'. The guidance note stated that artistic works offered on a commercial basis 'have traditionally been accorded some leeway under relevant sections of both the Programme and Sponsorship Codes, mainly because they were the stuff of television programmes long before rules were formulated to inhibit commercial influence in programmes', although such commercial products could not be 'actively promoted'. Finally, it stated:

> The ITC believes that viewers expect, and accept, a measure of 'puffery' in programmes with titles such as The Making Of . . . although, even here, there is no justification for an overtly promotional approach. Established format magazine and other programmes confound audience expectation if they pay undue attention to any one artistic work at the expense of any other.

In February 2001, the ITC (2001d) published the revised Programme Code that came into force in April. Section 8, dealing with 'commercial references in programmes' reiterated the veto on in-programme promotion of commercial products or services, but stated that 'programme related services' such as factsheets, helplines and websites' (formerly described as 'ancillary services') could be briefly mentioned *within* programmes provided there was a

clear relationship to the content of the programme and the promotion was 'editorially justified'. However, the new rules explicitly restricted *promotion* of books, videos, CD-ROMs, DVDs and music to the 'end of the programme'. Indicating this shift more broadly, the ITC (2000b:16) argued that the principle of separation of editorial and advertising was a 'longstanding feature of consumer protection' requiring 'clear underpinning by regulatory requirements' yet added:

> But it is clearly likely to change as the television market develops. In part, as the number of channels increases, and viewers make more active choices, the level of protection required will correspondingly diminish.

The cross-promotion rules did not explicitly address issues of transparency. In an earlier review the ITC (1996: 2) stated its concern about the way in which commercial communication and programme material were integrated, 'including the degree of transparency to viewers'. Such concern was reiterated as recently as 2000, in its consultation on interactive services. But there transparency functioned, in part, as a justification to liberalise rules so that, as Stephen Locke, then Director of Advertising and Sponsorship, explained, '[w]here the viewer is able to make a deliberate and informed choice it follows that certain elements of these rules can be disapplied' (ITC 2000c: 1). Although, in most cases of programme promotions and channel branding, issues of transparency rarely arise, where broadcasters promote commercial services or products, the corporate interest of the promoter in what is promoted may well not be explicit to viewers. The CPBF (2001a, 2001b) argued that the interests of those promoting services should be declared, or be otherwise explicit, so that viewers could make their own assessment of the value and integrity of the information provided.[29]

The chief, historically influential, form of systemic critique has argued that editorial and advertising, or commercial speech, should be separated. The ITC paper identifies two issues under editorial integrity: viewers should not be confused in distinguishing between programmes and advertisements, and programme agendas should not be distorted for commercial purposes (ITC 2001a: 14). The importance of the second is that it recognises that there may be social disbenefits from commercial influence on programme integrity and editorial 'independence' irrespective of the level of transparency of the commercial motivation or the benefits some viewers may gain from promotion. The ITC retained a rationale of editorial integrity but justified the extension of cross-promotion on consumer welfare grounds and determined the scope and rationale for restrictions largely on competition grounds. In doing so, restric-

tions on cross-promotion which had been sustained by the influence of more systemic concerns were relaxed.

Regulatory capture?

Dyson et al. (1988) argue that the clientalist relationship between the IBA and ITV, characteristic of corporatist 'private interest' government, was challenged by new forces in the 1980s, including new market entrants, but was then reasserted in new patterns of private-interest relationships between media corporations, regulators and government.[30] Does the ITC revision of rules on cross-promotion indicate either agency capture or clientalist 'orchestration' of interests? The problems of opacity arising from the complex and private nature of regulator-firm relationships makes this difficult to assess, but it is possible to draw some conclusions from the analysis of available evidence of actors' interests made above and by assessing the chief beneficiaries of regulatory action.

The ITV network and its two major players, Granada and Carlton, undertook a sustained campaign in favour of relaxation of cross-promotional restrictions. In a speech in June, ITV's chief Executive, Stuart Prebble (2001), called for some 'favouritism' from government:

> The digital terrestrial television platform is our one opportunity to break the stranglehold that Sky has exerted in this market. That means totally relaxing rules that currently prevent ITV from cross-promoting its pay service. It means encouraging and subsidizing the roll out of digital transmissions. It means encouraging, and if necessary subsidizing, television manufacturers to produce digital televisions.

Later the same month, a letter from Granada's chairman to Prime Minister Tony Blair seeking help to secure ONdigital's future sparked an acrimonious public row with Carlton. Allen's demands included: '[b]etter promotion of digital technology; a firm date for analogue switch-off; lifting of cross-promotion rules that stop ITV advertising ONdigital; and a strengthening of the digital terrestrial signal, currently unavailable to half the population.'[31] This lobbying effort achieved only mixed results. ITV certainly benefited from the relaxation of rules allowing cross-promotion of channels and services. However the rules on platform promotion significantly curtailed ITV's ability to promote ITV Digital (outside of advertising time). Non-terrestrial channels were subject to a largely unmodified regulatory regime allowing them greater scope for cross-promotional activity. However, the comparative advantage retained by terrestrial broadcasters (including the BBC) was a continuing source of criticism. Universal Studio's UK Managing Director, Janet Goldsmith argued that the ability of terrestrial channels to cross-promote digital channels, gave them a 'no-cost advantage in increasing their share of viewing

in multichannel homes' (Goldsmith 2003: 4). For Goldsmith, the [new] ITC rules were 'woefully inadequate':

> The rules were relaxed at the behest of a broadcasting establishment keen to make a faltering ITV Digital viable, secure a foothold in the Sky dominated pay-TV marketplace and play an effective part in the overall strategy designed to drive digital take-up.

However, if the ITC's initial proposals were favourable to ITV and ITV Digital, the final rules do not bear out this judgement. As formal submissions (and trade reports) indicated, commercial competitors were largely successful in urging the regulator to act against the perceived promotional advantages for ITV. In particular, BSkyB successfully influenced the ITC's final rules as the detailed arguments of its legal affairs department were rewarded in key revisions to the ITC's original proposals. BSkyB could now increase cross-promotion across its suite of channels and platforms during programme time, while its competitor platform (ITV Digital) was denied the promotional resources it had sought to compete.

In 2001/2 the regulated television industry was fiercely competitive; liberal corporatism had given way to a more *competitive*, market-oriented system (Curran and Leys 2000) in which firms competed for regulatory favours. At the same time, the ITC did not 'hold the ring' between competing interests (in accordance with liberal pluralist theory). Firms' conflicting interests, the ITC's resistance to a particular firm's demands and, to a lesser extent, its consultation efforts, counter the charge of systematic 'capture'. However, the revision of rules was framed by and for a narrow policy community. While there were interests within the policy community supporting a reduction in promotional clutter, notably advertisers (ISBA, IPA), there was a general consensus amongst commercial TV interests that opposed restrictions on in-programme promotions, and favoured regulation on competition grounds.

Arguably, the ITC's consultation processes marked an advance on those of the IBA. Nevertheless, in contrast to earlier consultations (Pilkington Committee 1962; Annan 1977) countervailing pressure from non-industry interests was weak. The shift towards a competition rationale occurred in a context in which liberal democratic concerns were articulated and qualified by the regulator, while systemic concerns (raised by the CPBF and to a lesser extent Public Voice) were displaced. The issue of cross-promotion was reported only in the trade press and media sections of the quality press where it was framed as a matter of competition between firms. As Leys (2001: 146) points out, the ITC was modestly successful in enforcing some public service obligations but proved less able to 'withstand changes in the spirit or even the letter of public service obligations that attracted little public interest'. Significantly, the cross-

promotion review was conducted within a narrow policy community with negligible public coverage and marginal non-industry involvement.[32]

With ITV Digital's collapse in May 2002, the ITC rules lost saliency. However, the announcement in July 2002 of a new free-to-air DTT service (later named 'Freeview'), offered by the BBC and Sky in partnership with Crown Communications, meant that new issues of cross-promotion would arise and regulatory attention would unavoidably need to encompass the BBC. Such rapid market changes indicated that the ITC rules, however broad their intentions, were particularist and incremental and thus conformed to a long-standing critique of UK policy and regulatory efforts to intervene in rapidly changing communications markets (Elliot 1981; Hitchens 1995; Marsden 1999; Feintuck and Varney 2006).

The ITC used its powerful and flexible discretionary code-making powers (Prosser 1997) to address the intensification of cross-promotion, powers that allowed it to address competition, consumer welfare and editorial issues. It introduced formal rules for promotional activity that was previously outside regulatory attention. But, at the same time, it responded to industry pressures by liberalising existing rules, allowing greater cross-promotion of channels and services. The ITC thus built upon its own incremental responses to increasing cross-promotion, but the review failed to create a single, durable set of guidelines, instead it opened up further inconsistencies between a new accommodation to developing forms of cross-promotion of channels and services, and rules restricting all licensees' promotion of commercial products and services.

Ofcom and cross-promotion

The Communications Act 2003 required the new regulator Ofcom to apply the ITC's codes until it drew up its own. In 2005 Ofcom published a new Broadcasting Code (Ofcom 2005b). This allowed broadcasters to promote 'programme related material' *within* programmes provided this was 'editorially justified' (10.6) and now allowed credit to be given to sponsors of such material provided it is 'brief and secondary' (10.8)

Speaking in July 2005, Ofcom chief executive Stephen Carter advocated a 'levelling up' of cross-promotion, announcing that Ofcom might allow commercial media groups to cross-promote their TV and radio stations to help commercial radio win back listeners from the BBC. Then in December, Ofcom announced a new review of cross-promotion. This, like the ITC's, was triggered by market changes. The success of Freeview was perceived as a threat to competitor services on Sky and cable. Launched in 2002, Freeview now reached 5 million homes, with a 30 channel line-up including ITV and Chan-

nel Four's digital channels, and in October 2005, ITV and Channel 4 joined the original shareholders, BBC, BSkyB and National Grid Wireless (formerly known as Crown Communications), taking a 20 per cent share each, and promising increased on-screen promotion.

Explaining the review Ofcom (2005g) argued that 'in the absence of regulation, the main terrestrial channels, BBC1, BBC2, ITV1, Channel 4 and Five, would have incentives to promote the availability of their services specifically on Freeview and the DTT platform and would therefore move away from the current requirement for neutrality in promoting digital TV' (1.7; 4.17). This was a specious argument given that the ITC rules already prevented such promotion. The second explanation given was the need to address airtime gaps as broadcasters were 'often left with remaining airtime' (1.3) once they had scheduled programmes and permitted advertising minutage.

The outcome of the review was that Ofcom significantly liberalised the existing ITC rules on cross-promotion (Ofcom 2006a). It did so by expanding the scope of permitted programme-related material and by introducing a new category of broadcasting-related services that expanded the scope of permitted cross-promotion. Provided there was a link to programme content, any programme related material could now be promoted, outside programme time, regardless of whether there was an ownership link or payment made. Programme-related material means 'products or services that are both directly derived from a specific programme and intended to allow listeners or viewers to benefit fully from, or to interact with, that programme'. This change allowed cross-promotion of programmes (for instance, 'This programme is also being shown on Channel B') or programme-related content on other channels including joint productions.

Beyond programme related content, the rules restrict broadcasters' cross-promotions, outside of advertising time, to broadcasting-related services. These are defined as including 'all broadcasting activities licensable by Ofcom, for example television and radio services' (Ofcom 2006b). They also include other services with a 'broadcasting feel', that is, services which deliver content similar to that delivered on a television or radio service via video on demand, mobile phone and broadband. It may also be a website where this provides 'deeper, richer content with a very clear and direct relationship to the overarching broadcasting service' (Ofcom 2006a: 17). This measure too was deregulatory, allowing broadcasters greater freedom to cross-promote digital services. Ofcom liberalised the rule requiring 30% ownership for cross-promotion, making this an indicator but not a strict requirement.

Ofcom decided to deregulate and remove all rules except in two areas. First cross-promotions (outside of paid advertising) were limited to broadcast-

ing-related service, and must not involve payment (to escape being included in advertising minutage). Ofcom argued this was 'necessary in order to protect consumers from promotions that provide no benefit to their viewing experience and to ensure the separation of television programmes from advertising' (Ofcom 2006a: 2). The second requirement was that Channels 3, 4 and 5 should maintain neutrality between digital retail TV services and digital platform. 'This is of particular importance as analogue-only homes must make choices about digital TV services in the run up to digital switchover and consumers should have the ability to make informed choices' (Ofcom 2006a: 3). The terrestrial broadcasters cannot promote Freeview at the expense of digital cable and satellite. Promotions that 'mention a digital retail television service and/or digital television broadcasting platform [must] treat all major digital retail television services and/or digital platforms in an equal and impartial manner' (Ofcom 2006a: 53). Promotions mentioning Freeview or Sky, must also name all other digital retail television services, and promotions that refer to a particular digital platform, such as digital terrestrial television ('DTT') or cable, must refer to all other digital platforms on which the broadcasting-related service is available. Promotions must treat digital services or platforms 'equally in respect of all aspects mentioned, such as pricing, brand names, availability and packages' (Ofcom 2006a: 53). Generic promotions for digital television are permitted.

Rules on the amount of promotional time were removed as were specific rules on in-programme programmes. However Ofcom argued that the latter were adequately covered by the existing rule restricting commercial references in programmes. Henceforth in-programme promotion would be subject to the provisions of Section 10 of the Broadcasting Code, which deals with commercial references in programmes, in the same way as references to any other services or products. Under the rules 'programme-related material may be promoted in programmes only where it is editorially justified' (10.6); the broadcaster must retain responsibility for all programme-related material (10.7); 'Programme-related material may be sponsored, and the sponsor may be credited when details of how to obtain the material is given. Any credit must be brief and secondary, and must be separate from any credit for the programme sponsor' (10.8). In addition, Ofcom's Rules on the Amount and Distribution of Advertising (RADA) was amended to remove the rule limiting programme promotion in centre breaks to 20 seconds ('the 20 second rule'). There would no longer be any restriction on the time devoted to promotions. The new rules took effect from 10 July 2006.

Policy process and actors

Ofcom's formal consultation period ran from December 2005 to February 2006. There were 18 responses. According to Ofcom the majority of respondents were supportive of its proposals. However, 12 submissions were allowed to remain entirely confidential, an unusually high proportion, and only seven were published. Six were from broadcasting organisations: BBC, BSkyB, Channel 4, Channel 5, Scottish Media Group, Paramount Comedy, with one non-industry submission from the CPBF (written by the author). The arguments made and positions taken were broadly similar to those for the ITC review. Commercial TV operators sought liberalisation in which they, rather than regulators, determined the level and extent of cross-promotional activities. However this liberalisation was tempered by efforts from some players to ensure that restrictions were placed on the promotion of Freeview and promotion by terrestrial broadcasters. BSkyB argued, successfully, that the incentives of the analogue broadcasters to promote Freeview and the DTT platform over other services and platforms justified special ex ante competition rules (BSkyB 2006:8). Sky's own extensive cross-promotion would not be affected by such measures.

Ofcom's approach conformed to its more general deregulatory and pro-market orientation (Freedman 2008; Hardy 2008b). Relaxation of the rule governing cross-promotion of broadcast channels was one of several deregulatory changes reported by Ofcom (2006b) in its 2006–7 Annual Report. Others included: revising the regulation of channel sponsorship to give broadcasters more freedom to pursue commercial opportunities, liberalising the use of the radio spectrum, and extending spectrum trading. The rules, Ofcom argued, were designed to reflect two key principles:

1. ensuring that cross-promotions on television are distinct from advertising, and informing viewers of services that are likely to be of interest to them as viewers; and
2. ensuring that promotions on television outside programmes do not prejudice fair and effective competition

Ofcom acknowledged concern to ensure the separation of programmes and advertising while harnessing viewer interests so as to support a positive case for promotion. Negative implications for viewers were acknowledged but dismissed in an extraordinary statement; section 5.44 reads (Ofcom 2005g):

> One of the 'disbenefits' identified in the Current Rules was 'irritation among viewers about the amount and nature of promotions'. Having reviewed the Act and the TWF,

it is not clear that Ofcom has any specific duties or responsibilities in this regard and it is therefore to some extent questionable whether 'viewer irritation' is in fact a sufficient basis upon which Ofcom may impose regulation. In any event, this problem should be self-limiting as broadcasters do not wish to lose audiences.

With a general duty to further the interests of citizens as well as consumers, the 2003 Communications Act provided ample basis for Ofcom to address such concerns.

There are evident benefits in promotion, enabling consumers to navigate and locate content and services of interest to them. However, the disbenefits, beyond the importance of separating editorial and advertising, were largely ignored. No regulatory restrictions were placed on the amount of promotions ('clutter' issues). While it is almost invariably in the broadcaster's interest to cross-promote, it is not necessarily in the viewer's interest. Further, the benefit that some viewers gain from promotions, including in-programmes, does not justify abandoning rules designed to protect the viewing experience or the interests of consumers, and citizens, as a whole. The negative impact of excessive or intrusive promotions may justifiably outweigh the benefits some consumers receive.

The Cross-Promotion Code did not apply to the BBC's public services, only the BBC commercial services. However, Ofcom called for the BBC to be brought under the Code and this was achieved. The BBC lay outside the rules, as Ofcom had no powers to regulate BBC cross-promotional activity (Ofcom 2005g: 6). However, Ofcom concurred with the BBC's commercial rivals that the rules should be extended to the BBC, and the Government responded by calling on the new BBC Trust to formulate rules based on the Cross-promotion Code (Ofcom 2006a: 4).. In its consultation paper, Ofcom acknowledged no differences between public service and commercial broadcasters. The case for public value in cross-promoting public service content, against the promotion of commercial services was entirely ignored. In March 2005, during the process of Charter renewal the BBC (2005: 8) published a report commissioned from Spectrum consultants which asserted the public value claim for its cross-promotion as helping to achieve 'audience reach and impact for the BBC's suite of services'.

Summary

Both the ITC and Ofcom made changes largely in response to competition concerns raised by powerful firms competing in rapidly changing media markets. In identifying the problems of cross-promotion that regulation should address, Ofcom's review marks a further shift away from concerns about th⁻

impact on broadcasting cultures as a whole, consumer concerns and the viewing experience, towards narrowly defined issues of inter-firm competition. Ofcom's review focused on competition issues and framed the problems arising from cross-promotion accordingly. More positively, Ofcom reaffirmed the rules and rationale restricting commercial references within programmes which cover 'all products and services, including broadcasting-related services'. Yet, the rules allowed greater scope for in-programme promotion. Issues of editorial integrity were merely noted for the most part with little expansive discussion or consideration. Greater weight was given to consumer concerns, identified in the study and in the commissioned research on viewers' attitudes, however, little, if any, weight was given to these in Ofcom's actual proposals.[33]

What occurred was a significant liberalisation of rules over the last decade, permitting an increasing amount and range of cross-promotions. The level of regulation, however, remains strikingly high when compared to the US. In particular, the UK still retains strong restrictions governing the promotion of commercial services, especially in programme time (chapter eight).

Cross-media Promotion and Regulatory Gaps

The relationship between powerful economic interests and regulation is both more complex and operationally contingent than many left or right inflected theories of regulatory 'capture' suggest.[34] However, there is considerable evidence that UK media policy and regulation have been shaped in ways which advance conditions favourable to the interests of powerful commercial companies. As such CMP may be seen within a much larger class of regulatory restraints on market behaviour and media performance which have been liberalised. But it is also a much more indeterminate object of policy and that status itself indicates, in part, the success of industry interests in preventing its emergence as an object of policy. Both the neglect of CMP and the manner in which it has been addressed as a 'regulatory issue' reveal the influence of corporate interests. Industry interests, though, remain heterogeneous and unstable in fast-changing, highly competitive and high-risk sectors. The ability to use media for self-promotional and cross-promotional purposes has prompted aggrieved parties to call on policy-makers, regulators and courts to act. Yet such industry challenges largely concern economically prejudicial behaviour and do not engage the broader critical and normative issues of which this study examines.

nfluence over policy and regulation is a key determinant of regu-
nt of CMP but not the only one. A second key factor is non-

interference based on principles of freedom of expression. Editorial cross-promotion lies on the highly contested boundary between 'protected' media speech and commercial speech. Cross-media promotion also frequently activates the contradictions and anomalies between the divergent treatment of broadcasting and the press in regulation. Third, convergence and new media, especially the Internet, have opened up new opportunities for 'regulatory bypass' (Barendt and Hitchens 2000) influencing in turn concentration on 'pragmatic' responses in policy and regulation, which limit the scope as well as intensity of regulatory action. Partial compliance or non-compliance with regulation has also been a contributory factor. States non-enforcement of the quota and advertising rules of the EC Television Directive, for instance, contributed to the call for harmonising rules downwards. A fifth factor has been that cross-media promotion lacks what Daintith (1998:359-360) calls 'legal substance':

> In such a situation the policy-maker may be more likely to resort to an instrument which draws on such a body of law than to one which requires the creation of quite new legal arrangements; and if he (sic) does, the shape of the measures he uses will be dictated by the terms in which the existing legal scheme is expressed.

Our review has shown that cross-media promotion has only been addressed to a limited extent as a 'regulatory issue' in the UK. Some BBC cross-promotion was explicitly curtailed following the period of scrutiny in the early 1990s. Various types of regulation have constrained cross-promotion in digital television. Yet, each of the various regulatory tools, and each main institutional approach, developed historically for discrete media sectors, has neglected cross-media promotion as a problem for regulation to tackle. Communications regulation has proved adaptable in identifying and tackling certain 'new' problems, such as those arising from interoperability, bottlenecks and gateway control of digital services (Graham 2000), yet cross-media promotion has remained largely neglected despite evidence and growing concern about its intensification. In line with the analysis in this chapter, the reasons for this have more to do with the influence of commercial and industrial interests on communications policy and regulation than on factors arising from technological change.

Regulatory responses to CMP also must be understood in the context of broader processes of regulatory innovation and 'reform' occurring in the 1980s and 1990s. From the 1980s media companies and advertisers lobbied government to liberalise rules on ownership, cross-ownership and content in broadcasting. The outcome has been increasing, if uneven, liberalisation. Through studies of the Sadler *Enquiry*, the ITC and Ofcom, we have identified the influence of corporate actors on policy, but such influence has interacted with

other factors. An organised lobby of publishers influenced the outcome of the Sadler *Enquiry*, however other factors, including the way in which the enquiry was conceived and conducted, made it susceptible to following an agenda set by the interests of commercial publishers against the BBC. The ITC resisted demands from powerful firms and did not act in accordance with crude 'capture' theories. The revision of rules, however, was framed by and for a narrow policy community governed by industry interests.

Corporate influence may be best understood and discerned in the way CMP has been constituted as a regulatory issue. Here the analytical concept of 'regulatory space' is particularly valuable to describe the 'arena of power within which groups and organisations vie for control' (Gibbons 1998: 9). For Hancher and Moran (1989: 277) regulatory space is defined by the 'range of regulatory issues subject to public decision'. A criticism of interest group theories of regulation is their tendency to infer policy influence from an account of the interests of actors themselves. Hancher and Moran's analytical construct of regulatory space seeks to overcome this by combining 'socio-legal, sociological, cultural and organizational elements' (Baldwin and Cave 1999: 30). Their focus is on the outcomes of competitive struggles between institutions and organisations that make up 'regulatory space' but also on the modes of exclusion of those outside. The organisation of regulatory space must be understood 'by reference to the social structure of industrial and state elites [but] it is not simply a product of those features [...]the allocation of power and influence within regulatory space is influenced both by legal tradition and by a wide range of social, economic and cultural factors' (Hancher and Moran 1989: 165). According to Hancher and Moran (1989:171):

> the connection between issues, arenas, and the character of economic regulation is shaped by both ideological and structural factors. Regulatory 'issues' are in an important sense ideological constructions: their recognition depends on social actors construing the world in a particular way; their allocation to a particular regulatory arena is likewise the result of a process of ideological construction.[35]

Similarly, Mosco and Reddich (1997: 21) argue that CPE perspectives need to address 'how or by what process political and economic power interacts in a hegemonic way to frame the agenda, prescribe the policy alternatives, and gain general social acceptance and institutional standing, even in the face of contradictions that give rise to opposition by social interests both during and after policy change'. Further, as Gibbons (1998: 10) notes:

> [I]n [UK] media regulation there is a subtle interplay between different layers of policy formation and decision making, drawing on a wide range of normative sources. . . . What are significant are the points at which each of these normative sources has an influence on the shape of regulation.

For Hancher and Moran (1989: 169), 'The innovative nature of markets under advanced capitalism therefore constantly disturbs the routine identification of regulatory issues, and their ready assignment to organizational domains'. Although their focus is economic regulation in the 1980s, this observation may also be applied to the constitution of CMP within dynamic market and regulatory change.

We have seen that there was a moment in the late 1980s when CMP, intensifying during a phase of deregulatory pressure, was addressed explicitly in relation to discrete media of newspapers and television. This moment included the active involvement of diverse social actors contesting the nature of the regulatory issue. Although the challenge to Murdoch was diffused, the TUC and other actors influenced Sadler's 'compound' perspective on remedying problems in editorial content. Subsequently, CMP emerged as a regulatory issue framed by corporate media actors within the evolution of a new paradigm of behavioural competition law. As cross-media promotion increased in scale and intensity it became subject to greater regulatory scrutiny. However, the way in which CMP has been constituted reflects the ascendancy of this new media paradigm and the powerful influence of corporate media interests.

Our study of the ITC showed that there has been a shift in regulatory rationales as cross-promotion has become an object of policy. In chapter two, four main types of problematisation of CMP were identified within four paradigms: competition (neoliberal), consumer welfare (consumer), editorial integrity (liberal democratic) and systemic (political economic). This mapping identified the nature of different responses to CMP; it also provides an analytical tool for considering the characteristics of shifts in dominant regulatory paradigms. The study of changes in UK broadcasting regulation shows that while regulation remains a key factor constraining CMP, there has been a shift from editorial-based rationales to competition ones. Liberal democratic concerns remain salient but have given way to competition and narrower consumer welfare concerns. In this process, a wider 'systemic' critique of CMP has been displaced and greater tolerance of CMP allowed.

One of the values of Hancher and Moran's account is that the framing of regulatory issues is understood not simply as a 'force of ideas' explanation of regulatory change (Baldwin and Cave 1999:18–33) but within a more complex account of the structuring of power and resources, and the constitution of policy networks. Yet part of the explanation for the way in which CMP has been constituted during the period studied has been the lack of significant challenges. Writing on UK media policy in the 1980s, Seymour-Ure (1987: 283) identified one cause of policy 'invisibility' as the lack of monitoring organisations:

If 'media policy' was not a construct in the public thinking and rhetoric of governments themselves, there has not been much of an alternative community to construct it.

After Sadler, CMP did not re-emerge as a significant policy issue amongst consumer groups, and various organisations and interests concerned with media policy and reform. As noted, only two non-industry groups responded to the ITC consultation. This lack of opposition is an important element. The countervailing force that might have arisen from alternative critical formulations of CMP was very largely nonexistent. For radicals, through the 1990s, CMP was subsumed into a critique of media ownership and was not developed, following the interventions to Sadler, as an explicit object of policy reform. The challenge to do so remains pressing.

Notes

1. The profitability of television in the 1960s and 1970s underpinned the practical effectiveness and legitimacy of regulatory controls and sustained sufficient industry support for regulation of what Peacock Committee called the 'comfortable duopoly': competition for audiences but not advertisers between the BBC and ITV. (see Leys 2001: 111; Curran and Seaton 2010).

2. This was prior to the 1990 Act that implemented a proposal made originally by the Annan Committee (Annan 1977: 464–468) for the removal of broadcasters' monopoly copyright on programme information.

3. Its survey of promotions (Sept-Oct 1991) identified 64 mentions for books, videos and records on ITV/C4 compared to 22 on BBC 1 and 2.

4. Western European broadcasting was firmly shaped by the ideas of public service, although these were institutionalised in various ways and realised to varying degrees. The principal beliefs underlying this system were that broadcasting should be organised and conducted in the public interest, so that neither state not commercial interests dominated, that it should provide a programme mix that adequately served the needs of democratic polity and met certain cultural and social goals through the quality, range and variety of programmes (Tracey 1998; Broadcasting Research Unit 1985; Hardy 2008a).

5. See Dahlgren (2000).

6. Colin Leys (2001:136) provides a detailed examination of what he described as the 'reconstitution of broadcasting as a field of accumulation, rather than as a set of primarily political institutions' and identifies four prerequisites of such change: the conversion of services into commodities; the creation of demand for those commodities; the conversion of the labour force into one willing to produce profits; and the intervention of the state to lower the risks of investment.

7. One comprised a potter at his wheel, another a kitten playing and the third a farmer and horse ploughing a field (Meech 1999: 37).

8. This research was identified by *Marketing* as an influence on the ITC consultation on cross-promotion, see Breech (2001). The research monitored output on commercial channels for two weeks in September 1999. According to its author, John Billett, 'The research shows that viewers see self-promotion and paid-for spot advertising as the same thing' (Kelso 2000). It argued that ad breaks on ITV and Sky exceeded ITC limits; both channels claimed they operated within ITC rules while the ITC declined to comment on the report.

9. Channel 4, like the BBC acquired secondary rights to programmes commissioned from less-powerful independents (see Leys 2001:125). ITV Network Centre was only allowed to buy rights to two airings of programmes, leaving rights to further sales in the hands of the producer.

10. For instance, John Marchant, Sponsorship Controller at Granada (in 1994), had previously been involved in sponsorship at Super Channel, a European satellite service deriving almost 50 per cent of its revenue from sponsorship, as well as Capital Radio (Leggatt 1993: 101, 107–8).

11. Cable company ntl's managing director, Stephen Carter, formerly chief executive of J Walter Thompson, and later Chief Executive of Ofcom (January 2003-October 2006) stated that multichannel TV was maturing from a manufacturing phase to a 'marketing phase' (Ellery 2001).

12. This requirement was ended on 1 January 1999 together with the phasing out of the Channel 4 funding formula (ITC 1998b)

13. See ITC (1998c, 1998d, 1998e, 1998f, 2001e, 2002c)

14. For a general survey see Leys (2001).

15. The wider context was a debate about public service media and public service principles in the 'digital age'. While there were free-market abolitionists, this focused on the extent to which the BBC should be allowed to provide services beyond its core television and radio services. Were the services promoted ones that were legitimate activities for the BBC? Was the separation of public service and commercial revenue maintained, or able to be maintained?

16. BIPA's membership included major newspapers publishers and their new media groups (Telegraph Group Ltd, News International, Guardian Unlimited, Associated New Media, Independent Digital) as well as commercial radio groups and publishing group EMAP.

17. The ITV Network Centre' audience target of 39 per cent in 1999 was only narrowly missed ('thanks to some ruthlessly 'down-market' evening scheduling' Leys 2001: 123), but ITV's share failed to reach the 40 per cent target set for 2000.

18. ITV Digital was officially put up for sale on 25 April 2002.

19. In fact, Channel Four suffered considerable losses on its digital ventures and its previously successful film production and distribution arm, Film Four, leading to job losses and restructuring in 2002. Film Four was relaunched as a FTA digital channel in July 2006.

20. The 1996 Broadcasting Act guaranteed ITV a digital simulcast of its terrestrial service on all platforms. However ITV objected to paying BSkyB's conditional access charge of approximately £20 million (Davies 2001a). ITV refused to allow its simulcast to be available on BSkyB's Digital satellite platform (until December 2001).

21. Interview with Ian Blair (2002) ITC Deputy Director of Programmes and Advertising. Robin Foster described cross-promotion as 'genuinely a difficult issue' (ITC 2001c).

22. The BBC's commercially funded television services in the UK (i.e., its joint ventures UK Gold, Play UK, etc.) had to conform to all relevant ITC codes. In its response the BBC challenged why restrictions on cross-promotion should not apply to cable or satellite channels since these may have market power and not face effective competition.

23. The ITC held frequent private meetings with key firms. Many of the submissions contained confidential and critical information on rivals that firms wished to share only with the ITC so that their inter-firm dealings were unaffected (Begg 2002; Blair 2002).

24. From 1998 the ITC (1998j) permitted on all channels 'masthead' programmes, 'made or funded by a periodical, newspaper, book or information software publisher' and which bear the name of the publication and carry content similar to the publication (McCall and Carter 1998; McCall 1997). The ITC stated that 'the effect of the inclusion of the magazine's name in the programme title was to act as a badge of origin for the programme content, not as a promotional tool for an advertiser to promote other, non-magazine, activities' (ITC 2000a:13). Masthead programming, marking a significant victory for media and advertiser lobbying, represented a clear breach of the requirement that sponsors do not 'influence the content or scheduling of a programme in such a way as to affect the editorial independence and responsibility of the broadcasters' (ITC 2000a: 8).

25. For a critique of market mechanisms in media registering and satisfying consumer preferences see Baker (2002, 1994). There is some evidence to support the argument that broadcasters respond to consumer dissatisfaction concerning promotions. BBC One controller Jana Bennet announced in May 2003 that she intended to cut the number of BBC promotions for new digital channels and Freeview following indications that trailers in programme junctions were annoying viewers (Thorpe 2003). The same article, quoted ITV's new Marketing Director, Jim Hyter (formerly at Channel Five), arguing that ITV was trying to 'clean up its act', cutting down on trails, while the BBC was increasing its promotions.

26. All broadcasting industry responses promoted regulatory outcomes favouring their firm's competitive position thus, supporting, in this specific sense at least, theories of regulation as an instrumental resource for firms seeking market leverage.

27. The ITC initially proposed that Channel 3 could mention the platform on which promoted programmes or services could be obtained provided such references were 'factual and non-discriminatory' (e.g. all service providers carrying the service must be mentioned)' and generic (e.g. digital terrestrial, digital satellite, cable), unless the service was only available from one service provider (e.g. ONdigital, Sky, NTL). In the Second Consultation, the ITC proposed a 'small additional restriction' in response to the competition concerns put to it. Service providers could now be mentioned only where the service was carried by all main platforms and then all main platform providers must be mentioned. At this time ITV 2, ITV Sport and Carlton's digital channels were not carried on BSkyB so the rules would prohibit any mention of the ITV Digital platform except in ITV's advertising time. Finally, the ITC required digital channels with market power to provide a feed 'clean' of references to interactive services addressing complaints from ITV Digital and cable operators about the promotion of services available only on Sky.

28. Source: author's interviews ITC Deputy Director of Programmes and Advertising Ian Blair (2002) and Michael Begg (2002) ITC official responsible for the consultation. This strengthens the inference that the review was prompted more by the build up of complaints from firms, notably BSkyB and Carlton and Granada, which also contributed to the focus being on competition rather than content issues.

29. The author wrote both submissions on behalf of the CPBF (2001a, 2001b).

30. The Independent Broadcasting Authority (IBA) 1972–1991.

31. In November 2001, Allen announced Granada's preliminary financial results and stated 'ITV Digital now benefits both from the strongest commercial brand in UK television and from regular cross promotion of its ITV channels; ITV 2 and the ITV Sports Channel'.

32. The review was covered in the trade press (*Broadcast* 2002) but received little wider coverage.

33. Ofcom's commissioned research (Ofcom 2005e) examined viewers attitudes to promotions. Ofcom (2006a: 42) concluded that '[o]verall, the research suggests promotional activity has far reaching benefits for viewers that outweigh some minor irritations'. In fact, 59 per cent of adults felt there were too many promotions on TV. Only 4 per cent strongly agreed with the statement 'I would be happy for more promotions and trailers to be shown on television', while 13 per cent slightly agreed. The research did show positive valuation of programme promotion, but failed to explore deregulation of CMP with respondents, although 40% actively objected to in-programme promotions.

34. For discussion on the concept of regulatory capture see Horwitz (1989); Hancher and Moran (1989); Makkai and Braithwaite (1995); Mosco (2009); Baldwin and Cave (1999: 24–5)

35. The emphasis placed on structure as well as ideology helps to avoid conceiving 'ideological struggle' in the framework of culturalist Marxism, as conflict fought out over the legitimation of ideas. Curran (1986: 97) notes that the effect of such thinking about ideological contestability *in* the media, during the 1980s, was 'to steer the Left away from a programmatic approach to the reform of the media'.

Product Placement

The US Federal Trade Commission (2005) defines product placement as 'a form of promotion in which advertisers insert branded products into programming in exchange for fees or other consideration'. Such placement ranges from the visual inclusion of brands, to verbal endorsement and sophisticated 'brand integration' such as that of Federal Express in the film *Cast Away* (2000) or the Halliburton security case dominating an early episode of *Lost*, which *The Economist* (2005) described as 'product placement to die for'. Brand integration, it is claimed, offers advertising effectiveness (if done appropriately), an important source of income for programme makers and/or broadcasters, and new forms of creative collaboration between advertisers and media. In the United States, product placement is now a $5 billion industry, increasing annually. In Western Europe, however, a very different regulatory culture has prevailed. Until 2007 European television policy upheld the principle of separation of advertising and programme content. Some states permitted product placement but most, including the UK, Ireland, Germany and Finland prohibited paid placement.[1] This chapter examines both the industry dynamics of product placement and the regulatory issues and debates that have intensified over the last five years. In contrast to intrafirm cross-media promotion, product placement or product integration usually involves transactions between separate economic parties, advertisers on the one hand and content producers, broadcasters or other distributors on the other. However, the common element is the integration of editorial and advertising in content. Changes in regulations governing commercial references in media content also directly affect the scope and range of CMP.

The FTC definition highlights an important distinction. Product placement is the placing of a product or brand in media content in return for payment or other valuable consideration. That needs to be distinguished from the presence of brands themselves. Advocates of product placement sometimes adopt a very broad definition to include any brand presence in media content and make the case for brand presence as verisimilitude. Argued thus, the case for brands is strong. There has been a close and enduring relationship between

brands and media content especially in entertainment media. Murdock (1992a: 226) notes how, from its inception, cinema has 'enjoyed an intimate relationship with mass consumption', filming a world 'saturated with branded goods and advertising displays'. Product placement in movies can be traced back to the Lumière films of the 1890s, and was well established in the Hollywood studio system by the 1920s (Newell et al. 2006; Eckert 1991). The Hollywood studios extracted commercial fees for product promotion and endorsement in movies from the early years of the 20th Century. The key issue, however, is brand presence arising from a transactional relationship, using payment for 'placement'. This is particularly important when considering regulation. The UK, for instance, permits unpaid prop placement, in which branded goods are supplied for television productions, while prohibiting paid placement.

There is nothing new about the integration of advertising and media content. Yet, commentators are right to emphasise increasing use of product placement in films from the early 1980s (Lehu 2009). In the United States product placement has become more intensive and more intrusive—driven by powerful commercial dynamics and a largely unregulated or weakly regulated environment. There are no federal rules governing product placement in movies (Siegel 2004). Some twenty brands were featured in the movie *The Dukes of Hazzard* (2005), including Beefeater Fun, Budweiser, Cadillac, Coca-Cola, Dodge, Doritos, Ford, Levi's, Miller, Motorola, Nike, Ray-Ban, Tabasco, Volvo and Yahoo!

In *Cast Away* (2000) Tom Hanks plays a FedEx (Federal Express) worker alone on a desert island, who obeys company rules not to open the packages washed up with him for months into his increasingly desperate plight. One journalist's account of the 'flagrant product placement' in the film, criticises the 'aesthetic compromises the brand forces the film to make' (Abramovich 2001: 2). The film illustrates Andersen's observation that commodities increasingly shape story lines and have become integrated as essential plot elements (Andersen 2000: 4–5). As well as the interweaving of placement into plot, *Cast Away* showed the evolving complexity of product placement deals. There was no direct payment, instead Fed Ex's chief executive was an investor in the film's production company and a friend of the scriptwriter who worked alongside Fed Ex's director of global brand management for two years on the project (Friedman 2004).

Product Placement in US Television

The Advertiser described 2002 as marking a decisive shift from sellers' control by TV companies to buyers' control by advertisers. It went on: 'The buyer wants more than just spots. . . . Contests, sweepstakes, and the doors to product placement and commercial integration into content kick open'. Certainly, according to various indicators, product placement has increased in volume and intensity in the 2000s. According to Nielsen Media Research, product placement occurrences on US network TV prime time rose to 22,046 in the first three quarters of 2007. On cable TV, for the same period Nielsen found 136,078 occurrences. Product placements with a combined visual and audio reference on US network television went up by 17% in 2006 to 4,608, and by 13% to 5,190 in 2007. There were 118,000 individual product placements across 11 top US channels in first three months of 2008 alone.

Marketers used the term 'product integration' to describe a refinement beyond placement in which brands are dominant features during a programme. One report (Poniewozik 2001: 76) noted:

> Product placement used to be simpler. Jerry Seinfeld gave shoutouts to Snapple and Junior Mints (gratis) to give his sitcom versimilitude. . . . But after *Survivor*'s success "product integration" . . . is taking in-show advertising to a new level of sophistication and stealth. Products are becoming part of the show, be it the Taco Bell that's the site of a "murder" investigation on a new reality show or an SUV used in a TV-staged transcontinental race.

In 2007, *American Idol* featured 4,349 product placements, topping the list of network TV programmes with product integration. Coca-Cola's deal with *American Idol* has involved logo-ed cups in front of the three judges, the traditional green room renamed 'Coca-Cola Red Room', specially taped segments labelled 'Coca-Cola Moments', as well as plugs by the show's hosts (Friedman and Halliday 2002).

In the first quarter of 2008, TNS Media Intelligence found that brand appearances, in the form of product placement and integration, averaged 12 minutes and eight seconds per hour in primetime network television, all in addition to 14 minutes of regular commercial breaks (TNS 2008). Between 1999 and 2004, product placement on television grew at an average rate of more than 2 percent—double that of placements in film. In the 2004–05 season, the broadcast networks alone (ABC, CBS, NBC, FOX, UPN, WB) displayed a staggering 100,000 product placements. PQ Media, which tracks the placement business, calculated that in 2004, the value of all TV placements grew by 46.4% to almost $2 billion, with 34% annual growth to $2.9 billion in 2007. However, even in the largest market, the United States, PP

revenues are small compared to traditional TV advertising, representing less than 2% of total advertising revenues in 2004 (PQ Media 2005).

Product placement and reality television

The surge in product placement is partly attributable to the success of reality TV shows. PQ Media's CEO Patrick Quinn asserted, 'I think the real inflection point for product placement—why we've seen this huge upswing in the growth of the marketplace—is *Survivor* in 2000' (Anderson 2006a). *Survivor*'s producer, Mark Burdett convinced CBS to take the show with a deal whereby product placement would offset some production costs. The reality TV genre has expanded for reasons of production economies as well as market popularity, not least in providing a ready vehicle for product placement. NBC's 2003 reality show, *The Restaurant*, was also created by Mark Burdett, who said he looked on it as much as a marketing vehicle as a television show. *The Restaurant* was produced by Interpublic, one of the largest advertising agencies, and offered 'top clients access to product integration deals', including Coors beer, American Express and Mitsubishi. According to McChesney (2004:150): 'this partnership was lucrative, as viewers were treated to obvious hawking of products intended to be part of the story line of this "reality" show'. *The Restaurant* was notable too because it excited critical debate among marketing professionals. The editor of *Advertising Age*, Scott Donaton (2004: 152) described the show as 'nearly unwatchable' due to 'product placements that are aggressive, intrusive and clunky—anything but the seamless blend necessary to make them bearable, never mind bringing them near to the (perhaps unattainable) standard of enhancing the programming'. Donaton instead approved *Queer Eye for the Straight Guy* (first shown on the US Bravo cable network in 2003 and subsequently shown in the UK on Channel Four in 2004) as 'mixing in products without ever stomping on the story'.

While there is evidently a continuum from subtle editorially 'appropriate' brand placements to intrusive promotion, reality TV has proved an attractive vehicle for marketers and programme-makers alike. In programmes like *The Apprentice (US)*, shown on NBC, brands have been fully integrated into episodes, such as when competitors vie to develop brand extensions for companies such as Levis. According to the Writers Guild of America, during the third season of *The Apprentice* (US) in 2004, Burger King, Dove Body Wash, Sony PlayStation, Verizon Wireless and Visa reportedly paid upwards of $2 million per episode to have their products incorporated into plotlines. Burger King paid a reported $2 million for one sponsored episode in which contest-

ants tried to write advertising copy for its latest product, then 'donned Burger King's blue and yellow uniforms and struggled to perform jobs easily managed by high school dropouts' (Furia 2005). Product integration has also increased in local TV, especially in programme syndication. Meredith Corporation's hour-long lifestyle show *Better* (named after the company's *Better Homes & Gardens* magazine) featured short videos (infomercials) for State Farm Insurance. According to *Advertising Age* (Steinberg 2009), 'National and local product integration is one way Meredith generates revenue from its *Better* program. Up to eight minutes of the syndicated national show can be "localized," which could include the sale of local product integration, as well as sponsorship of news and entertainment features'.

Dynamics of Product Placement

Product placement has proved attractive for a host of reasons, some common across media and others connected to the particular forms of production and modes of consumption. In filmed entertainment, product placement extends the promotional opportunities to all the various windows for viewing. This can be a cost-effective means of promotion; 'as a film gets aired repeatedly from its theatrical debut to televised broadcast and home video rentals, the cost of product placement per thousand exposures decreases to mere pennies' (Lee 2008: 208). Such aggregation of promotional hits has become increasingly important as audiences fragment across an expanding digital universe and media demassify (Lehu 2009). PP can provide marketers with an effective way of reaching audiences, including those harder to reach by other means. Film has proved an attractive way to reach young people in the 12–24 market, valued by advertisers but lighter consumers of television. For the same reason PP in online content is expected to increase sharply as well as providing an important source of revenue for original production given the difficulties surrounding other means of consumer payment for online content. Placements in entertainment media, in settings where consumers are relaxed and want to be entertained, can be powerfully conducive to selling.

As a form of 'stealth' or 'camouflaged' advertising PP can be very effective. Brands can benefit from their association with stars. Seeing a favourite character or actor use a particular product can be persuasive. Placement can have greater credibility and can overcome resistance to designated advertising amongst some target audiences. Placement deals can enable brands to be displayed without competition. While the promotional effect is subject to

relative degrees of risk, depending on the nature of the placement contract, the balance of editorial power, advertiser influence, and media context, paid placements are forms of marketing pursued to enhance brand appreciation and identification. A further attraction for marketers, examined further below, is that placements can circumvent rules on advertising which otherwise restrict the manner in which products, such as tobacco, alcohol, HFSS foods, or services, are displayed.

Today, these various benefits need to be reframed in the context of a deeper crisis for television advertising. In general, the advertising revenue on which advertiser-financed commercial television depends has tended to fall. This has occurred because of the expansion of channels competing for advertising and audiences, declining expenditure on advertising during periods of economic downturn, and because of the shift of advertising expenditure from television to other media, notably the Internet. Integrating advertising into programmes has been regarded as a solution to two problems: the declining reach and effectiveness of TV 'spot' advertising, and the rising costs of programme production. Arguably, the single most important driver for product placements in television is their contribution to combatting 'advertising avoidance', embedding promotions so that these will not be skipped by viewers (Lee 2008; Wenner 2004). Digital video recorders (DVRs) are only the latest in a line of innovations from the remote control and VCR onwards enabling viewers to bypass ads. As McAllister (1996) shows, fears about by-passing adverts intensified in the 1970s when the remote control allowed audiences to 'zap' and channel hop, avoiding ad breaks. VCRs allowed audiences to fast-forward ads but also enabled more repeat opportunities to view ads. More recently, the digital video recorder (DVR), also described as the personal video recorder (PVR), has generated further debate on ad-avoidance, although fears of in-built ad-avoidance technology did not materialise in most of the commercially available DVRs. The ability to store programmes and scan ads does increase the capacity of ad avoidance, however. According to Forrester Research more than half the people with a DVR routinely skip commercials.

In the UK *Media Week*'s cover in September 2005 read 'How product placement could beat the PVR threat'. The crisis of traditional advertising can be easily exaggerated, not least to promote ad-integration, and avoidance is certainly not a new phenomena. Yet, marketers are increasingly framing their strategies in response to the weakening of traditional advertising vehicles. Pressure to integrate advertising and media content has therefore intensified under conditions that make ad-dependent media more willing to accede to marketers' demands. There are then 'various economic, technological and social transformations propelling "advertainment," the merger between the

advertising and entertainment industries, and they do not show signs of abating anytime soon' (Lee 2008). With a strong commercial logic and an expanding industry to arrange and broker deals, product placement has, like synergy, become part of the earliest stages of creative planning and financing of media content.

Product integration has proved attractive to production companies as a way of defraying production costs and as a source of revenue alongside programme sales. Who benefits financially from product placement revenues, though, depends on the deals made between advertisers, placement agencies, programme-markers, programme commissioners, broadcasters, re-broadcasting channels and other programme providers. For channel owners, product placement provides an additional source of advertising revenue beyond designated advertising or sponsorship, although there are concerns that product placement revenue may cannibalise other advertising revenue.

Normalisation

In autumn 2000, ABC (the US network owned by Disney) reached a deal with Campbell's, a major TV advertiser, to be primary sponsor of eight episodes of *The View*, a daytime talk show. Two features generated wider comment and controversy. The deal included scripted segments in each programme in which Campbell's Soup was the centre of attention in addition to Campbell advertising during commercial breaks. The second factor was that one of the show's hosts, and its co-producer, was Barbara Walters, one of ABC's most prominent news personalities. Walters' co-executive producer, Bill Geddie, acknowledged the concern that a big sponsor might compromise the show but asserted (Branch 2000):

> nobody controls our content. We're willing to plug shamelessly, but we have limits. The integrity of the show has to be maintained.

One condition of the deal, he said, was that *The View* would be free to poke fun at Campbell. However, the extensiveness of the deal itself weighs against such independence. Pitched to Campbell by sales executives at ABC, the deal included special announcements at the beginning and end of the show, as well as banner ads and links to Campbell's web site from the ABC *The View* site.

Marketing opportunities are now routinely considered in programme commissioning and the production process. Professionals with marketing expertise are recruited into senior positions, and new positions created to ensure that product placement is integrated at the earliest stages. For instance, in April 2008 CBS Television Distribution, the syndicated-programming arm

of CBS Corp., created a special unit to introduce product integration into the early stages of programme development. Greg Bennett, who filled the newly created position of senior VP-branded integration and online, said the aim was to develop 'an in-house agency' that can talk 'to the ad agencies and the promo agencies in their lingo'. CBS Television Distribution syndicates shows such as *Jeopardy!*, *Wheel of Fortune*, *The Oprah Winfrey Show*, *Judge Judy* and *Entertainment Tonight* (Steinberg 2009).

Product placement in games and multimedia

Dubbed 'the third generation of advertising', in-game product marketing has grown significantly in the last few years, especially as the demographic reach of games has extended across the generations. As TV's ability to reach mass audiences has diminished, marketers have looked to new vehicles. Games publisher Codemasters launched Toca Race Driver 3, featuring a game strand dedicated to the new Honda Civic marque; Puma clothes featured in Activision's True Crime: Streets of LA; a poster for the television series *Lost* featured in Anarchy Online (Kilby 2006).

Regulating Product Placement in the United States

Product placement is not unregulated in the United States, but it is very lightly regulated compared to most Western European states, and such rules as exist are also lightly enforced. There are no restrictions on product placement in films. The only exceptions are where promotions may fall foul of restrictions on advertising certain products such as tobacco or in limited instances where self-regulation applies. In broad terms, the US government does not prohibit product placement in films or broadcast television. There are, however, regulations governing two specific instances of product placement in broadcasting. The so-called 'payola' laws require broadcasting networks and stations to disclose paid placement and to list all sponsors, with the exception of donated products, products supplied for nominal consideration or where the purpose of the product's placement is the promotion of realism. The rules date from the radio scandal in the 1950s, triggered by revelations made in congressional investigations that deejays were being paid by record labels to promote or air certain songs. Payola, a term used to describe such commercial bribery for editorial endorsement, was made illegal in the United States. The other rules concern disclosure.

FCC rules require that all commercial messages must be clearly disclosed to viewers. The rules are contained in sections 317 and 507 of the Communications Act of 1934, as amended, and sections 73.1212 and 76.1615 of the Commission's rules. Section 317(a) (1) of the Communications Act requires that broadcasters disclose 'any money, service, or other valuable consideration' that is paid to or charged by the broadcaster in exchange for product placements. Broadcasters are not required to disclose product placements for goods offered without charge or for a nominal fee. Section 317(c) of the Act requires that broadcasters exercise reasonable diligence in obtaining from their employees or any other person with whom they deal directly in connection with a program for broadcast, information about product placement arrangements, so that appropriate disclosures may be made. Section 507 imposes a duty of disclosure upon anyone involved in the production or preparation of the broadcast matter so that the licensee can air the required disclosure, which it must do even if no consideration has been paid to the station itself. So at the time of airing broadcasters or cable operators must inform the audience that such matter is sponsored, paid for or furnished whether whole or in part, and disclose on whose behalf such consideration was made. As Lee (2008: 215) comments 'the law requires continuous disclosure up the production and distribution chains, which ultimately places on the broadcaster the responsibility of identifying the sponsor(s)'.

Section 317 (a) (1) provides that no disclosure is necesssary in respect of material that is furnished 'without charge or at a nominal charge'. The 1934 Act requires disclosure, but precise rules are left to the FCC which also retains authority to waive disclosure requirements if it determines that public interest, convenience, or necessity does not require them. The disclosure rules have been the subject of intense lobbying over recent years. Before examining this it is important to address another regulatory agency, the Federal Trade Commission (FTC). The FTC regulates marketing communications and has power to intervene where an unfair or deceptive act or practice affects commerce and leads to substantial consumer injury. So far it has not intervened to regulate product placement (Lee 2008). In 2002 the US campaign group Commercial Alert petitioned the FTC arguing that the failure to adequately identify and disclose PP arrangements was deceptive and injurious to consumers. In response the FTC (2005) argued that there was no 'pervasive pattern of deception and substantial consumer injury attributable to product placements', and decided that 'an industry-wide ruling was inappropriate at this time'. The FTC argues that product placement differs from other forms of advertising and sponsorship in that it does not make claims about products and so does not

give rise to harm for consumers, since there can be no deception without a claim.[2]

Pressure for regulatory change

Dean Ayers, President of ERMA, commenting on *Cast Away* (Abramovich 2001) said:

> Only five years ago, people were hiding. They thought what they did was wrong and that the public was against it. They found out that the public is actually for it. The production people are for it. The companies are for it. There is really only a very small segment of people who are opposed to product placement.

This confident assertion of normalisation has plenty of support. However criticism of PP has increased and influenced the policy-making process. In recent years, pressure has grown for the FCC to strengthen the requirements for disclosure of product placement. In 2003 Commercial Alert filed a Petition for Rulemaking that called on the FCC to establish more stringent disclosure requirements in films and television programmes. It has called for 'concurrent disclosure', with onscreen notices so that TV viewers and radio listeners should see or hear an immediate message telling them that something said or shown had been paid for by a commercial advertiser. The proposal was contested by pro-industry lobbies such as Freedom to Advertise (FAC) and by the Washington Legal Foundation, both of which raised First Amendment concerns and argued that such advertising did not cause substantial consumer harm and so did not justify regulatory intervention. FAC claimed that concurrent disclosure would be intrusive, so much so that it would constitute a 'government ban on product placement' and de facto censorship of commercial speech. These advocacy groups called instead for an FCC Notice of Inquiry.

In 2005 a coalition of the Writers Guilds of America, West and East, and the Screen Actors Guild proposed disclosure at the beginning and end of programmes and called for limits on product placement in children's programmes. Speaking at FCC and congressional hearings these organisations, and others, kept up the pressure for action. The FCC did announce it would launch a proceeding at the end of 2007 but then deleted the item from its agenda (Lasar 2008). However, in 2008 a formal comment cycle began with interested parties invited to respond. The FCC began proceedings in 2008 declaring both a Notice of Inquiry and Notice of Proposed Rulemaking. In June, 23 groups called for action to curb 'advertainment', TV programmes replete with product placement. The focus for many advocacy groups was advertising in children's programmes. The Campaign for a Commercial Free

Childhood represented a broad coalition of liberal left, conservative and religious organisations including Children Now, Free Press, the Parents Television Council, the Benton Foundation, the United Church of Christ. For such groups the intensive commercialisation of children's TV is the focus, while for others it is the ability of marketers to promote unhealthy high fat, salt and sugar (HFSS) foods through embedded persuasion. Research by the US Institute of Medicine, for instance, found that companies promoting unhealthy food and drink were increasingly targeting children through product placement as well as other means (McGinnis et al 2005). Children's television is also an area in which the FCC has special powers to act, arising from earlier regulatory struggles (Horwitz 1989; Kline 1995).

The Children's Television Act of 1990 requires broadcasters to air a minimum of educational TV programming and empowers the FCC to set time and content limits on commercials. Insisting that it requires a strict separation of advertising and programming content in children's fare, the FCC (2008:10) has asserted that 'embedded advertising in children's programming would run afoul of our separation policy because there would be no bumper between programming content and advertising'. Commissioner Michael Copps stated (FCC 2008: 20), '[i]t is my strong initial belief that embedded advertising in children's programming is already prohibited' and expressed the hope that 'we can move quickly to clarify our rules in this area as necessary and to take any appropriate enforcement action'.

Campaigners have demanded that the sponsor identification rules be reviewed. The rules include the requirement that[3]:

> the video portion of such announcement should be given in letters of sufficient size to be readily legible to an average viewer; should be shown against a background which does not reduce their legibility, and should remain on the screen long enough to be read in full by an average viewer.

Broadcasters can comply with the rules by including an announcement in either the beginning or end credits of the programme. In practice, however, corporate sponsors are mentioned in small type during fast-moving end credits. Such disclosure usually flows past so quickly that it is barely noticed by viewers. Moreover, some broadcasters fail to disclose altogether without incurring regulatory sanction.

Announcing the inquiry, FCC Chairman Kevin Martin stated: 'there is a growing concern that our sponsorship identification rules fall short of their ultimate goal: to ensure that the public is able to identify both the commercial nature of the programming as well as its source. I believe it is important for consumers to know when someone is trying to sell them something'.[4] FCC

Commissioner Jonathan Adelstein, a Democrat, advocated tighter rules and more prominent on-air disclosure. He stated (Schatz 2005):

> I don't think it's adequate to just have [sponsorship identification] quickly run by on a scroll so that someone would need to pause their DVR and get out a magnifying glass to read it. That's not real disclosure.

Adelstein left the FCC in 2009 and, while pressure continues, no substantive change in identification rules has yet been announced. However, responding to pressure on a related issue, the FCC issued a notice that broadcasters should disclose Video News releases under the sponsor identification rules (FCC 2005). A further area of regulatory concern is branded entertainment. In the early 1970s, the FCC drew up a test to determine when a programme is categorized as an advertisement. The FCC stated, '[t]he primary test is whether the purportedly non-commercial segment is so interwoven with, and in essence auxiliary to the sponsor's advertising (if in fact there is any formal advertising) to the point that the entire program constitutes a single commercial promotion for the sponsor's products or services'. As Lee (2008: 218) comments, the test is 'fairly broad, abstract and gives a high degree of protection to producers and broadcasters'. She goes on:

> For example, even if a program were peppered with product placements, as long as the program is not constructed around the sole purpose of advertising a specific product, it will not be considered an advertisement. Other than this test, the FCC has been fairly quiet about what it takes to push a non-commercial enterprise into the commercial arena. Given the lenient standards, producers generally rest easy, even though the line dividing the two spheres remains murky'.

The courts have been reluctant to intervene and have generally concluded that entertainment content is non-commercial and entitled to First Amendment protection. There remains a lack of regulatory clarity as to when programme content that has traditionally been afforded strong constitutional protection becomes commercial speech 'which receives less protection and entails a different set of applicable legal rules' (Lee 2008: 205).

While the practices of product placement and brand integration have become increasingly prevalent and normalised amongst media and marketing professionals, this has been accompanied by growing pressure for stronger regulatory action. Whether the FCC proceedings will result in significant changes is yet to be determined, with scepticism from many commentators about FCC commitment to establish new rules in the face of powerful opposition from advertising and media industry interests.

UK Regulation and Product Placement

The 1954 Television Act, which established advertiser-financed broadcasting in the UK, had authorised the clear separation between programmes and advertising and required the Independent Television Authority (ITA) to ensure compliance.[5] The Act prohibited any material which was, or appeared to be, 'supplied or suggested by any advertiser' and stated:

> nothing shall be included in any programme broadcast by the Authority which could reasonably be supposed to have been included therein in return for payment or other valuable consideration to the relevant programme contractor

From the start, however, there were problems concerning the relationship between advertising, programme production and editorial content. The ITA intervened to prevent programme *compères* from appearing in adjacent advertising breaks to endorse products. But a more significant controversy concerned advertising magazines. 'Admags', also known as 'shoppers guides', were programmes of 15 minutes or more in which branded goods were advertised and promoted by characters in settings such as a public house (Murdock 1992a; Sendall 1982). The ITA acted to prevent advertiser-produced programmes (since these breached the ban on sponsorship), but it continued to allow advertising magazines. However, the Pilkington Committee on Broadcasting, established by the Conservative government in 1960, disapproved and recommended prohibition: the ad mags 'blur in several ways a crucial distinction intended by the [Television] Act' between programmes and advertising (Pilkington Committee 1962: 81). The integration of promotions into entertainment programmes, and endorsement of branded products by popular 'trusted' figures meant that (1962: 81):

> The more interesting the magazines become—and we have seen that it is on their intrinsic interest that their place in programming is justified—the greater the likelihood that the viewer will, on another level of his mind, cease to realise that he is being sold something.

The government announced that ad mags would not be permitted in the new licences and the format was discontinued in 1963. Since then, there has been ever mounting pressure for product integration, especially following the expansion of commercial broadcasting in the 1990s and the shift to 'lighter touch' regulation by the ITC. However, UK broadcast regulation has remained, on the whole, successful in maintaining the separation of programmes and advertising. For commercial television, the regulator (ITC, then from 2004 Ofcom) has two main rules which have worked together to regulate PP.

First, paid placement is strictly prohibited (Section 10.5 of the Broadcasting Code). In Ofcom's rules (inherited from the ITC) Section 10.5 reads:

> Product placement is defined as the inclusion of, or a reference to, a product or service within a programme in return for payment or other valuable consideration to the programme-maker or broadcaster (or any representative or associate of either).

Second, are rules on 'undue prominence'. Under section 10 of Ofcom's Broadcasting Code 'Products and services must not be promoted in programmes' (Rule 10.3) and 'No undue prominence may be given in any programme to a product or service' (Rule 10.4).

In 2005, Channel Four was fined £5,000 for promoting Red Bull on a daytime chat show, the *Richard and Judy Show*.[6] Ofcom's Broadcasting Code conforms to requirements set out in the Communications Act 2003, which include the need to maintain independent editorial control of programme content, as required by Section 319 (4). Section 319 (2) (h) requires 'that the inclusion of advertising which may be misleading, harmful or offensive in television and radio services is prevented'. Section 319 (2) (l) requires 'that there is no use of techniques which exploit the possibility of conveying a message to viewers or listeners, or of otherwise influencing their minds, without their being aware, or fully aware, of what has occurred'. Although this maintains the longstanding ban on subliminal advertising, product placement and brand integration activity would, critics argue, also breach this section of the Act.

In the UK, successive television regulators (IBA, ITC, Ofcom) have banned product placement in UK programmes. Although paid placement is prohibited in UK production for broadcast, there have been important exceptions. Product placement is not prohibited in films and no disclosure requirements apply to films shown on UK television. Non-domestic films or television programmes that contain PP are also permitted and are not subject to any disclosure requirements. For television, 'the inclusion of products or services in a programme acquired from outside the UK and films made for cinema' do not fall under the rules on product placement provided that 'no broadcaster regulated by Ofcom and involved in the broadcast of that programme or film directly benefits from the arrangement' (Section 10.4 note). However, undue prominence rules do apply. In 2008, for instance, Ofcom ruled that episodes of *American Idol* that aired on ITV 2 breached UK rules on undue prominence despite having been re-edited for transmission in the UK.

While PP is prohibited, prop placement, where goods are supplied to programmes is allowed, provided that there is no payment or other valuable consideration. Under the code, broadcasters may include 'references to prod-

ucts or services acquired at no, or less than full, cost, where their inclusion within the programme is justified editorially. On television, a brief, basic text acknowledgement of the provider of these products or services may be included within the end credits of the programme. This is permitted only where the identity of the product is not otherwise apparent from the programme itself' (Section 10.5).

A thriving 'prop placement' industry has developed in the UK, as elsewhere. Many of the key players lobby for liberalisation of the rules (see below). There are also powerful incentives amongst the key players who interact—programme producers, advertisers and intermediary 'prop placement' agencies—to circumvent the rules to the maximum extent permitted. Not surprisingly, there are instances of 'undue prominence' for brands in placements that elicit no regulatory sanction but which are often noted by commentators. There are also indications of deals done to feature products, the details of which remain confidential and opaque.

The BBC has similar guidelines for its PSB services. Advertising is prohibited on the BBC's public service channels. While the BBC's commercial television services have always been subject to the same code as commercial broadcast licensees, the Communications Act 2003 and the BBC Charter and Agreement in 2006, granted Ofcom powers to regulate all BBC radio and television in accordance with its codes, with powers to fine broadcasters, including the BBC, up to £250,000 for serious code breaches. The BBC has come under fire for alleged instances of product placement and has issued apologies for placements occurring in programmes made by independent producers for the BBC. Pfanner (2005) reported on the removal by the BBC of the Apple logo from a laptop shown in the drama serial *Spooks* following allegations in print media 'that it had allowed marketers to slip products and brand names into its programming in exchange for cash or other favors'.

Changes in European television regulation

While each national government has its own audiovisual policies, EU member states must also implement the common rules set out in the EU Television Directive first established in 1989 (the 'Television Without Frontiers' Directive), amended in 1997 and recast as the Audiovisual Media Services Directive (AVMSD) in 2007. The Television Directive has been the main instrument of European television regulation, revised in 1997, not least to include new provisions on advertising, teleshopping and self-promotional channels. The Television Directive upheld the 'separation principle' and the 'identification principle'. Article 10 (1) required television advertising to be 'readily recognis-

able as such and kept quite separate from other parts of the programme service by optical and/or acoustic means'. It also prohibited surreptitious advertising. This is defined as:

> the representation in words or pictures of goods, services, the name, the trade mark or the activities of a producer of goods or a provider of services in programmes when such representation is intended by the broadcaster to serve advertising and might mislead the public as to its nature. Such representation is considered to be intentional in particular if it is done in return for payment or for similar consideration.

Although 'product placement,' the paid placement of branded goods or service in programmes, was not specifically named, many member states considered it to be outlawed under the ban on surreptitious advertising. The Directive sets a common framework and minimum standards for advertising and programmes across all EU member states. Many states, like the UK, had also established domestic regulation prohibiting product placement.

The principles, first, of the separation of editorial and advertising and second, that programme agendas should not be distorted for commercial purposes have been central to the Western European 'public service' model of broadcasting. Product placement has generally been considered by European countries as a form of surreptitious advertising. Some countries have a strict ban on paid placement, however the rules vary across EU member states, as have both their interpretation and enforcement. States are reviewing their rules in 2009 and several are expected to liberalise (see below) but current rules and approaches vary markedly (Bird and Bird 2002). In France, product placement is not regulated although the technique could be regarded as surreptitious advertising. It is permitted by the CSA in audiovisual works over which the broadcaster does not have control. In Germany, product placement is allowed when it is justified by editorial needs, but is otherwise forbidden. The supplier of prizes in games and shows can be mentioned twice and a short optical presentation of the prize is allowed. Sweden and the Netherlands apply the principle of 'undue prominence': naming or showing products is only allowed if it fits in the editorial context of the programme and on the condition that the presence is not accentuated. The Norwegian Broadcasting Act provides that products and/or services cannot be spoken of and/or shown in a promotional manner in broadcasting programmes. Like Germany, there are special rules for the presentation of products as prizes. Product placement takes place in Portugal where it is admitted within the same terms as sponsorship in the Advertising Code. In Austria, broadcasters are permitted to sell product placements in films and other fictional programming, provided these are disclosed in credits. Austria's public broadcaster, ORF, runs about 1,000 product placements annually in shows it produces or commissions. The an-

nual income from PP was around €20 million, or $24 million, towards its €800 million budget. Employing a separate sales staff for these placements, chief financial officer Alexander Wrabetz claimed that programme makers were not unduly influenced by marketers whose products are plugged during shows (Pfanner 2005).

The Audiovisual Media Services Directive

In 2007 the Commission unveiled the latest version of the Television Directive, now called the Audiovisual Media Services Directive (2007/65/EC). The Directive was finally approved in late 2007 after a lengthy process of drafting, consultation and lobbying formally underway since 2001. Product placement policy has been part of a broader process to revise regulation in the transition from traditional television to new means of communication, like the internet, cellular, video-on-demand, etc. The new Directive extends regulation of broadcast television to 'television like' services available online and to some aspects of so-called 'non-linear' services (such as VOD). The Directive has been a key target for lobbying interests because it sets the framework for the amount and scheduling of advertising, as well as content and other rules. The Commission proposed for the first time to allow paid placement in European programmes. The variable approach towards regulating product placement by member states was one reason given by the Commission for introducing clearer rules on PP, but advertisers and broadcasters had also lobbied intensively for the rules to be relaxed. A fierce debate ensued with many MEPs (socialists and greens in particular), consumer, trade union and civil society groups opposed. The European Parliament failed to approve the Commission's original proposals for a radical shift to a more permissive approach on PP and moderated these. The outcome is that the new Directive reaffirms the general prohibition on product placement but allows individual member states to opt out and permit PP in films, series, sports and light entertainment, although not in news or children's programmes. This is also subject to rules requiring that such programmes are identified to viewers (for instance by onscreen identification) and that editorial independence is not thereby undermined.

UK policy action and debates. Anticipating the EU rule change, Ofcom consulted in 2006 on permitting PP, prohibited under section 10.5 of the Broadcasting Code (Ofcom 2005b), but concluded that there was a strong polarization of views and made no recommendation. However, in 2008 the issues were debated with renewed vigour as the Government consulted on implementing the new Directive and ensuring domestic law and regulation

complied. Government lawyers identified that Ofcom's existing rules were not sufficient to implement the Directive, and so product placement rules became part of the government's consultation. At the end the consultation, in March 2009, Culture Secretary Andy Burnham announced that the ban on PP would be maintained, although this would be reviewed again in two years time. An intense period of lobbying appeared to have reached a conclusion, in the UK at least, although, as examined below, this proved to be short-lived. This next section illustrates some of the key arguments made and some of the lead actors and interest groups involved. It focuses on the UK but sets this in the wider framework of European policy debates.

Those favouring relaxation of rules represent a powerful convergence of interests from advertisers, ad agencies, commercial broadcasters and content providers (with the exception of some public service broadcasters). As Harcourt (2005) notes in her analysis of European Community policy, no significant media policy can be pursued without the support of large media groups. In both EU and UK contexts, however, there are notable differences amongst companies and industry groupings. The central division amongst broadcasters remains that between commercial companies that overwhelmingly favour PP and public service broadcasters, most of whom oppose. Those most opposed tend to be those like the BBC, whose channels do not carry advertising or commercial sponsorships. Another division is between those companies whose existing or predicted business models see limited benefit from PP or who fear that ad revenues may transfer to PP vehicles. Newspaper publishers fear that concessions to advertisers in the broadcast environment may further entice advertisers away from print. The European Newspaper Publishers Association (2005: 1), argued:

> Simply put, the newspaper publishers in Europe are exposed to increasing pressure from advertisers asking them to weaken the separation of advertising and editorial principle to allow product mentions in articles or avoid bad reports of the advertiser company which advertises in that newspaper; all this at the ultimatum of the advertiser pulling all of their advertising and moving to other media, notably broadcast. The separation principle, which is also a widely accepted media industry norm until present, therefore needs to be maintained for audiovisual content, to prevent even higher manipulation by advertisers as seen in the USA.

For many years UK groups such as the Advertising Association have played a leading role in European policy networks. Lobby groups include the European Association of Communications Agencies (EACA), European Advertising Standards Alliance (EASA), and World Federation of Advertisers, European Advertising Tripartite (EAT). On the whole advertising lobby groups reiterated long-held arguments seeking minimal regulation and favouring industry self-

regulation. On product placement, EACA (European Association of Communication Agencies; 2003: 6) said:

> Product placement, and other forms of so-called 'surreptitious' advertising will, we believe, grow in importance as advertisers seek ever more innovative and creative ways of promoting their brands. We believe that this is a good thing, representing as it does a potential source of revenue to broadcasters—revenue that should lead to an improvement in the choice and variety of programmes available to viewers.

Lobbyists recognised that the principle of separation represented a 'roadblock' and sought to marshal persuasive arguments to shift from separation to identification. EACA argued that it was in the best interests of all parties (advertisers, broadcasters and viewers) that PP was completely transparent, and thus not 'surreptitious', being identified in programmes' credits (or other means of identification), but also asserted that rules applicable to TV should not be imposed in 'interactive', on-demand environments. As the European Commission itself reasoned (EC 2005):

> For product placement to be made possible, the principle of separation should cease to be an essential criterion and should simply be one of the means to enable users to identify commercial content and to distinguish it from editorial content. This option has been supported by broadcasters and advertisers.

Critics of this approach argued for retaining the principle of separation of editorial and advertising. This was argued on consumer welfare grounds (transparency, disclosure); liberal democratic principles (integrity and independence of editorial within programmes and output); and on critical (CPE) grounds, namely, the need to provide 'system-wide' protection against the domination of commercial 'speech' (see below). The Commission argued for regulation of product placement to provide consistency across European media practice and regulation. The central case made, however, was an economic one. For lead architect Viviane Reding (2008), EU Commissioner for Information Society and Media: 'the liberalisation was introduced in the Audiovisual Media Service Directive in particular in order to allow broadcasters and producers to find additional or alternative sources of financing and hence to improve the level-playing field with US competitors'.

PP could help to reduce European governments' spending on national audiovisual industries and help to reduce the audiovisual trade deficit with the United States. The global competitiveness argument was framed not just in terms of economic benefits but the disbenefits of retaining stricter regulations than competitors such as the US, India and Japan. Producers of imported programmes had a competitive and financial advantage, and, it was objected, revenues from imported PP aired in Europe did not reach European broad-

casters. The argument was also given a cultural inflection. Calling on the UK government to liberalise, Reding (2008) asserted that:

> an overly restrictive approach in this area will prevent broadcasters and producers accessing important revenue sources thereby depriving them of the means necessary to ensure diversity and quality of programmes.

The argument about product placement itself was rarely addressed in cultural terms, however, except by opponents. Proponents of PP, noticeably, did not make the case that PP was culturally beneficial. However several commentators did argue for PP as providing 'realism'. This conflated the presence of brands in programmes with that of paid placement. Unlike unpaid prop placement, which meets audiences' desire for realism, critics argued product placement opens the way for programme agendas to be distorted for commercial purposes. Others argued that consumer protection was less necessary in an increasingly consumer-driven media environment, and the level of protection imposed by outright prohibition was outweighed by the pro-consumer benefits of market expansion. Regulation was increasingly unnecessary as consumer power, market mechanisms and firm's interests towards their consumers provided self-righting tools.

There was a separate, lively debate amongst media and marketing professionals about the likely economic significance of PP as well as its effectiveness as a marketing tool. While this debate was mostly framed, uncritically, in terms of promotional impacts, ethical matters were not entirely ignored. The editor of *Marketing* Craig Smith argued (2005), 'it is the desire to outsmart ad-avoiding viewers that motivates the supporters of product placement on TV. How can we defend another argument that, because brands are part of everyday life, we should allow paying brands to surreptitiously pervade our programming'?

Yet the debate mostly took place in the trade press where sentiment was predominantly in favour, or neutral, with only infrequent airing of the case against PP. Newspaper reporting was limited, confined to the quality press and specialist trade media. Examination of coverage over five months in 2005 during the EC's public consultation on the Directive across all UK print media reveals that 317 articles mention product placement. However, the number mentioning proposed changes in regulation of product placement is much smaller. 48 articles mentioned the issue, 20 in the national press (plus eight in online versions only), 14 in specialist trade media, one regional newspaper, four other magazines, and one news agency report. There was very limited public mediated debate about the proposed changes in regulation; the public were not informed.

Large industry groups and associations have huge resources to influence policy while opposing voices are weaker and with the exception of some consumer groups, relatively resource-poor. Of 72 submissions made to the EC paper on product placement (EC 2005), most represented commercial media businesses (30), advertising (7), governments or regulators (12). Some fifteen responses came from NGOs including the CPBF and VLV. While key industry groups have well-established European policy networks and permanent resources in Brussels, most public interest organisations remain national. The two main exceptions are the European Alliance of Listeners' and Viewers' Associations (Euralva) and the larger and more powerful network for consumer organisations, BUAC. The latter however has wide policy areas to cover. There has been no sustained transnational consumer voice to match industry on the issue.[7]

The formation of UK policy

Commercial media and advertising interests in the UK have been powerful advocates for liberalisation. Recognising the regulatory traditions, a key feature of the debate in the UK has been efforts to reassure publics that PP would be introduced with sensitivity, that those involved can be trusted to act responsibily and in the interests of consumers. However, these claims were accompanied by arguments that PP was an urgently needed source of revenue with an important role in meeting the crisis of funding for commercial broadcasters. Proponents of PP had good grounds for confidence. Both the government and Ofcom favoured the market-led provision of communication with a presumption against regulatory intervention except where strictly justified. Ofcom, in particular, interpreted its brief in distinctly neoliberal terms. Ofcom's aims, chairman David Currie wrote, were to 'support growth of healthy and dynamic communication industries, to assist markets to work effectively though competition and by ensuring consumers are appropriately informed, also to protect consumers from demonstrable abuses of the market. Ofcom operates with a bias against intervention' (Ofcom 2005a: 3).

Ofcom undertook a consultation on PP launched in December 2005 and completed March 2006. This was framed as an assessment of how PP could and should be introduced, enabling Ofcom to act swiftly in changing the current UK rules following the expected liberalisation by the EC. Ofcom's 'pre-consultation discussions with stakeholders' involved industry groups only, with no consumer or public interest groups represented. *Campaign* reported that '[n]oises from Ofcom suggest it is a case of how not whether product placement can be introduced to broadcasting' (3 June 2005). However, actual

responses to the consultation varied: most broadcasters favoured the controlled introduction of product placement while consumer and viewer groups were opposed. The National Consumer Council opposed PP, describing it as 'stealth advertising tactic too far' and arguing there is a 'fundamental and irreconcilable gap between advertisers' ultimate expectations of product placement . . . and viewers' concerns'. Of the 67 responses to the consultation, Voice of the Listener and Viewer (VLV), Public Voice and the CPBF opposed the introduction of product placement, as did most individuals who responded. The CPBF argued product placement would represent a serious erosion of the separation of content and advertising and would lead to a deepening commercialisation of broadcasting. Permitting product placement would also undermine the existing capacity for effective regulation of programme content, advertising content, and rules governing marketing communications. For instance restrictions in the BCAP advertising code to prevent brand associations which may be damaging in various ways (cars and speed, alcohol or cigarettes and sexual allure, 'junk' food promotion to children) are much less enforceable in programme content. As Ofcom itself noted: 'anomalies . . . could arise were consistency with the advertising code principles to be insisted upon' (Ofcom 2005d: 22).

Ofcom commissioned research to gauge consumer attitudes. While small-scale and imperfect, this showed that 90 per cent of those questioned were either wary or strongly disapproved of allowing more prominent and more frequent placements (Ofcom 2005e). The outcome of the consultation was that Ofcom made no formal call for change. Instead, it noted the strength of views of both sides and found no settled consensus for change. Nevertheless, many proponents were encouraged by Ofcom officials and indications of growing support for PP. *Media Week* (Hargrave and Lennon 2005) was confident that the argument for allowing subtle and responsible PP was gaining support:

> The regulator [OFCOM] is signalling a willingness to allow placement and all are agreed it needs to be subtle; the only sticking point looks set to be who walks away with the cheque.

By August 2006, ITV's brand partnership director, Gary Knight, praised Ofcom for adopting 'a mature approach to product placement, accepting that a market in this area could be opened up without adversely affecting viewers' enjoyment of programmes.' (*Marketing* 2006).

The Parliamentary Committee for Culture, Media and Sport also called for commercial broadcasters to be permitted to introduce PP. Then, in June 2008, a speech by Culture Secretary Andy Burnham sent shockwaves through

the industry. While indicating that the government would listen to the arguments when it consulted later that year, Burnham (DCMS 2008a) made clear his own views:

> I think there are some lines that we should not cross—one of which is that you can buy the space between the programmes on commercial channels, but not the space within them.

The following month the government indicated it favoured prohibiting PP in all types of television programmes (DCMS 2008b). In fact, Burnham's statement was in line with concerns expressed in previous statements. Back in 2005 the government urged 'caution in abandoning the principle of separation [between advertising and content] to allow product placement' (DCMS 2005). It identified a number of significant risks including:

> First, that broadcasters' editorial decisions, both in terms of programming commissioned and the content of programmes, could be skewed in order to maximise the opportunities for placing products for promotional purposes. Secondly, viewers may not know when they are being sold to, as identification at the beginning of the programme, as is suggested, could either be missed or forgotten by the time the promotion takes place.

The then Broadcasting Minister, James Purnell (2005) (later Culture Secretary) told a EU conference on the Directive:

> . . . one strength of the current Directive is in ensuring a clear and distinct difference between programming and commercial promotions, so that as Charles Allen [Chairman of ITV] said, "audiences know when they are being sold to". This separation, I believe, is absolutely vital to maintaining the confidence of consumers in the editorial integrity of programmes.

However, the previous Culture Secretary, Tessa Jowell (2003), had signalled a pro-market, light regulatory approach that was expected to extend to PP. She reasserted the principle of separating editorial and advertising but affirmed the government's preference for a lighter approach to on-demand AV services:

> Viewers do not need to be over-protected—technology will increasingly allow them to delete advertising (though not virtual advertising), and they can make their views known on the intrusiveness of such advertising, including banners, according to the programme content (e.g. sport or film). Furthermore, in our view, a large proportion of viewers are capable of knowing, without visual or acoustic guidance, when they enter the interactive environment, but we accept that . . . there is a strong case for promoting media literacy.

In March 2009, Burnham announced that the government would maintain the rules that prevent PP in programmes made for British television broadcast-

ing. The government had decided that 'no conclusive evidence has been put forward that the economic benefit of introducing product placement is sufficient to outweigh the detrimental impact it would have on the quality and standards of British television and viewers' trust in it' (DCMS 2009a). Endorsing arguments made by the CPBF and others, Burnham acknowledged 'very serious concerns about blurring the boundaries between advertising and editorial'. One reason for this outcome was that the economic case made had failed to convince. A key factor in Ofcom's earlier decision not to recommend liberalisation was that the economic benefits were predicted to be modest. Revenues from PP were expected to be £25–35 million over five years (Ofcom 2005, 4.14; DCMS 2009), although in the later consultation, some industry proponents calculated much higher revenues. ITV, suffering heavy losses in advertising revenue, led calls for liberalisation:[8]

> It is imperative that advertiser-funded television companies are able to tap into new revenue streams if they are to sustain anything like current levels of investment in programming. This has increasingly led broadcasters, advertisers and agencies to seek to offer a more integrated relationship between programming and commercial communication. (ITV 2004)

Such calls, however, tended to sit ill with the contrary message of reassuring incrementalism. There were notable contradictions between claims of urgent economic need alongside assurances that PP would be subtle and barely noticed by viewers. As ITV, PACT and others presented it, we would have product 'placement' but not promotion, with no interference by advertisers in editorial decisions. Opponents argued that paying for prominence would undermine, however gradually, all the existing safeguards, and abandon the principle that advertising and programmes should be kept separate. The author argued, we are asked to believe both that PP is desperately needed to save struggling commercial broadcasters and that these selfsame players will not compromise commissioning, programme making or editorial integrity to serve commercial goals. In themselves, promotional arrangements between advertisers and media are notoriously difficult to police. That is why the twin safeguards of undue prominence rules together with prohibiting paid placement must remain (Hardy 2009b; CPBF 2008).

Significantly too Channel Four broke ranks with the other commercial PSBs and opposed PP. Burnham announced that the Government's decision would hold until a review in 2011/12. It was always likely that this decision would be reversed sooner if, as polling suggested, Labour lost the forthcoming General Election in 2010; both main opposition parties, the Conservatives and the Liberal Democrats would allow PP. However, it was the Labour government itself that moved towards a policy u-turn. Burnham's successor Ben

Bradshaw announced in September 2009 that the government was minded to permit product placement, and launched a consultation in late 2009 (Bradshaw 2009; DCMS 2009b). Bradshaw justified the policy reversal on the new conditions arising from a steep fall in TV advertising revenue. ITV, which had led the lobbying effort, was delighted. The consultation's long list of concerns, however, contrasted with Bradshaw's claim that liberalising PP amounted to removing 'regulation for regulation's sake'. The consultation asked whether PP should be permitted and if so what safeguards were needed, covering identification, editorial independence, programme-type exemptions, and marketing restrictions. Having overseen tighter rules on advertising products such as alcohol, and HFSS foods, there were obvious contradictions for the Government if it allowed marketers to bypass these by paying for presence in programmes instead. The proposals met strong opposition from health and children's organisations, churches, teaching unions, media campaign groups, as well as internal opposition from several government Ministers. On 9 February 2010 Bradshaw announced that the Government would introduce legislation to allow product placement in programmes made or commissioned by UK television companies, but would ban it outright in certain categories: alcoholic drinks; foods and drinks high in fat, salt or sugar; gambling; smoking accessories; over-the-counter medicines; and infant formula (in addition to tobacco manufacturers' products and prescription medicine prohibited by the AVMSD). Ofcom would be tasked with determining how signalling to viewers would take place and with ensuring that 'product placement should not affect editorial independence, be unduly prominent, or directly encourage purchase' (DCMS 2010). Such concessions, while important, hardly exhausted the range of advertising rules that PP undermines, and failed entirely to counter the wider damage resulting from integrating commercial and media speech. With PP already permitted in VOD services, computer games or online content, brand integration can only be expected to increase.

Policy analysis

The framework for analysis of policy positions outlined earlier can be applied in analysis of product placement. Four main policy paradigms were outlined: Neoliberal competition; consumer welfare; liberal democratic; critical (political economic). In EU and UK policy debates all of these positions have been actively articulated. The broad pattern conforms to that for CMP, although there are some important variants. The main pattern has been that of a shift towards a neoliberal policy position. EU liberalisation policy in particular represents a privileging of market considerations and market principles. Yet,

the case for liberalisation of PP has engaged with, and been couched in terms of liberal democratic and consumer welfare paradigms as well. This is predictable given the need to shift from a policy of 'separation' of editorial and advertising, which was rooted in both: protecting consumers from a lack of transparency in marketing communications, and seeking to ensure editorial integrity. These liberal and consumer welfare rationales have remained influential, as shown by the formulation of PP policy. Yet, they are also residual, and weakened, elements in European media policy. Abandonment of the principle of separation is the clearest illustration of the reordering of policy values.

EU policy on PP has been described as shifting from a prohibitive to a restrictive stance (Avshalom and Levi-Faur 2008). Certainly, that is so in comparison with the US (and Canada), which the authors describe as permissive. EU policy-making, retaining institutional processes that reflect societal as well as business interests, did not accede to demands for complete liberalization. How many states will liberalise PP to the full extent permitted by the AVMSD will not be clear until into 2010 when they complete their implementation of the Directive.

If the EU represents a shift to neoliberalism, the position of the UK government represents another configuration. Viewers' organisations and public interest media groups called for restrictions on PP, but these groups have tended to have limited influence on media policy. The issue of PP did though engage more powerful and influential health and consumer welfare groups. Health groups warned that marketers would promote unhealthy foods in programmes, by-passing the newly strengthened advertising rules designed to limit the promotion of HFSS foods to children (Hardy 2009a).

UK policy debate was shaped by the influence of clearly articulated principles, and established policy, concerning editorial integrity and the clear separation of editorial and advertising. Ministerial endorsements enabled this 'traditional' position to be reasserted in the new context. Plenty of proponents of PP argued that such rules were archaic, established for an obsolescent television environment of 'push' media, and paternalistic (see below). But this position was countered from within government. What was articulated was a strong version of liberal democratic and consumer arguments. Government endorsed the principle of transparency: consumers should know when they are in a selling environment. In doing so it argued that the disclosure proposed for PP was insufficient. There was also articulation of a critical argument identifying system-wide effects if PP was permitted. PP would damage the cultural quality of programmes. Significantly, this was harnessed to an economic argument. Burnham warned against losing the international reputation Britain

enjoyed for high quality, ad-free programmes. Crucially, the economic case *for* PP was contestable, making Burnham's argument, to examine other sources of revenue first before acceding to PP, sustainable. So, advocacy within government was important, creating space for critical discourses to be aired. Divisions within industry, such as Channel Four's opposition to PP, was another important factor, as was the influence of a coalition of health, consumer and media interests that articulated opposition to the corporate media and advertising lobby. Public consultations also provided some degree of levelling between organised interests, with the government emphasising the *quality* of arguments made in reaching its decision.

The deepening crisis for ad-financed television provided the ostensible grounds for Bradshaw's intended reversal of Burnham's decision. Most commentators agreed that there were economic benefits from PP, although how much 'new' income and who would benefit remained contested. By the end of 2009, most EU states, except Denmark, had taken steps to permit PP in commercial television following the permissive line taken in the Audiovisual Media Services Directive, although Germany and France were still debating exclusions for public service media. UK Government policy was therefore moving in line with the EU and the space Burnham had opened up for an influential critique of commercial integration, appeared to be diminishing.

Comparing the US and UK. The range of policy perspectives in the US and UK reflects the underlying regulatory framework and governing principles in each, and the framing of desirable and 'achievable' policy. In the US, reformers have focused on improving identification and transparency in an overwhelmingly commercial media system. Public interest groups were able to win support from some FCC commissioners and within Congress for a review and strengthening of the rules. A critical political economic paradigm has been very well articulated by radical scholars, consumer and media reform groups. Some have called for PP to be made illegal in children's programmes (Crispin Miller in Galician 2004: 222). However, whether on the basis of calculations of feasibility (political and public support) or desirability, advocacy of outright prohibition of PP is very rare. Instead, the focus has been on strengthening disclosure and identification, although this has been advanced for different purposes. For Adelstein, identification remedies the consumer welfare problem that PP causes. He told one interviewer (Schatz 2005) 'There's nothing wrong with product placement so long as it's disclosed as required by law'. The Writers Guild called for a (self-regulatory) industry code, while stating it would call on the FCC to intervene if the industry failed. The union called for 'full and clear disclosure' at the beginning of programmes, strict limits to product integration in children's programmes, extension of rules to cable 'where some

of the most egregious abuse is found' and management recognition of 'a voice for storytellers, actors, and directors, arrived at through collective bargaining, about how a product or brand is to be integrated into content' (Writers Guild of America 2005). For more radical advocates, identification interrupts and disrupts commercial integration. It can therefore serve to heighten critical media literacy and even make product placement unworkable, as critics of such measures also assert.

Media literacy has been promoted as an important means of equipping people with the skills to decode media and marketing communications. Without doubt it can play an important educative role, and the support for media literacy strategies by governments is to be welcomed, although few, if any, radicals would propose that media literacy strategies alone are sufficient to regulate commercial media, however much they can help people to interrogate media content. So, it is also important to note that media literacy has been proposed in the context of industry arguments to shift the regulatory burden from *ex ante* rules on content and behaviour, to consumers. Anti-statist libertarians, cultural critics who associate regulation with the imposed preferences of a narrow cultural elite, and a broader range of supporters of 'new media' who equate it with user-choice have supported pro-market liberalisation. Many, therefore, would agree that such shifts to consumer self-regulation and 'choice' are appropriate, so that on-demand media services are not unduly restricted. In a policy submission to the UK government, Endemol (2000: 16–17) argued 'On the Internet, advertising and content are often more closely linked together, with advertisers increasingly becoming partners in e-commerce. In the broadband environment, it will be difficult to enforce traditional rules separating editorial content from advertorial and advertising [. . .] The key is to have educated consumers who know when they are in a commercial area'.[9] Here concern for media literacy masks a call for relaxing restrictions on commercial integration. The power to 'decode' is promoted as an adequate substitute for the removal of powers to regulate media content.

Burnham's decision on PP was criticised by industry actors as well as some media commentators and academics (Hackley 2009) as a traditionalist defense of regulations that were framed in a long-vanished media environment. Such regulatory intervention was paternalistic, it was argued, in failing to grant sufficient power and authority to media users to determine what content and services they accessed for themselves. Yet, the argument that viewers can rein in content producers by exercising their market power to 'switch over' or 'switch off' is seriously flawed. The influence of consumers on producers in advertiser-financed markets is not straightforward and direct, and the level of substitutability of AV programmes and cultural goods also varies considerably.

The market is a poor mechanism for registering opposition to or dissatisfaction with product placement. Complaints mechanisms can play an important role, but on their own they do not offer either a sufficient means of regulating the industry or a reliable gauge to public attitudes and concerns.

Future policy on PP in both the US and UK will be strongly influenced by research findings on the economic importance of PP in funding cultural production and on consumer attitudes. The economic case for PP, while judged insufficient by Burnham, has been reasserted by his successor Bradshaw. The case for maintaining restrictions on PP will be required to show evidence of public support. This is undoubtedly a challenge as a significant amount of the academic (and industry) research conducted to date has been narrowly compartmentalised, much linked to an agenda of assessing the advertising effectiveness of PP. While it is beyond the scope of this study to review the existing research, contemporary studies indicate a spectrum of views from outright opposition to acceptance, even appreciation, of brand placement, with tolerance greatest amongst the young and those most accustomed to commercial media fare, as in the US.[10] Yet, research for Ofcom (2005e) found over 90% in the UK were wary or strongly disapproved of noticeable product placement. Another survey (Ofcom 2005c: 272–4) showed a year on year fall in consumer acceptance of all forms of advertising on TV, with tolerance for more advertising falling from 19 to 12 per cent, programme sponsorship (from 35 to 24 per cent) and trailers and promotions down from 29 to 21 per cent (BBC) and 27 to 19 per cent (commercial channels). 77 per cent felt advertisements interfered with their enjoyment of programmes; only 4 per cent said the amount of advertising could increase 'quite a bit' before it bothered them. A US survey found that three quarters of respondents considered TV product placement too pervasive and distracting (see McChesney 2004: 165, 328).

Unlike unpaid prop placement, which meets audiences' desire for realism, product placement opens the way for programme agendas to be distorted for commercial purposes. According to David Young, Director of the Writers Guild of America *West*, '[p]roduct integration goes far beyond the long-standing practice of using real commercial products as props. It forces professional television writers to disguise commercials as story lines and destroys the line between advertising and editorial content'.[11] The argument that consumers will be protected by identification displaces broader concerns about editorial integrity, artistic integrity and the risks of ongoing distortion of programme agendas and editorial content for commercial purposes, 'promoting the promotionally friendly', as Hoynes (2002) puts it. The principal issue is not whether or not viewers are deceived; some are, some of the time, and some

are not. The issue is that the practice itself is deceptive, buying the capacity to be promotional without making this clear and transparent for viewers. We have compared policy responses in the US and UK and engaged with a range of critical perspectives. In line with broader analyses of media policy, this shows increasing convergence towards a model of market-led regulation found in the US. But examining PP shows the value of micro-analyses of policy to reveal the unevenness of convergence and countervailing forces. UK government policy upheld and reasserted the principle of separation that paid placement would undermine. Yet this position proved vulnerable in the face of intensive lobbying by commercial media interests as the deepening financial crisis compounded the structural decline in TV advertising revenue. The European Commission displaced, while not abandoning altogether, the separation principle, while, in the United States a counter-current is evident in calls to reverse commercial integration and strengthen disclosure.

Notes

1. At the time of writing most EU states were amending national law or regulations to implement the AVMSD, with most EU members states expected to permit product placement, subject to AVMSD, or additional, restrictions.

2. In December 2009 the FTC (2009) introduced revised guidelines on endorsements and testimonials. While the rules are mainly intended to apply to advertisers, rules on disclosure of material connections require that reviewers of products (such as programme hosts, guests, posts by bloggers etc.), where cash or in-kind consideration is received to review the product, disclose the material connection with the seller of the product or service, regardless of the nature of the review.

3. FCC 2d 75 (1970) in regard to NBC; cited in Lee (2008: 217).

4. Statement of FCC Chairman Kevin J Martin on Sponsorship Identification Rules and Embedded Advertising, MB Docket No. 08–90 (26 June 2008).

5. The ITA was the first in the UK of a new model of regulatory agency, influenced by the Progressive Era regulatory commissions established in the US, combining a degree of independence from government with adjudicatory, regulatory and policy-developing functions (Baldwin and Cave 1999: 3, 69).

6. The *Richard and Judy Show* was found to have breached the ITC Programme Code regarding commercial references in programmes for a show on 17 December 2002. The presenters were found guilty of making free plugs for their autobiography when they announced that it was on sale from the Channel 4 shop.

7. Avshalom and Levi-Faur (2008) analysed submissions on PP to the EC's 2005 consultation and public hearings in 2006. They found that in 2005, the actors were divided almost equally between local (53%) and supranational/international actors (47%), whereas the Parliament hearings in 2006 were dominated by supranational/international actors (76%). The majority of actors were businesses with a direct or indirect interest in PP; state and public interest actors made up 33% in 2005 but only 24% in 2006.

8. UK subscription revenue outstripped net advertising revenue for the first time in 2003. The overall rate of growth of advertising in 2004 was 7%, but while mutichannel's ad revenue was up 17.4% (to £794 million) commercial analogue channels only gained a little over the rate of inflation up 4.7% to £2,686. Of these channels ITV 1 suffered the lowest growth 2.9%.

9. In March 2009 Endemol announced plans to insert PP into web catch-up services. It was collaborating with MirriAd, a company specialising in digitally inserting CGI overlays.

10. Livingstone et al. (2005: 60) found 'Although viewers are well aware when they are confronted with commercial messages on television . . . the changing conditions of advertising, sponsorship, branding, merchandising, paid-for-content, and other forms of promotion through broadcasting, the internet and mobile phones, set new literacy requirements. Little research exists on adults' critical awareness of such promotional practice'

11. David Young, Executive Director Writers Guild of America, West, letter to CPBF, 22 October 2008.

Promotional Speech
and Media Reform

Media Power: Policy Reform and Critical Media Theory

This book has assessed the factors giving rise to increasing cross-media promotion and examined the extent to which regulation has shaped and constrained CMP. This chapter begins by reviewing the main evidence and arguments presented. This provides the context for considering implications for policy and regulation and bringing together, in the final part, analytical and normative concerns of the study.

The Dynamics of Cross-Media Promotion

As media markets have become more competitive, firms have been able to obtain competitive advantages by extending the reach of promotions and reducing marketing costs through intra-firm promotions. Multi-sectoral integration has increased the scope for intra-firm promotion. CMP has thus been fuelled by changes in media ownership, assisted by deregulatory politics involving the relaxation of ownership, content and behavioural regulations. CMP has been greatly facilitated by technological changes enabling the redistribution and repurposing of content across a variety of digital media. This has occurred in the context of broader changes in media and advertiser relationships, in marketing and merchandising techniques, and changing patterns of media use and consumption.

Market innovation in cross-media promotion is most evident in the US system. The 'American experience' (Sepstrup 1986) of commercialisation, indicates the likely trajectory for other media systems, such as the UK. The conditions and factors giving rise to greater cross-promotion in the United States are increasingly apparent in the UK. Case studies examining UK newspapers and television promotion have shown the nature and outcomes of corporate pressures to increase intra-firm cross-promotion.

Problems of cross-media promotion

Amongst the principal problems of CMP are the integration of editorial and advertising and the shaping of media content in accordance with corporate media interests. We showed the nature of the problem in the study of cross-promotion of Sky in NI newspapers. Only the corporate commercial interests within News Corp. adequately explain the disparities in coverage between NI and comparable papers. Cross-promotion provided competitive advantages for Sky (even though many other factors influenced the collapse of ONdigital/ITV Digital). But CMP raises problems of media power not just market power. CMP may be used to promote corporate or commercial interests in editorial at the expense of fairness to competitors' or viewers' interests. More broadly, CMP may undermine editorial independence. With the extension of promotional speech into media content, the separation between editorial and advertising is eroded. Where there is lack of disclosure, corporate or commercial interests may be disguised.

Our study of television revealed how factors driving increased promotion in the US are increasingly evident in the UK. Greater channel competition, media integration, commercialisation and the intensification of media marketing and branding have led to increasing CMP. Evidence of normalisation was found in the enhanced status and resources granted to promotions and in accounts of professional and trade media. CMP has been increasingly perceived in accordance with a marketing logic derived from entertainment marketing rather than within the critical and ethical concerns of news journalism. The normalisation of CMP may thus be identified as a specific component of broader processes whereby values of entertainment marketing have extended to news and public service media formerly shaped by other governing values. However, there remain powerful countervailing forces. The commercialisation of news journalism is contested by an important, if weakened, defence of journalistic standards. Wider peer scrutiny, via news media and dedicated journalism review journals, can also serve to articulate the challenges to corporate integration and serve as forms of 'soft' regulation (see Bunton 2000). In the UK, broadcasting regulation maintains strong rules on the independence and impartiality of news, as well as commercial references. Analysis of normalisation, then, must be undertaken carefully, building on empirical case studies. The US indicates the most likely trajectory, but the UK media system is significant because the resolution of tensions and conflicts between public service and market values at all levels remains more indeterminate, while both systems are alterable.

Paradigms and Policy Proposals

We began in part one by considering the different ways in which CMP is addressed and problematised in key approaches to media and policy. This provides the context for assessing policy implications and concrete proposals arising from the different traditions. Four key paradigms propose regulatory action according to different, if overlapping, rationales: neoliberal, consumer welfare, liberal democratic, and critical political economy.[1] Our study has shown evidence of a shift in their influence on policy and regulation. Yet CMP remains 'problematic' precisely because it attracts concerns articulated across the paradigms that remain influential to varying degrees. Each of these traditions has also generated proposals for action that remain options for future policy. This section, then, examines policy implications from the various traditions and illustrates these with specific proposals drawn from the UK, elsewhere in Europe, and the United States.[2]

Competition

The neoliberal paradigm proposes that market mechanisms are generally sufficient and preferable to interventionist measures. This may be argued on the grounds that CMP generates no significant adverse economic effects (Eastman 2002), or that market competition restrains firms who may expect to lose market share (consumers; advertisers) if they cross-promote excessively or intrusively, or undermine consumer expectations. Where necessary, however, competition regulation may be required to address problems of market dominance and abuse of a dominant position. For Stelzer (2001: 156) the appropriate policy response for broadcasting and other industries is 'deregulate and rely on markets, preserved in their competitive state by a vigorous antitrust policy when necessary'.

This study has shown that competition (anti-trust) regulation in the UK and EC has only addressed CMP to a limited extent. Competition regulation can identify relevant problems including anti-competitive behaviour and misuse of a dominant position. It may be exercised to prevent or restrict adverse economic impacts on markets. Historically, competition regulation has adopted non-economic public policy considerations to varying degrees. However there has been a discernible shift away from public interest measures (used mainly to defend state monopolies) towards more rigorous, but narrow, economic-based assessments of market power. We have addressed and shared criticism about the adequacy of competition regulation as a substitute for sectoral regulation for media pluralism (Doyle 2002a; Feintuck and Varney

2006; Collins and Murroni 1996: 61–62). [3] The ITC's 'quasi-competition' formulation of 'promotional impacts' (2001b) illustrated the difficulties of capturing promotion as a measure susceptible to economic market analysis. Under competition regulation, only significant economic effects on markets are likely to trigger action, rendering issues of media power concerning editorial quality, or the promotional or persuasive qualities of content, largely extraneous or at best secondary. As we have seen competition is increasingly favoured over sectoral regulation, and its role in regulating communications market is certain to increase. However, market power measurements are insufficient to capture problems of media power, editorial independence and commercial integration generated by CMP.

Consumer welfare

Consumer welfare underpins rationales for advertising regulation, for consumer protection measures such as identification and labelling of goods and services, disclosure and transparency. This tradition has generated grounds for controlling commercial speech, albeit by different regulatory mechanisms, where that speech breaches rules safeguarding consumers. The contested borders between editorial and advertising content are also spaces where consumer welfare and liberal democratic paradigms meet. Intellectually these may be distinguished, but institutionally regulatory bodies generally incorporate and mix rationales, and both advertising and editorial codes apply to publishers, for example.[4] Respecting freedom of expression, most consumer welfare remedies have thus relied on self-regulation by publishers and media professionals rather than legal or administrative enforcement.

In Europe, media and advertiser interests have organised, largely successfully, in favour of pro-business liberalisation to allow transnational advertising campaigns. In the EU, advertising constraints have been considered impediments to the circulation of goods and services in the internal market. In the US there has been a long struggle since the 1970s by corporations, including media firms, to extend constitutional protection to commercial speech (see Schiller 1989; Ramsay 1996; Allen 2001; Baker 1989; McChesney 2008). These are the most influential trends, but there have also been countervailing efforts to secure greater disclosure of commercial interests in media content. In the US, in July 2001, a pressure group, Citizens for Truth in Movie Advertising, began legal action against major Hollywood studios claiming that industry junkets and hospitality had compromised film critics' opinions (Campbell 2001a, 2001b). The resulting 'reviews', used for promotional purposes, constituted false or misleading advertisements the group argued,

thus breaching California law. As we have seen there has been mounting pressure to strengthen sponsor identification rules in the US, while in the UK the Government, albeit temporarily, supported calls for product placement to remain prohibited in spite of powerful industry support for liberalisation.[5]

Rules on cross-promotion in UK broadcasting show the influence of consumer welfare rationales, setting limits on 'excessive' promotion and restricting the scope of cross-promotion to information and services deemed of value to viewers. Yet, as we saw, regulations have been relaxed, allowing increasing promotion. CMP itself has not developed as an object of consumer protection. In part this reflects the ambivalence arising from the recognised benefits for consumers of media promotion. In part it reflects the weak influence on policy of the largely unorganised voices of media users who are critical of intrusive and excessive promotions, despite the avowed 'pro-consumer' rationale adopted for policy. Promoting consumer protection and the principles of consumer welfare can provide influential policy rationales. To date, however, such efforts have done more to highlight contradictions and raise awareness than shape regulations that restrict CMP directly. Richer research is needed on users' and viewers' opinions to inform the policy process and democratise policy-making.

Liberal democratic policy responses

From the complex historical and philosophical variations within liberal democratic traditions arise a spectrum of media policy recommendations. These include support for market intervention, ranging from structural regulation to limit media concentration and cross ownership, to social market remedies to safeguard pluralism. However, the liberal tradition is characterised by favouring self-regulation over statutory provisions to protect media freedom, and by raising objections to regulatory interference that may have a negative impact on freedom of expression (see Scanlon 1990; Lichtenberg 1990).[6] The liberal democratic paradigm includes proposals which have particular bearing on CMP. Disclosure measures are addressed separately below, but two chief remedies are professional codes of conduct and measures to protect journalistic autonomy.

Protection of media workers. A key remedy against corporate influence on media content is to safeguard journalistic autonomy. The main principles are to facilitate editors and journalists in acting on behalf of the public interest and protect them against undue proprietorial or other interference. More radical proposals seek to establish forms of worker representation in management, greater industrial democracy or worker control (Allaun 1988: 107; Gibbons

1992: 290). Industrial democracy has thus been conceived as 'a way of defend-ing the press against proprietors whose vested interests now compromise its editorial integrity' (Curran 1986b: 120).

Professional codes. Codes of professional conduct for owners and media workers uphold standards including editorial integrity and autonomy. The European Federation of Journalists, the regional organisation of the International Fed-eration of Journalists, representing journalists' unions and members, calls for editorial statutes and other legal provisions safeguarding the independence of journalists. In addition to codes of conduct drawn up by the professionals themselves, the EFJ calls for a European legislative framework to safeguard editorial independence and ensure compliance by publishers. Such measures are intended to ensure that no censorship is imposed externally (from gov-ernment, public authorities or private interests) or internally (EFJ 2002: 44):[7]

> no restriction or impediment to the exercise of professional journalism imposed on the editorial staff from internal sources with the intention of suppressing information regarding the financial affairs, business or other activities of the parent company or its business partners or of unfairly promoting the economic interests of advertisers, sponsors, or business partners

Editorial statutes seek to secure media independence by regulating the internal relationships between editorial staff, business and advertising departments, managers and directors. Such statutes usually provide for an editorial council to be consulted on decisions affecting the appointment of editors and matters of editorial policy. Editorial staff have the right to prevent interference by management or third parties in editorial content (UNESCO 1999: 20–22). Such measures, where effective, provide protection and support for journalists to challenge the imposition of CMP. There have been numerous demands for such press laws in the UK, but to date these have been resisted in favour of a modest self-regulatory code.[8] While the liberal democratic paradigm encom-passes stronger measures such as those proposed by the EFJ, it is tested and threatened in so far as professionalism and self-regulation do not work ade-quately.

Critical political economy

Critical political economy challenges the adequacy of liberal democratic re-sponses to problems both identify. Where liberal democracy seeks to remedy problems within the terms of market capitalism, critical political economy proposes systemic reforms, insisting on remedying the inequities of modern capitalism to further democratic rule. Nevertheless, policy agendas and reform

proposals have tended to be generated from a mixture of Marxian and radical democratic traditions (McChesney 1999; Mosco 2009; Murdock 1992b). From the critique of concentration, conglomeration and convergence, political economy proposes structural regulation. Historically this has sought to reduce media monopolies and accruals of media power by restricting ownership within and across media sectors.

In Britain, radical reform agendas through the 1980s and 1990s promoted anti-monopoly measures and restrictions on cross-ownership (CPBF 1996; Curran 1986b; Allaun 1988). These proposals influenced Labour policies until the party reversed its position after 1994 (Freedman 2003; 2008).[9] There are undoubtedly considerable challenges in designing and implementing structural regulation (see Iosifides 1997; MacLeod 1996; Doyle 2002a). However these are ultimately political decisions concerning ways of exercising available resources to shape national and supranational regulation. As Doyle (2002a: 179) states 'effective and equitable upper restraints on ownership are vitally important tools that no responsible democracy can afford to relinquish'. With the shift towards 'a neoliberal agenda that is commercially oriented and market-centred' structural reform of ownership has receded from the policy agency (Hamelink 2002: 251; McQuail and Siune 1998).

Restricting cross-ownership would reduce the opportunity for many kinds of intra-firm cross-promotion. It would not directly prevent inter-firm promotion, although here competition regulation could be used to tackle anti-competitive agreements. Structural regulation can help to ensure diversity of ownership but cannot guarantee plurality of voice. Likewise, ownership rules can delimit CMP across media subject to them, but they do not provide a direct means of restricting CMP content and practices. There is therefore risk of contradictions and anomalies arising from the application of structural rules. However it is the unlikelihood of sufficient restrictions on cross-ownership being re-established that underlines the need to consider the potential of other approaches.

Transparency and disclosure. Measures to secure 'transparency' through disclosure of interests are proposed in various traditions. Transparency is connected to the underlying legal requirement in most jurisdictions to identify paid for content as advertising. Here the law, as Baker (2002:108) describes, discourages otherwise rational market behaviour to use payment to secure favourable or advantageous coverage: '[t]he often possible market solution, payment for inclusion, is typically characterized as corruption unless the favourable content is labeled as advertising'. Disclosure of ownership links and of commercial interests in editorial and advertising may discourage competitive abuses between firms. Market mechanisms will be enhanced if consumers have better

information on which to exercise choice of supplier. The liberal democratic paradigm sees disclosure as a measure to counter conflicts of interest, safeguarding the relationship of media to citizens. As the previous chapter showed, disclosure is also supported by, and has origins in, some more radical perspectives. Here disclosure is conceived not as a solution to conflicts of interest and media power but as a means of highlighting and exposing these in an effort to encourage critical media literacy, raise awareness and stimulate demand for reforms.[10]

Transparency may be viewed as an objective in itself or as a means to achieve wider aims of media pluralism. For instance, the Council of Europe's *Measures to Promote Media Transparency* in 1994 (CoE 1994; Cavallin 1998) grew out of efforts by the EC and Council of Europe to tackle media concentration. The Recommendation is designed to ensure that regulators have the necessary information on media ownership structures and business operations and can identify 'third parties who might exercise an influence on their independence'. Yet, it also acknowledges the importance of transparency 'to enable members of the public to form an opinion on the value which they should give to the information, ideas and opinions disseminated by the media'[11]. Here consumer welfare concerns join liberal democratic ones. Citizens must have sufficient information about the underlying interests expressed in the media that inform, influence or entertain them.

Transparency also underpins various efforts to ensure the integrity of journalism. In 2002 the International Public Relations Association (IPRA) launched a campaign for media transparency whose principal aim is to combat the practice of 'cash for editorial' operating in many countries around the world. The IPRA's research indicated that common problems included editors and journalists asking for inducements to publish news releases or feature items, company news releases appearing in exchange for paid advertising elsewhere in the publication, advertisements disguised as editorial, material appearing through influence or payment by a third party, and publications asking for payment not to publish certain stories. The focus of such campaigns is on the incidence of unethical practices between public relations professionals and the media (see Davis 2002; Davies 2008). However, transparency may be extended to media organisations themselves dealing both with intra-firm editorial promotion and erosion of boundaries between editorial and (self) advertising, especially when the latter is misleading. Many countries also have a legal requirement that the name of the publisher be provided in newspapers.

In addition to the regulatory proposals discussed above, there is a wider range of radical measures that seek to empower citizens in various ways. These are usually formulated in broader contexts of challenging media power, corpo-

rate power, and combatting adverse effects of advertising and consumer cul-
ture (McAllister 1996). From the 1990s, there has been a resurgence of media
activism and campaigning pertinent to CMP although this is usually focused
on a wider target of corporate dominance of the economic and political sys-
tem. Hamelink (2002) summarises key issues raised by a broad and diverse
movement for 'globalisation with a human face' in challenging the neoliberal
political agenda. These include knowledge, global advertising, privacy, intellec-
tual property rights, trade in culture, media concentration and the electronic
'commons'. Cross-media promotion may be amongst the issues addressed, but
the focus of criticism is generally broader, considering the commercialisation
of formerly public spaces (Schiller 1989; Klein 2000), the pervasiveness and
reach of advertising and consumer culture (McAllister 1996), and concentra-
tion of power by global media corporations (Herman and McChesney 1997).

Policy Proposals: Towards a Compound Approach

The proposals for reform, described below, incorporate structural regulation,
competition regulation, behavioural and also media content controls. What is
proposed is a 'compound' approach that seeks to combine and integrate
various measures considered above.

The case *for* structural regulation and *against* content restriction has been
forcefully argued by Baker (2002). Baker shares the trenchant criticism, ex-
pressed in the US civil libertarian tradition, of proposals to suppress or restrict
expressive media content conceived of as 'bad'. For Baker (2002: 117) 'the
imprudence of suppression applies even more forcefully to laws that would
prohibit activities, like creating and gaining access to expressive content that
some people plausibly view as aspects of their basic freedom'. For Baker (1989)
commercial speech does not warrant the same high level of protection that
should be afforded communication as a means of self-expression and self-
fulfilment. However, distinguishing the promotional (commercial) from
expressive (editorial) can be very difficult, and to this extent Baker's argument
would also apply, in part, to restrictions on promotional content in editorial.
Baker proposes instead structural intervention (2002: 120):

'Structural interventions' refer to rules that allocate (or create) authority or
opportunities. In effect structural rules are, unlike either subsidies or suppressions, an
inevitable part of the social world. They operate, however, like subsidies in benefiting
or enabling particular behaviour. And unlike suppression, they do not prohibit any
communication. Finally, like subsidies, they should have a justification or purpose
other than stopping particular expressive acts even if that may at times be their
effect.[12]

Baker (2002: 102, 120) cites measures to prevent concentration, restrict ownership to legal entities for whom the purchased entity would be its primary business, and to increase ownership and control by media workers. If CMP would only be addressed indirectly through such structural regulation, that is, for Baker, a substantive benefit since beneficial content and behavioural outcomes may arise without the risks of direct content regulation.

Structural regulation remains the most important regulatory approach to address CMP and to counter, if not reverse, the trends described in this book. However, this book also argues that behavioural and content measures, drawing on existing regulatory approaches, must also be pursued. While acknowledging the dangers of interference in speech, there are compelling reasons to build upon restrictions on commercial speech and incorporate these into a more explicit response to CMP. In particular, with the ascendancy of libertarian free speech theory influencing electronic media (Schiller 2000), it is particularly important to examine the scope and justifications for extending provisions, such as those in UK broadcasting regulation, for separating editorial and advertising.

The principal justifications for regulating CMP can be drawn from the various paradigms examined: first, principles of pluralism, concerned with the diversity of information, ideas, and cultural expression made available to citizens; second, principles of the separation of editorial and advertising; third, principles of integrity of information for citizens and consumers; finally, principles of fair competition. These rationales, and the regulatory measures they give rise to, need to be combined since each is insufficient on its own. However this is not to argue against discretion in identifying the particular circumstances in which CMP is problematic nor in the appropriate choice of regulatory intervention. There is a spectrum of forms of CMP from non-commercial promotion, transparent context-specific information (both usually unproblematic) to integrated editorial promotion of commercial products and services (usually problematic).

Sadler (1991:1) proposed that in addition to structural regulation, 'newspapers and television programmes should disclose clearly to their readers and viewers their other media interests, both specifically when reporting or commenting on media issues and generally on a regular basis'. A starting point for reform would be to establish such disclosure requirements and to extend transparency standards as far as possible across all media. Where media companies, are promoting products, services or channels in which they have an interest such interests should be declared, or be otherwise explicit, so that viewers may make their own assessment of the value and integrity of the information provided. Such safeguards could also play a useful role in foster-

ing a culture of public awareness and intervention, as well as supporting professional media workers' defence of editorial standards (see Hoffmann-Riem 1996: 341). In support of the above, Gibbons (1992: 299) concluded in his review of measures to tackle proprietorial interference that 'the imposition of common standards of practice is likely to be the most successful in balancing a feasible competitive base with the preservation of editorial values'.[13]

Structural regulation provides the necessary framework governing ownership of media resources. Where the problem concerns the effect of cross-promotion on competition, structural and behavioural (competition) as well as content restrictions could be placed on the manner in which intra-firm or associated interests were permitted to be promoted. As well as disclosure measures, the principle of separation of editorial and advertising would need to be articulated coherently throughout the legal and regulatory framework.[14] These proposals, therefore, require content regulation to apply across media. In contrast to broadcasting, publishing and non-broadcast entertainment media have been mainly governed by principles of freedom of expression. As we have seen there are objections on free speech grounds to any interference in content. The dangers of curtailing free speech, combined with the protection of property rights, are principal reasons for caution in legal restraints, especially within liberal democratic paradigms.[15] However, we have also examined arguments supporting restrictions in order to protect press freedom from proprietorial interference and to safeguard editorial autonomy.[16] In addition, CMP lies on the contested border between 'protected' and commercial speech. The proposals above would extend justifications for regulating advertising to encompass promotional (commercial) speech by media organisations themselves.

Requirements for disclosure of interests and clear separation of editorial and advertising do not address all problems of CMP. Many, if not most, forms of CMP are explicit forms of branding. Far from there being a lack of disclosure, the problem is the form and intensity of explicit promotion and commodification. The first objection then concerns the limited scope of disclosure measures. In addition, rules on disclosure may be said to make cross-promotion a mandatory requirement, perversely serving to legitimise and extend cross-promotion. More broadly, given the dynamic evolution of promotional forms, it is unlikely that disclosure measures will not be used to enhance cross-promotion. Yet, such problems may be addressed in part through specific rules prohibiting promotion (and disclosure), such as rules restricting broadcasters' promotion within programmes.

Given the political dangers and practical impediments to regulating all elements of promotional content, measures requiring disclosure of interests

and clear separation of editorial and advertising provide arguably the most reliable and circumscribed tools. Beyond these strict measures, the problems of distinguishing and tackling the promotional quotient in speech become much more difficult and the regulatory tasks and risks greater. The manner in which editorial and advertising are separated must be determined in ways which are context-specific, and keep pace with evolving media forms, with user expectations and informed democratic deliberations. Without doubt, this task is increasingly difficult as media and marketing communications merge and the boundaries between editorial and advertising blur; however, it remains a vital principle to insist on their separation.

If disclosure and separation identify standards for regulation we must also address enforcement.[17] What regulatory approaches might be adopted? A general approach would be to encourage self-regulation via codes but to underpin this with a legal-regulatory framework capable of ensuring compliance with basic standards. This proposal is in line with efforts to overcome deregulation debates (Ayres and Braithwaite 1992) and to seek to capture the benefits of both voluntary and enforced regulation. Over the last decade UK Communications policy has shifted from command and control towards self-regulation and co-regulation, approaches favoured in EU communications regulation. However the adequacy of industry-led compliance and enforcement remains a critical issue. Formal codes could increase awareness amongst professionals and generate both peer and public scrutiny. Yet, given the pervasiveness and normalisation of CMP, the effectiveness of voluntary self-regulation must remain highly questionable, however desirable. In any case, the evidence of the powerful forces driving CMP and the liberalisation of regulation, support the case for effective, 'backstop' legal powers for regulatory enforcement.[18]

Another set of objections concerns legitimation, encompassing cultural, political, legal and technical concerns. The market paradigm presumes that consumer dissatisfaction should be registered within markets. Alternatively, regulatory/complaints mechanisms provide a route for citizen/consumers to lodge complaints. The justification for regulatory action should arise from evidence, either from markets or regulators, that there is a problem that the market alone may not or cannot remedy. Yet, as McAllister (1996, 2000) and others identify, normalisation is also a consumer phenomenon. There is evidence of socio-cultural and generational divides on such issues as the acceptability of product placement. As stated, the legitimacy of regulation will need the underpinning of consumer research. Yet there are plenty of grounds to challenge the adequacy of commercial media markets to register dissatisfaction with commercialism (Baker 2002). Second, while markets are imperfect means of capturing responses to CMP, complaints mechanisms will usually

only attract a small number. One of the most critical challenges for any reform proposals will be to generate research about the public demand, need and consequences of regulation. Researching social attitudes towards CMP will be a vital prerequisite.

The policy proposals outlined above would constitute a compound approach. They include measures to regulate content and behaviour as well as ownership and market structure. The prospects for adoption of such regulation of cross-media promotion at UK, or indeed supranational, level remains slight. UK Ministers have continued to rule out 'any form of statutory regulation of the press' (Jowell 2003; DCMS 2003) although the separate regulation of press and broadcasting is under growing pressure as these continue to converge.[19] However, the UK government has successfully applied pressure on the PCC to reform its practices, one route that could lead to incorporation of a cross-promotion code.

CMP has only been established to a limited extent in media regulation but its formation is not foreclosed. The conditions for emergence of regulatory issues are not set by the limits of formal regulatory powers but by the interaction of social forces. As concentration, convergence and advertiser power increase, it is likely that there will be more editorial cross-promotion breaching the walls between editorial and promotional speech. That is likely to be accompanied by calls for further regulatory intervention from different quarters, from consumer welfare bodies, who have largely neglected cross-media promotion to date, from firms seeking to use what competition powers are available, from media and other professionals and from academics, media reform campaigners and civil society groups.

Cross-promotion and Media Theory: Beyond Citizenship Rationales

The contribution of analysis of CMP to the wider debates concerning media ownership, concentration and conglomeration is to highlight the importance of addressing problems of media power which have been neglected by both policy-makers and by analysts. We argued in chapter two that critical political economy provides the most adequate critique but that it tends to share with liberal pluralism a hierarchisation of political speech which has led to an insufficient account of CMP. Here we will pursue this argument further, highlighting key problems but also showing that the tradition of critical political economy also provides the potential and scope to address and overcome these problems.

Limitations of citizenship rationales

From the early 20th century many democrats identified the problem that public communications organised on a purely commercial basis could not serve the functions required of a democratic system (Murdock 1992b: 23). Such arguments influenced the creation of systems of media regulation designed to safeguard and promote the public interest. We have examined how, from the 1980s, increasing marketisation in communication systems and accompanying shifts in policy have favoured a neoliberal competition paradigm. In the 1990s, in response to this reshaping of communications and the vigorous promotion of market mechanisms and consumer models, radical critics sought to reassert against market liberalism 'a conception of citizenship—based on a politics of diversity and difference—which can provide a new justification for public communications and offer alternative definitions of empowerment to those promoted by the market' (Murdock 1992b: 22; Garnham 1990: 120). This radical democratic approach, influenced critical political economy, combining a critique of both market and statist systems and drawing on socialist, democratic, social market, human rights and other theories (Curran 1996; 2002; Baker 2002). It represents a break from traditional Marxism in acknowledging the importance of civil society, citizenship and political community, while asserting human rights and social justice against maintenance of an order based on protection of private property rights.

Citizenship has thus been a central discourse of liberal and radical reformers in the UK, United States and elsewhere in response to trends of consolidation, commercialism and liberalising deregulation (see Dahlgren 2001; McChesney 1997; Venturelli 1998). The claim that media should serve the needs of citizens has been asserted to challenge the way in which 'broader questions about community, power, participation, and the public interest are either neglected or reframed so consumers and citizens are defined as one and the same' (Croteau and Hoynes 2006:224). This opposition may be defined as one between human rights and economic rights doctrine (Venturelli 1998: 256–70), between the political rights of democracy and the economic rights and contractual freedoms of liberalism.

Feintuck (1999; Feintuck and Varney 2006) argues for a reformulation of UK regulatory rationales around citizenship.[20] The 'fundamental, democratic principle that justifies or legitimates media regulation' should be 'the objective of ensuring that a diverse, high-quality range of media are made available to citizens, in the interest of seeking to avoid social exclusion' (1999:199). According to Feintuck, this 'citizen participation' approach to freedom of expression provides a 'clear public interest' rationale for regulating the media in all its forms. It also represents a strategy to restore the centrality of public policy

considerations in response to the commercial dominance of media systems and paradigmatic shifts in regulation (see Meier and Trappel 1998). Such citizenship rationales are expansive. Feintuck proposes 'universal availability of diverse media output' as the 'organising principle' for regulation. There are, however, intrinsic limitations to citizenship rationales and there are also problems arising from the limited manner in which such rationales have been adopted by policy-makers. Both of these must be addressed if CMP is to be adequately incorporated.

Problems of adoption. Labour's communications policy illustrates the nature of the problem. Labour's evolving policy acknowledged tensions between consumer and citizenship rationales, the balance of which varied across different policy documents and formulations between the Green Paper, *Regulating Communications* (DTI/DCMS 1998) and the Communications Act 2003. A central task for policy is defined as balancing the need to 'safeguard democracy' while encouraging open and competitive markets. *The Consultation on Media Ownership Rules* (DCMS/DTI 2001: 6) states:

> We want to encourage competition and economic growth, by being as deregulatory as possible. However, we must also allow the media to continue to perform its vital role in democratic society, as a forum for public debate and opinion.

For many critics, the claims of serving and safeguarding citizens were flatly contradicted by the combination of pro-market reforms, relaxation of ownership rules, weakening of key regulatory powers and lack of democratic accountability and governance (CPBF 2002b). Nevertheless, the concept of citizenship informs many elements of Labour communications policy including its qualified defence of public service media, 'information society' policies on access to services, and promotion of media literacy.

Labour policy embraced market liberalism, sanctioning further relaxation of structural controls justified, in part, on the grounds that 'new competition legislation should be more effective in preventing companies from abusing a dominant market position' (DCMS/DTI 2001: 11). With such safeguards, the perceived economic, trade and consumer benefits arising from greater consolidation and cross-ownership may be pursued, while the regulatory problems of media integration are addressable by competition law. However, this was tempered by a social market critique of market failure (DTI/DCMS 2000:35):

> Left to itself, however, the market may tend to focus investment only on more popular types of content, and therefore not deliver the full diversity of services that viewers and listeners want to receive. That is why public service broadcasting and positive content regulation . . . will remain essential in the new competitive environment.

This extends economic arguments that either monopolies or 'externalities' may give rise to market failures, adversely affecting consumer welfare, by asserting social and cultural values. Such values, dominant in 'public interest' paradigms are now subsidiary to market liberal arguments but are reincorporated through the discourse of 'market failure'.[21] Competition regulation alone cannot ensure that 'a significant number of media voices will continue to be heard' or secure access for entrants and 'cannot directly address concerns over editorial freedom or community voice' (DCMS/DTI 2001: 8). Market failures therefore justify additional measures to safeguard quality, plurality and diversity including 're-aligning' ownership rules (DCMS/DTI 2001: 8). Ownership regulation for mass media remains 'the best means of tempering commercial logic to the needs of democracy and citizenship' (2001:12). However, regulation, justified by market failure, is expected to be phased out as markets become fully competitive: '[p]lurality concerns may diminish, as more people gain access to the range of services now available on digital TV and radio and the Internet' (DTI/DCMS 2000: 36, 34–45).

As the consultation paper on media ownership (DCMS/DTI 2001: 7) put it, regulation is needed to ensure pluralism, 'giving the citizen access to a variety of views that, in a competitive market, maintain their own balance'. Media integration, however, is increasingly viewed as unproblematic or as giving rise to limited concerns to be set against perceived economic and consumer welfare benefits. In this policy context, certain limitations of citizenship rationales are exposed. Above all, if pluralism and diversity are limited to information and opinion exchange functions, then wider safeguards can be more easily abandoned.

'Intrinsic' problems. To speak of 'intrinsic' problems of citizenship rationales is to address tendencies rather than encompass the full variety of ways in which citizenship claims may be advanced. First, as we have argued (chapter two), both critical political economy and liberal democracy share a hierarchisation of speech in which the principal justifications for regulation concern the political speech functions of media. A consequence of this has been neglect of CMP and failure to integrate CMP within analysis of media power or in policy proposals. An influential model of media citizenship has been derived from Habermas's original account of the public sphere (Habermas 1989) and adopted in arguments to oppose market dominance and justify expansion of non-commodified or public service media (Garnham 1990, 1997; Croteau and Hoynes 2001: 208; Hardy 2008a: 95-96). Of the numerous criticisms to which the Habermasian public sphere has been subject (see Goldsmiths Media Group 2000; Curran 2002), those most salient to our analysis here concern the treatment of non-political speech and exchange, and entertainment media.

The public sphere model primarily addresses the informational role of the media serving the needs of rational decision-making citizens. It privileges the exchange of information and opinion in line with liberal media theory. The latter, Curran argues (2002: 237-9), neglects the entertainment activities of media on the untenable grounds that these are not part of rational exchange and not concerned with public issues. This critique has been amplified by numerous media scholars (Garnham 1997; McGuigan 1996, 1998; Dahlgren 1995; Hesmondhalgh 2007). Political theorists, communications and feminist scholars have challenged and deconstructed information/entertainment divisions, addressing how politics is constituted through entertainment (see Street 2001: 60-79). The separation between the politics of information and entertainment must also be overcome in the sphere of communications policy. An adequate critique of CMP capable of justifying policy can only arise by extending analytical and normative concerns beyond the sphere of political information and 'public sphere' functions. This, in turn, connects with a broader review of the limitations of what McGuigan (1996) calls the 'politics of information'.

In addressing these deficiencies, critical political economy provides the greatest potential to engage with problems of cross-promotion in their breadth and complexity. However, to do so various arguments and insights need to be combined and existing connections strengthened. I have argued (Hardy 2008a) there are three principal features:

i. *An expanded concept of citizenship.* Together with information, citizens must have access to the broadest range of viewpoints, expressed in the widest range of possible voices and forms (Murdock 1992b). While this formulation privileges information, it connects a much broader range of media provision and mediated communication to underlying values of citizenship. A 21^{st} century version also needs to emphasise broader communication rights to create and participate, not merely receive.

ii. *Critique of market liberalism.* A market oriented media system does not provide adequate means to distinguish between people's private and individual role as consumers and their public and collective role as citizens (Hoynes 2002: 3) or reflect non-market preferences (Baker 2002). Market pressures may not consistently promote diversity and fairness in media content (Entman 1985). However, radical democratic approaches also challenge the limitations of statist alternatives to market provision and acknowledges the value of markets in meeting market-expressed preferences and benefits arising from market competition and innovation.

iii. Complex model of how the media should be organised. This multidimensional assessment of state and market informs radical democratic models of how the media should be organised that draw on another key argument, namely, that there are different functions required of media in a democratic system that can best be served by having a combination of media sectors differentially organised, controlled and financed, generating different media spaces and styles. Curran (2002) provides the best exposition of such a model, proposing a core public service sector encircled by private, social market, professional and civil media sectors. For Baker (2002) this model is best able to serve a 'complex democratic perspective', one that combines and goes beyond elite, republican (participatory) and liberal pluralist democratic theories. It seeks to ensure that the system is not controlled by either the state or market, while incorporating both state regulation and private media. There is dynamic disequilibria in the system: the various sectors not only provide different purposes but also ways of influencing the performance of other sectors to strengthen independence, enhance diversity and generate quality.

Addressing the problems of CMP illustrates the limitations of citizenship arguments based on democratic necessity. There is a paradox here. A radical critique of corporate and commercial media power gives rise to an assertion of citizenship rationales. But the latter provides weak grounds for addressing problems that do not impact on the core requirements of citizens, and this critical lacuna has consequences for policy interventions. A central argument of radical media reformers is that media commercialization and concentration are eroding the public sphere, failing to provide the 'cultural and information needs . . . necessary for democracy' (*Voices 21*, in Raboy 2002: 267). This remains a principal concern but it needs to be strengthened by combining more explicitly liberal concerns regarding media independence and 'integrity' to entertainment and non-political content, and consumer welfare/protection concerns about the transparency of commercial speech with a democratic tradition concerned with information and the exchange of ideas and opinions. The tradition of critical political economy has privileged the latter but provides the scope for integration.

As we have seen, even a narrow focus on information and political speech functions of media provides some grounds for problematising CMP. Articulating the problem of corporations promoting their own interests, Smith (1991:19–20) writes:

> The question is, should a media enterprise use the influence of one of its parts (and that inflated by multiple-title ownership) to pursue the interests of another? Readers, it may be argued, know what they are reading and ought to be able to discount legitimately advanced arguments that they suspect of being tendentious. But can they?

Do they? The argument that they may make a free choice is, perhaps, no longer sufficient in the era of the abundance of information [. . .] A democratic society surely needs all or most of its citizens to have been exposed to contradictory opinions. Is it enough for those differences and contradictions to be merely somewhere available?

This Millean argument centres on the diversity and contestability of ideas. In order to make free choices citizens must be able to weigh and test claims, including claims made by media companies promoting their associated products and services. Smith's argument goes some way to combining democratic and consumer welfare arguments but nevertheless focuses on information diversity. Where there is sufficient access to 'contradictory' opinions from alternative sources, it is not clear on what grounds self- or cross-promotion remains problematic.

For Sepstrup (1986: 399) '[i]t is a basic consumer right that communication should clearly separate editorial material and advertising'. US scholar McAllister (2000: 101), however, advances this as a citizenship claim: '[a] major premise that justifies the existence of modern media systems in a democracy in the separation of media content from advertising'. This asserts that citizenship rationales may be extended to address the erosion of boundaries between commercial and media speech. Yet, this expanded rationale must still relate problems of CMP to democratic functions. It is questionable how far and how adequately democratic claims can be extended in this way.

What, then, might movement beyond citizenship rationales comprise? Earlier we argued for a combination of approaches derived from advertising and media regulation. This may now be reformulated as combining citizen and consumer protection rationales. The significance of the latter is that consumer protection can be distinguished from the adoption of consumer arguments within neoliberalism. Instead of establishing the consumer as sovereign, consumer protection acknowledges asymmetries of power. Justification for regulating CMP draws then on competition, consumer welfare, liberal democratic and critical political economic arguments. Synthesising these provides a means of overcoming the disjunction by which growing problems of media power are answered by rationales based narrowly on the function of media to serve citizens.

As a tool to consolidate market power, CMP may lead to a reduction in the range and diversity of media content. That content may be primarily informational or encompass a broader range of cultural expression. Synergy promotes content that can be reformatted and repurposed: '[i]t is simple, recognisable, uncontroversial and transferable brands—Teletubbies, Pokemon, Harry Potter—which suit this business model, not complex, medium-specific,

challenging or unfamiliar media texts' (Hoynes 2002:4). Writing about Disney, Andersen (2000: 7) argues '[i]n this seemingly monolithic environment, one supernarrative after another becomes the vehicle for a vast enterprise of multiple promotion, crowding out a more diverse imaginative entertainment landscape'. Here the requirement for diversity of imagery, as well as information and ideas (see Murdock 1990) provides grounds for critique of CMP. CMP may increase market power and raise barriers to market entry that serve to limit the range and diversity of content available. CMP also increases the influence of brands and texts relative to those lacking such promotional resources. A further 'systemic' critique concerns the dominance of a commercial ethos across the media that 'serves to close down creative alternatives, offering only a narrowly acceptable range of content tied to corporate megaprofits' (Andersen 2000:7). If one problem of CMP may be conceived in terms of media diversity, another concern, connecting citizenship and consumer welfare, is that content may be misleading.

A third problem connects liberal democratic with more radical critiques, namely, the problems of misrepresentation or distortion arising from the interests of those who own or control media. Here CMP may be incorporated into long-standing concerns about proprietorial, corporate and commercial influence, requiring measures to strengthen editorial independence.

The fourth problem of CMP is the influence of commercial values on media content. Here, the strand of political economic analysis, developed by Herbert Schiller, has much to contribute. Schiller (1989) examines how processes of commodification have extended into places and practices once organised according to a different social logic based on universality, access, social participation and citizenship. Schiller provides a critical account of the way in which First Amendment rights (freedom of speech) have been claimed by corporations (whatever their main economic activity) and used by media corporations to protect themselves against social obligations or control.[22]

In *Culture Inc.*, Schiller (1989: 43) argues that the symbolic outputs of cultural industries 'are essentially elements of corporate expression. Corporate speech, therefore, has become an integral part of cultural production in general'. Here, Schiller reveals the tendency to totalisation for which Frankfurt School theorists are criticised (Negus 1997; Tomlinson 1999). Nevertheless, *Culture Inc.* inspires a research agenda based on analysing the interaction of corporate power, law and cultural expression. In contrast to Habermas, Schiller engages directly with communications policy, and his conception of public space allows for entertainment and cultural expression, as well as information, to be incorporated.

The chief task outlined above is to reconnect critiques of commercial speech with the political speech underpinnings of public sphere theory. This arises from identifying problems of concentration and conglomeration that are not adequately addressed within an informational/public sphere framework. Amongst the greatest danger of shaping policy focused mainly on political speech/citizenship rationales is that changes affecting the expansion and integration of promotional speech may be ignored or discounted. Against the policy trajectories, outlined above, it is essential to reintegrate them.

Conclusion

There has been a long debate about corporate media influence. As Smith (1991:14) writes:

> Since the early years of the century there have been repeated expressions of fear about the loss of an essential disinterestedness in journalism as a result of the growth of newspaper combines, and there have been many fitful attempts to stop newspaper proprietors from gobbling up one another.

Underlying anti-monopoly measures established for the press and broadcasting in both America and Britain were concerns about commercial influence on media content. To address cross-media promotion is at once to engage with problems of multimedia expansion in the 21st century and to reconnect with critical concerns articulated at the beginning of the 20th century, notably in Europe and America, about the capitalization and concentration of communications (McChesney 1998: 5). In the intervening years systems of regulation have been devised to tackle problems of market and media power. As these regulatory structures have been dismantled or weakened, CMP has increased while regulatory attention has diminished.

Amongst the mounting problems of media power, or the priorities for reform, cross-media promotion cannot claim privileged status. However this book has argued that CMP represents a problem of media conglomeration and integration requiring regulatory action that is integral to establishing a fully democratic media system. CMP highlights a lacuna in public policy—it marks faultlines across the moving tectonic plates of media policy. It highlights important and insistent problems arising from media concentration and convergence, which ultimately must either be discounted or addressed, and it challenges the scope and adequacy of available paradigms to do so.

Notes

1. Two other paradigms examined largely dispense with regulatory solutions. Libertarianism rejects interference with media property rights and speech rights in a free market. Postmodernism, while irreducible to singular tendencies, includes an important strand of argument challenging the possibility of disaggregating promotional from 'non-promotional' or 'independent' media content (Wernick 1991). While engaging with governance in cultural politics (see McGuigan 1996) and law, postmodernism has been antithetical to prescriptive policy recommendations. From an opposed position some Marxian critical realists share with postmodernists a profound scepticism about (state) regulatory agency.

2. Policy proposals must be situated in their specific historical context. Here I draw more freely on a variety of policy responses, mainly from the UK and US. However, such policy proposals have invariably been developed for different regulatory systems and as interventions which seek to engage with specific political, legal, cultural, ideological and organisational configurations.

3. Feintuck (1999:191) states: 'In the absence of measures dedicated to the support of broader public-interest matters, the application of essentially economic forms of intervention, such as the mechanisms of competition law, appear to confirm rather than resist the commodification of the media'.

4. In the UK, publishers are bound by Clause 1.2j of the British Codes of Advertising and Sales Practice to distinguish editorial from advertising. However, while advertising (commercial speech) is subject to statutory laws, media law does not place any substantive restrictions on editorial cross-promotion or on promotional speech in non-broadcast content.

5. Friedman (Galician 2004: 247) calls for disclosure not only of PP agreements but also 'cases of intracorporate cross-promotion (AOL and CNN appearing in Warner movies, etc.').

6. Curran (1986: 92) describes a 'voluntaristic social responsibility approach' as advocating a voluntary press charter to safeguard editorial standards and independence while remaining 'deeply hostile to any form of state intervention in the media'.

7. See Gibbons (1992: 289) 'Preserving freedom of the press entails, then, the protection of the freedom to make editorial judgements on the basis of values that are independent of the partisan views of particular, powerful individuals'.

8. In 1980s Baistow (1985: 109; see also Curran 1986: 101–2) proposed a 'press charter' to be overseen by an independent press authority, which would include safeguards for the independence of editors and their protection from improper pressures from proprietors, advertisers, trade unions and other organisations. For more recent arguments see O'Malley and Soley (2000).

9. Labour's 1985 party programme proposed measures to prevent further media concentration and prohibit joint control of the press, commercial radio and television (see Curran et al. 1986: 211). For a critique of Labour's policy in government see Baistow (1985: 96–7).

10. CMP is now included in the AQA A-level syllabus (2009) for Media Studies (UK).

11. This Recommendation adopts the position of other CoE policy statements that 'media concentration at the national and international levels can have not only positive but also harmful effects on media pluralism and diversity which may justify action by governments'.

12. See also Gibbons (1992: 297) 'Where proprietorial control or corporate influence cannot be proved or quantified, diversification may be seen as the minimum response consistent with a liberty to speak'.

13. For Gibbons this explicitly included Sadler's proposals. Of course, *how* this might be imposed is much more difficult to answer.

14. This proposal accords with what Curran (1986: 99) describes as '[p]ublic service remodelling of the press'.

15. For instance, Scanlon (1990) argues that it would be unrealistsic and even dangerous to grant to legislatures or to judges the power to engage in detailed regulation of expression based on their conceptions of perfectly fair and undistorted discussion. It would be unrealistic, because we lack a sufficiently clear and widely shared view of what these ideals come to, and any actual discussion will fall short. It would be dangerous assigning powers to political institutions to prohibit any expression that falls short of their conception of these ideals. Nevertheless, Scanlon approves of legal action on clear examples of speech that would count as unfairness or distortion on any account.

16. Baker (1994: 135) distinguishes between the US constitutional protection of editorial freedom and permissible restrictions on editors acting as agents for advertisers' speech. Requirements for identification of corporate interests would almost certainly be ruled unconstitutional on the grounds of intrusion by the state into the function of editor (Baker 1994:133–136). However, Baker does cite several cases upholding the principle that identification requirements for advertiser-influenced content are permitted.

17. As our newspaper study showed, the 1994 code on cross-promotion has been weakly enforced, in line with broader failures of press self-regulation (O'Malley and Soley 2000, Petley 1997).

18. As political economic critiques emphasise, measures to improve journalism by focusing on the activity and behaviour of journalists fail to address the problems of corporate power and market structures shaping such 'behaviour'.

19. Every previous attempt to introduce statutory controls such as a right to reply has failed (O'Malley and Soley 2000). In 2002, responding to newspaper lobbying against the Communication Bill's public interest test on newspaper takeovers, Jowell assured the industry that the government had 'no plans to extend content regulation to newspapers' (Kane 2002; see also Gibson 2002). Earlier that year, the Government backed away from plans to outlaw chequebook journalism following intense lobbying by the newspaper industry (Wells 2002). It is almost inconceivable that acknowledgment of problems arising from editorial cross-promotion would alone encourage a reversal of policy on press regulation.

20. Writing soon after Labour's election victory in 1997 Feintuck (1999: 212, 192) saw no prospect of the new government (re)nationalising sectors of the economy but considered 'it was possible to envisage a new government with citizenship explicitly at the centre of its agenda, imposing stewardship arrangements in relation to national assets that form the essential aspects of citizenship and democracy'.

21. The government adopted elements of an influential argument by Graham and Davis (1997) whereby justifications for public service broadcasting are rooted in market failures arising from the characteristics of media markets (see Curran and Seaton 2003: 397). These include the public good characteristics of media products, the need to take account of negative social and cultural 'externalities' arising from the character and scope of market

transactions (Baker 2002). Regulation is also required because economies of scale and scope confer advantages on large firms tending towards market dominance and concentration.

22. Such tendencies are inherent in the First Amendment itself whose 'conceptual and political logic privileges prevailing conditions in the market place, the proprietary structures in communication benefit from the prohibition on government to guarantee structures of public space in the common interests' (Venturelli 1998: 258). Schiller (1989: 56) argues that corporations offering media and communication services are particularly intent on securing privileged (First Amendment) status because it exempts them from social obligation and accountability.

Bibliography

(Some book subtitles have been removed for reasons of space)

Abramovich, A. (2001) 'Company Man', *Feed* (no longer available).

Adorno, T. and Horkheimer, M. (1979) [1944] 'The Culture Industry: Enlightenment as Mass Deception' in T. Adorno and M. Horkheimer, *Dialectic of Enlightenment* (trans. by J. Cummings), London: Verso.

Aitman, D. (1996) 'EC and United Kingdom Competition Law Developments' in E. Barendt (ed) *The Yearbook of Media and Entertainment Law 1996*, Oxford: Oxford University Press.

Albarran, A. B. and Chan-Olmsted, S. (1998) *Global Media Economics*, Ames:Iowa State Univ. Press.

Alger, D. (1998) *Megamedia*, Lanham, : Rowman and Littlefield.

Allaun, F. (1988) *Spreading the News: A Guide to Media Reform*, Nottingham: Spokesman/CPBF.

Allen, D. (2001) 'The First Amendment and the Doctrine of Corporate Personhood: Collapsing The Press–Corporation Distinction', *Journalism: Theory, Practice And Criticism*, 2 (3): 255–278.

Allen, G. (2000) *Intertextuality*, London: Routledge.

Allen, G. (2005) 'Intertextuality', *The Literary Encyclopedia*, http://www.Litencyc.com /php/stopics.php?rec=true&UID=1229 (accessed 24 January 2006).

American Demographics (2000) 'Scaling the Media Web', (6 November).

Andersen, R. (1995) *Consumer Culture and TV Programming*, Boulder, CO: Westview Press.

—— (2000) 'Introduction' in R. Andersen and L. Strate, *Critical Studies in Media Commercialism*, Oxford: OUP.

Andersen, R. and Strate, L. (2000) *Critical Studies in Media Commercialism*, Oxford: OUP.

Anderson, N. (2006). Product Placement (19 March), http://arstechnica.com/gadgets/news/ 2006 /03/productplacement.ars.

Annan, Lord (chair) (1977) *Report of the Committee on the Future of Broadcasting*, Cmnd. 6753, London: HMSO

AOL-Time Warner (2001) 'First Meeting of AOL Time Warner with Investors and Analysts' (31 January), New York: Time Warner Inc.

Arvidsson, A. (2006) *Brands: Meaning and Value in Media Culture*, London: Routledge.

ASA (Advertising Standards Authority) (1999) Adjudication 10th March, London: ASA.

Associated Press (2009) 'TV Vampires Cloak Friday's', *Los Angeles Times* (12 June), http://www.nytimes.com/aponline/2009/06/12/arts/AP-US-LA-Times-HBO.html (accessed 13 June 2009).

Aufderheide, P. (1999) *Communications Policy and the Public Interest: The Telecommunications Act of 1996*, New York: The Guilford Press.

Auletta, K. (1992) *Three Blind Mice*, New York: Vintage Books.

—— (1998) 'Synergy City', *American Journalism Review*, Available at http://ajr.newslink.org/special/auletta1.html (accessed 31 August 2000).

—— (2001) 'Leviathan: How Much Bigger Can AOL Time Warner Get?', *The New Yorker* (29 October): 50.

—— (2002) 'The Drive to Achieve Synergy Is Often Journalism's Poison', interview with Patrick Phillip, http://www.iwantmedia.com/people/people22.html (accessed 29 January 2009).

Avshalom, G. and Levi-Faur, D. (2008) 'The Politics of Product Placement in the European Union: Between Commercial Pressures and Social Norms', Second Biennial Conference on '(Re)Regulation in the Wake of Neoliberalism', organized by the Standing Group on Regulatory Governance of the ECPR, Utrecht, 5–7 June.

Ayres, I. and Braithwaite, J. (1992) *Responsive Regulation*, Oxford: Oxford University Press.

Bagdikian, B. (1989) 'Conquering Hearts and Minds: The Lords of the Global Village', *The Nation* (New York), 12 June.

—— (1997) *The Media Monopoly* (5th Edition), Boston: Beacon.

—— (2000) *The Media Monopoly* (6th Edition), Boston: Beacon.

—— (2004) *The New Media Monopoly*, Boston: Beacon.

Baistow, T. (1985) *Fourth-Rate Estate: An Anatomy of Fleet Street*, London: Comedia.

Baker, C. E. (1989) *Human Liberty and Freedom of Speech*, New York: OUP.

—— (1994) *Advertising and a Democratic Press*, Princeton, NJ: Princeton University Press.

—— (1998) 'The Media That Citizens Need', *Univ. of Pennsylvania Law Review* 147 (2): 317–408.

—— (2002) *Media, Markets, and Democracy*, Cambridge: Cambridge University Press.

—— (2007) *Media Concentration and Democracy*, Cambridge: Cambridge University Press.

Baker, K. (1993) *The Turbulent Years: My life in Politics*, London: Faber and Faber.

Baker, R. (1997) 'The Squeeze: Some Advertisers Step Up the Pressure on Magazines to Alter Their Content', *Columbia Journalism Review* (September/October).

Balasubramanian, S. K. (1994) 'Beyond Advertising and Publicity: Hybrid Messages and Public Policy Issues', *Journal of Advertising*, 23 (4): 29–46.

Baldasty, G. J. (1992) *The Commercialization of News in the Nineteenth Century*, Madison: University of Wisconsin Press.

Baldwin, R. and Cave, M. (1999) *Understanding Regulation*, Oxford: Oxford University Press.

Baldwin, R., Scott, C. and Hood, C. (eds) (1998) *A Reader on Regulation*, Oxford: OUP.

Baldwin, T., McVoy, D.S., Steinfield, C. (1996) *Convergence*, Thousand Oaks, CA: Sage.

Bardoel, J. and d'Haenens, L. (2008) 'Public Service Broadcasting in Converging Media Modalities', *Convergence*, 14(3): 351–360.

Barendt E.M. (1987) *Freedom of Speech*, Oxford: Clarendon Press.

—— (1993) *Broadcasting Law*, Oxford: Clarendon Press.

Barendt E. M. and Hitchens L. (2000) *Media Law: Cases and Materials*, London: Longman.

Barnett, S. (1989) *Cross-media Ownership and Its Impact on Public Opinion: A Case Study*, London: Broadcasting Research Unit (available from Voice of the Listener and Viewer).

Barnett, S. and Curry, A. (1994) *The Battle for the BBC*, London: Aurum Press.

Barnett, S. and Gaber, I. (2001) *Westminster Tales*, London: Continuum.

Barnett, S., Barwise, P., Curran, J., Seaton, J., and Silvestone, R. (2003a) Letter to the Editor, *Financial Times* (February 25): 16.

Barnett, S., Barwise, P., Curran, J., Seaton, J., and Silvestone, R. (2003b) 'Logic of Keeping a Basic Protection', Letters to the Editor, *Financial Times* (February 28): 18.

Barnouw, E. (1978) *The Sponsor: Notes on a Modern Potentate*, New York: Oxford University Press.

Barnouw, E. et al. (1997) *Conglomerates and the Media*, New York: The New Press.

Barthes, R. (1977) *Image-Music-Text*, London: Fontana.

Baxter, J. (ed) (2001) *Commercial TV: 2001 Market Report*, Middlesex: Key Note.

BBC (1999) *Commercial Policy Guidelines*, London: BBC.

—— (2000a) *Producers' Guidelines*, London: BBC.

—— (2000b) *Annual Report and Accounts 1999/2000*, London: BBC.

—— (2001a) *Everyone's BBC: Connecting with Our Audience*, London: BBC.

—— (2001b) *Annual Report and Accounts 2000/2001*, London: BBC.

—— (2003) *Annual Report and Accounts 2002/2003*, London: BBC.

—— (2005) *Rationale for On-air Promotional Activities*, Report by Spectrum, London: BBC.

Beck, A. (ed) (2003) *Cultural Work: Understanding the Cultural Industries*, London: Routledge.

Beesley, M. (ed) (1996) *Markets and the Media*, London: Institute of Economic Affairs.

Begg, M. (2002) Interview with the author (11 June).

Belfield, R., Hird, C. and Kelly S. (1991) *Murdoch: The Decline of an Empire*, London: MacDonald.

Belsey, A. and Chadwick, R. (1992) (eds) *Ethical Issues in Journalism and the Media*, London:Routledge.

Bennett, N. (1998) 'The Dash for Digital', *Daily Telegraph* (2 Aug): 5.

Bennett, T. and Woollacott, J. (1987) *Bond and Beyond*, Basingstoke: Macmillan.

Bennett, W. L (2008) *News: The Politics of Illusion*, London.

Berry D. (ed) (2000) *Ethics and Media Culture: Practices and Representations*, Oxford: Focal Press.

Bevins, A (1992) *The Independent* (3 February): 19.

Billen, N. (1998) 'A New Look Service for the Digital Age' *Daily Express* (1 October): 57.

Bird and Bird (2002) *Study on the Development of New Advertising Techniques* (with Carat Crystal), Brussels: EC.

Bishop, S. and Walker M. (1999) *The Economics of EC Competition Law*, London: Sweet & Maxwell.

Blair, I. (2002) Interview with the author (24 July).

Blake, A. (2002) *The Irresistible Rise of Harry Potter*, London: Verso.

Blumler, J.C. (1992) 'Vulnerable Values at Stake' in J.C.Blumler (ed) *Television and the Public Interest: Vulnerable Values in West European Broadcasting*, London: Sage.

Bogart, L. (2000) *Commercial Culture*, New Brunswick (USA): Transaction Publishers.

Born, G. (2004) *Uncertain Vision*, London: Secker & Warburg.

Born, G. and Prosser, T. (2001) 'Culture and Consumerism: Citizenship, Public Service Broadcasting and the BBC's Fair Trading Obligation', *Modern Law Review* 64: 5, 657–687.

Bourdieu, P. (1984) *Distinction* (trans. Richard Nice), London: Routledge.

Bradshaw, B. (2009) *Speech to the Royal Television Society* (16 September), London: DCMS. Available at http://www.culture.gov.uk/reference_library/minister_speeches/6348.aspx (accessed 17 September 2009)

Branch, S. (2000) 'Hosts of ABC's 'The View Praise Campbell Soup in Eight Paid Spots, *The Wall Street Journal Interactive* (14 November).

Breech, P. (2001) 'ITC Issues Cross-Promotions Proposals' in *Marketing* (10 May).

Briggs, A. and Burke, P. (2002) *A Social History of the Media*, Cambridge: Polity.

British Journalism Review (1989) 'Why We Are Here', *BJR* 1 (1) : 2–6.

British Media Industry Group (1994) *The Future of the British Media Industry*, London: BMIG.

Broadcast (2002) 'A Mixed Message' (22 February):13.

Broadcasting Research Unit (1985) *The Public Service Idea in British Broadcasting–Main Principles*, London: Broadcasting Research Unit.

Bromley, M. (2000) 'The Manufacture of News–Fast Moving Consumer Goods Production, or Public Service? In D. Berry (ed) *Ethics and Media Culture*, Oxford: Focal Press.

Bromley, M. and O'Malley, T. (1997) *A Journalism Reader*, London: Routledge.

Brooker, W. (2001) 'Living on *Dawson's Creek*: Teen Viewers, Cultural Convergence, and Television Overflow', *International Journal of Cultural Studies*, 4(4): 456–472.

Brown, A. and Walsh, A. (1999) *Not for Sale: Manchester United, Murdoch and the Defeat of BSkyB*, Edinburgh: Mainstream Publishing Company.

Brown, M. (1990) 'Broadcasting Bill 'undermines BBC trading activities'', *The Independent* (2 March).

—— (1999) 'Media Diary', *The Guardian* (4 October): 5 (Media).

Brown, R. (1998a) 'Poor Old Ray Snoddy. I Wouldn't be the Media Editor of the Murdochian Times for all the TVs in China' *The Independent* (9 March): 2 (Media).

—— (1998b) 'Media: Rob Brown's Column', *The Independent* (30 March): 2 (Media).

Brunsdon, C. (1991) 'Satellite Dishes and the Landscape of Taste', *New Formations* 15.

BSkyB (British Sky Broadcasting) (2000) Chairman's Statement (3 November).

BSkyB (2006) *Response of British Sky Broadcasting Limited* , London: Ofcom

Bunton, K. (2000) 'Media Criticism as Professional Self-Regulation' in D. Pritchard (ed) *Holding the Media Accountable: Citizens, Ethics and the Law*, Bloomington: Indiana University Press.

Burrell, I. (2003) 'Jowell Threatens Tougher Media Laws if Murdoch Takes Control of Five', *The Independent* (3 June): 7.

Burt, T. (2003a) 'Call to Amend Media Bill to Protect Channel Five', *Financial Times* (25 February): 2.

—— (2003b) 'Absolutely Nothing to Be Ashamed of, Flextech's Lisa Opies on the Joys of Running an Unapologetically Commercial TV Company', *Financial Times* (13 May): 20.

Burt, T. and Larse P. T. (2003) 'Direct TV is about Changing the Whole Model of News Corp's Output in the US', *Financial Times* (12 February): 15.

Bushell, G. (1998a) 'Gary Bushell's Digital View' (1 October): 13.

—— (1998b) 'Natural Horn Thriller' *The Sun* (14 October).

Calcutt, D. (1990) *Report of the Committee on Privacy and Related Matters*, London: HMSO.

Calhoun, C. (ed) (1997) *Habermas and the Public Sphere*, Cambridge, MA: MIT Press.

Campbell, D. (2000) 'After the Wall', *American Journalism Review* (March).

Campbell, D. (2001a) 'Film Fans Sue Over 'Corrupt' Reviews, *The Guardian* (10 July).

—— (2001b) 'Story of the decade!', *The Guardian*, (25 July): 2-3 (Sections 2).

Caporaso, J. and Levine D. (1992) *Theories of Political Economy*, Cambridge: CUP.

Cappo, J. (2003) *The Future of Advertising*, New York: McGraw-Hill.

Carlton, Granada and ITV Digital (2001) *Submission to ITC Consultation*, London: ITV Digital.

Carpini, M. and Williams, B. (2001) 'Let Us Infotain You: Politics in the New Media Environment' in W. L. Bennett and R. Entman (eds) *Mediated Politics*, Cambridge: CUP.

Carr, F. (2002) 'Common Convergence Questions' (2 May), http://www.poynter.org /content /content_view.asp?id=9614 (accessed 8 April 09).

Carter, M. (2000) 'Promotional Breakdown', *Broadcast* (15 September): 16-17.

Carvajal, M. and García Avilés, J. A. (2008) 'From Newspapers to Multimedia Groups', *Journalism Practice*, 2 (3): 453-462.

Cavallin, J. (1998) 'European Policies and Regulations on Media Concentration', *International Journal of Communications Law and Policy*. Available at www.digital-law.net/IJCLP/ 1_1998/ijclp_webdoc_3_1_1998.html (accessed 12 July 2002).

Channel Four (2001) *Submission to ITC Review of Cross-Promotion*, London: ITC.

Chenoweth, N. (2001) *Virtual Murdoch*, London: Secker and Warburg.

Chihara, M. (2003) 'Harry Potter and the Great Big Hoopla', *AlterNet*, (16 June), http://www. alternet.org/story/16174/harry_potter_and_the_great_big_hoopla/(accessed 5 Jan. 2007).

Chippendale, P. and Horrie, C. (1990) *Stick It Up Your Punter*, London: Heinemann.

Chippendale, P. and Franks, S. (1991) *Dished! The Rise and Fall of British Satellite Broadcasting*, London: Simon and Schuster.

Clark, A (2009) 'Set Backs Push Time Warner Towards Big Losses', *The Guardian* (8 January): 25.

Clifford, S. (2009a, April 10). Front of *Los Angeles Times* has an NBC 'Article.' *The New York Times*, B3.

Clifford, S. (2009b, June 12). "Magazine Cover Ads Subtle, Less So." *The New York Times*, B3.

Cole, B. and Oettinger, M. (1978) *Reluctant Regulators*, Reading, MA: Addison-Wesley.

Coleman, J. and Rollet, B. (1997) *Television in Europe*, London: Intellect.

Collins, R. (1994) *Broadcasting and Audio-Visual Policy in the European Single Market*, Luton: John Libbey.

Collins, R. (ed) *Converging Media? Converging Regulation?*, London: IPPR.

Collins, R. and Murroni, C. (1996) *New Media, New Policies*, Cambridge: Polity.

Columbia Journalism Review [CJR] (1997) "The Real Dangers of Conglomerate Control," *Columbia Journalism Review* (March/April).

Compton, J. R. (2004) *The Integrated News Spectacle: A Political Economy of Cultural Performance*, New York: Peter Lang.

Congdon, T., Graham, A., Green D. and Robinson, B. (1995) *The Cross Media Revolution: Ownership and Control*, Luton: John Libbey.

Copyright Tribunal (1992) *News Group Newspapers Limited and Independent Television Publications Limited*, London: Copyright Tribunal.

Cornford, J. and Robins, K. (1999) 'New Media' in J. Stokes and A. Reading (eds) *The Media in Britain*, London: Macmillan.

Corrigan, D. (2004) 'Convergence Works for Media Owners but Not News Consumers', *St Louis Journalism Review* 14–15.

Couldry, N. (2000) *Inside Culture*, London: Sage.

Council of Europe (CoE) (1975) *Recommendation 747 on Press Concentrations*, Strasbourg: CoE.

—— (1991) *Programme Sponsorship and New Forms of Promotion on Television*, Mass Media Files No 9, Strasbourg: CoE.

—— (1993) *The Council of Europe and Media Freedom*, Strasbourg: CoE.

—— (1994) *Recommendation R(94)13 on Measures to Promote Media Transparency*, Strasbourg: CoE.

—— (1996) *Law and Practice of the European Convention on Human Rights and the European Social Charter.* (Contributing authors D. Gomien, D. Harris and L. Zwaak) Strasbourg: CoE.

—— (1997) *Report on Media Concentrations and Pluralism in Europe*, Committee of Experts on Media Concentrations and Pluralism (MM-CM) rev. edn., Strasbourg: CoE.

—— (2000) *Case-law Concerning Article 10 of the European Convention on Human Rights*, Directore General of Human Rights, DH-MM (2000) 6, Strasboug: CoE.

CPBF (2000) *Comments on the Communications Reform White Paper*, London: CPBF.

—— (2001a) *Response to the ITC Consultation Paper on Cross-promotion in Commercial Television*, London: CPBF.

—— (2001b) *Response to the Second ITC Consultation Paper*, London: CPBF.

—— (2002a) *Response to the DTI/DCMS Consultation on Media Ownership*, London: CPBF.

—— (2002b) *Submission on the Draft Communications Bill*, London: CPBF.

—— (2008) *Submission to DCMS on implementation of AVMSD*, London: CPBF

Croteau, D. and Hoynes, W. (2001) *The Business of Media: Corporate Media and the Public Interest*, Thousand Oaks, CA : Pine Forge Press.

—— (2003) *Media /Society: Industries, Images and Audiences*, 3rd edition, Thousand Oaks, CA: Pine Forge Press.

—— (2006) *The Business of Media: Corporate Media and the Public Interest*, 2nd edition, Thousand Oaks, CA: Pine Forge Press.

Curran, J. (1977) 'Capitalism and Control of the Press 1800–1975' in J. Curran, M. Gurevitch and J. Woollacott (eds) *Mass Communication and Society*, London: Arnold.

—— (1978) 'Advertising and the Press', in J. Curran (ed) *The British Press: A Manifesto*, London: Macmillan.

—— (1986a) 'The Impact of Advertising on the British Mass Media' in R. Collins, J. Curran, N. Garnham, P. Scannell and C. Sparks (eds) *Media, Culture and Society*, London: Sage.

—— (1986b) 'The Different Approaches to Media Reform' in J. Curran et. al. *Bending Reality: The State of the Media*, London: Pluto.

—— (1990) 'Culturalist Perspectives of News Organizations: A Reappraisal and a Case Study' in M. Ferguson (ed) *Public Communication: The New Imperatives*, London: Sage.

—— (1995a) 'Regulation and Deregulation of the British Media' in K.E. Gustafsson (ed) *Media Structure and the State: Concepts, Issues, Measures*, Götenberg University.

—— (1995b) *Policy for the Press*, London: IPPR.

—— (1996) 'Mass Media and Democracy Revisited' in J. Curran and M. Gurevitch (eds) *Mass Media and Society*, London: Arnold. 2nd Edition.

—— (2000) 'Press Reformism 1918-98: A Study of Failure' in H. Tumber (ed) *Media Power, Professionals and Policies*, London: Routledge.

—— (2002) *Media and Power*, London: Routledge.

Curran, J. (ed) (2000) *Media Organisations in Society*, London: Arnold.

Curran, J. and Leys, C. (2000) 'Media and the Decline of Liberal Corporatism in Britain' in J. Curran and M-J. Park (eds) *De-Westernizing Media Studies*, London: Routledge.

Curran, J. and Seaton, J. (1997) *Power without Responsibility: The Press and Broadcasting in Britain*, 5th Edition, London: Routledge.

—— (2003) *Power without Responsibility*, sixth Edition, London: Routledge.

—— (2010) *Power Without Responsibility*, seventh edition, London: Routledge

Currie, D. and Siner M. (1999) 'The BBC Balancing Public and Commercial Purpose' in A. Graham et al (eds) *Public Purposes in Broadcasting*, Luton: Univ of Luton Press.

Dahlgren, P (1995) *Television and the Public Sphere*, London: Routledge.

—— (2000) 'Key Trends in Eurropean Television' in J. Wieten, G. Murdock and P. Dahlgren (eds) *Television Across Europe: A Comparative Introduction*, London: Sage.

—— (2001) 'The Transformation of Democracy' in B. Axford and R. Huggins (eds) *New Media and Politics*, London: Sage.

Dahlgren, P. and Sparks, C. (eds) (1991) *Communication and Citizenship*, London: Routledge.

Dailey, L. Demo, L. and Spillman, M. (2005) 'Most TV/Newspapers Partners At Cross Promotion Stage', *Newspaper Research Journal*, 26 (4): 36-49.

Daintith, T. (1998) 'Legal Measures and their Analysis' in Baldwin, R., Scott, C. and Hood, C. (eds) *A Reader on Regulation*, Oxford: Oxford University Press.

David Graham and Associates (2000) *Out of the Box. The Programme Supply Market in the Digital Age. A report for DCMS*, London: David Graham and Associates.

—— (2001) *Summary of Responses to the White Paper*, London: DCMS.

Davies, N. (2008) *Flat Earth News*, London: Chatto & Windus.

Davis, A. (2002) *Public Relations Democracy*, Manchester: Manchester University Press.

deCordova, R. (1994) 'The Mickey in Macy's Window: Childhood, Consumerism, and Disney Animation' in E. Smoodin (ed) *Disney Discourse*, New York: Routledge.

Demetz, P. (1962) 'Introduction' in P. Demetz (ed) *Brecht*, London: Macmillan.

Department of National Heritage (DNH) (1995) *Media Ownership: The Government's Proposals*, London: HMSO.

—— (1997) *Guide to Media Ownership Regulation*, London: DNH.

Department of Trade (1981) 'Consent in a Case of Urgency to Transfer of Newspapers not Economic as Going Concerns and Intended to Continue as Separate Newspapers', Secretary of State for Trade (John Biffen) (27 January).

DCMS (Department for Culture, Media and Sport) (1999) *The Future Funding of the BBC. Report of the Independent Review Panel*, London: DCMS.

—— (2005) *UK Government response to EC paper on Commercial Communications*, London: DCMS.

—— (2008a) Speech by Secretary of State to the Convergence Think Tank (11 June). Available at http://www.culture.gov.uk/reference_library/minister_speeches.

—— (2008b) *Public Consultation on Implementing the EU Audiovisual Media Services Directive*. http://www.culture.gov.uk/reference_library/consultations/5309.aspx.

—— (2009a) Written Ministerial Statement on the Implementation of the Audiovisual Media Services Directive (11 March), http://www.culture.gov.uk/reference_library /minister_speeches/5932.aspx (accessed 11 March).

—— (2009b) Consultation on Product Placement on Television, London: DCMS http://www. culture.gov.uk/reference_library/consultations/6421.aspx.

—— (2010) Written Ministerial Statement on Television Product Placement (9 February), London: DCMS.

DCMS and DTI (2001) *Consultation on Media Ownership Rules*, London: DCMS.

—— (2000) *A New Future for Communications*, Cm 5010. London: The Stationery Office.

Deuze, M. (2004) 'What is Multimedia Journalism?', *Journalism Studies*, 5(2): 139–152.

Donaton, S. (2004) *Madison and Vine*, New York: McGraw-Hill.

Donnelly, K.J. (1998) 'The Classical Film Score Forever?: Batman, Batman Returns and Post-Classical Film Music' in Steven Neale and Murray Smith (eds) *Contemporary Hollywood Cinema*, London: Routledge. pp.142–155.

Douglas, T. (1999) 'Carlton and United Need Strong Brand for Cross-Media Synergy', *Marketing Week* (2 December):17.

Dovey, J (ed) (1996) 'The Revelation of Unguessed Worlds' in J. Dovey (ed) *Fractal Dreams: New Media in Social Context*, London: Pluto.

Doyle, G. (1999) 'Convergence: 'A Unique Opportunity to Evolve in Previously Unthought-of-ways' or a Hoax?' in C. Marsden and S. Verhulst (eds) *Convergence in European Digital TV Regulation*, London: Blackstone Press.

—— (2002a) *Media Ownership: The Economics and Politics of Convergence and Concentration in the UK and European Media*, London: Sage.

—— (2002b) *Understanding Media Economics*, London: Sage.

DTI (Department of Trade and Industry) (1992) Press Notice (6 August).

DTI and DCMS (1998) *Regulating Communications*, Cmd. 4022, London: The Stationery Office.

Du Gay, P. (ed) (1997) *Production of Culture/Cultures of Production*, London: Sage.

Dupagne, M. and Garrison, B. (2006) 'The Meaning and Influence of Convergence,' *Journalism Studies*, 7(2): 237–255.

Dyson, K. and Humphreys, P. with Negrine, R. and Simon, J-P. (1988) *Broadcasting and New Media Policies in Western Europe*, London: Routledge.

Dyson, K. and Humphreys, P. (eds) (1990) *The Political Economy of Communication*, London: Routledge.

EACA (2003) Review of the "Television Without Frontiers" Directive, 15 July, Brussels: EACA

Eagleton, T. (1990) *The Ideology of the Aesthetic*, Oxford: Blackwell.

Eastman, S. (ed) (2000) *Research in Media Promotion*, Mahwah, NJ: Lawrence Erlbaum Associates Inc.

Eastman, S., Ferguson, D., Klein, R. (2002) *Promotion and Marketing for Broadcasting, Cable and the Web*, London: Focal Press.

Eckert, C. (1991) 'Carole Lombard in Macy's Window' in C. Herzog and J. M. Gaines (eds) *Fabrications: Costume and the Female Body*, London: Routledge.

Economist, The (2001a) 'Media Mind their Ad Revenues', The Economist.com (25 October) (Global Agenda section).

—— (2001b) 'Harry Potter and the Synergy Test', *The Economist* (US edition) (10 November).

—— (2005) 'The Rapid Growth of Product Placement' (27 October).

Edgar, A. (2000) 'The 'Fourth Estate' and Moral Responsibilities' in D. Berry (ed) *Ethics and Media Culture: Practices and Representations*, Oxford: Focal Press.

EFJ (European Federation of Journalists) (2002) *Legislating for a Democratic Media in Europe*, Brussels: EFJ

Ellery, S. (2001) 'Ad Industry Reborn', *Broadcast* (4 May): 17.

Elliot, M. (1981) 'Chasing the Receding Bus: The Broadcasting Act 1980' *Modern Law Review* 44 November, 683-692.

Elliot, S. (1992) 'One Happy CBS Advertiser: Itself' *New York Times* (April 4).

Endemol (2000) Submission to Gov. White Paper, A New Future for Communications, June.

Entman, R. (1985) 'The Marketplace of Ideas Revisited: Newspaper Competition and First Amendment Ideals: Does Monopoly Matter?', *Journal of Communication*, Summer.

Erdal, I.J. (2007) 'Researching Media Convergence and Crossmedia News Production', *Nordicom Review* 28 (2007): 51-61.

European Advertising Standards Alliance (1997) *Advertising Self-Regulation in Europe*, Brussels: EASA.

European Commission [EC] (1989) Directive 89/552/EEC, on the Co-ordination of Certain Provisions Laid Down by Law, Regulation or Administrative Action in Member States Concerning the Pursuit of Television Broadcast Activities, OJ 1989 L298/23. Brussels: EC.

—— (1990) *Communication by the Commission to the Council and to the European Parliament on Audio-visual Policy*, COM (90): 78 (21 February), Brussels: European Commission.

—— (1992) *Pluralism and Media Concentration in the Internal Market. An Assessment of the Need for Community Action*. Com (1994) 353, Brussels: European Commission.

—— (1994) *Europe and the Global Information Society*, Bangemann Task Force Report to the European Council, Brussels: EC.

—— (1996) *Commercial Communication in the Internal Market, Green Paper from the Commission*, Brussels: EC.

—— (1997a) *Green Paper on the Convergence of the Telecommunications, Media and Information Technology Sectors, and the Implications for Regulation*, COM (97) 623, Brussels: EC.

—— (1997b) *Second Report from the Commission to the European Parliament, the Council and the Economic and Social Committee on the Application of Directive 89/552/EEC 'Television without Frontiers'*, Brussels: EC.

—— (2005) 'First Issues Paper on Revision of the Television without Frontiers Directive,' Brussels: EC.

—— (2007) *Audiovisual Media Services Directive*, Brussels: EC.

European Institute for the Media (Europäisches Medieninstitut) (1989) *Events and Issues Relevant to Competition in Satellite Television Between British Satellite Broadcasting and News International, Research Programme on Mulit-media Concentration and the Free Flow of Information, Case Study No. 1*, Manchester: European Institute for the Media.

European Newspaper Publishers Association (2005) ENPA response to the Television without Frontiers Issues Paper on Commercial Communications, Brussels: ENPA

European Parliament (1990) *Resolution on Media Takeovers and Mergers OJ C68/137*, Strasbourg: European Parliament.

—— (1992) *Resolution of 16 September 1992 on Media Concentration and Diversity of Opinions OJ C284/44*, Strasbourg: European Parliament.

—— (1993), *Report of the Committee on Civil Liberties and Internal Affairs on Freedom of Expression, Press Freedom and Freedom of Information DOC_EN\RR\237\237310*, Strasbourg: EP.

Euromedia Research Group (1992) *The Media in Western Europe*, London: Sage.

Evans, E. (1983) *The Forging of the Modern State*, London: Longman.

Evans, H. (1994) [1983] *Good Times, Bad Times*, London: Phoenix.

Facenda, V. (2005) 'The Business of Show Biz', *Retail Merchandiser*, (1 June): 25-29.

FAIR (2000) 'In the Soup at the *View*: ABC Allows Corporate Sponsor to Buy Talkshow Content', *FAIR* Action Alert (20 November).

Fallon, I. (1989) 'BSB Reaches for the Sky' *The Sunday Times* (30 April).

FCC (2008) Notice of Inquiry and Notice of Proposed Rule Making, FCC 08-155 (26 June), Washington D.C.: Federal Communications Commission

Featherstone, M. (1991) *Consumer Culture and Postmodernism*, London: Sage.

Federal Communications Commission (FCC) (1998) *Review of Ownership Rules* No 98-35.

—— (2005) 'Commission Reminds Broadcast Licencees, Cable Operators and Others of Requirements Applicable to Video News Releases.' FCC 05-84, MB Docket No 05-171, Washington, DC: FCC.

Federal Trade Commission (FTC) (2005) Letter from Mary K. Engle, Assoc. Dir. for Adver. Practices, FTC to Gary Ruskin, Exec. Dir., Commercial Alert (10 February). Available at http://www.ftc.gov/os/closings/staff/050210productplacemen.pdf.

Federal Trade Commission (2009) *Guides Concerning the Use of Endorsements and Testimonials in Advertising*, 16 CFR Part 255, Washington: FTC.

Feintuck, M., (1999) *Media Regulation, Public Interest and the Law*, Edinburgh: Edinburgh University Press.

Feintuck, M. and Varney, M. (2006) *Media Regulation, Public Interest and the Law*, 2nd Edition, Edinburgh: Edinburgh University Press.

Feldman, D. (1993) *Civil Liberties and Human Rights in England and Wales*, Oxford: Clarendon.

Ferguson, M. (ed) (1990) *Public Communication: The New Imperatives*, London: Sage.

Fine, J. and Elkin, T. (2002) 'On the House', *Advertising Age* (18 March): 1.

Fiske, J. (1982) *Introduction to Communication Studies*, London: Routledge.

Flew, T. (2002)'Broadcasting and the Social Contract' in M. Raboy (ed) *Global Media Policy in the New Millennium*, Luton: University of Luton Press.

Foley, C., Bryan C. and Hardy, J. (1994) *Censored: Freedom of Expression and Human Rights*, London: Liberty.

Foster, H. (ed) (1985) *Postmodern Culture*, London: Pluto.

Franklin, B. (1997) *Newszak and News Media*, London: Arnold.

Franklin B. and Murphy D. (1997) 'The Local Rag in Tatters? The Decline of Britain's Local Newspapers', in M. Bromley and T. O'Malley (eds) (1997) A Journalism Reader, London: Routledge.

Freedman, D. (2003) Television Policies of the Labour Party 1951-2001, London: Frank Cass.

—— (2008) The Politics of Media Policy, Cambridge: Polity.

Friedman, T. (2004) Cast Away and the Contradictions of Product Placement' in M.L. Galician (ed.) Handbook of Product Placement in the Mass Media, NY: Best Business Books.

Friedman, W. and Halliday, J. (2002) 'Product Integrators Tackle Learning curve', Advertising Age, 73 (42): 18-20.

Frith, S (1996) 'Entertainment' in J. Curran and M. Gurevitch (eds) Mass Media and Society, London: Arnold.

Frost, C. (2000) Media Ethics and Self-Regulation, Harlow: Longman.

Fuller, L. (1997) 'We Can't Duck the Issue: Imbedded Advertising in the Motion Pictures' in K. Frith (ed.) Undressing the Ad: Reading Culture in Advertising, New York: Peter Lang.

Furia Jr., J. (2005) 'Plot Line: Drink Pepsi!', Commercial Alert. www.comercialalert.org/ newsarchive.php?article_id=812&subcategory_id=&category=&year2005&month=10&day =23 (accessed 27October 2005).

Galician, M.-L. (ed.) Handbook of Product Placement in the Mass Media, Binghamton, NY: Best Business Books.

Galligan, A. (2004) 'Truth is Stranger than Magic: The Marketing of Harry Potter', Australian Screen Education (22 June).

Gans, H. (1980) Deciding What's News, London: Constable.

Garnham, N. (1990) Capitalism and Communications, London: Sage.

—— (1997) 'The Media and the Public Sphere' in C. Calhoun (ed) Habermas and the Public Sphere, Cambridge Massachusetts: MIT Press. (First Publ. 1992).

—— (2000) Emancipation, the Media and Modernity, London: Sage.

Gibbons, T. (1992) 'Freedom of the Press: Ownership and Editorial Values', Public Law (Summer): 279-299.

—— (1998) Regulating the Media, Second Edition, London: Sweet & Maxwell.

—— (1999) 'Concentrations of Ownership and Control in a Converging Media Industry' in C. Marsden and S. Verhulst (eds) Convergence in European Digital TV Regulation, London: Sweet & Maxwell.

Gilens, M. and Hertzman, C. (2000) 'Corporate Ownership and News Bias: Newspaper Coverage of the 1996 Telecommunications Act', The Journal of Politics 62:369-386.

Giles, F. (1986) Sundry Times, London: John Murray.

Gill, A. A. (1998a) 'It Cuts Both Ways', The Sunday Times (25 October 1998): 34-35 (Culture).

—— (1998b) 'Shiny Nappy People', The Sunday Times (22 November): 30-31 (Culture section).

Gitlin, T (1997) 'Introduction', E. Barouw et al. Conglomerates and the Media, New York: The New Press.

Glaser, J. (1998) 'Coming Distractions: ABC News Goes to the Movies', Columbia Journalism Review 37: 13-14.

Glencross, D. (1996) 'Television Ownership and Editorial Control' in E.M. Barendt (ed) The Yearbook of Media and Entertainment Law 1996, Oxford: Oxford University Press.

Goggin, G. (2000) 'Pay per Browse? The Web's Commercial Futures' in D. Gauntlett (ed) web.studies: Rewiring Media Studies for the Digital Age, London: Arnold.

Goldberg, D., Prosser, T. and Verhulst, S. (1998a) Regulating the Changing Media: A Comparative Study, Oxford: Oxford University Press.

—— (1998b) EC Media Law and Policy, London: Longman.

Golding, P. and Murdock G. (1996) 'Culture, Communication and Political Economy' in J. Curran and M. Gurevitch (eds) Mass Media and Society, 2nd Edition, London: Arnold.

Golding, P. and Ferguson, M. (eds) (1997) Cultural Studies in Question, London: Sage.

Goldsmith, J. (2003) 'Angry over Cross-promotion', Financial Times, (29 July): 4.

Goldsmiths Media Group (2000) 'Central Issues' in J. Curran (ed) Media Organisations in Society, London: Arnold.

Gomery, D. (1998) 'Hollywood Corporate Business Practices and Periodizing Contemporary Film History' in S. Neale and M. Smith (eds) Contemporary Hollywood Cinema, London: Routledge.

Goodwin, A. (1992) Dancing in the Distraction Factory, Minneapolis: Univ. of Minnesota Press

Goodwin, P. (1998) Television under the Tories: Broadcasting Policy 1979-1997, London: BFI.

Gopsill, T. (1991) 'Anatomy of a whitewash', The Journalist (April), London: NUJ.

Graham, A. and Davies, G. (1997) Broadcasting, Society and Policy in the Multimedia Age, Luton: John Libbey.

Graham, A. et al (1999) Public Purposes in Broadcasting, Luton: Univ. of Luton Press.

Greenslade, R. (1998) 'Basking in the Sun' (21 September) The Guardian (Media)

—— (2003) 'Their Masters's Voice', The Guardian (17 February).

Griffiths, A. (1998) 'Sun puts up £1m gameshow prize', Campaign (4 September).

Guardian, The (1991) 'A Scud for the BBC', Leader, (13 March).

—— (2002) AOL Suffers a Double Blow (July 19): 26.

—— (2008) 'Harry Potter Breaks 400m in Sales' (18 June) http://www.guardian.co.uk/business/2008/jun/18/harrypotter.artsandentertainment, (accessed 20 June 2008).

Guillou, B. (1984) Les stratégies multimedias des groupes de communication, Paris: La Documentation Française.

Gunther, M. (1995) 'All in the Family', American Journalism Review (October). http://findarticles.com/p/articles/mi_hb3138/is_n8_v17/ai_n28661151/?tag=content;co 11 (accessed 6 April 2009)

Gutstein, D. with R. Hackett and NewsWatch Canada (1998) 'Question the Sun!: A Content Analysis of Diversity in the Vancouver Sun Before and After the Hollinger Take-over', Burnaby, BC: School of Communication, Simon Fraser University.

Habermas, J. (1989) [1962] The Structural Transformation of the Public Sphere: An Inquiry into a Category of Bourgeois Society (Trans. T. Burger), Cambridge: Polity Press.

Hackett, R. and Carroll, W. K. (2008) Remaking Media, London: Routledge.

Hackett, R. A. and Uzelman, S. (2003) 'Tracing Corporate Influences on Press Content: A Summary of Recent NewsWatch Canada Research', Journalism Studies, 4 (3): 331-346.

Hackett, R. A. and Gruneau, R. with Gutstein, D. Gibson, T. and NewsWatch Canada (2000) The Missing News: Filters and Blind Spots in Canada's Press, Canadian Centre for Policy Alternatives, Toronto: Garamond Press.

Hackley, C. (2009) 'Is Andy Burnham Right to Ban Product Placement on UK Television?', http://www.rhul.ac.uk/Management/News-and-Events /News /2009/product_placement _hackley.html. (accessed 1 April 2009).

Hall, A. (1998) 'Green's Finger on the Control Button' *The Telegraph* (15 November).

Hallin, D. (2000) 'Commercialism and Professionalism in the American News Media' in J. Curran and M. Gurevitch (eds) *Mass Media and Society*, Third Edition, London: Arnold.

Hallin, D. and Mancini, P. (2004) *Comparing Media Systems*, Cambridge: CUP.

Hamelink, C. (2002) 'The Civil Society Challenge to Global Media Policy' in M. Raboy (ed) *Global Media Policy in the New Millennium*, Luton: University of Luton.

Hamilton, J. (2004) *All the News That's Fit to Sell*, Princeton: Princeton U. Press.

Hancher, L. and Moran, M. (1989) 'Organizing Regulatory Space' in L. Hancher and M. Moran (eds) *Capitalism, Culture and Economic Regulation*, Oxford: Clarendon Press.

Hansard (1989) *Second Reading Debate on Broadcasting Bill*, Vol 164, No. 20: 51 (18 December).

Hansen, A. Cottle, S. Negrine, R. and Newbold, C. (1998) *Mass Communication Research Methods*, Baskingstoke: Macmillan.

Harcourt, A.J. (1996) 'Regulating for Media Concentration: The Emerging Policy of the European Union' (1996) *Utilities Law Review* 202–210.

—— (2005), *The European Union and the Regulation of Media Markets*, Manchester: Manchester University Press.

Hardt, H. (2000) 'Conflicts of Interest: Newsworkers, Media and Patronage Journalism' in H. Tumber (ed) *Media Power, Professionals and Policies*, London: Routledge.

Hardy, J. (2004a) *Convergence and Commercial Speech: The Dynamics and Regulation of Cross-Media Promotion in UK Media*, PhD thesis, Goldsmiths College, Univ. of London.

—— (2004b) 'Safe in Their Hands? New Labour and Public Service Broadcasting', *Soundings*, 27:100–114.

—— (2008a) *Western Media Systems*, London: Routledge.

—— (2008b) 'Ofcom, Regulation and Reform', *Soundings* 39: 76–86.

—— (2009a) 'Advertising Regulation' in H. Powell et al (eds) *The Advertising Handbook*, London: Routledge.

—— (2009b) 'Burnham agrees to keep product placement ban', *Free Press* 169 (March-April), London: CPBF

Hargrave, S. and Lennon, A. (2005) 'Brand Placing Poses a Challenge for TV', *Media Week* (20–27 September): 23–25.

Harris, N. (1992) 'Codes of Conduct for Journalists' in A. Belsey and R. Chadwick (eds) *Ethical Issues in Journalism and the Media*, London: Routledge.

Hart, P. and Hollar, J. (2005) 'Fear & Favor 2004—The Fifth Annual Report,' FAIR. Available at www.fair.org/index.php?page=2486 (Accessed 10 January 2006).

Hatfield, S. (1998a) 'Farewell Fickle Finger', *The Times* (7 August).

—— (1998b) Editor's Comment, *Campaign* (11 September).

—— (1998c) 'Newspapers: The Client from Hell', *The Times* (20 November).

Hawkes, N (1998) 'How Digital Television Works' in *Digital Times, The Times in association with SkyDigital* (1 October): 4–6

Heffernan, R. (2001) *New Labour and Thatcherism*, Basingstoke: Palgrave.

Hein, K. (2003) 'Matrix Reloads', Brandweek, (3 February): 3.

Henry, B. (ed) (1986) British Television Advertising: The First 30 years, London: Century Benham.

Henry, G. (1990) 'BBC Constrained says Checkland' The Guardian (2 March).

Herman, E. (1999) The Myth of the Liberal Media, New York: Peter Lang.

Herman, E. and McChesney, R. (1997) The Global Media, London: Cassell.

Hesmondhalgh, D. (2007) The Cultural Industries, 2nd Edition, London: Sage.

Hickey, N. (1998) 'Money Lust: How Pressure for Profit is Perverting Journalism' Columbia Journalism Review (July/August).

Hiestand, J. (2003) 'Cross-promoton: The Theme for Parks and their Television Relatives', Amusement Business 115 (40): 7.

Hills, J. and Michalis, M. (1997) 'Technological Convergence: Regulatory Competition. The British Case of Digital Television', Policy Studies Vol 18 (3/4).

Hills, M. (2002) Fan Cultures, London: Routledge.

Hitchens, L.P. (1995) "Get Ready, Fire, Take Aim', The Regulation of Cross Media Ownership—An Exercise in Policy Making', Public Law (Winter): 620–641.

—— (1994) 'Media Ownership and Controls: A European Approach' Modern Law Review (57): 585–601.

Hoffmann-Riem, W. (1996a) Regulating Media: the Licencing and Supervision of Broadcasting in Six Countries, New York: Guilford Press.

—— (1996b) 'New Challenges for European Multimedia Policy: A German Perspective', European Journal of Communication Vol 11(3): 327–346.

Hofmeister, S. (1994) 'In the Realm of Marketing the Lion King Rules', New York Times (12 July): 1(C).

Hoggart, P. (1998) 'All Square Eyed' in Digital Times, The Times (1 October): 7

Hollar, J., Jackson, J. and Goldstein, H. (2006) Fear & Favor 2005, New York: FAIR. Available at http://www.fair.org/index.php?page=2848 (accessed 11 January 2008)

Home Office (1978) Broadcasting, Cmnd.7294, London: HMSO

—— (1988) Broadcasting in the '90s: Competition, Choice and Quality, CM517, London: HMSO.

Horsman, M. (1998) Sky High: The Amazing Story of BSkyB—And the Egos, Deals and Ambitions that Revolutionised TV Broadcasting, London: Orion Business Books.

Horwitz, R (1989) The Irony of Regulatory Reform, NewYork: Oxford University Press.

House of Lords Select Committee on Communications (2007) 'Minutes of the Visit to New York and Washington DC', 16–21 November 2007.

—— (2008) The Ownership of the News, Volume I: Report, HL Paper 122–I, London: The Stationery Office.

Hoynes, W. (2002) 'Why media mergers matter' (16 January), Open Democracy (www.opendemocracy.net/debates/article.jsp?id=8&debaateId=24&articleId=47) (accessed 18 January 2002)

Hoyt, M. (2000) 'With 'Strategic Alliances' the Map Gets Messy', Columbia Journalism Review (January/February).

Huang, J.S. and Heider, D. (2007) 'Media Convergence: A Case Study of a Cable News Station', The International Journal of Media Management, 9 (3): 105–155.

Humphreys, P. (1996) Mass Media and Media Policy in Western Europe, Manchester Univ. Press.

—— (2000) 'Regulating for Pluralism in a Digital Age' in T. Lees, S. Ralph, J. Langham Brown (eds) *Is Regulation Still an Option in a Digital Universe?*, Luton: University of Luton Press.

Investors Chronicle (2001) 'Multimedia Magic' (30 November): 38 (Global View).

Iosifides, P (1997) 'Methods of Measuring Media Concentration', *Media Culture and Society*, 19 (4): 643–663.

IPC (2000) IPC Submission to the Consultation on the Communications White Paper, 12 July, London: DCMS

ITC (Independent Television Commission) (1992) 'Advertising by Competing Broadcasters', *News* (17 December), London: ITC.

—— (1996) Review of ITV code of Programme Sponsorship, Explanatory Memorandum (20 September), London: ITC.

—— (1997a) 'BSkyB Can Cross-Promote Pay-Per-View Services, ITC Decides', *News* (23 December) London: ITC.

—— (1997b) *Annual Report and Accounts 1996*, London: ITC.

—— (1997c) Advertising Guidance Note No.11. Services Ancillary to Programmes Included in Channel 3, 4 and 5 Services, London: ITC

—— (1998a) *Annual Report and Accounts 1997*, London: ITC.

—— (1998b) 'ITC Announces End of Channel 3 and Channel 4 Cross-Promotion', *News* (14 April) , London: ITC.

—— (1998c) *The ITC Code of Advertising Standards and Practice*, London: ITC.

—— (1998d) *ITC Programme Code*, London: ITC.

—— (1998e) *ITC Code of Programme Sponsorship*, London: ITC.

—— (1998f) *ITC Rules on the Amount and Scheduling of Advertising*, London: ITC.

—— (1998g) *Consolidated Statement of ITC Rules on Cross-promotion of Digital Television Services*, London: ITC.

—— (1998h) 'ITC Consolidates Guidance on Cross-promotion of Digital Television Services' News release (5 October), London: ITC

—— (1998i) *TARIS Trends in Television, October 1998*. Produced for the ITC by Taylor Nelson Sofres plc, London: ITC.

—— (1998j) 'Revised ITC Code Clears Way for Masthead on all Commercial Channels' (20 July).

—— (1998k) 'ITC Requires ITV Promotions for Digital to be Pulled' (20 November).

—— (1999a) *ITC Competition Policy Procedures: Consultation Document*, London: ITC.

—— (1999b) *Looking Forward 2000*, London: ITC.

—— (1999c) *Television Audience Share Figures* , (27 January), London: ITC.

—— (1999d) 'Unreasonable Discrimination against BSkyB', Advertising Complaints reports, March, London: ITC.

—— (2000a) *The ITC Code of Programme Sponsorship* (draft for consultation), Autumn, London: ITC.

—— (2000b) *Communications Reform White Paper. ITC Response*, London: ITC.

—— (2000c) 'ITC Consults on a Light Touch Approach to the Regulation of Interactive Services', (29 February), London: ITC.

—— (2000d) 'Guidance Note on Aspects of Undue Prominence' in *ITC Programme Complaints and Findings Report*, November, London: ITC.

—— (2001a) *Consultation Paper on Cross-Promotion in Commercial Television*, London: ITC.

—— (2001b) *Second ITC Consultation on the Promotion of Programmes, Channels and Related Services on Commercial Television*, London: ITC.

—— (2001c) 'ITC Invites Comments on Proposed Guidelines on Cross-promotion' (3 May) London: ITC.

—— (2001d) *ITC Annual Report and Accounts 2000*, London: ITC.

—— (2001e) *The ITC Programme Code*, London: ITC

—— (2002a) *New ITC Rules on the Promotion of Programmes, Channels and Related Services on Commercial Television*, London: ITC.

—— (2002b) 'ITC Publishes New Rules on the Promotion of Programmes, Channels and Related Services on Commercial Television' News release (15 January), London: ITC.

—— (2002c) *The Programme Code*, London: ITC.

—— (2002d) *Annual Report and Accounts for 2001*, London: ITC.

ITV (1963) *Annual Review*, London: ITV.

—— (2004) *Submission to Ofcom Consultation on Product Placement*, London: Ofcom.

ITV Network (2001) *Submission to ITC Consultation on Cross-Promotion*, London: ITC.

Jackson, A. (1998) 'Coldcall' *The Times* (3 October): 8.

Jackson, J. and Hart, P. (2002) Fear & Favor 2001 ~ The Second Annual Report, Extra! March/April, New York: FAIR. Available at http://www.fair.org/index.php?page=2044 (accessed 11 January 2008)

Jackson, J. Hart, P and Coen, R. (2003) Fear and Favor 2002 – The Third Annual Report, Extra! March/April, New York, FAIR. Available at http://www.fair.org/index.php?page=1130 (accessed 11 January 2008)

James, S. (1997) *British Government: A Reader in Policy Making*, London: Routledge.

Jempson, M. (ed) (1993) *Report of Special Parliamentary Hearings on Freedom and Responsibility of the Press*, Bristol: Crantock Communications.

Jenkins, H. (2002) 'Interactive Audiences?' in D. Harries (ed) *The New Media Book*, London: BFI

—— (2006) *Convergence Culture*, New York: New York University Press.

Jensen, E. (2001) 'Headline News Faces Criticism for Channeling Viewers', *Los Angeles Times* (20 August) F5:1.

Jin, D.Y. (2008) 'Neoliberal restructuring of the global communication system: mergers and acquisitions', *Media, Culture and Society*, 30 (3): 357-371.

Johnson, B. (1998) 'The Goldfinger on Digital TV's Button', *The Telegraph* (28 September):36.

Joint Committee on The Draft Communications Bill (2002) Note by the Bill Team on Competition Law and the BBC (May). Available at http://www.publications.parliament.uk/pa/jt200102/jtselect/jtcom/169/2070804.html (accessed 10 May 2003).

Jowell, T. (2003) Speech to Westminster Media Forum (30 April). http://www.culture.gov.uk/press_notices/archive_2003/speech_wmf.htm (accessed 10 May 2003)

Jung, J. (2001) 'The Influence of Media Ownership on News Coverage. A Case of CNN's Coverage of Movies', AEJMC annual meeting Washington, DC (ERIC Document Reproduction Service No ED 459 505).

Kaitatzi-Whitlock, S. (1996) 'Pluralism and Media Concentration in Europe: Media Policy as Industrial Policy' in *European Journal of Communication* 11 (4): 453-83.

Kane, F (2002) 'Press Gangs up Against Bungling Bill' *The Observer* (8 December)

Keane, J. (1991) *The Media and Democracy*, Cambridge: Polity Press.

—— (1998) *Civil Society: Old Images, New Visions*, Cambridge: Polity Press.

Keeble, R. (2001) *Ethics for Journalists*, London: Routledge.

Kelso, P. (2000) 'TV Ad Breaks 'Over the Limit'' *The Guardian* (24 August).

Kilby, N. (2006) 'Product Placement: Who Wants to be a Player?', *Marketing Week* (2 March): 30.

Kiley, S. (2001) 'The Middle East's War of Words', *The Evening Standard* (5 September).

King, A. (1998) 'Thatcherism and the Emergence of Sky Television', *Media, Culture and Society* 20: 277-293.

Kirpatrick, D. (2003) 'Merchandisers Try to Harness Harry Potter's Magic', *The New York Times* (16 June): 9.

Klein, N. (2000) *No Logo*, London: Flamingo.

Kline. S. (1995) *Out of the Garden: Toys and Children's Culture in the Age of TV Marketing*, London: Verso.

Kristeva, J. (1980): *Desire in Language*, New York: Columbia University Press.

Kuhn, R. (2007) *Politics and the Media in Britain*, Basingstoke: Palgrave.

Kunkel, D. (1988) 'From a Raised Eyebrow to a Turned Back: The FCC and Children's Product-Related Programming', *Journal of Communication* 38 (4): 197-209.

Kunz, W.M. (2007) *Culture Conglomerates*, Lanham, Maryland: Rowman and Littlefield.

Lange, A. and Van Loon, A. (1991) *Pluralism, Concentration and Competition in the Media Sector*, Strasbourg: CoE.

Lasar, M. (2008) 'Reform Groups Want FCC to Take on Product Placement Epidemic', *Ars Technica* (22 June). Available at http://arstechnica.com/old/content/2008/06/reform-groups-want-fcc-to-take-on-product-placement-epidemic.ars (accessed 25 April 2009).

Lee, S. (2008) 'Product Placement in the United States: A Revolution in Need of Regulation', *Cardoza Arts and Entertainment*, 26: 203-232.

Lee, T. and Hwang, H. F. (1997) 'The Impact of Media Ownership—How Time and Warner's Merger Influences *Time*'s content', Chicago AEJMC (ERIC Document Reproduction Service No ED 417 448).

Leggatt, T. (1993) 'The Sponsorship of Television Programmes' in Sir R. Shaw (ed) *The Spread of Sponsorship in the Arts, Sports, Education, The Health Service and Broadcasting*, Newcastle: Bloodaxe.

Lehu, J.-M. (2009) *Branded Entertainment*, London: Kogan Page.

Leiss, W. Kline, S. and Jhally, S. (1997) *Social Communication in Advertising*, 2nd edition, New York: Routledge.

Letwin, S. (1992) *The Anatomy of Thatcherism*, London: Fontana.

Levy, D. (1999) *Europe's Digital Revolution*, London: Routledge.

Leys, C. (2001) *Market-Driven Politics: Neoliberal Democracy and the Public Interest*, London: Verso.

Lichtenberg, J. (ed.) (1990) *Democracy and the Mass Media*, Cambridge: Cambridge Univ. Press.

Lister, M. et al. (2009) *New Media: A Critical Introduction*, London: Routledge.

Littlejohn, R. (1998) 'Richard Littlejohn', *The Sun* (11 September): 11.

Livingstone, S., Van Couvering, E. and Thumim, N. (2005) *Adult Media Literacy*, London: London School of Economics.

Los Angeles Times (1999) 'To our readers', *Los Angeles Times*, (19 December) (accessed 5 January 2000).

Lowrey, W. (2004) "Everyone Else Has a TV Weatherman on the Weather page': Institutional Isomorphism and Commitment to Newspaper-TV Partnering', AEJMC annual convention, Toronto, August.

MacLeod, V. (ed) (1996) *Media Ownership and Control in the Age of Convergence*, London: IIC.

Macpherson, C. (1985) [1962] *The Political Theory of Possessive Individualism*, Oxford: OUP.

Makkai. T. and Braithwaite J. (1995) 'In and Out of a Revolving Door: Making Sense of Regulatory Capture', *Journal of Public Policy*, 1 61-78.

Maltby, R. (1998) 'Nobody Knows Everything: Post-Classical Historiographies and Consolidated Entertainment' in S. Neale and M. Smith (eds.) *Contemporary Hollywood Cinema*, London: Routledge.

Mandese, J. (1997) 'Ad Efficiencies Often Thicker Than Blood', *Advertising Age* 12 May (s30).

Manning, P. (2000) *News and News Sources :A Critical Introduction*, London: Sage.

Marketing (2006) 'Ofcom under Carter', (9 August): 26.

Marsden, C. (1999) 'Judicial Review of UK Commercial Terrestrial TV Ownership: Shotgun Marriage and Divorce in a Very British Affair', *Utilities Law Review* 10 (3) (May-June).

Marsden, C. and Verhulst, S. (eds) (1999) *Convergence in European Digital TV Regulation*, Blackstone Press.

Marshall P.D. (2002) 'The New Intertextual Commodity' in D. Harries (ed) *The New Media Book*, London: BFI.

—— (2004) New Media Cultures, London: Arnold.

Martinson. J. (1999) 'Sleeping with the Enemy', *The Guardian*, (22 November).

—— (2001) 'Three-in-a-bed is Standard Procedure', *The Guardian* (19 February) (New Media).

Masters, G. (2003) 'Characters Sell', *Retail Merchandiser* (1 June) 43 (6): 45-46.

Mattelart, A. (1991) [1989] *Advertising International: The Privatisation of Public Space*, (trans. M. Channan), London, Routledge.

May, D. (1990) 'Sadler—A Rose Caught between Two Thorns', *Campaign* (29 June).

McAllister, M. (1996) *The Commercialization of American Culture: New Advertising Control and Democracy*, Thousand Oaks, CA: Sage.

—— (2000) 'From Flick to Flack: The Increased Emphasis on Marketing by Media Entertainment Corporations' in R. Andersen and L. Strate, (eds) *Critical Studies in Media Commercialism*, Oxford: Oxford University Press.

—— (2002) 'Television News Plugola and the Last Episode of *Seinfeld*', *Journal of Communication*, 52 (2): 383-401.

—— (2005) 'Selling *Survivor*: The Use of TV News to Promote Commercial Entertainment' in A. N. Valdivia (ed) *A Companion to Media Studies*, Oxford: Blackwell.

McCall, A. (1997) *Masthead Television*, FT Management Report, London: FT Media.

McCall, A. and Carter, M. (1998) *The Campaign Guide to Advertiser-Supported TV Production*, Haymarket Management Reports, London: Haymarket Business Publications.

McChesney, R (1993) *Telecommunications, Mass Media and Democraccy: The Battle for the Control of U.S. Broadcasting, 1928-1935,* New York: Oxford University Press.

—— (1997) *Corporate Media and the Threat to Democracy,* New York: Open Media/Seven Stories.

—— (1998) 'The Political Economy of Global Communication' in R. McChesney, E. M Wood and J.B. Foster (eds) *Capitalism and the Information Age: The Political Economy of the Global Communication Revolution,* New York: Monthly Review Press.

—— (1999) *Rich Media, Poor Democracy: Communication Politics in Dubious Times,* Urbana: University of Illinois Press.

—— (2000) 'The *Titanic* Sails On–Why the Internet Won't Sink the Media Giants', *EXTRA!,* Journal of FAIR (March-April).

—— (2002) 'The Global Restructuring of Media Ownership' in M. Raboy (ed) *Global Media Policy in the New Millennium,* Luton: University of Luton Press.

—— (2004) *The Problem of the Media,* New York: Monthly Review Press.

—— (2007) *Communication Revolution,* New York: The New Press.

—— (2008) *The Political Economy of Media,* New York: Monthly Review Press.

McGinnis, M.J., Gootman, J.A. and Kraak, V. I. (eds) (2005) *Food Marketing to Children and Youth: Threat or Opportunity?,* Washington: Institute of Medicine.

McGuigan, J. (1992) *Cultural Populism,* London and New York: Routledge.

—— (1996) *Culture and the Public Sphere,* London: Routledge.

—— (1998) 'What Price the Public Sphere?' in D.K. Thussu (ed.) *Electronic Empires: Global Media and Local Resistance,* London: Arnold.

McLaughlin, C. (2003) Letter to the Editor, *Financial Times* (1 April).

McLean, S. (1998) 'Digital: The Reason for, and Answer to, All My Problems', Digital Times, *The Times* (1 October): 18-19.

McManus, J. (1994) *Market-driven Journalism: Let the Citizen Beware?,* Thousand Oaks, CA: Sage.

McQuail, D. (1977) *Analysis of Newspaper Content. Report for Royal Commission on the Press,* Cmnd. 6810-4. London: HMSO.

—— (1987) *Mass Communication Theory,* 2nd edition, London: Sage.

—— (1992) *Media Performance,* London: Sage.

—— (1994) *Mass Communication Theory: An Introduction,* 3rd edition. London: Sage.

—— (1997) 'Policy Help Wanted: Willing and Able Culturalists Please Apply' in P. Golding and M. Ferguson (eds) *Cultural Studies in Question,* London: Sage.

McQuail, D. and Siune, K. (1992) 'Wake up, Europe!' in K. Suine and W. Truetzschler (eds) *Dynamics of Media Politics: Broadcast and Electronic Media in Western Europe,* London: Sage.

McQuail, D. and Siune, K. (eds) (1998) *Media Policy: Convergence, Concentration and Commerce,* London: Sage.

McQuail, D. and Windalh, S. (1981) *Communication Models,* London: Longman.

Meech, P. (1999) 'Television Clutter–The British Experience', *Corporate Communications: An International Journal,* Vol 4, No1: 37-42.

Meehan, E. (1991) '"Holy Commodity Fetish, Batman!": The Political Economy of a Commercial Intertext' in R.E. Pearson and W. Uricchio (eds) *The Many Lives of the Batman: Critical Approaches to a Superhero and his Media,* New York: Routledge.

—— (2005) *Why TV Is Not Our Fault,* Lanham, MD: Rowman and Littlefield.

Meenaghan, D. 1998 'Current Developments and Future Direction in Sponsorship', *International Journal of Advertising*, Vol. 17, No 1: 3–28.

Meier, W. and Trappel, J. (1998) 'Media Concentration and the Public Interest' in D. McQuail and K. Siune (eds) (1998) *Media Policy*, London: Sage.

Merril, J. (1974) *The Imperatives of Freedom*, New York: Hastings House.

Michael, J. (1990) 'Regulating Communications Media: From Discretion of Sound Chaps to the Arguments of Lawyers' in M. Ferguson (ed) *Public Communication*, London: Sage.

Midgley, C. (1998) 'Sofa, So Good, for the Duchess of Talk', *The Times* (3 October): 3 (5LL).

Mill, J. S. (1998) [1859] *On Liberty*, Edited by J.Gray, Oxford: Oxford University Press.

Miller, D. (1994) *Don't Mention the War*, London: Pluto Press.

Miller, M.C. (1990) 'Advertising: End of Story' in M.C. Miller (ed) *Seeing Through Movies*, New York: Pantheon Books.

Mirror, The (1998a) 'TV Rivals Won't Reach for the Sky' (29 September): 32.

—— (1998b) 'Fergie: An Apology' (9 October): 17.

Mitchell, A. (1996) 'Evolution', *Marketing Business* (October): 38.

Monopoly and Mergers Commission (1985) *The British Broadcasting Corporation and Independent Television Publications Limited*, Cmnd. 9614. London: HMSO.

—— (1992) *Television Broadcasting Services*, Cm. 2035, London: HMSO.

Morley, D. (1995) 'Theories of Consumption in Media Studies' in D. Miller (ed) *Acknowledging Consumption: A Review of New Studies*, London: Routledge.

Morris, N. (1998) 'Murdoch Anger at Man United Probe', *The Mirror* (31 October): 2.

Mosco, V. (1996) *The Political Economy of Communication*, London: Sage.

Mosco, V. (2009) *The Political Economy of Communication*, 2nd Edition, London: Sage.

Mosco, V. and Reddick, A. (1997) 'Political Economy, Communication and Policy' in M. Bailie, D. Winseck and S. Yoon (eds) *Democratizing Communication?*, Cresskill, NJ: Hampton Press.

Munro, C. (1997) 'Self-regulation in the Media', *Public Law*, Spring, 6.

Murdoch, R. (1998) 'You've Got to Follow the Money—A Joint Venture in Europe is the Way Forward', *The Times* (27 November): 43.

Murdock, G. (1989) 'Critical Enquiry and Audience Activity' in B. Dervin, L. Grossberg, B. J. O'Keefe and E. Wartella (eds) *Rethinking Communication, Volume 2: Paradigm Exemplars*, Newbury Park: Sage.

—— (1990) 'Redrawing the Map of the Communications Industries: Concentration and Ownership in the Era of Privatization' in M. Ferguson (ed) *Public Communication*, London: Sage.

—— (1992a) 'Embedded Persuasions: The Fall and Rise of Integrated Advertising' in D. Strinati and S. Wagg (eds) *Come on Down?*, London: Routledge.

—— (1992b) 'Citizens, Consumers, and Public Culture' in I. M. Skovmand and K.C. Schroder (eds) *Media Cultures: Reappraising Transnational Media*, London: Routledge.

—— (2000) 'Digital Futures: European Television in the Age of Convergence' in J. Wieten, G. Murdock, P. Dahlgren (eds) *Television Across Europe: A Comparative Intoduction*, London: Sage.

—— (2003) 'Back to Work: Cultural Labor in Altered Times' in A. Beck (ed) *Cultural Work: Understanding the Cultural Industries*, London: Routledge.

Murdock, G. and Golding, P. (2005) 'Culture, Communications and Political Economy' in J Curran and M. Gurevitch (eds) *Mass Media and Society*, London: Hodder Arnold.

Murray, S. (2001) 'Media Convergence's Third Wave: Content Streaming', paper given at Public Right to Know conference, Australian Centre for Independent Journalism at UTS, Sydney, 26–28 October, http://acij.uts.edu.au/pr2k/murray.html (accessed 17 May 2002).

—— (2002) 'Harry Potter, Inc. Content Recycling for Corporate Synergy', M/C 5 (4). Available at http://journal.media-culture.org.au/0208/recycling.php (accessed 1 Feb 2003).

Nava, M., Blake, A., MacRury, I., Richards,B. (eds) (1997) *Buy This Book*, London: Routledge.

Negrine, R. (1994) *Politics and the Mass Media in Britain*, London: Routledge, 2nd Edition.

Negroponte, N. (1995) *Being Digital*, London: Hodder and Stoughton.

Negus, K. (1997) 'The Production of Culture' in P. Du Gay (ed) *Production of Culture/Cultures of Production*, London: Sage.

Neil, A. (1989) Speech by Andrew Neil, Executive Chairman, Sky TV to Seminar on Satellite Communications of The English Speaking Union of the Commonwealth (19 July).

—— (1997) *Full Disclosure*, 2nd Edition, London: Pan Books.

NERA (1991) 'The Sadler Enquiry: Competition and Entry Conditions in the TV and National Newspaper Industries' in J. Sadler *Enquiry into Standards of Cross Media Promotion*, Cm1436. London: HMSO.

New Media Markets (1998) 'Newspapers Slow to Give ONdigital Listings' (26 November).

Newell, J., Salmon, C.T. and Chang, S. (2006) 'The Hidden History of Product Placement', *Journal of Broadcasting & Electronic Media*, 50(4), 575–594.

News Corporation (1989) *Annual Report*, New York: News Corporation.

News International (1989) *Competition, Diversity and Cross-Media Ownership. A Response to BSB's Joint Memorandum*, London: News International Plc.

—— (2000) *Response to Invitation for Comments on the Communications Reform White Paper*, London: News International Plc.

Newspaper Publishers' Association, Newspaper Society, Scottish Daily Newspaper Society, Scottish Newspaper Publishers' Association and Periodical Publishers Association (1994) *Cross-Media Promotion Code*, London: Newspaper Society.

Newspaper Society (1994) 'Publishers Unite to Launch Cross-media Promotion Code' (18 May).

Nicol, A., Millar, G. and Sharland, A. (2001) *Media Law and Human Rights*, London: Blackstone.

Nielsen (2007) 'Harry Potter Charms the Entertainment Industry' *PR Newswire US* (10 July).

Nozick, R. (1974) *Anarchy, State and Utopia*, New York: Basic Books.

Nua (2000) 'Newspapers Adapt to the Web' Report (1 September). Available at www.nua.

O'Carroll, L and McGurran, A. (1998) 'It's a disgrace', *The Mirror* (16 October): 4–5

O'Malley, T. (1994) *Closedown? The BBC and Government Broadcasting Policy, 1979–92*, London: Pluto Press.

—— (1997) 'Labour and the 1947-9 Royal Commission on the Press' in M. Bromley and T. O'Malley (eds) *A Journalism Reader*, London: Routledge.

—— (1998) 'Demanding Accountability: The Press, the Royal Commissions and Pressure for Reform, 1945-77' in H. Stephenson and M.Bromley (eds) *Sex, Lies and Democracy: The Press and the Public*, London: Longman.

O'Malley, T. and Soley, C. (2000) *Regulating the Press*, London: Pluto Press.

O'Sullivan, T., Dutton, B. and Rayner, P. (1998) *Studying the Media*, London: Arnold.

OECD (1993) *Competition Policy and the Changing Broadcast Industry*, Paris: OECD.

Ofcom (2005a) *Annual Report 2004/5*, London: Ofcom.

—— (2005b) *The Ofcom Broadcasting Code*, London: Ofcom.

—— (2005c) *Communications Market 2005*, London: Ofcom.

—— (2005d) *Product Placement: A Consultation*, London: Ofcom.

—— (2005e) *Television promotions - what the viewers think'*, a report of the key findings of a qualitative and quantitative study, London: Ofcom.

—— (2005f) *Analysis of current promotional activity on television. A report of the key findings of a content analysis study*, London: Ofcom.

—— (2005g) *Review of the cross promotion rules: consultation document*, London: Ofcom.

—— (2006a) *Review of the cross-promotion rules: Statement*, London: Ofcom.

—— (2006b) *Cross-promotion Code*, London: Ofcom.

—— (2006c) *Summary of responses to consultation on issues relating to product placement*, London: Ofcom. October.

Office of Fair Trading (OFT) (1996) *The Director General's Review of BSkyB's Position in the Wholesale Pay TV Market*, London: OFT.

Oftel (Office of Telecommunications) (1997) Submission to the ITC on Competition Issues Arising from the Award of Digital Terrestrial Television Multiplex Licences, London: OFTEL.

Olson, S. (1987) 'Meta-Television: Popular Postmodernism' in *Critical Studies in Mass Communication*, Vol. 4, No.31: 284–300

Ono K. A. and Buescher, D. T. (2001) 'Deciphering Pocahontas: Unpacking the Commodification of a Native American Woman', *Critical Studies in Media Communication*, 18 (1): 23–43.

Paul, N. (1985) *Principles for the Press: A Digest of Press Council Decisions 1953–1984*, London: The Press Council.

PCC (Press Complaints Commission) (2009) *Editor's Code of Practice*, London: PCC.

Pew Research Centre, Project for Excellence in Journalism (PEJ) (2001) *Before And After: How The War on Terrorism Has Changed The News Agenda* (November). Available at http://www.journalism.org/node/299 (accessed 19 December 2001)

—— (2002) *Local TV News Project 2002*. http://www.journalism.org/node/225 (Accessed 15 May 2006).

Peterson, T. (1963) [1956] 'The Social Responsibility Theory' in F. S. Siebert et al. *Four Theories of the Press*, Univ. of Illinois Press.

Petley, J. (1997) 'No Redress from the PCC', *British Journalism Review*, 8 (4).

—— (1999) 'The Regulation of Media Content' in J. Stokes and A. Reading (eds) *The Media in Britain*, Basingstoke: Macmillan Press.

Petley, J. and Romano, G. (1993) 'After the Deluge: Public Service Television in Western Europe' in T. Dowmunt (ed) *Channels of Resistance*, London: BFI.

Pew Research Centre and Columbia Journalism Review (2000) *Journalists Avoiding the News. Self-Censorship: How Often and Why*, Pew Research Centre. http://people-press.org/report/39/ (accessed 5 May 2000).

Pfanner, E. (2005) 'Product placements Cause a Stir in Europe', *International Herald Tribune*, (3 October).

Pilkington Committee on Broadcasting (1962) *Report of the Committee on Broadcasting*, Cmnd. 1753, London: HMSO.

Poniewozik, J. (2001) 'This Plug's for you', *Time* (18 June): 76.

Porter, H (1998) 'Mandelson makes it look good' *The Telegraph* (1 Nov): 34.

POST (Parliamentary Office of Science and Technology) (2001) *E is for Everything? Public Policy and Converging Digital Communications, Report 170*, London: POST.

Potter, B. (1998) 'Granada sells direct share holding in BSkyB', *The Telegraph* (14 October): 29.

Potter, J. (1989) *Independent Television in Britain. Vol 3: 1968–1980*, Basingstoke: Macmillan.

Powell, H., Hardy, J, Hawkin, S. and MacRury, I. (eds) (2009) *The Advertising Handbook*, 3rd Edition, London: Routledge.

PQ Media (2005) *Product Placement Spending in Media*, Stamford, CT: PQ Media.

Prebble, S, (2001) Speech, reproduced in *The Independent* (26 June).

Preston, P. (2000) 'Bad News. The Net Boys Have No Interest in Real News', *The Guardian* (17 January).

Price, C. J. (1998) 'Does Power Change the News? A Content Analysis of Network News Coverage of the Telecommunications Act 1996', Paper presented in the News Division at the Broadcast Education Association meeting, Las Vegas.

—— (2003) 'Interfering Owners or Meddling Advertisers: How Network Television News Correspondents Feel About Ownership and Advertiser Influence on News Stories', *Journal of Media Economics*, 16 (3) 175–188.

Price, M.E. and Weinberg, J. (1996) 'United States' (2) in V. MacLeod (ed) *Media Ownership and Control in the Age of Convergence*, London: International Institute for Communications.

PriceWaterhouseCoopers (2009) *Insights. Entertainment & Media Analysis and Trends in US M&A Activity 2009*, http://www.pwc.com/extweb/pwcpublications.nsf/docid/ 6B9511900FF64 CFF8525755A005B9328/ $File/TS_insights_EM_US_2009.pdf (accessed 16 June 2009).

Private Eye (1998a) 'Street of Shame', 946 (20 March): 6.

—— (1998b) 'Plugged In', 962, (30 October): 6.

—— (1998c) 'Eye TV', 965, (11 December): 12.

Proffitt, J. M., Yune Tchoi, D., McAllister, M. (2007) 'Plugging Back into The Matrix: The Intertextual Flow of Corporate Media Commodities', *Journal of Communication Inquiry*, 31 (3): 239–254.

PROMAXBDA (2009) 'About PROMAXBDA'. Available at http://www.promaxbda.org/ about.asp?n=promaxbda (accessed 16 May 2009).

Prosser, T. (1997) *Law and the Regulators*, Oxford: Clarendon Press.

Purnell, J. (2005) Speech of James Purnell, UK Minister for Broadcasting at 'Between Culture and Commerce' conference, Liverpool, 22 September. Available at http://ec.europa.eu/ avpolicy/reg/history/consult/liverpool_2005/index_en.htm.

Raboy, M. (ed) (2002) *Global Media Policy in the New Millennium*, Luton: Univ. of Luton Press.

Ramsay, I. (1996) *Advertising, Culture and the Law*, London: Sweet & Maxwell.

Randall, D. (1996) *The Universal Journalist*, London: Pluto.

Rappleye, C. (1998) 'Cracking the Church-State Wall: Early Results of the Revolution at the *Los*

Angeles Times', *Columbia Journalism Review* (January/February).

Reding, V. (2008) Letter to Secretary of State Rt Hon Andy Burnham, (11 December). http://www.culture.gov.uk/reference_library/foi_requests/6020.aspx (accessed 17 April 09).

Reding, V. (2008) *Letter to Rt Hon Andy Burnam MP*, London: DCMS.

Reid, A. (2001) 'Is Channel 4 Over-egging Its Position in Digital TV', *Campaign* (11 May): 18.

Revoir, P. (2003) 'ITV Digital "Never Stood a Chance"', *Broadcast* (20 June): 3.

Riedman, P. (2001) 'Advertorial Seeps into Search Sites. Paid Listings on Results Pages are Becoming the Norm', *Advertising Age*, Feb.

Robertson, G. (1983) *People Against the Press*, London: Quartet.

Robertson, G. and Nicol, A. (1984) *Media Law*, London: Sage.

—— (2002) *Media Law*, London: Penguin.

Robinson, B. (1995) 'Market Share as a Measure of Media Concentration' in T. Congdon et al. *The Cross Media Revolution: Ownership and Control*, Luton: John Libbey.

Rooney, D (2000) 'Thirty Years of Competition in the British Tabloid Press: The *Mirror* and the *Sun* 1968-1998' in C. Sparks and J. Tulloch (eds) *Tabloid Tales: Global Debates over media standards*, Lanham, Maryland: Rowman and Littlefield.

Royal Commission on the Press 1947-1949 (1949) Cmnd 7700, London: HMSO.

Royal Commission on the Press 1961-62 (1962) Cmnd 1811, London: HMSO.

Royal Commission on the Press 1974-1977 (1977) Cmnd 6810, London: HMSO.

Sadler, J. (1991) *Enquiry into Standards of Cross Media Promotion: Report to the Secretary of State for Trade and Industry*, Cm1436. London: HMSO.

—— (2002) Interview with the author (20 November)

Sánchez-Tabernero, A. Denton, A., Lochon, P.-Y., Mounier, P., Woldt, R. (1993) *Media Concentration in Europe*, Dusseldorf: European Institute for the Media.

Sánchez-Tabernero, A. and Carvajal, M. (2002) *Media Concentration in the European Market*, Universidad de Navarra.

Scanlon. T. M. (1990) 'Content Regulation Reconsidered' in J. Lichtenberg (ed) *Democracy and the Mass Media*, Cambridge: Cambridge University Press.

Schatz, A. (2005) 'FCC's Adelstein Talks Product Placement', *The Wall Street Journal* (8 June).

Schatz, T. (1997) 'The Return of the Hollywood Studio System' in Barnouw, E. et al, *Conglomerates and the Media*, New York: The New Press.

Schiller, D. (2000) *Digital Capitalism*, Cambridge, MA: MIT Press.

Schiller, H. (1989) *Culture Inc. The Corporate Takeover of Public Expression*, Oxford: OUP.

—— (1996) 'United States' in V. MacLeod (ed) *Media Ownership and Control in the Age of Convergence*, London: IIC.

Schudson, M. (2000) 'The Sociology of News Production Revisited (Again)' in J. Curran and M. Gurevitch (eds) *Mass Media and Society*, 3rd edition, London: Arnold.

Scott, B. (2005) 'A Contemporary History of Digital Journalism', *Television and New Media* 6 (2): 89-126.

Seaton, J. (1998) 'A Fresh Look at Freedom of Speech' in J. Seaton (ed.) *Politics and the Media*, Oxford: The Political Quarterly.

Seitz, M. Z. (2000) 'Strange Bedfellows: Journalism in the Shadow of Synergy, *The Star-Ledger* (Newark, New Jersey), Spotlight (12 November):1.

Sendall, B. (1982) *Independent Television in Britain. Volume 1: Origin and Foundation, 1946–62*, London: Macmillan.

Sepstrup, P. (1986) 'The Electronic Dilemna of Television Advertising', *European Journal of Communication* Vol 1: 383–405.

Seymour-Ure, C. (1987) 'Media Policy in Britain: Now You See It, Now You Don't', *European Journal of Communication* 2: 269–288.

—— (1991) *The British Press and Broadcasting since 1945*, Oxford: Blackwell.

Shaw, D. (1999) 'Special Report: Crossing the Line', *Los Angeles Times* (December 20): V1

Shawcross, W. (1997) *Murdoch: The Making of a Media Empire*, New York: Simon and Schuster.

Shoemaker, P. J. and Reese, S. D. (1996) *Mediating the Message*, New York: Longman.

Siegel, P. (2004) 'Product Placement and the Law' in M.-L.Galician (ed.) *Handbook of Product Placement in the Mass Media*, Binghamton, NY: Best Business Books.

Singer, J. (2004) 'Strange Bedfellows? The Diffusion of Convergence in Four News Organizations, *Journalism Studies*, (5) 1: 3–18.

Siune, K. and Truetzschler, W. (eds) (1992) *Dynamics of Media Politics*, London: Sage.

Smith, A. (1776) *An Inquiry into the Nature And Causes of the Wealth of Nations*. Available at http://www.adamsmith.org/smith/won-intro.htm (accessed 19 December 2009)

Smith, A. (1991) *The Age of Behemoths*, New York: Priority Press.

Smith, C. (1999) Speech to Royal Television Society Conference, 17 September 1999. Available at www.digitaltelevision.gov.uk/press_notices/cdms245_99.html (Accessed 23 July 2002).

—— (2005) Editorial, *Marketing* (2 June).

Smulyan, S. (2001) *Selling Radio: The Commercialization of American Broadcasting, 1920–1934*, Washington, DC: Smithsonian Institution Press.

Snoddy, R. (1989) 'Evidence to Be Called on Cross-media Promotions', *Financial Times* (16 December): 4.

—— (1990) 'Media Promotion Inquiry Will Look into Ownership', *Financial Times* (3 March): 4.

—— (1991) 'Publishers Plan to Sue Over BBC's Advertising' *Financial Times* (12 April):7.

—— (1992) The Good, the Bad and the Unacceptable, London: Faber.

—— (1998a) 'It's Our Job to Tell the Truth about the Corp' *The Times* (6 March): 45.

—— (1998b) 'Digital, Here in Two Weeks', *The Times* (18 September): 46.

—— (1998c) 'The Future has Begun', *The Times* (25 September): 46.

—— (1998d) ''ONdigital Sets Launch Date', *The Times* (26 September): 23.

—— (1998e) 'Received Wisdom' Digital Times (supplement), *The Times* (1 October): 27.

—— (1998f) 'Granada Sells BSkyB stake', *The Times* (14 October): 23.

—— (1998g) 'Start-up Costs Hit News Corp' *The Times* (13 November): 28 (4M Edition).

—— (2003) 'Take Five on Ownership', *The Times* (2 May): 21 (T2).

Soley, L. (2002) *Censorship Inc*, New York: Monthly Review Press.

Sparks, C. (1999) 'The Press' in J. Stokes and A. Reading (eds) *The Media in Britain*, Basingstoke: Macmillan.

—— (2000) 'From Dead Trees to Live Wires: The Internet's Challenge to the Traditional Newspaper' in J. Curran and M. Gurevitch (eds) *Mass Media and Society*, London: Arnold.

—— (2004) 'The Impact of the Internet on the Existing Media' in A. Calabrese and C. Sparks

(eds) *Toward a Political Economy of Culture*, Lanham, MD: Rowman and Littlefield.

Sparks, C and Tulloch, J (2000) *Tabloid Tales: Global Debates over Media Standards*, Lanham, MD: Rowman & Littlefield.

Sparks, R. Young, M.L., Darnell, S. (2006) 'Convergence, Corporate Restructuring, and Canadian Online News, 2000-2003', *Canadian Journal of Communication* 31 (2). http://www.cjc-online.ca/index.php/journal/article/viewArticle/1802/1922 (accessed 6 January 2009).

Spurgeon, C. (2008) *Advertising and New Media*, London: Routledge.

Squires, J. (1994) *Read All About It!*, New York: Times Books.

Steinberg, B. (2009) 'Product Placement Goes Local', *Advertising Age*, http://adage.com/madisonandvine/article?article_id=135549 (accessed 30 March 2009).

Stelzer, I. M. (2001) *Lectures on Regulatory and Competition Policy*, London: IEA.

—— (2003) Interview with the author (22 October).

Sterling, C.H. and Kitross, M. (2002) *Stay Tuned*, 3rd Edition, Philadelphia: LEA.

Stirton, L. and Lodge M. (2002) 'Embedding Regulatory Autonomy: The Reform of Jamaican Telecommunications Regulation 1988-2001, Discussion Paper No.5, Centre for Analysis of Risk and Regulation, London: London School of Economics and Political Science

Street, J. (2001) *Mass Media, Politics and Democracy*, London: Palgrave

Sun, The (1998a) 'Gold Trafford' (7 September): 1.

—— (1998b) 'Skyly Delighted' (7 September):4-5.

—— (1998c) 'Thanks a Billion' (8 September): 6.

—— (1998d) 'The Sun Says' (9 September):3.

—— (1998e) 'TV of the future starts today' (1 October): 12-13.

—— (1998f) 'Free Tomorrow/ Get Our TV Mag and you Can Bin the Rest' (9 October): 1, 23.

Sunday Times, The (1998) Digital TV, Turning You on (supplement) (4 October).

Tait, R. (2003) 'FTCreative Business', *Financial Times* (18 February).

Tambini, D. (2003) 'New Law, New Democratic Deficit', *The Guardian* (13 May): 19.

Taylor, P. (1999) *EC and UK Competition Law and Compliance*, London: Sweet & Maxwell.

Teather, D. (2002) 'Wanted—Some Harry Potter Magic', *The Guardian* (14 January).

Telegraph, The (1998) 'Mandrake: Scotch Missed' (15 November).

Telotte, J. P. (2003) 'The *Blair Witch Project*: Film and the Internet' in S.L. Higley and A. Weinstock (eds) *Nothing That Is: Millennial Cinema and the Blair Witch Controversies*, Wayne State University Press, 2003.

Thompson, J. B. (1995) *The Media and Modernity*, Cambridge: Polity Press.

Thorpe, V. (2003) 'BBC Forced to Cut Back Trailers as Viewers Find Them a Turn-off', *The Observer* (11 May).

Thurman, N. and Lupton, B. (2008) 'Convergence Calls: Multimedia Storytelling at British News Websites', *Convergence*, 14 (4): 439-455.

Thussu, D. (2000) *International Communication*, London: Hodder Arnold.

Time Warner (2007a) '*Harry Potter and the Order of the Phoenix* Dominates Box Office' (July 15), http://www.timewarner.com/corp/newsroom/pr/0,20812,1643709,00.html (accessed 28 January 2008).

—— (2007b) 'Warner Bros. Pictures' Harry Potter Films Combine to Become the Biggest Film Franchise in History' (10 September).

Times, The (1985) 'The Times and the BBC: A Statement' (19 June).

—— (1998) Digital Times (Supplement) (1 October).

TNS Media Intelligence (2008) 'TNS Media Intelligence Reports US Advertising Expenditures Increased 0.6 Percent in First Quarter 2008', http://www.tns-mi.com/news/06112008.htm. Accessed 30 October 2008.

Toffler, A. (1970) Future Shock, London: Bodley Head.

Tomlinson, J (1999) Globalization and Culture, Cambridge: Polity.

Toynbee, P. (2003) 'The Threat to Our TV from this Corrupter of Politicians', The Guardian (30 April).

Tracey, M. (1998) The Decline and Fall of Public Service Broadcasting, Oxford: Oxford Univ. Press.

TUC (1991a) TUC (Trades Union Congress) (1991a) Finance and General Purposes Committee, Media Policy, F&GP 7/2 (25 March), London: TUC.

TUC (1991b) 'Sadler Report Dismays TUC', News Release, (29 April), London: TUC.

TUC (1991c) Letter from Norman Willis, General Sec. to Peter Lilley, Secretary of State, DTI.

Tunstall, J. (1986) Communications Deregulation, Oxford: Blackwell.

—— (1996) Newspaper Power, Oxford: Oxford University Press.

Tunstall, J. and Machin, D. (1999) The Anglo-American Media Connection, Oxford: OUP.

Tunstall, J. and Palmer, M. (1991) Media Moguls, London: Routledge.

Turner, G. (1999) 'Tabloidization, Journalism and the Possibility of Critique', International Journal of Cultural Studies, Vol. 2 (1): 59-76.

Turner, K. J. (2004) 'Instinuating the Product into the Message: An Historical Context for Product Placement' in M-L. Galician (ed) Handbook of Product Placement, NY: Best Business.

Turow, J. (1992a) Media Systems in Society, New York: Longman.

—— (1992b) 'The Organisational Underpinnings of Contemporary Media Conglomerates', Communication Research, 19 (6): 682-704.

—— (1997) Breaking Up America: Advertisers and the New Media World, Chicago: Univ. of Chicago Press.

Underwood, D. (1995) When MBAs Rule the Newsroom, New York: Columbia University Press.

—— 1998) 'It's Not Just in L.A.' Columbia Journalism Review (January/February).

UNESCO (1999) Preserving Media Independence, (Compiled by C. Hamelink), Paris: UNESCO.

Van Cuilenburg, J. and McQuail, D. (2000) 'Media Policy Paradigm Shifts: In Search of a New Communications Policy Paradigm' in B. Cammerts and J-C. Burgelman (eds) Beyond Competition: Broadening the Scope of Telecommunications Policy Brussels: VUB University Press.

Venturelli, S. (1998) Liberalizing the European Media, Oxford: Clarendon Press.

Voorhoof, D. (1995) Critical Perspectives on the Scope and Interpretation of Article 10 of the European Convention on Human Rights, Mass Media Files No.10, Strasbourg: CoE.

Waddington, D. (1990) 'Waddington Backs Independent Press Complaints Commission' The Times (22 June): 6.

Waetjen, J and Gibson, T.A. (2007) 'Harry Potter and the Commodity Fetish: Activating Corporate Readings in the Journey from Text to Commercial Intertext', Communication and

Critical/Cultural Studies, 4 (1): 3-26.

Waldman, S. (1999) 'Sites for Sore Eyes', *The Guardian* (8 Nov) Media.

Wall Street Journal (2000) 'Hosts of ABC's *The View* Praise Campbell's Soup in Eight Paid Spots', (14 November).

Warde, A. (1994) 'Consumers, Identity and Belonging: Reflections on Some Theses of Zygmunt Bauman' in R. Keat, N. Whitely and N. Abercrombie (eds) *The Authority of the Consumer*, London: Routledge.

Wasco. J. (1994) *Hollywood in the Information Age*, Cambridge: Polity Press.

—— (2003) *How Hollywood Works*, London: Sage.

Wayne, M. (2003) Post-Fordism, Monopoly Capitalism, and Hollywood's Media Industrial Complex, *International Journal of Cultural Studies*, 6(1): 82-103.

Weatherill, S. (1997) *EC Consumer Law and Policy*, London: Longman.

Weinraub, B. (1996) 'Entertainment Studio Executives are Alarmed by a Surge in the Costs of Marketing Movies', *New York Times* (12 August): D7.

Wells, M. and Perkins, A. (2003) 'Puttnam to Lead Five Rebels', *The Guardian* (26 March).

Wenner, L. A. (2004). "On the Ethics of Product Placement in Media Entertainment", *Journal of Promotion Management*, 10: 101-132.

Wernick, A. (1990) *Promotional Culture, Advertising, Ideology and Symbolic Expression*, London: Sage.

WGAE (*Writers Guild of America, East*) (2007) 'Broadcast Newswriters Speak About News Quality', New York: WGAE.

Whish, R. (1989) *Competition Law*, London: Butterworths. 2nd Edition.

—— (2001) *Review of the BBC's Fair Trading Commitment and Commercial Policy Guidelines*, London: DCMS.

Wilks, S. (1999) *In the Public Interest: Competition Policy and the Monopolies and Mergers Commission*, Manchester: Manchester University Press.

Williams, D. (2002) 'Synergy Bias: Conglomerates and Promotion in the News', *Journal of Broadcasting and Electronic Media*, 46(3), 453-472.

Williams, G. (1996) *Britain's Media: How They Are Related*, London: CPBF.

Williams, R. (1974) *Television: Technology and Cultural Form*, London: Fontana.

Williams, W. (1996) 'The Online Threat to Independent Journalism'. *Extra!* (Nov./December).

Winseck, D. (1998) 'Pursuing the Holy Grail: Information Highways and Media Reconvergence in Britain and Canada', *European Journal of Communication*, Vol 13 (3) September.

Writers Guild of America (2005) 'Entertainment Guilds Call for Industry Code of Conduct or FCC Regulation for Product Integration in Programming and Film', News Release (14 November), New York: WGA

Wolf, M. (1999) *The Entertainment Economy*, London: Penguin Books.

Young, H. (1993) *One of Us*, London: Pan Books.

Index

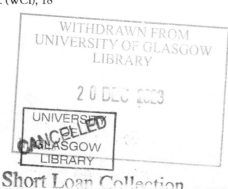